American / True Colors

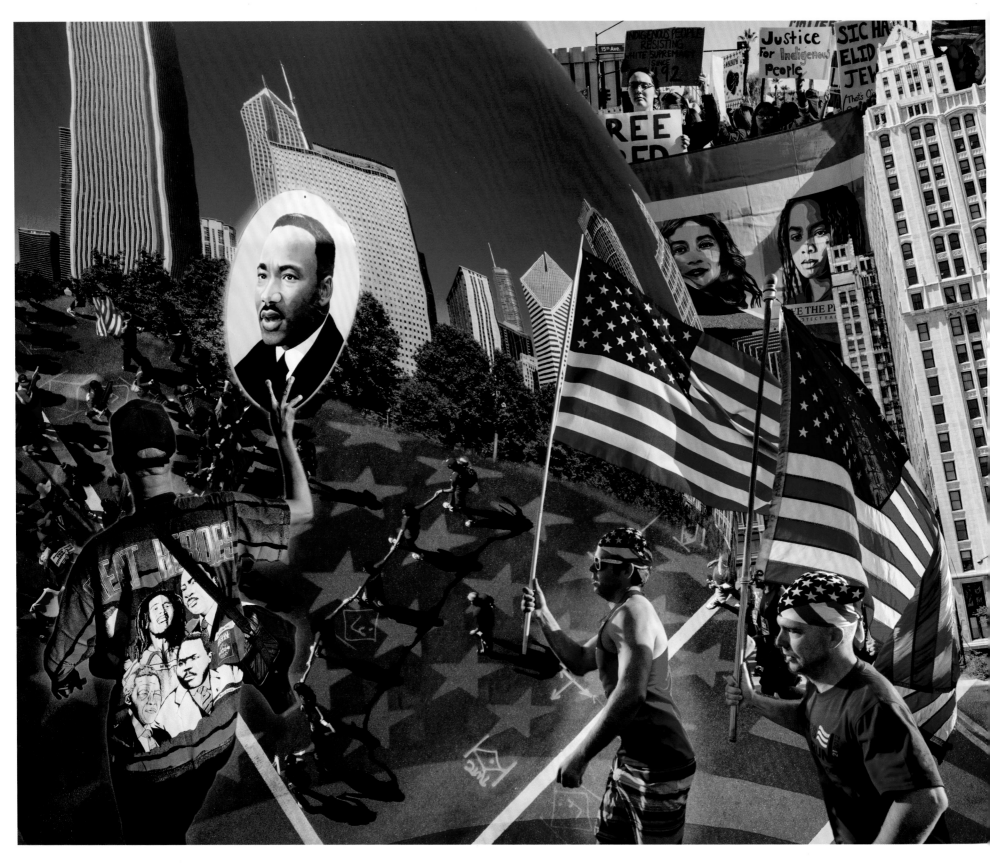

American / True Colors

Stephen Marc

**with an introductory essay
by Bill Kouwenhoven**

**and an interview with the artist
by Rebecca A. Senf**

George F. Thompson Publishing
in association with
the Center for the Study of Place
and in collaboration with
Stephen Marc

Dedication and Acknowledgments

For all the souls lost during the COVID-19 pandemic and the violence of systemic racism and the families left behind.

For all the healthcare professionals, first responders, and other essential workers not only for their heroic efforts during the pandemic, but also for their service every day.

For all the dedicated activists who are genuinely in the struggle to make America and the world a better place.

And, finally always, for the Ancestors.

Special thanks to:

My family, friends, and mentors who have supported me and exercised their patience with me in so many ways over the years, making it possible for me to do what I do.

And the people whose paths I have crossed to make this project come to life, especially those who I photographed and those who shared their wisdom so I had a better understanding of where I was and what I was witnessing.

Contents

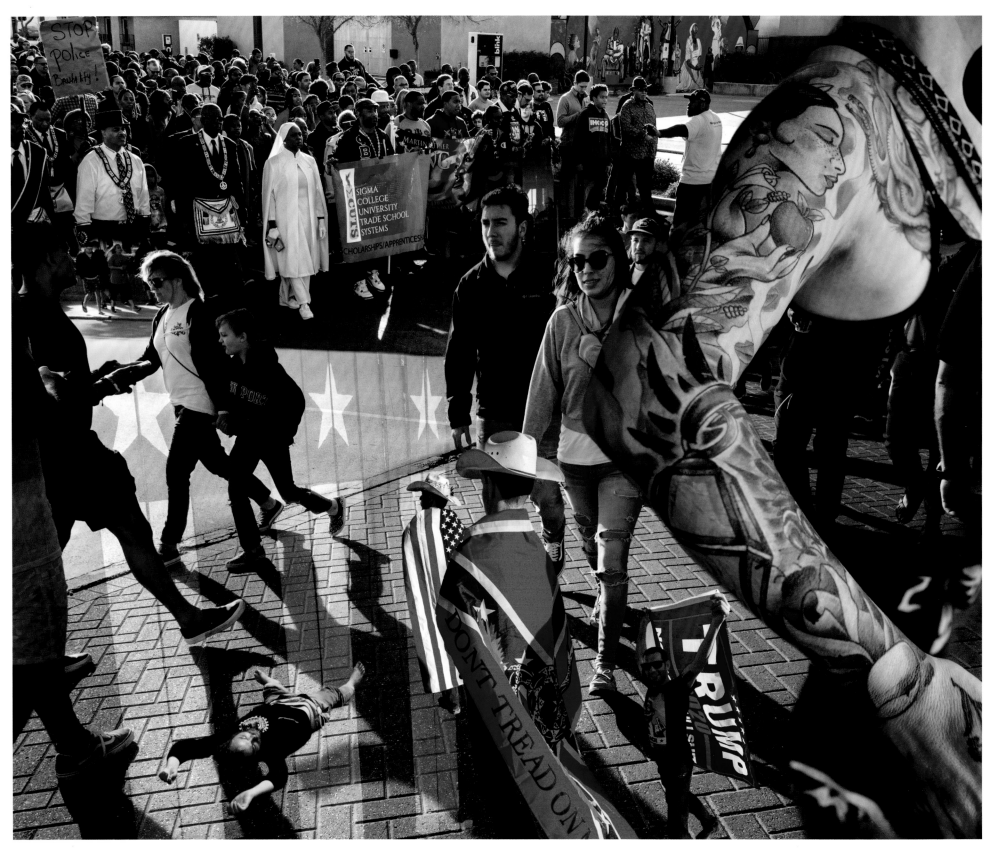

O, Say Can You See?
Stephen Marc's Americans

BY BILL KOUWENHOVEN

Back in 1831, Samuel Francis Smith, then a student at Andover Theological Seminary in Andover, Massachusetts, penned "My Country 'Tis of Thee," whose opening lines are familiar to all Americans:

> My country, 'tis of thee,
> Sweet land of liberty,
> Of thee I sing;
> Land where my fathers died,
> Land of the pilgrims' pride,
> From ev'ry mountainside
> Let freedom ring!

It is with irony that we remember that this hymn is actually a reworking of the reverential tune for "God Save the King," against which said King, George III of England, the colonialists had rebelled some fifty-five years earlier. And it is with irony that we recall that this "unofficial" national anthem, sung in school assemblies even today, seconded our true "National Anthem," the

one Francis Scott Key scribed during the battle at Fort McHenry in Baltimore Harbor in 1814 during the War of 1812, the one that begins, "O, Say Can You See . . ." And the story continues: The "Star Spangled Banner," one of the most unsingable songs in the world, itself was based upon a popular English drinking song, and it became the foremost sung version of the "Manifest Destiny" of the young United States of America.

The questions "Whose liberty?" and "Whose freedom?" have been debated and contested since the earliest days of the Republic when the signers, in the first paragraph of the Declaration of Independence on July 4, 1776, steadfastly proclaimed the ideals of the newly declared nation:

> We hold these truths to be self-evident, that all men are created equal, that they are endowed by their Creator with certain unalienable Rights, that among these are Life, Liberty and the pursuit of Happiness.

It has taken a long time—a Civil War and a handful of Amendments to the Constitution and suffrage and Civil Rights and LGBTQ and BLM movements—to bring us closer to a more inclusive "Land of Liberty." And the striving of most citizens towards creating a more perfect union that seeks to fulfil those "unalienable Rights" has been a fundamental of American life since July 4, 1776.

The United States of America still represents what President Abraham Lincoln described in 1862 as "the last best hope of earth" for a democracy.[1] To be sure, the nature of an inclusive republic has changed over the years, and sometimes America confronts itself with images and actions that contradict these ideals of "Life, Liberty and the pursuit of Happiness." Witness Robert Frank's revelatory photographs of America from the mid-1950s, eighty-three of which were published first in France by Delpire as *Les Américains* in 1958 and then in the United States by Grove Press in 1959 as *The Americans*, with a thrilling, ecstatic introduction by Beat writer Jack Kerouac. Frank's images, the result of two years' worth of criss-crossing the continental United States in an old Ford Business Coupe while on a Guggenheim fellowship, confronted the saccharine bliss of post-World War II America's image of itself with a darker reality, as seen from the streets and roadsides of a booming country that seemed to be at the height of its power in the world. Kerouac, author of *On the Road* (1957), the seminal American text from the 1950s, exalted in Frank's vision:

> That crazy feeling in America when the sun is hot on the streets and music comes out of the jukebox of from a nearby funeral, that's what Robert Frank has captured in these tremendous photographs taken as he travelled on the road

around practically 48 states in an old used car (on a Guggenheim fellowship) with the agility, mystery, genius, sadness, and strange secrecy of a shadow photographed scenes that have never been seen before on film . . .[2]

Kerouac reveled in Frank's massive project of making more than 28,000 photographs in two years and described a swirling cacophony of images that encompassed what, for him, was a more real America beyond or behind the myths promulgated by the media during the Eisenhower era. Consider this description:

> The humor, the sadness, the Everythingness, and americannest of these pictures! Tall thin cowboy rolling butt outside Madison square garden new york for rodeo season, sad, spindly, unbelievable. . . . Long shot of night road arrowing into immensities and flat of impossible to believe America in New Mexico under the prisoners' moon. . . . Under the whang whang guitar star . . .

In another riff, he continues:

> Old man standing hesitant with oldman cane under old steps long since torn down. . . . Madman resting under American flag canopy in old curbsted car seat in fantastic Venice California back yard . . .

Then, think about this, as seen from the eyes of Kerouac, an American, looking through the eyes of Frank, a foreigner:

> St Petersburg fla the retiree old codgers on a bench in the busy mainstreet leaning on their cans and

talking about social security and one incredible I think Seminole or half Negro woman pulling on her cigarette with thoughts of her own, as pure a picture as the nicest tenor solo in jazz . . . Wow, that woman, pulling on her cigarette and thinking her own thoughts: Such an image of independence and I don't give a fuck about what other people think . . . A perfect solo image.

This rawest of raw copies of the first draft of Kerouac's introductory text to one of the great feats in photography—*The Americans*—sets the stage for an equally challenging, if more euphoric, body of work: Stephen Marc's *American/True Colors*. Begun more than fifty years after Frank, Marc addresses the U.S. in all its glory and contradictions. Marc also relied on the road trip a la Frank and Kerouac across the continental Lower 48 in airplanes and rental cars (wings and wheels), but Marc's work spans the twelve years during the presidencies of Barack Obama and Donald Trump. The resulting images are now compiled and enshrined between the covers of this magical book. The earliest image is from late 2007 of not-yet-President Barack Obama on the campaign trail, and from there Marc takes us on an unforgettable survey of festivities, rallies, celebrations, protests, counter-protests, and everyday activities right up to the last public gatherings before COVID-19 required the national shutdown in March 2020. In 250 photographs, Marc presents a swirling phantasmagoria of our modern, still imperfect Union.

Of course, as Kerouac wrote about Frank I'd like to riff about Marc in a sustained rush of breathless exhilaration about the fantastic possibilities of life lived to the fullest in the public spaces of twenty-first century America, but I am not Jack Kerouac. Still, I am going to give it a try because Stephen Marc's images are the most incredible celebration of Americans and the American vernacular imaginable. His vision leaves me breathless, and his kaleidoscopic images are vibrant testimony to the love he feels for our contradictory and self-contradicting land, one that too often seems at war with itself over the very shape of these United States.

These images scream: "O, Say Can You See?" They scream: "Look at me! This is my story." Marc's is a multi-layered visual story about America that his subjects, from coast to coast, witting or unwitting, want to share. Note how the people whom Marc photographs embrace him, feeling so comfortable in his presence. Pulled together, the book is a collective portrait of a bubbling society, chaotic and in ferment—like John Dos Passos's *U.S.A. Trilogy* from the 1930s, also notable for its "Camera Eye" perspective, a play on the "Camera I," the expressed vision of the author/narrator/seer/visionary.[3]

From the very first image in *American/True Colors* to the last, from sea to shining sea, Marc's pictures, like Frank's, abound with flags. All sorts of flags: flags flown, flags worn, flags in Flagstaff, Arizona. . . . Mostly they are the classical Stars and Stripes, representing the official flag of the U.S. of A., but there are others: the Confederate flag popularly but mistakenly called the "Stars and Bars," the actual battle flag of the Confederate States of America (with its white trim), sarcastic flags like the one that says "Bite Me" displayed by a pro-Second Amendment supporter in Phoenix, Arizona, and juxtaposed, on the opposite page, by a man wearing a stylized Confederate flag hat with the logo "Southern Bred" in front of the State Capitol of South Carolina on the day of the signing ceremony to officially retire the Confederate battle flag from being flown on the Capitol grounds.

We can go on: There is the boy with two stars sculpted into his hair cut during a Super Sunday Parade in New Orleans standing shyly before another Mardi Gras Indian in feathers identified as the Flag Boy by the logo on his costume whom Marc encountered before they joined the procession with their chief and the rest of the tribe. Then there's Jon Ritzheimer, flashing his flag tats in Phoenix at an anti-Islam rally in front of the Islamic Community Center. He went on to join an anti-government stand-off in Oregon. There are all sorts of war re-enactors. As we know, modern America is the product of many wars on the continent: against Indigenous peoples and other colonial powers—and—as we have seen in the Black Lives Matter Movement—against its own citizens. There are cowboys reenacting the Wild West mythos and dancers celebrating Azatlan, the land of the pre-conquest peoples of the Southwest. There are the spunkier celebrations: the mermaid parades at Coney Island and the skateboarders of Robert Frank's "fantastic Venice, California." Even Fredrick Douglass, the most photographed man in history back in his day, makes an appearance through the presence of a re-enactor riding in a stretch HUMVEE during a Fourth of July parade in, you guessed it, Flagstaff.

O, Say Can You See where we are going with this?

In *The Americans*, Robert Frank made much of a politicized, segregated, and economically unequal America during its rise as a world power in the 1950s. But, for all the images of a highly politicized America that Marc made along the course of his own on-the-road experiences, we sense in Marc a shared feeling of community. Maybe I should phrase that differently. Frank's America during the 1950s is more like Kerouac's—to be found "on the road" where individuals and couples are often seen isolated from their community. Marc's America is the opposite: In "taking his camera to the streets," he finds community everywhere, with people interacting every which way. To Frank, America's roads relate to journeys and discovery and often loneliness; to Marc, America's streets are all about community, society, and interactions with others.

I don't say this lightly: Regardless of where he is, Marc has the ability to charm the paint off walls and to find humor in the most absurd of situations. He's able to access both sides of the political/racial/societal/economic/gender barriers that often separate one America from another America. Whether Marc is at a Black Lives demo or a Gay Pride rally, a pro-immigration protest or an anti-abortion event, a Veteran's Day or Fourth of July parade, a pro-Trump or anti-Trump rally, or just taking part of an everyday scene, he can work all the angles and come back with, what Kerouac would have called, the most "Americannest" of pictures.

Witness Marc's singularly important picture from the Ku Klux Klan rally a week after South Carolina's de-flagging day in 2015 (page 29). The first thing that catches the eye is the back side of the head of a State Trooper, a black guy entrusted with keeping separate demonstrators at peace: namely, hard-core supporters of the Confederate flag hanging with members of the KKK, virtually all white folk, and a mixed group of counter-demonstrators supporting the flag's removal. Among the swirl of Confederate battle flags on the grounds of the State Capitol are a bunch of white Klan members displaying a black banner with symbolically silhouetted Klan figures in their traditional white-hooded robes and the logo—way too ironic for my poor soul—"The Original Boys 'n Hood," a reference to Boyz 'n da Hood, the legendary black Gangsta Rappers from Atlanta.

Marc has photographed Americans differently than Robert Frank did. For one thing, Frank was Swiss, and he explored and discovered an America he had only heard about or read about in Europe. He saw America from the position of an outsider and thus tended to focus on isolated figures and couples, suggesting a dark side to prospering America. Marc, on the other hand, is an African American from Chicago and Champaign, Illinois, who had already crisscrossed America numerous times. He thus anticipated what he was getting into when he started this project, and yet he let himself be swept along by the "madding crowd" (as Thomas Hardy would say) to find new dimensions and new stories among the kaleidoscopic connections he instinctively found among the people he met and situations he encountered along the way.

Robert Frank's America doesn't exist today, except in vestigial amounts, and, with a few exceptions, we do not recognize "his" Americans. Another America has emerged in the new millennium—one that is increasingly urban and multi-racial. Yet, for all of America's contradictions, Marc reminds us that America remains a unique place, where we are all neighbors in the crowd, even if not all of us see it that way. The band Sisters of Mercy put it this way: "You say we're almost all alone together, all alone."[4] That is a vision not far removed from Robert Frank's. With respect to the photographs in *American/True Colors*, as I search through that sort of mad jukebox that Kerouac loved, albeit with different taste, I find my personal take in "We Are Family," the 1979 hit by the band Sister Sledge, a song written to remind us that, despite our myriad differences, whether we like it or not, whether alone or not:

We are family
Living life is fun and we've just begun

I got all my sisters with me
To get our share of this world's delights

We are family
(High) high hopes we have for the future

Get up everybody and sing
And our goal's in sight
no, we don't get depressed . . .[5]

That hopeful view is close to Stephen Marc's way of looking at life in America today.

To end on a teaser, let's turn to another key image: not of the kid with stars in his hair (page 21) but of the kid sipping his soda at the Bud Bilkin Parade in Chicago (page 184). As Marc tells it, he was setting up down low, photographing while backing up to keep from being run over by the bunch of kids who zoomed into the frame with that "Mister, take my picture" attitude that demands to make a statement that screams, "Look at me, too!' While across several frames, without being moved, the kid just keeps sipping his drink in a moment of ultimate cool. Yes! Marc got that scene nailed cold!

That is *the* picture for me in this phenomenal body of work. It is, as Jack Kerouac would've said, the apotheosis of America. It is "as American as a picture can be." And so why not end by paraphrasing Kerouac's ultimate compliment to Robert Frank? To Stephen Marc, I give this message: You got eyes.

Notes

1. Abraham Lincoln, from the closing paragraph of his December 1, 1862, letter to the U.S. Congress, one month before signing the Emancipation Proclamation.

2. This and subsequent quotations come from the first draft (1957) of Jack Kerouac's "Introduction" for Robert Frank's The Americans. Credit: The New York Public Library, New York City, Astor, Lenox and Tilden Foundations, The Henry W. and Albert A. Berg Collection of English and American Literature. Reprinted by permission of John Sampas, Estate of Jack Kerouac.

3. The trilogy, published by Harcourt Brace in 1938, included three novels: The 42nd Parallel (1930), 1919 (1932), and The Big Money (1936).

4. From the song 'I Was Wrong" from their ironically titled album, Vision Thing (1990), itself a subtle dig at then-presidential candidate George H. W. Bust's 1988 phrase admitting a lack of "grand dreams" for America. Source: East/West Records and Elektra Records (1990).

5. Written by Bernard Edwards and Nile Rogers, recorded by Sister Sledge, Cotillion Records/Atlantic Records (1979).

American / True Colors

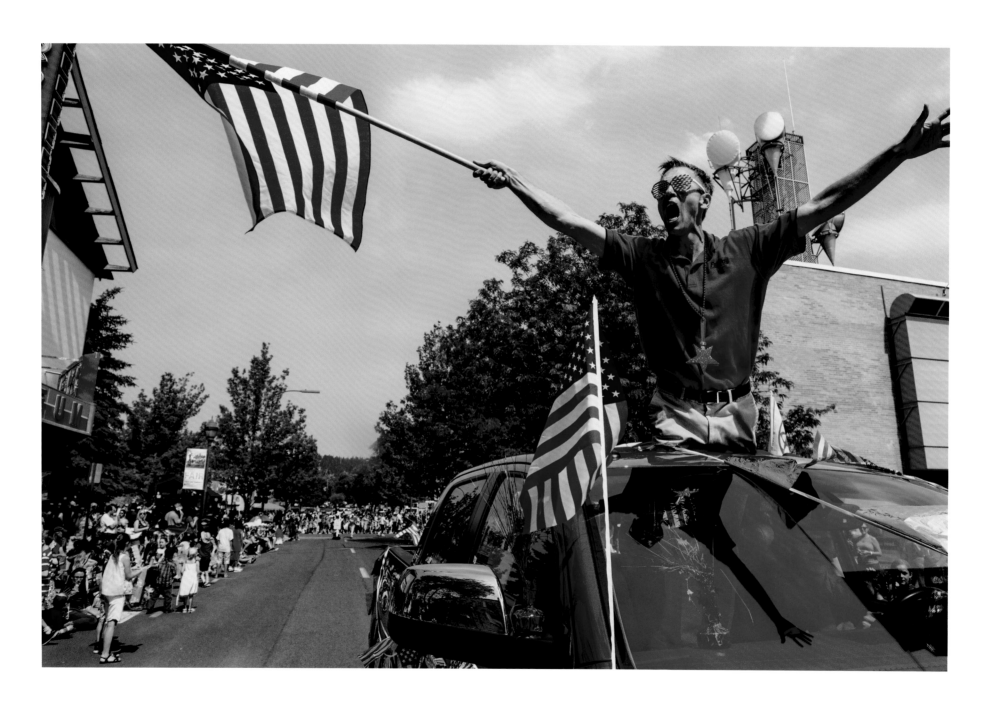

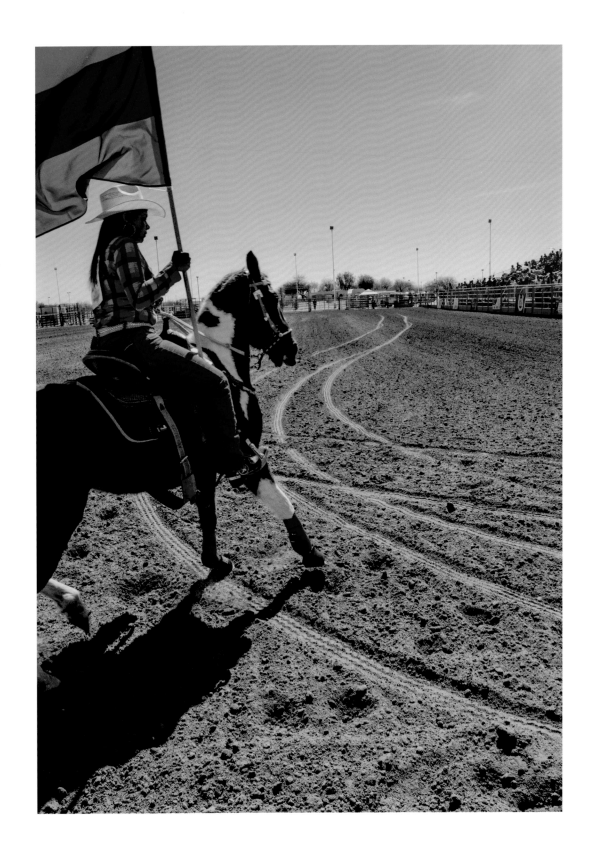

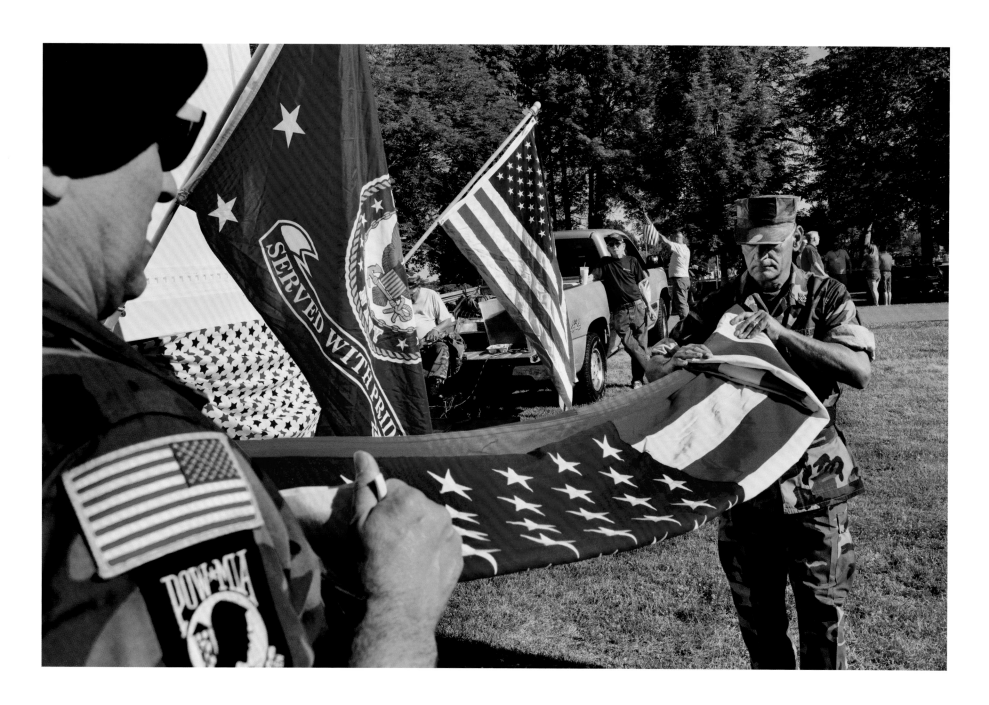

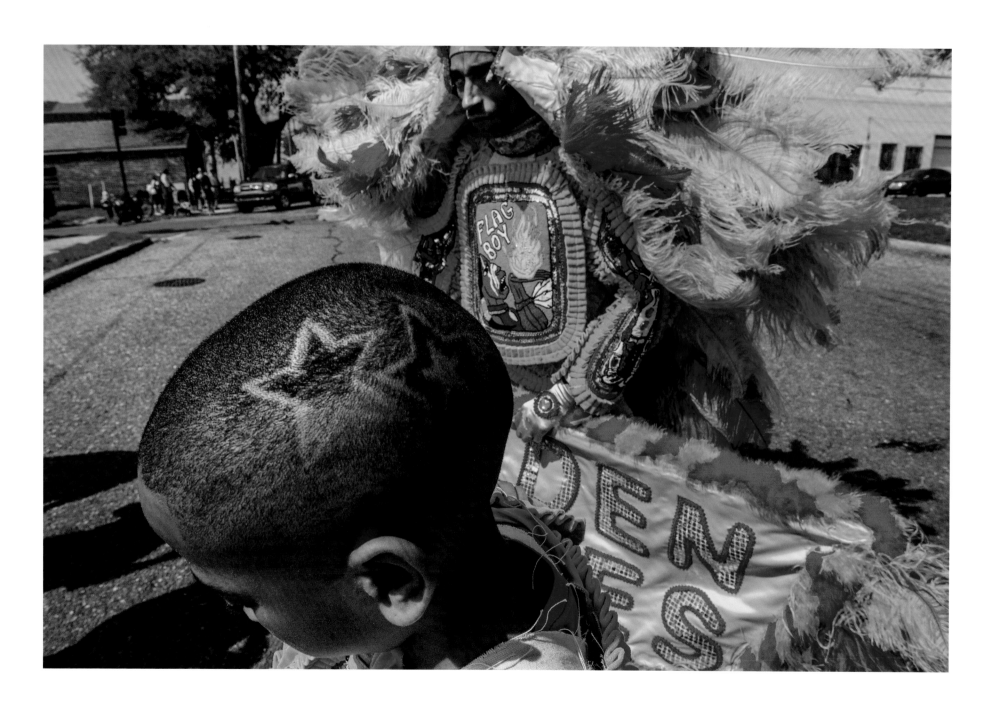

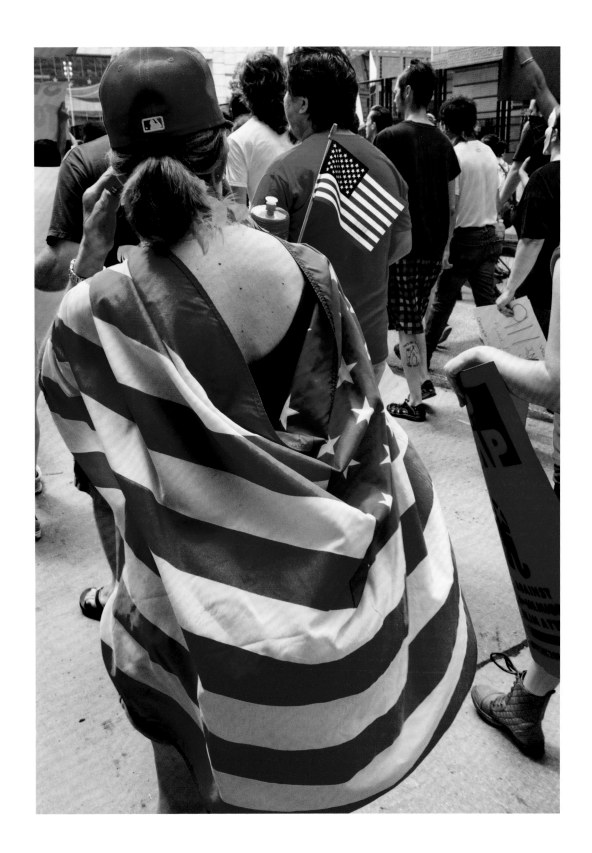

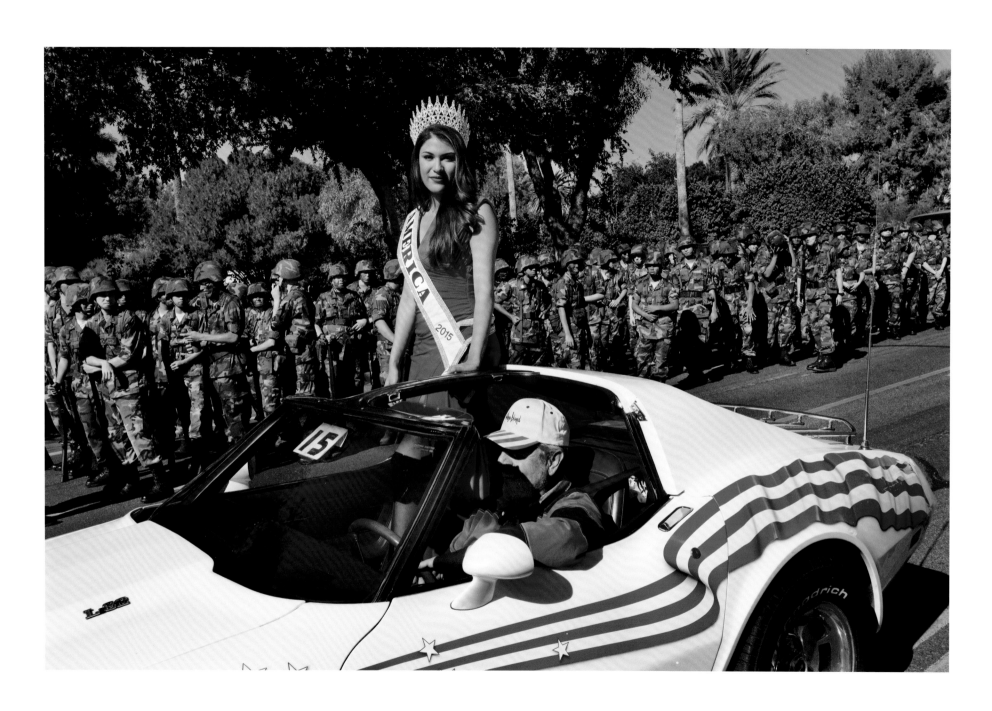

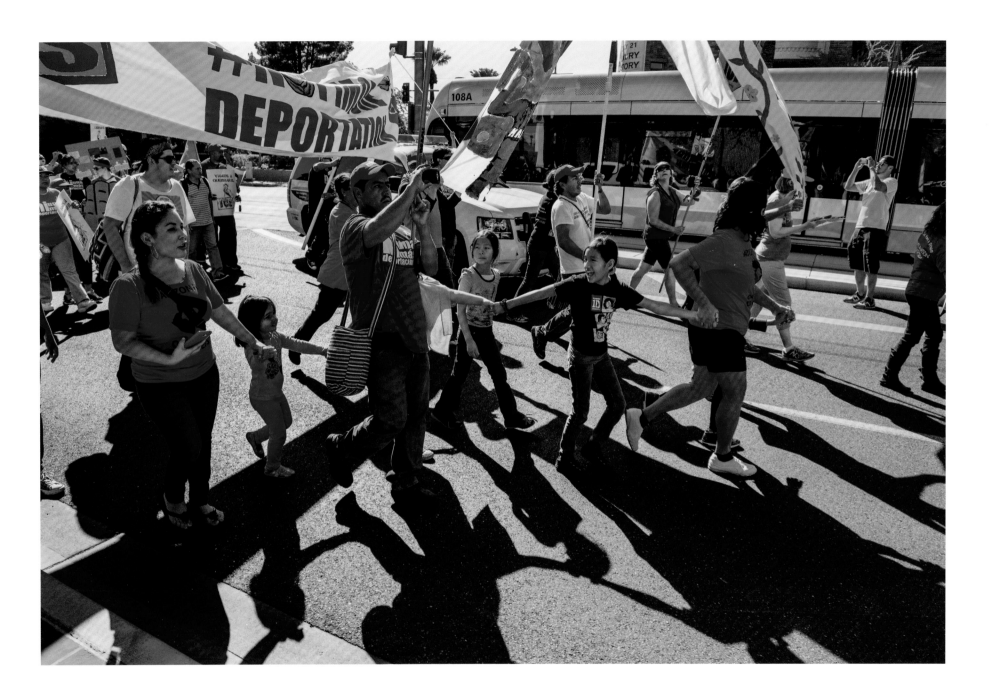

24 Phoenix, AZ

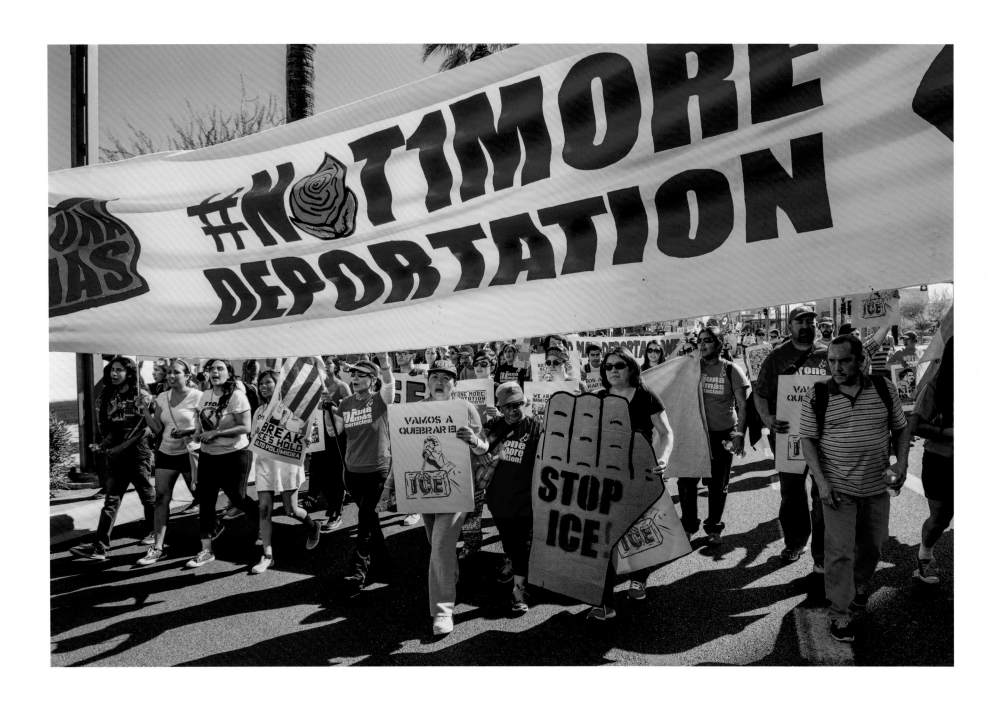

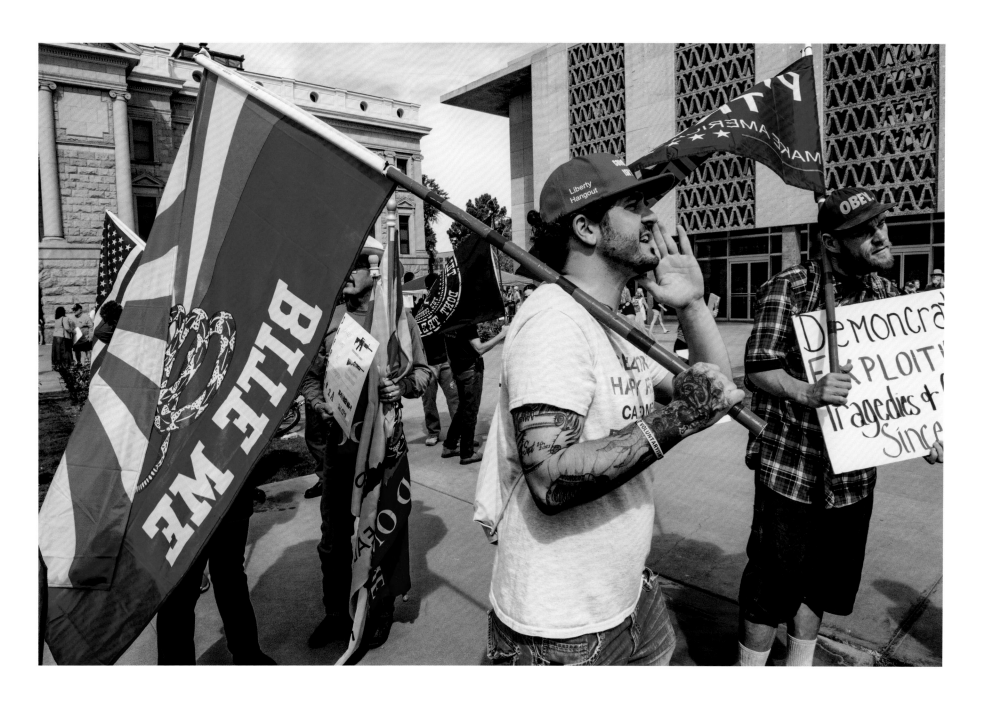

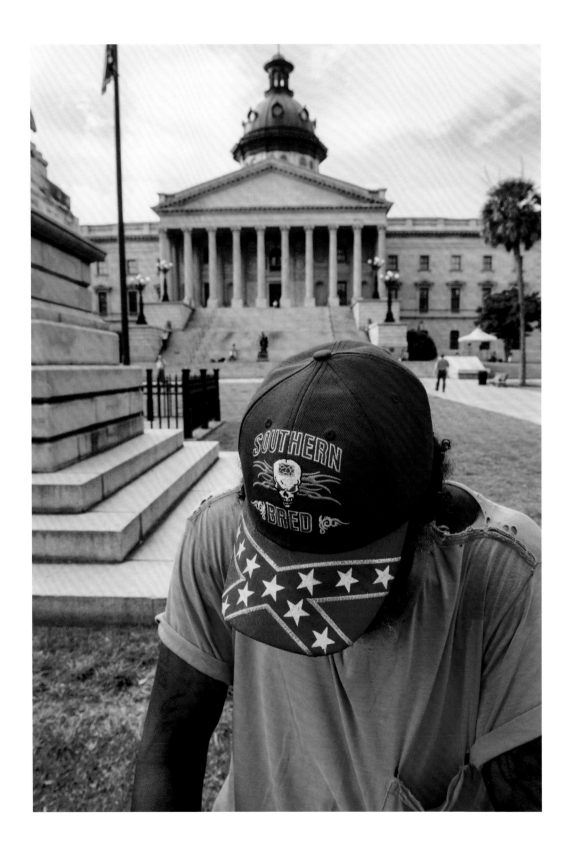

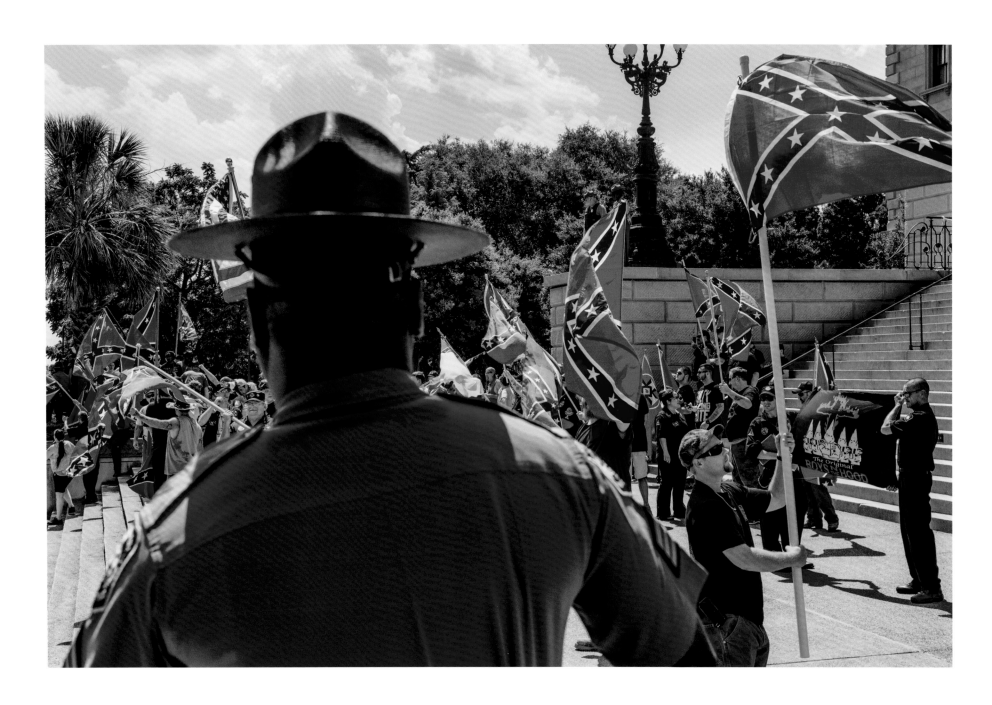

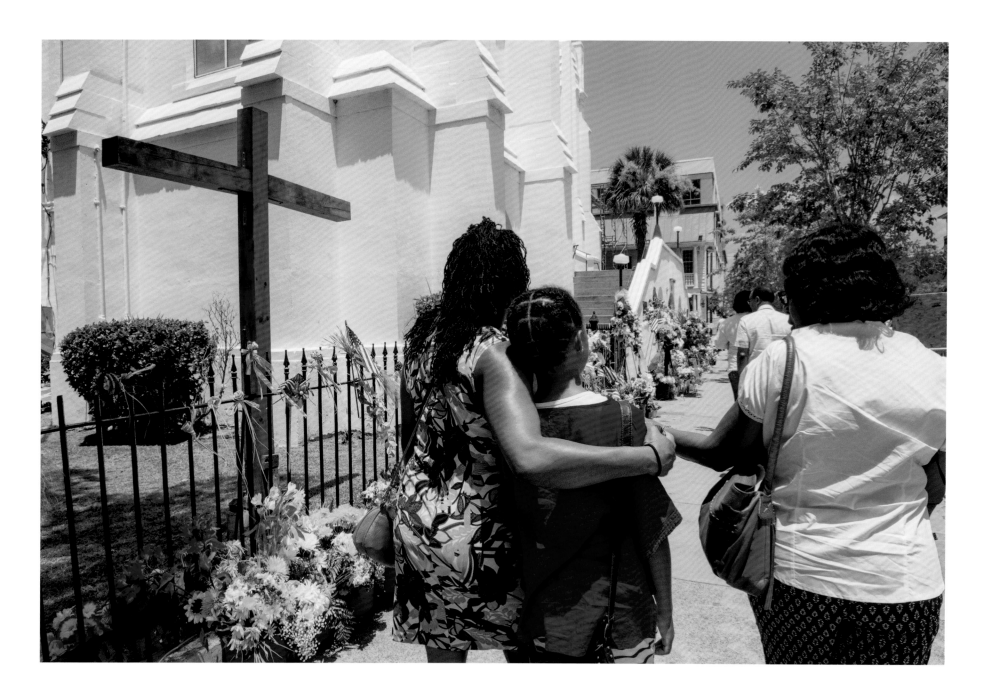

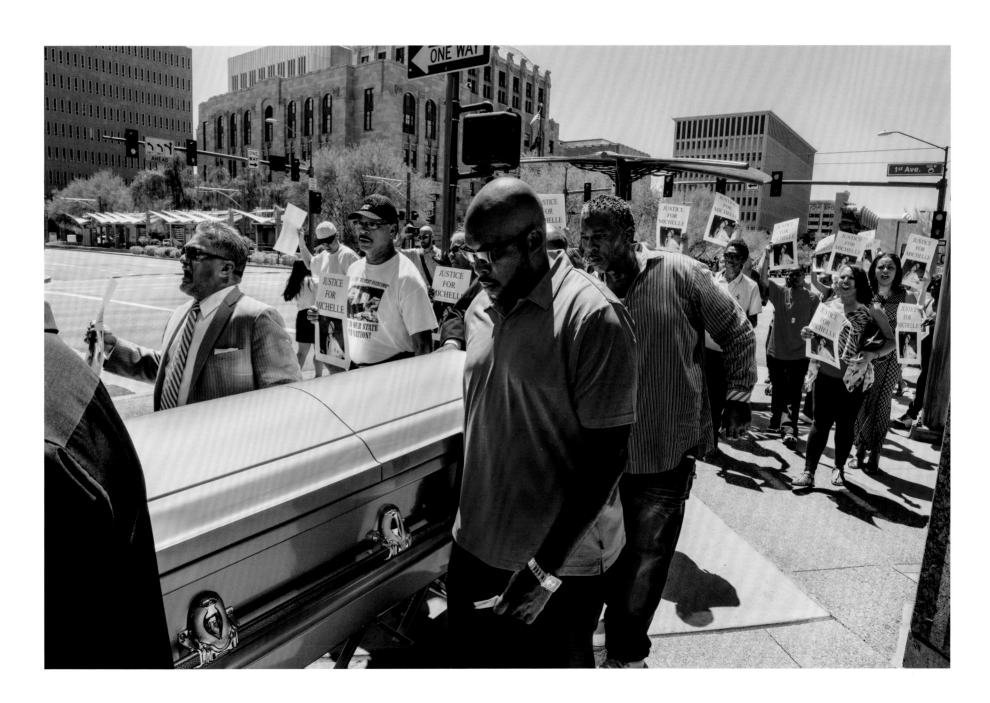

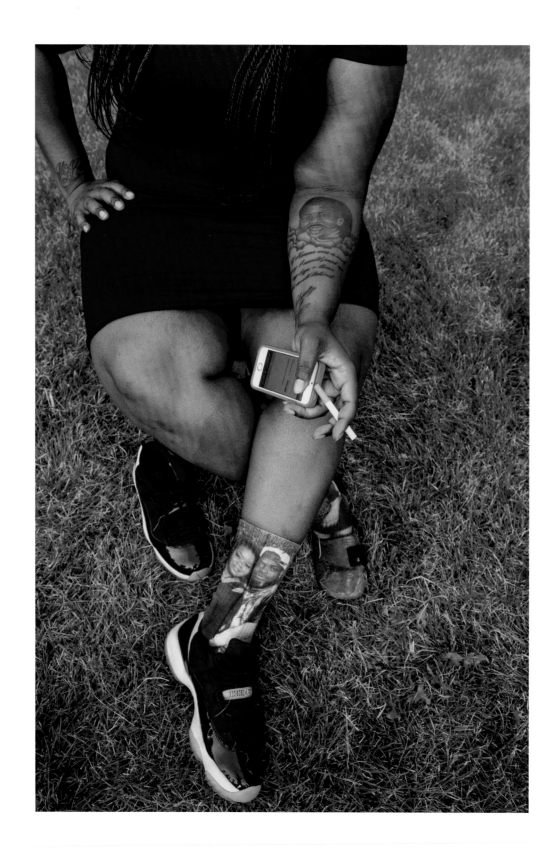

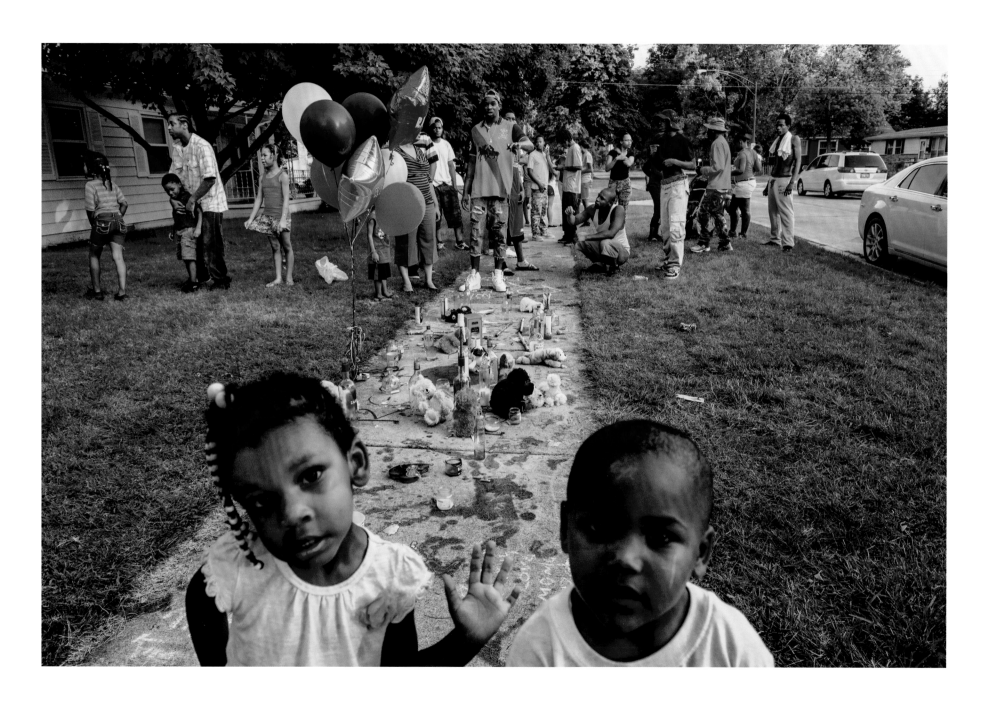

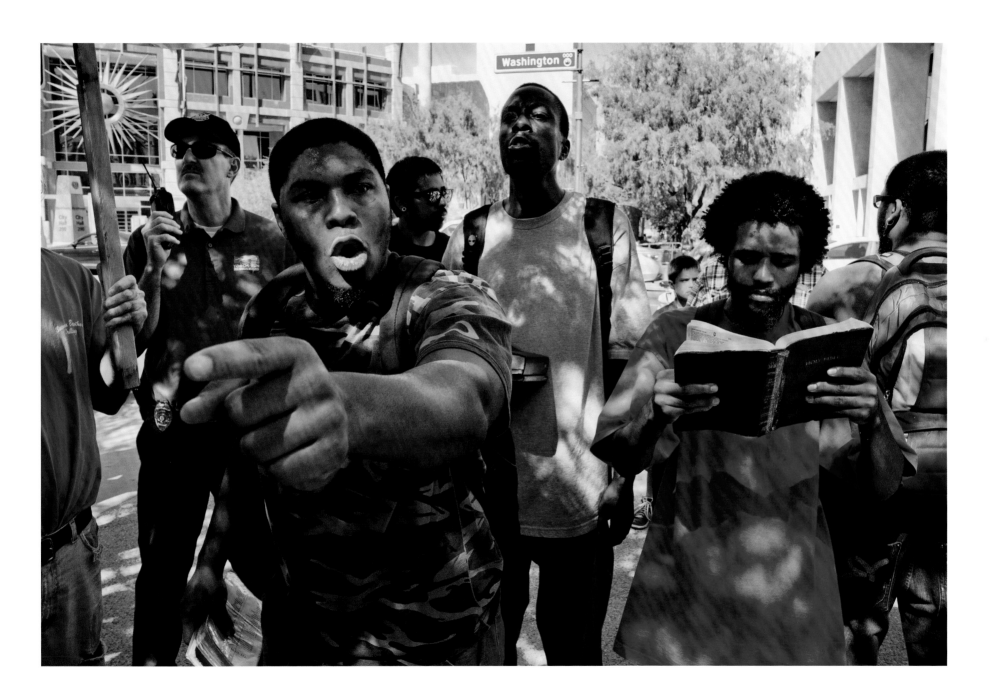

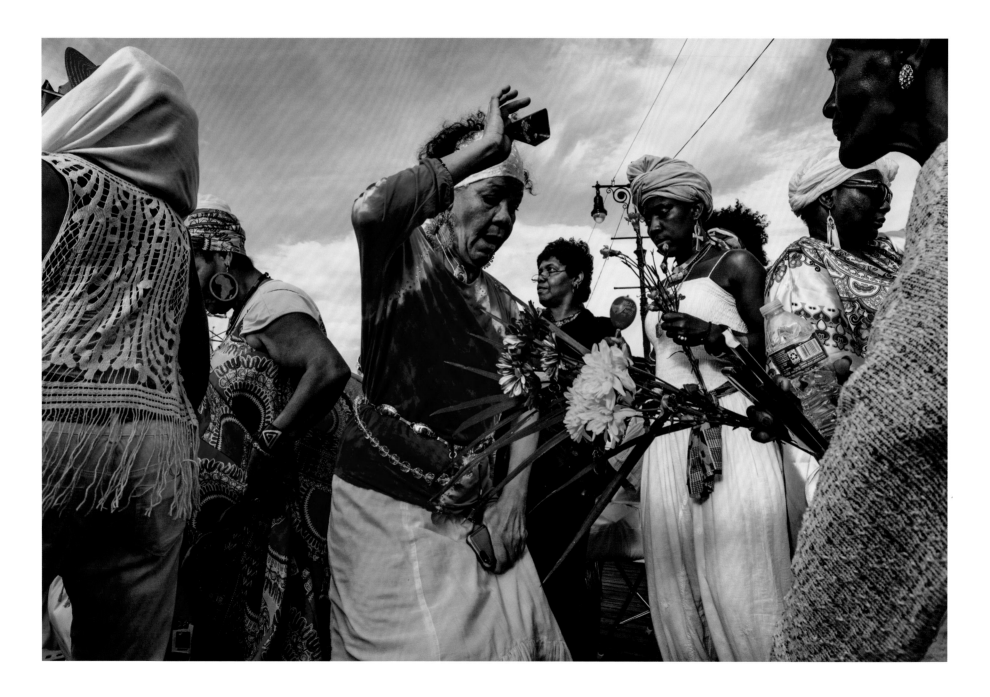

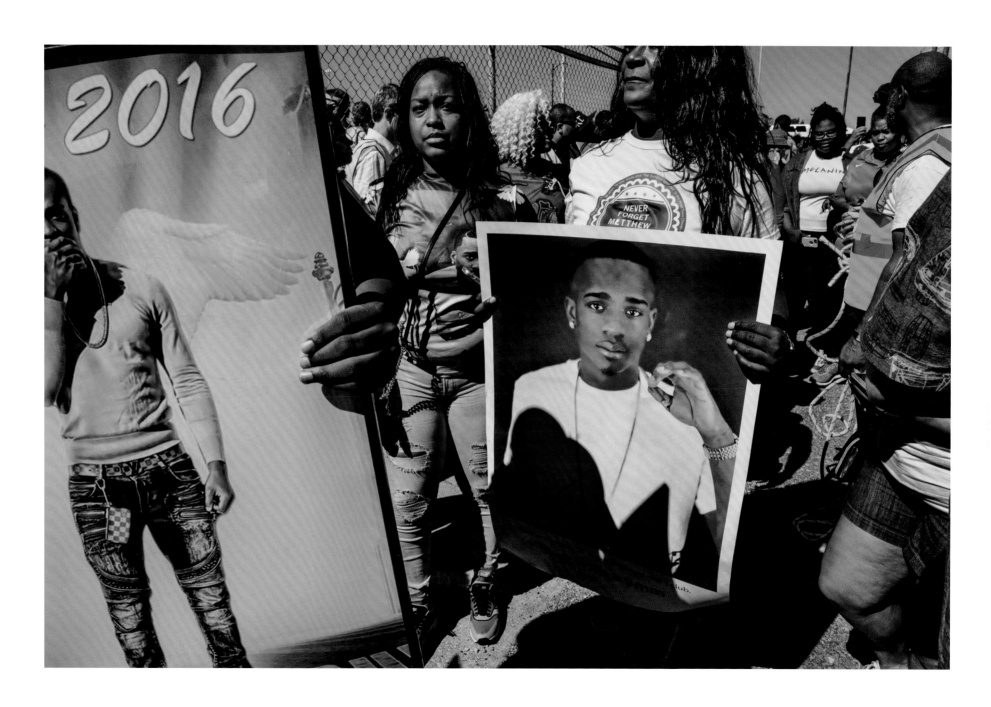

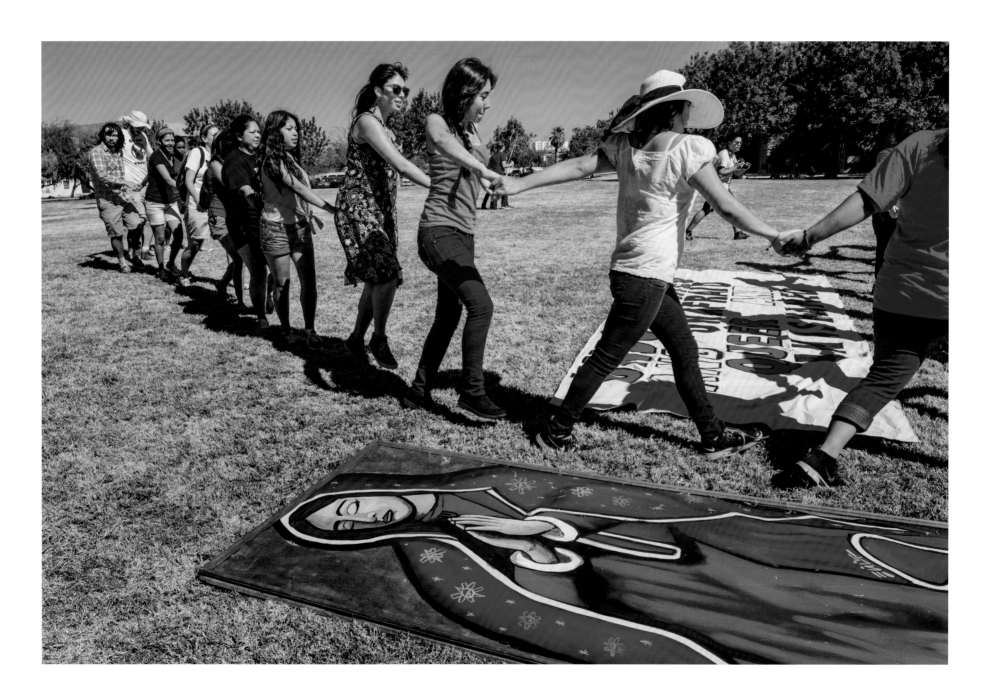

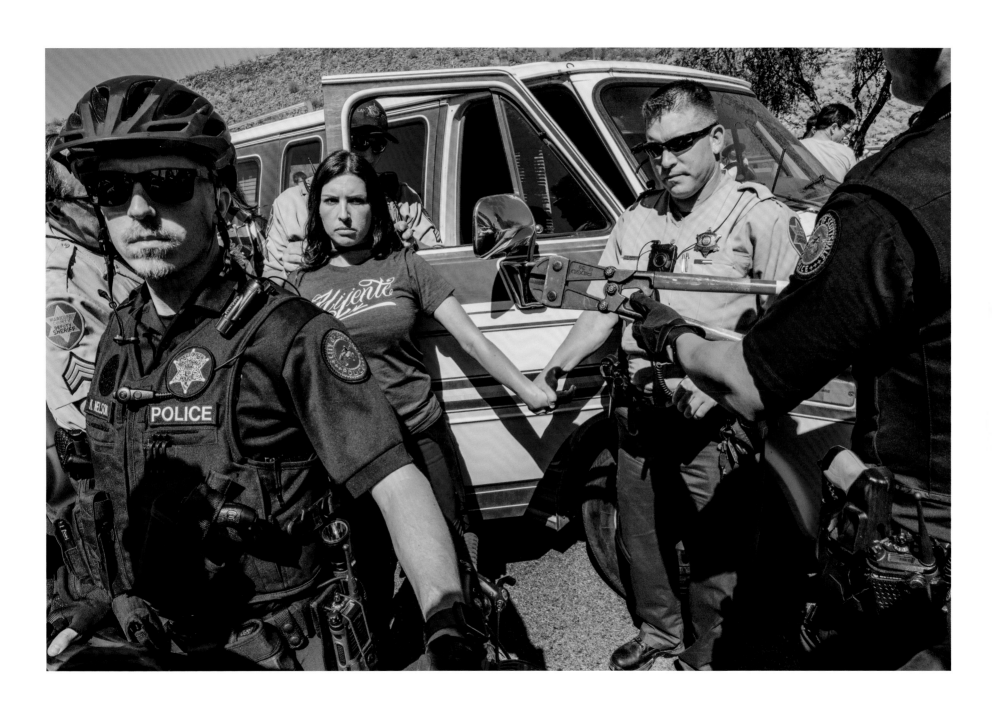

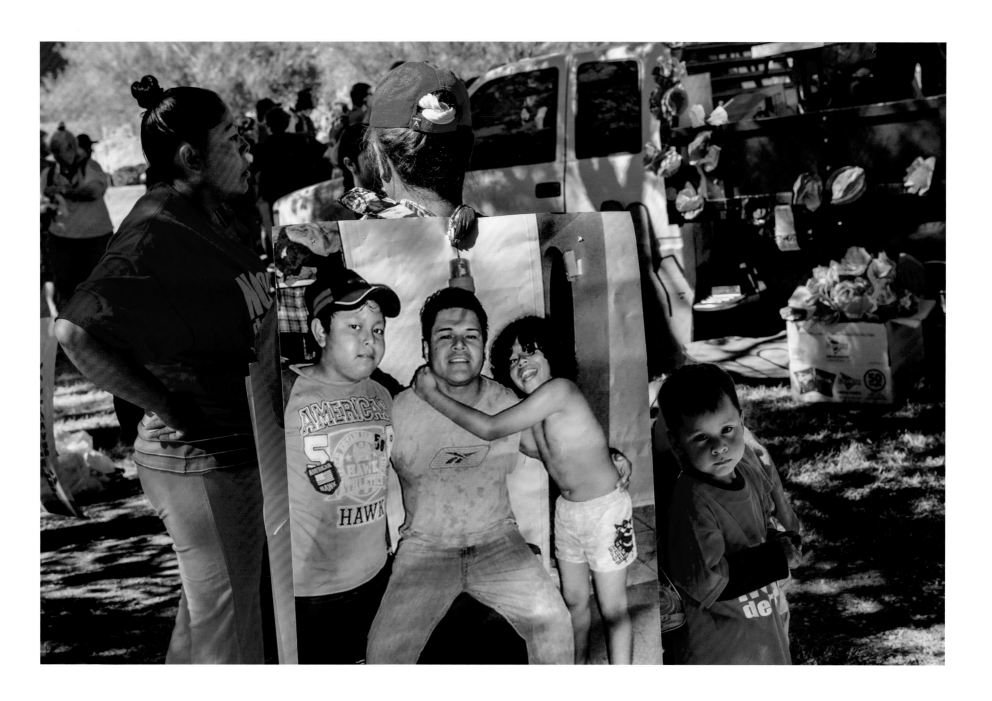

40 Phoenix, AZ

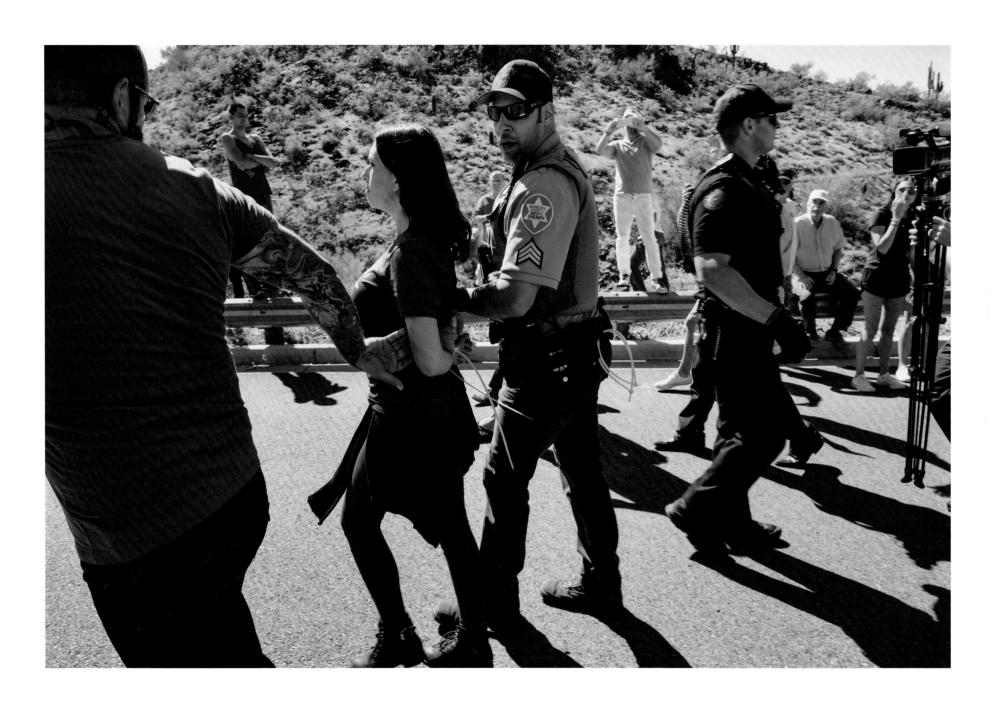

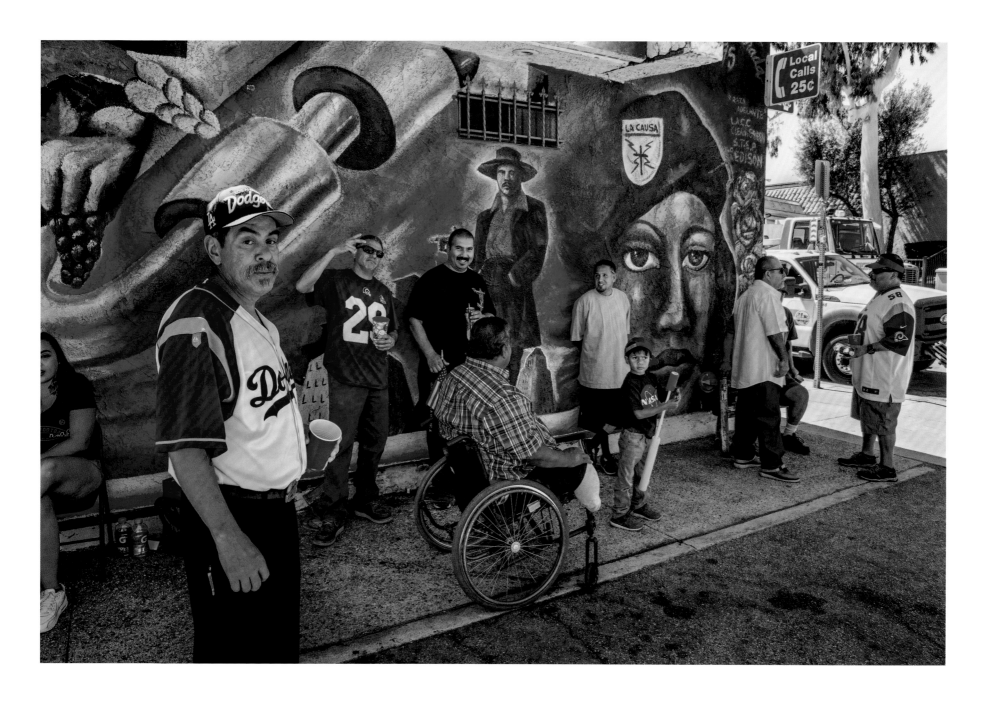

42 East Los Angeles, CA

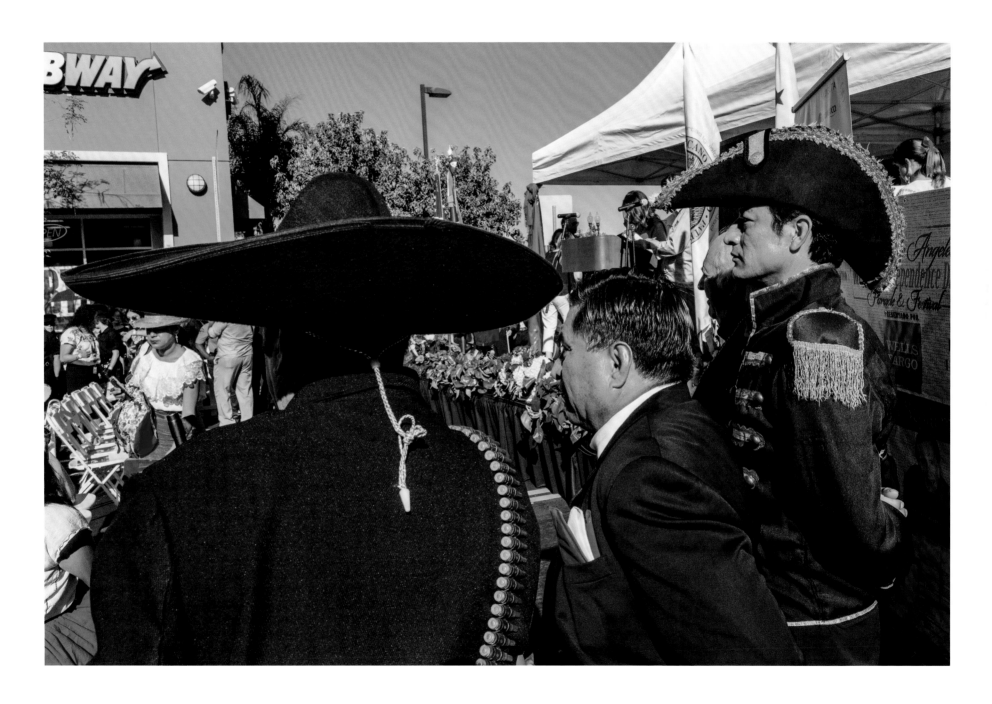

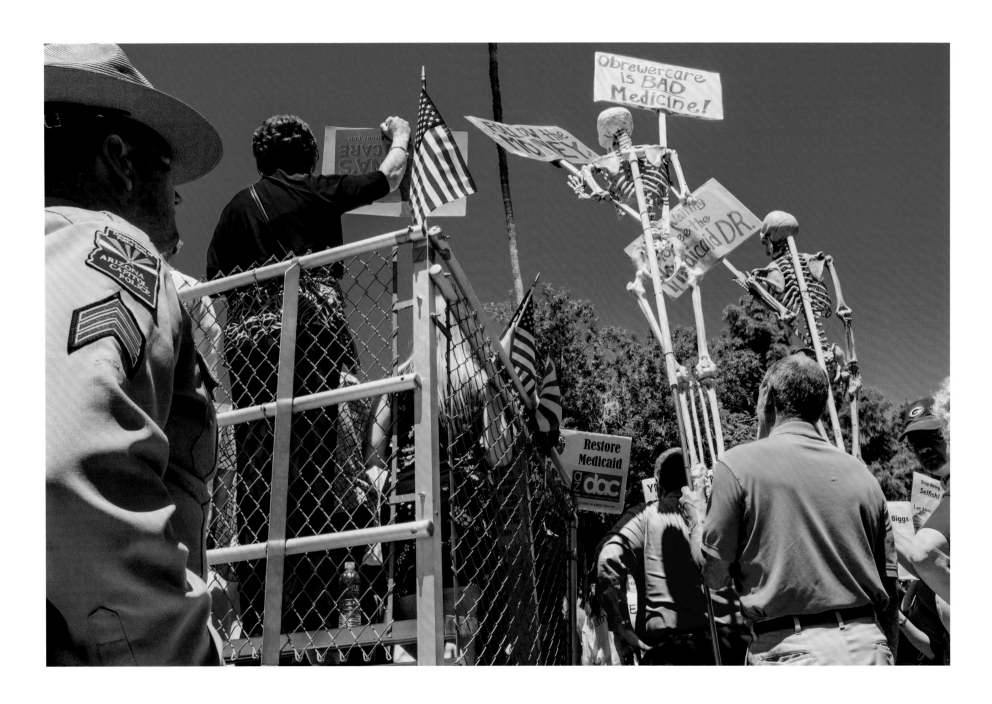

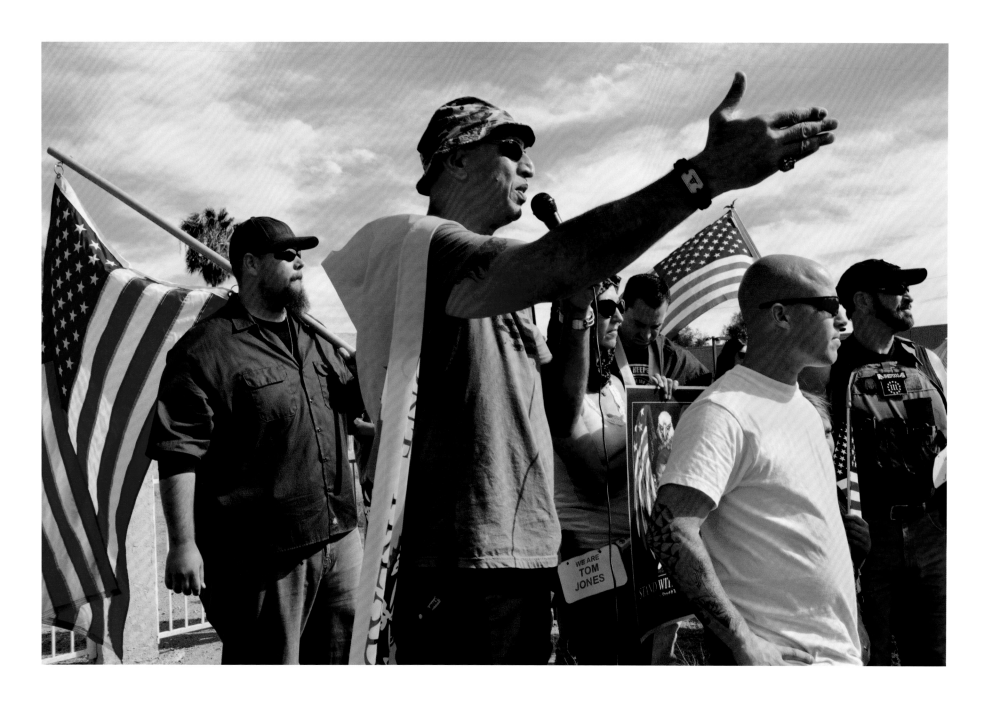

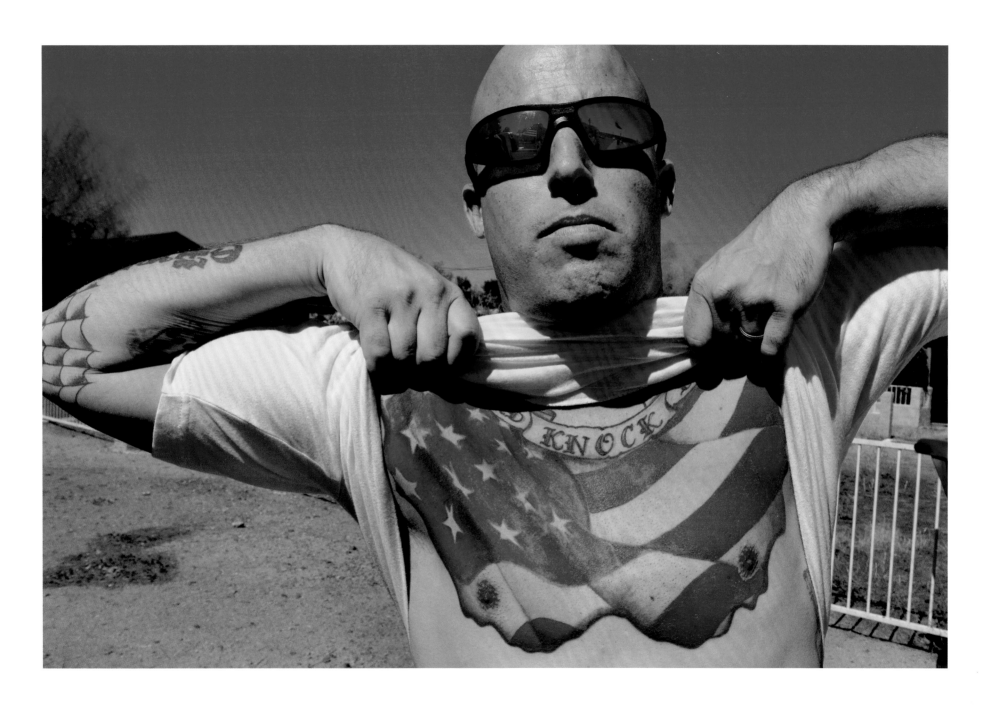

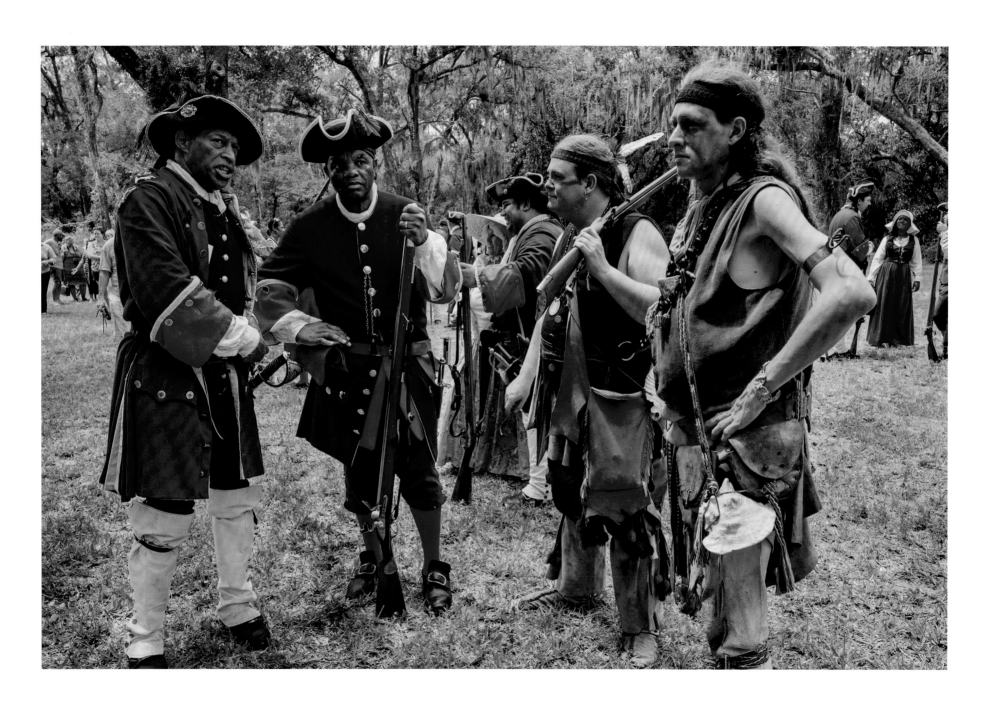

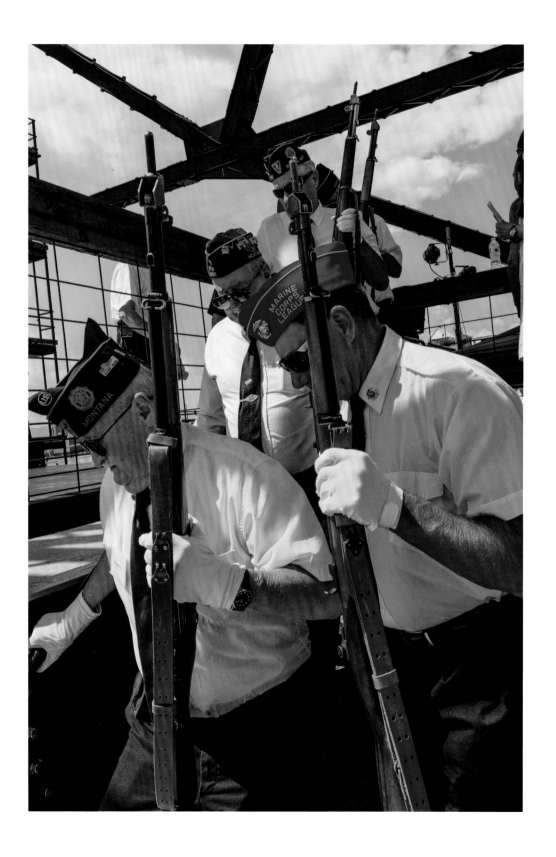

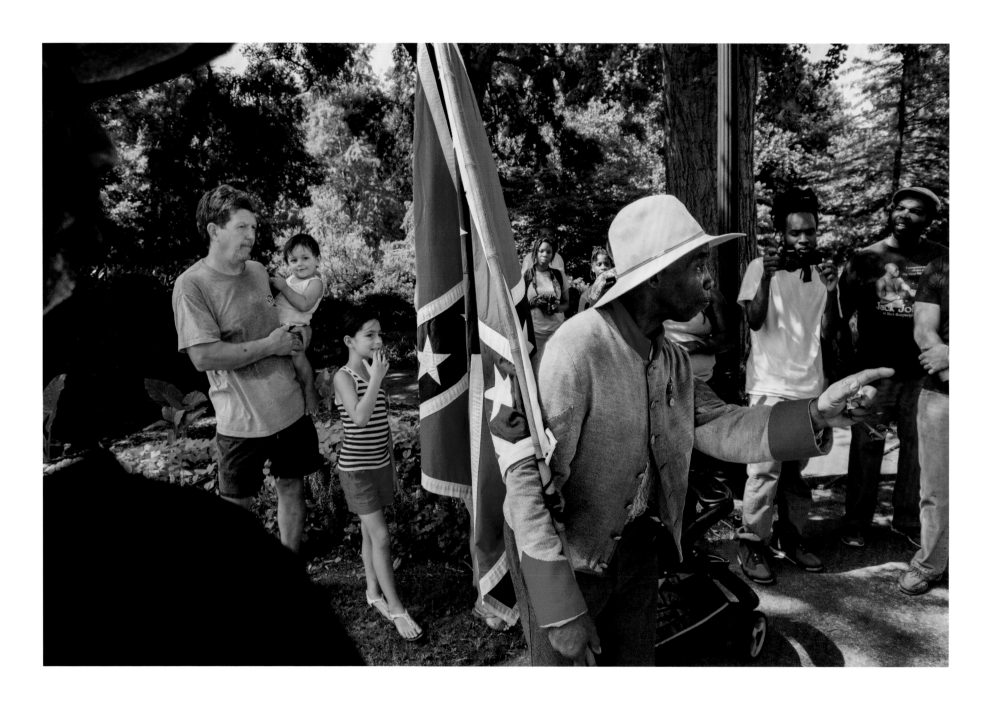

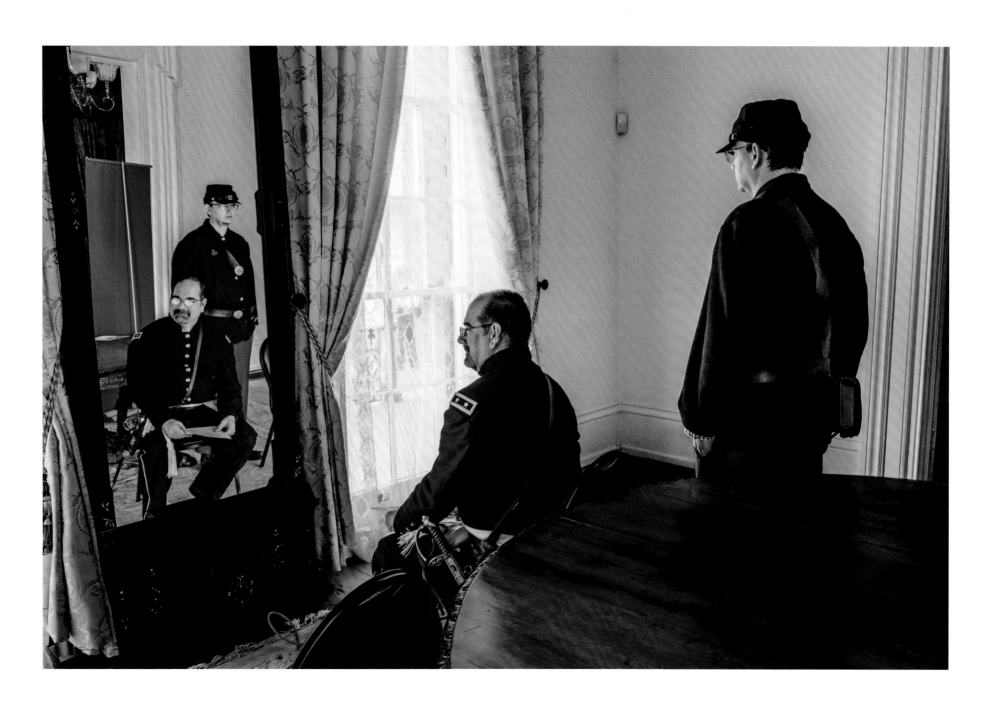

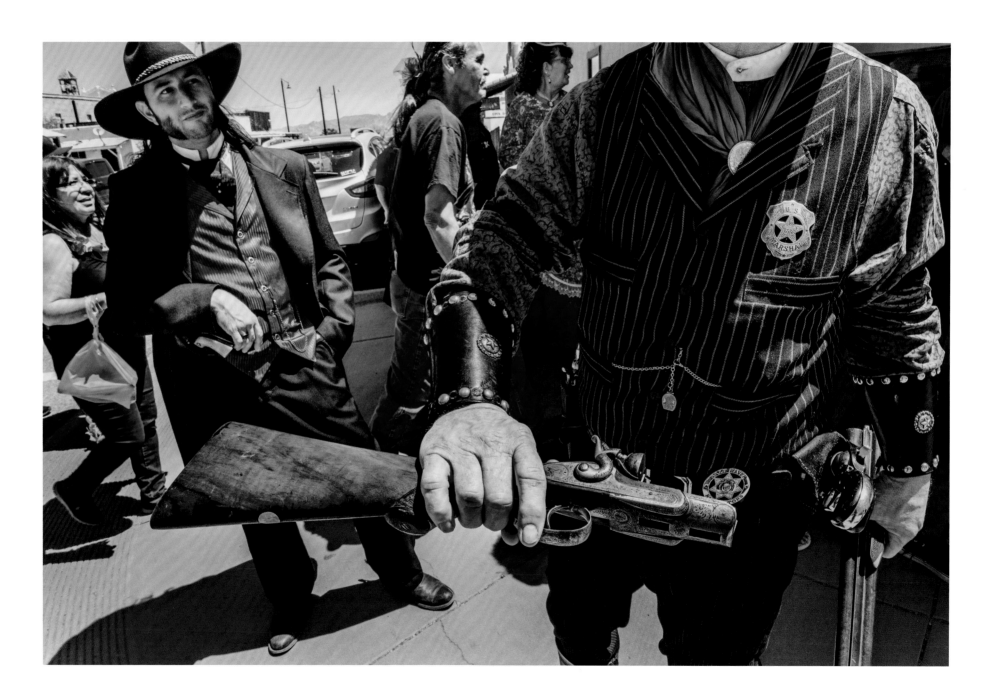

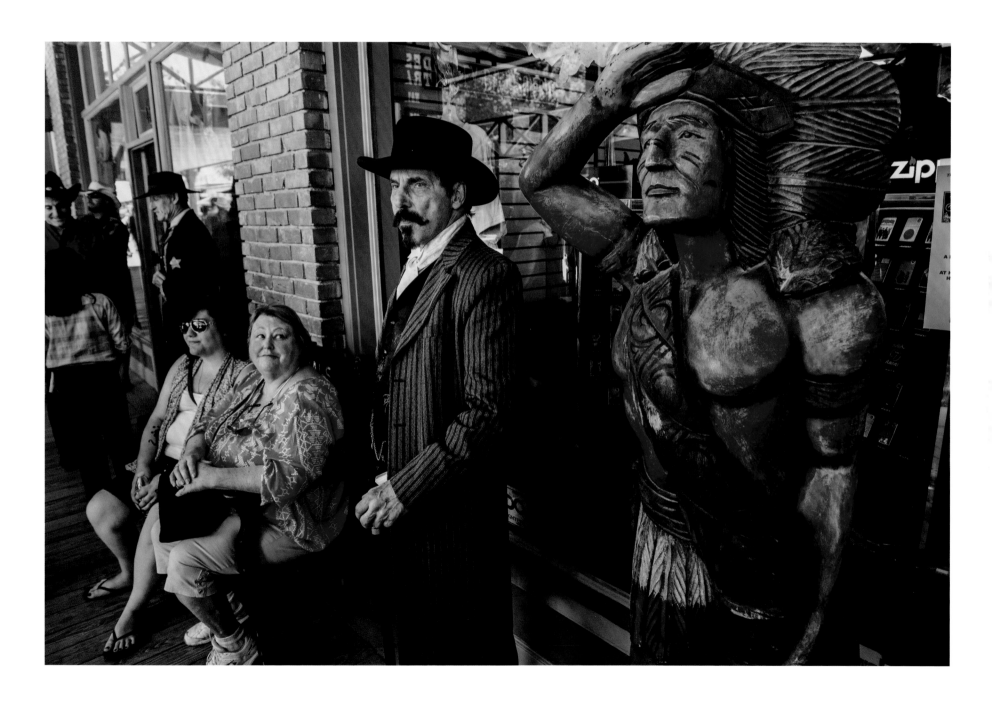

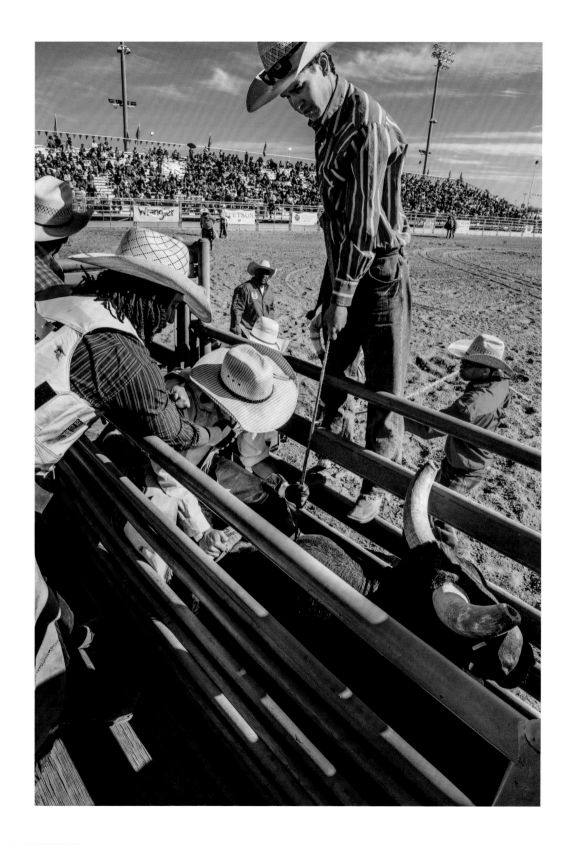

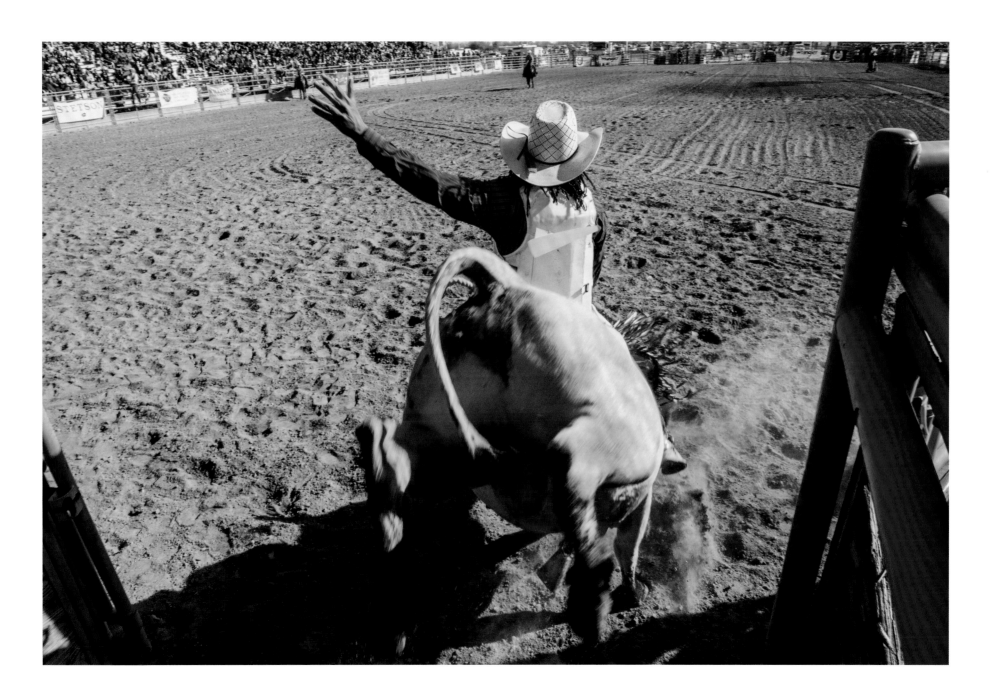

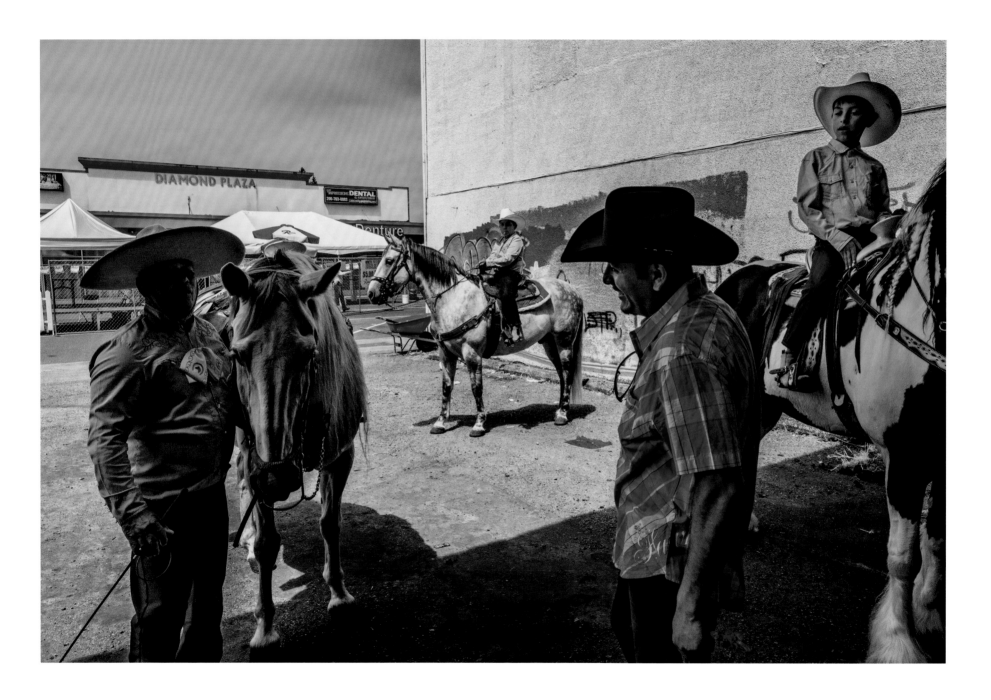

56 Seattle, WA

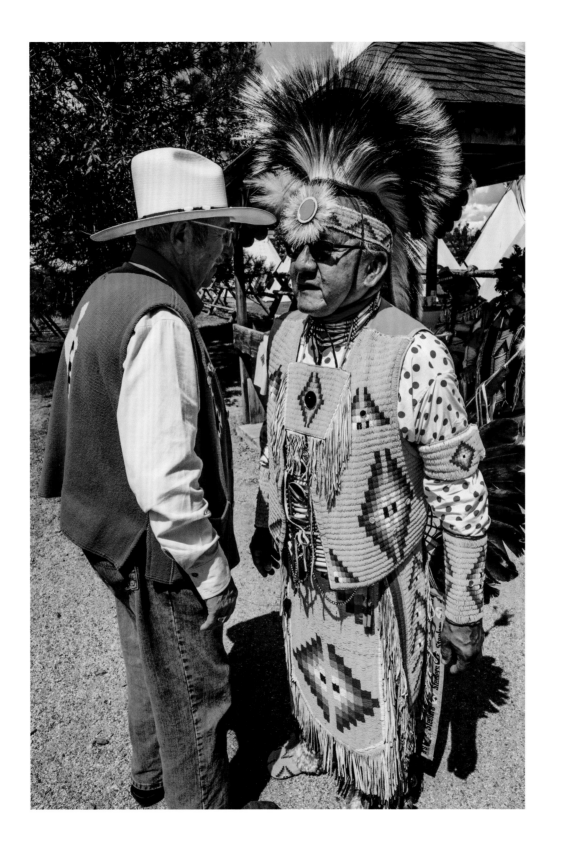

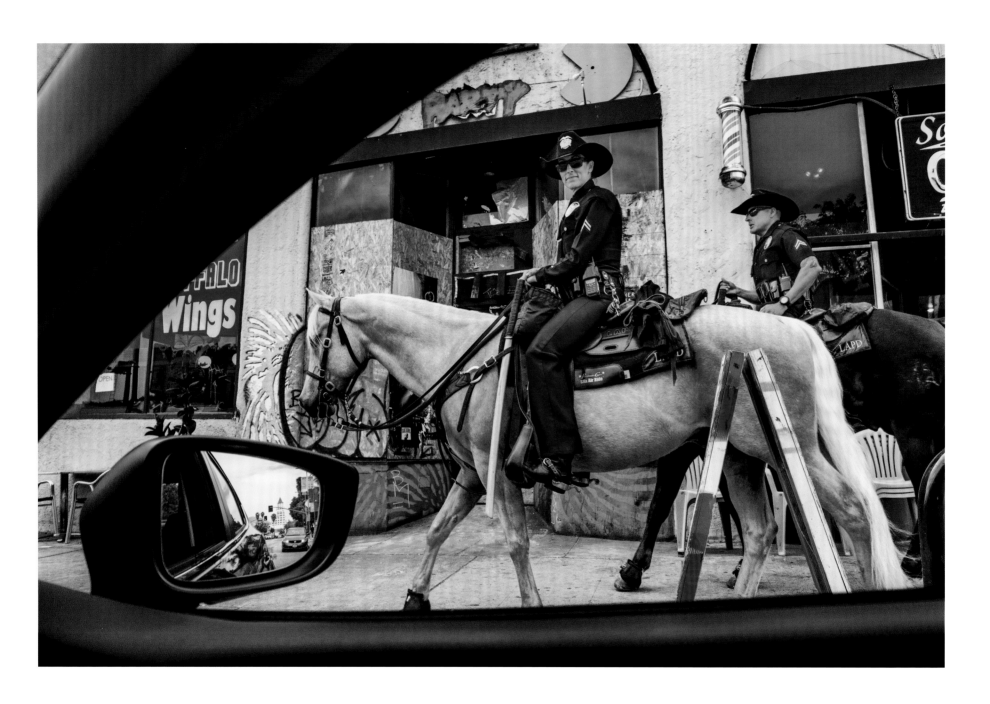

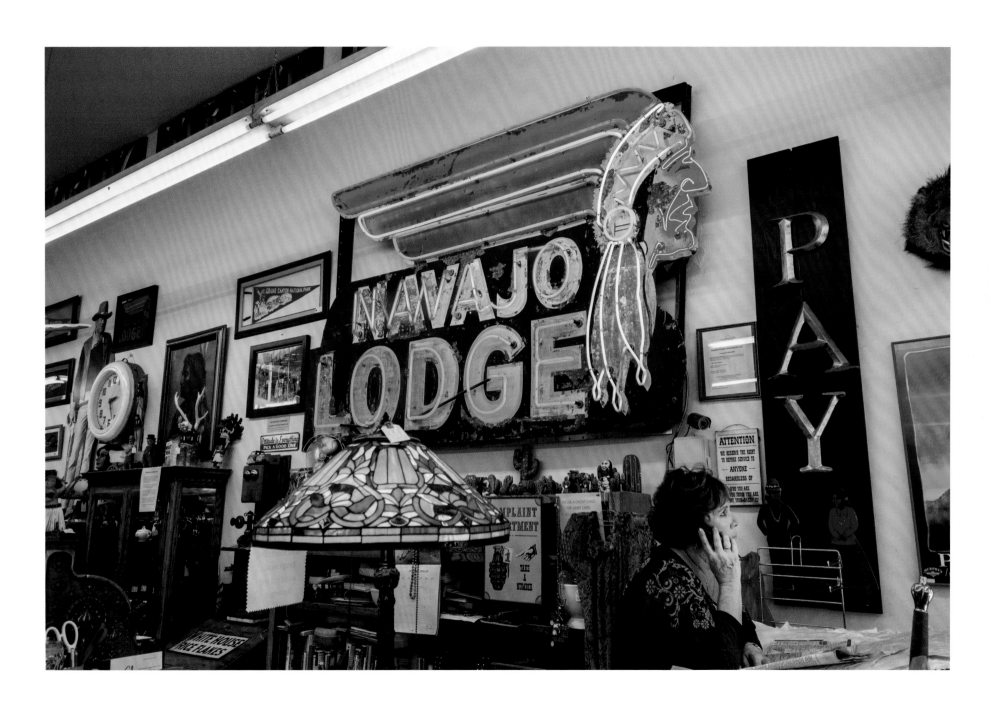

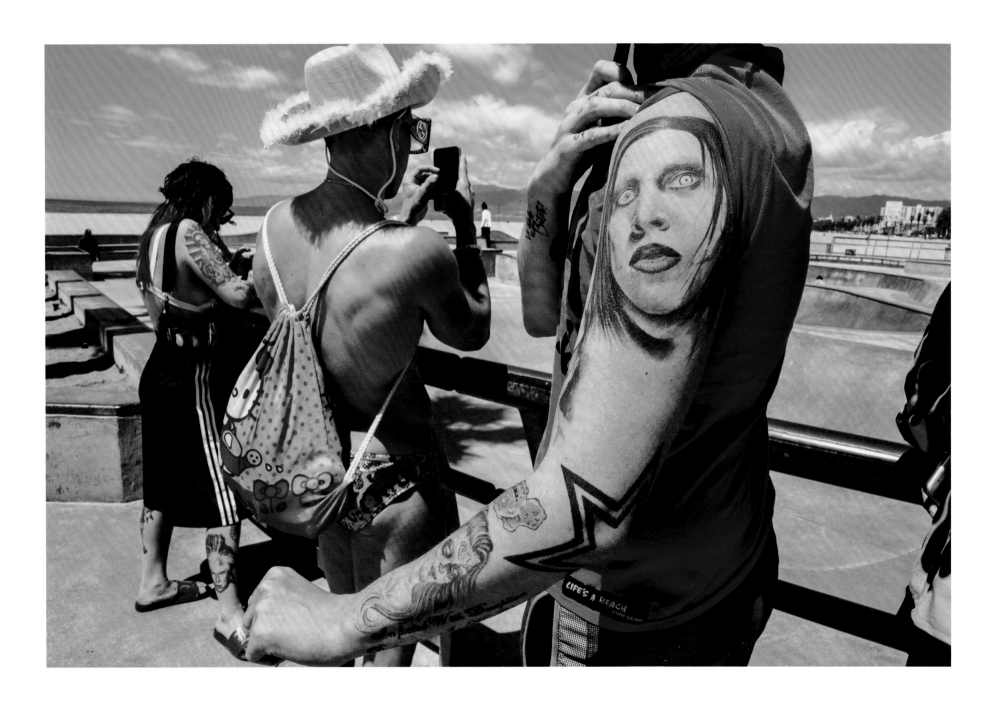

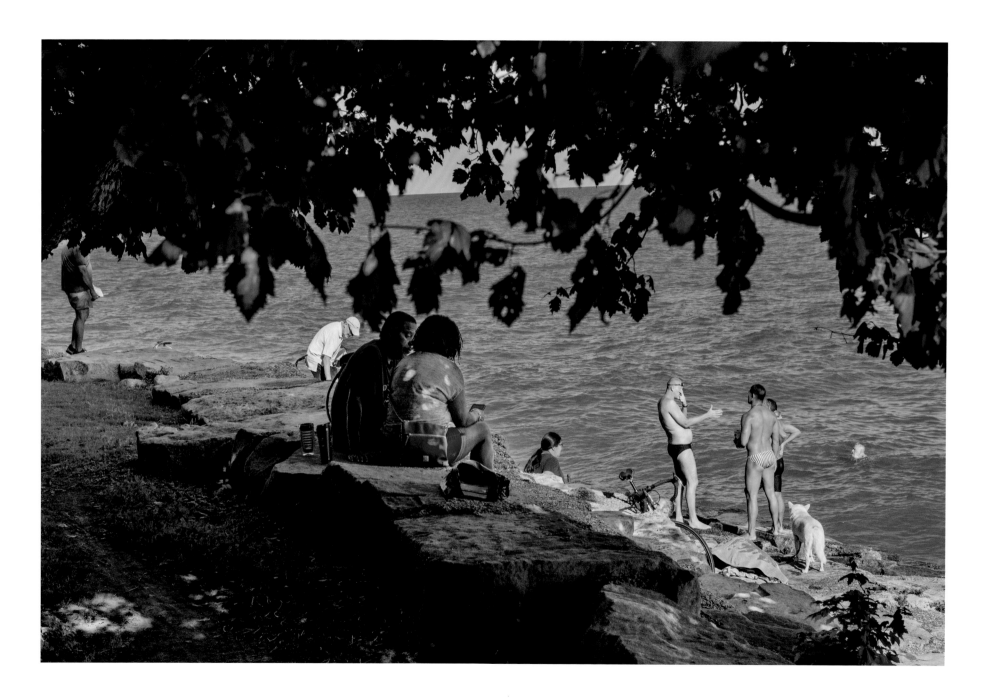

62 Chicago, IL

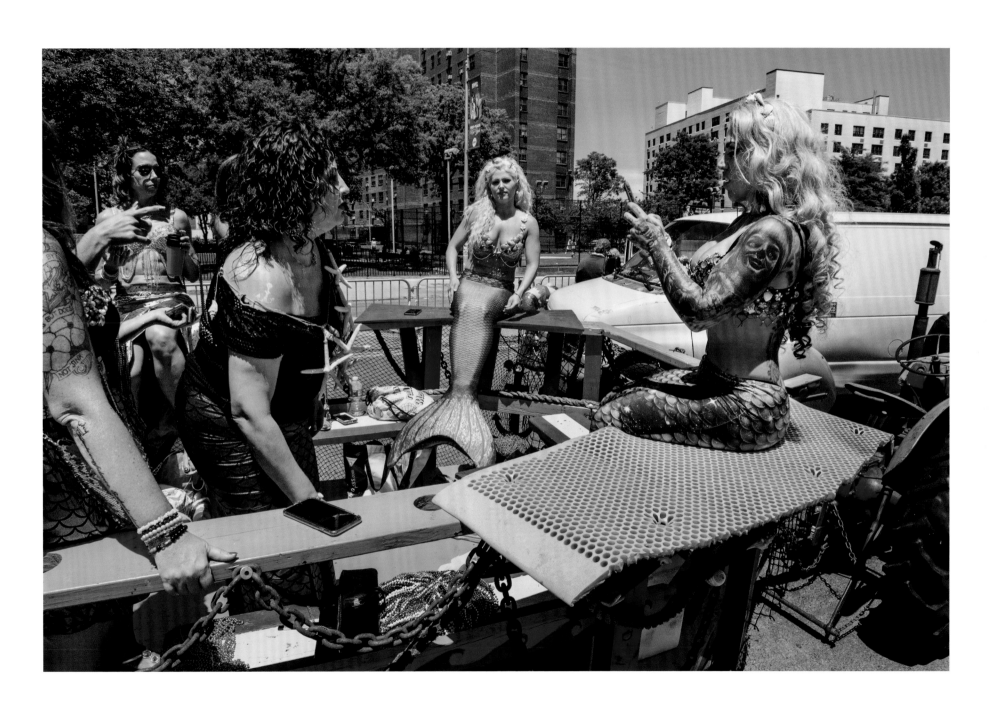

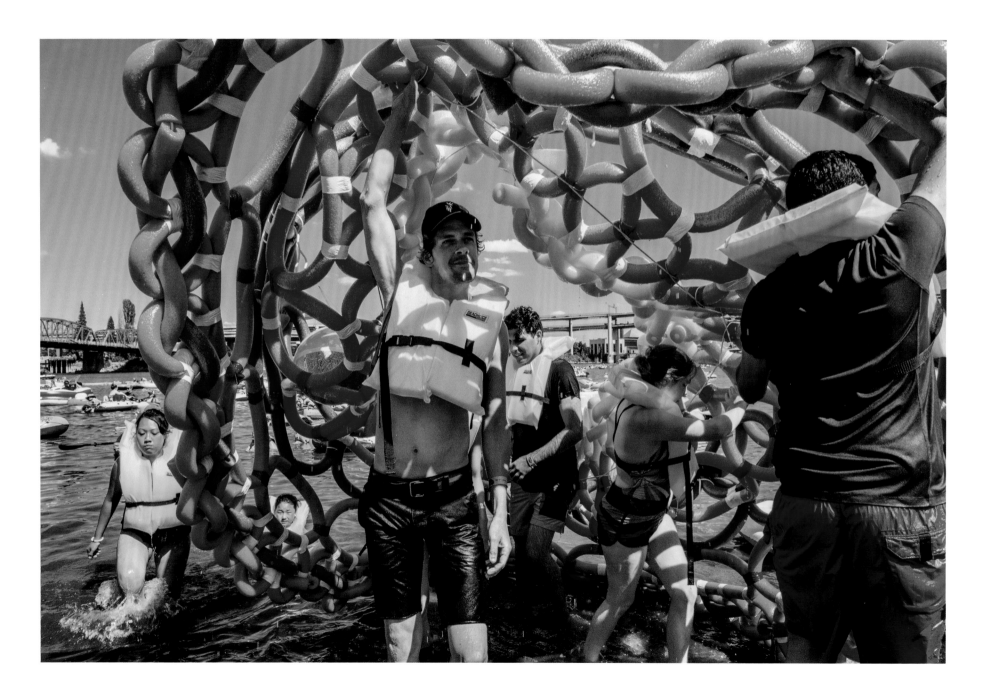

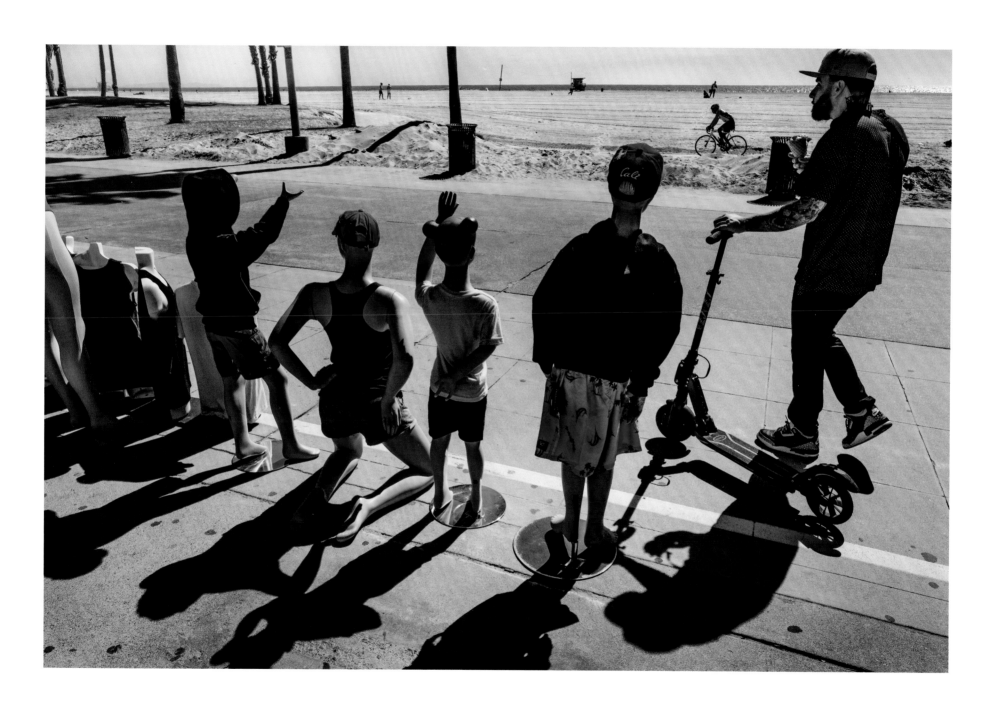

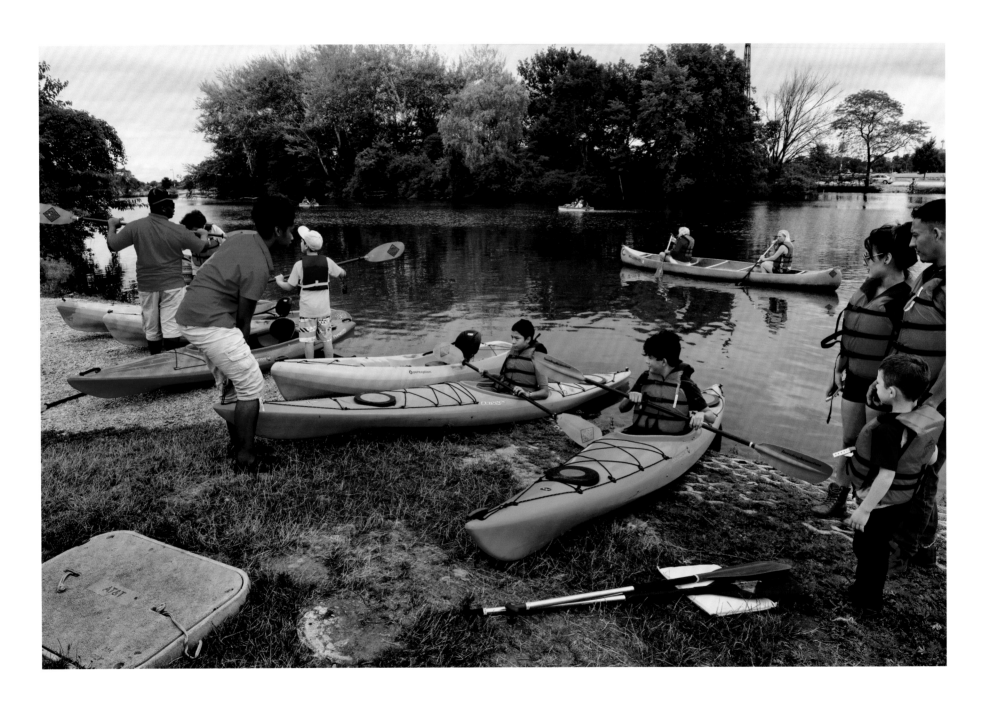

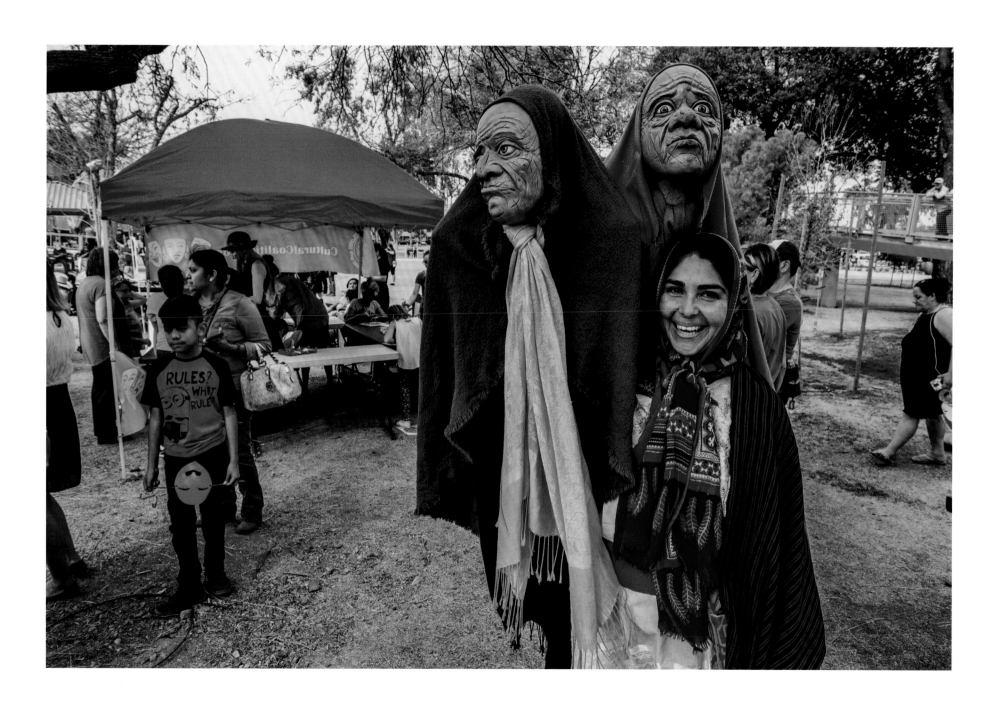

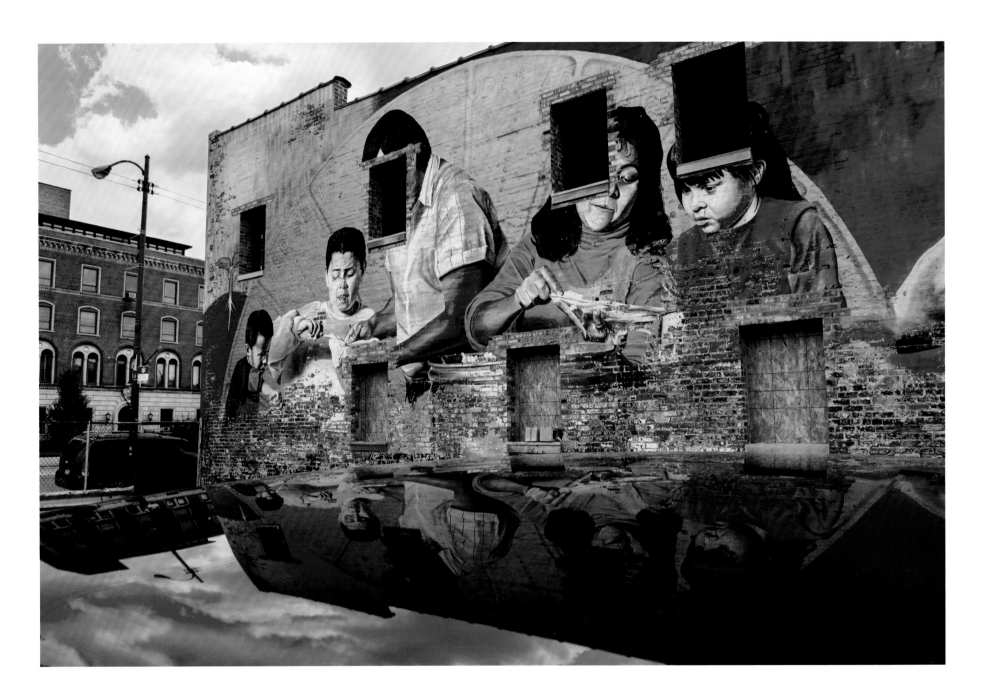

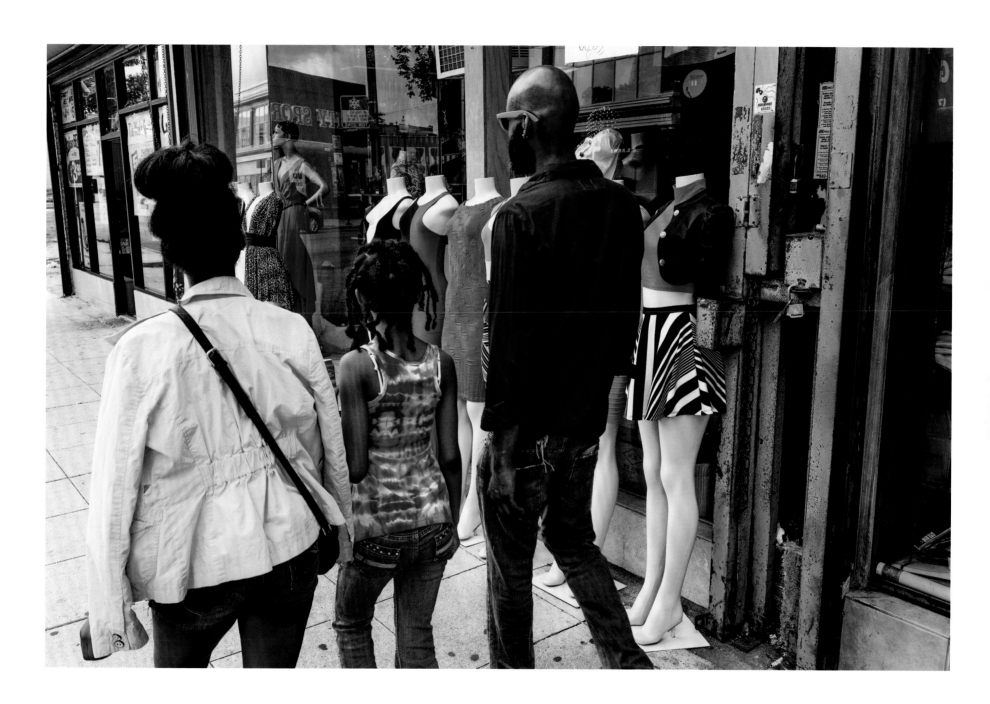

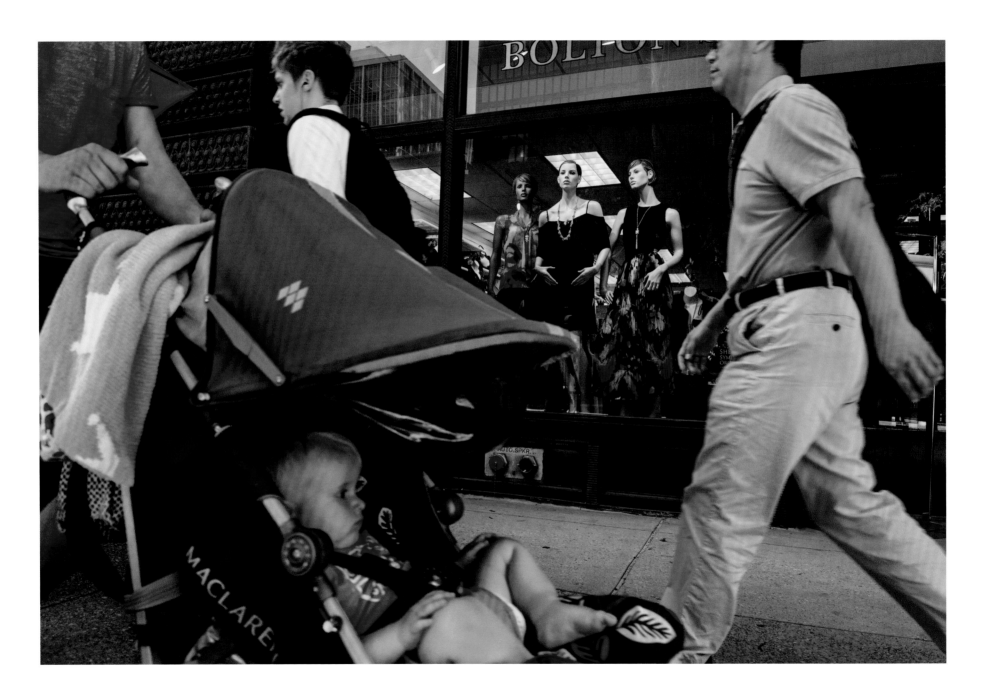

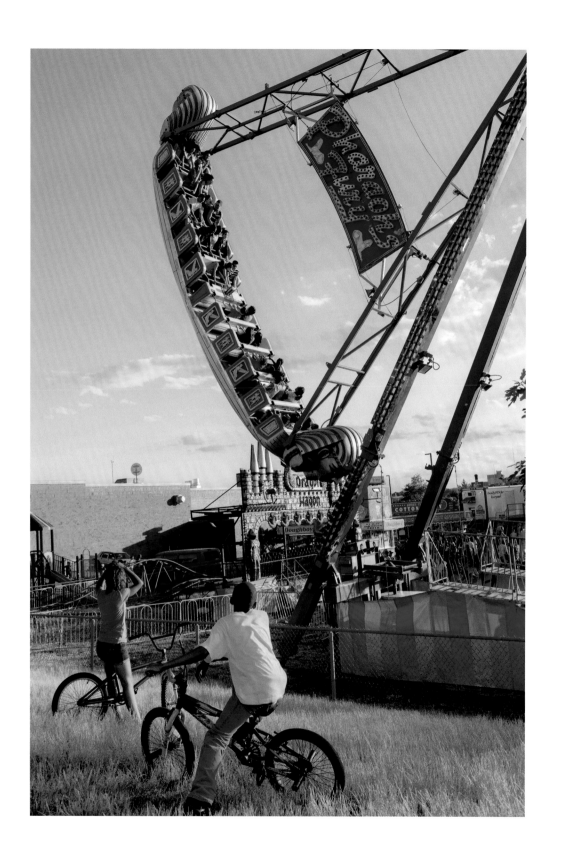

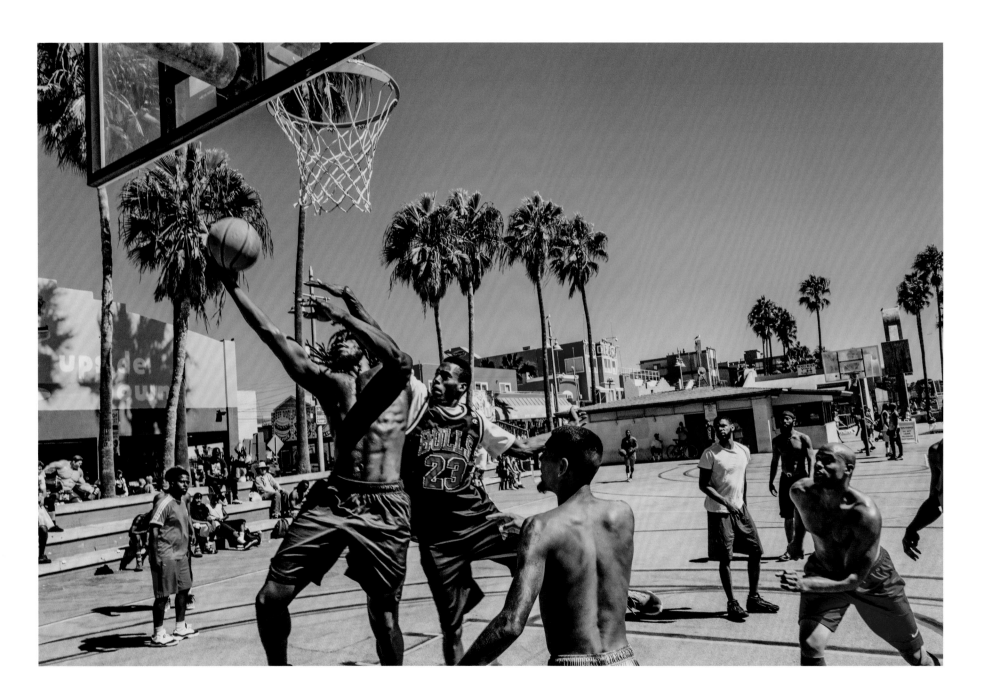

72 Los Angeles, CA

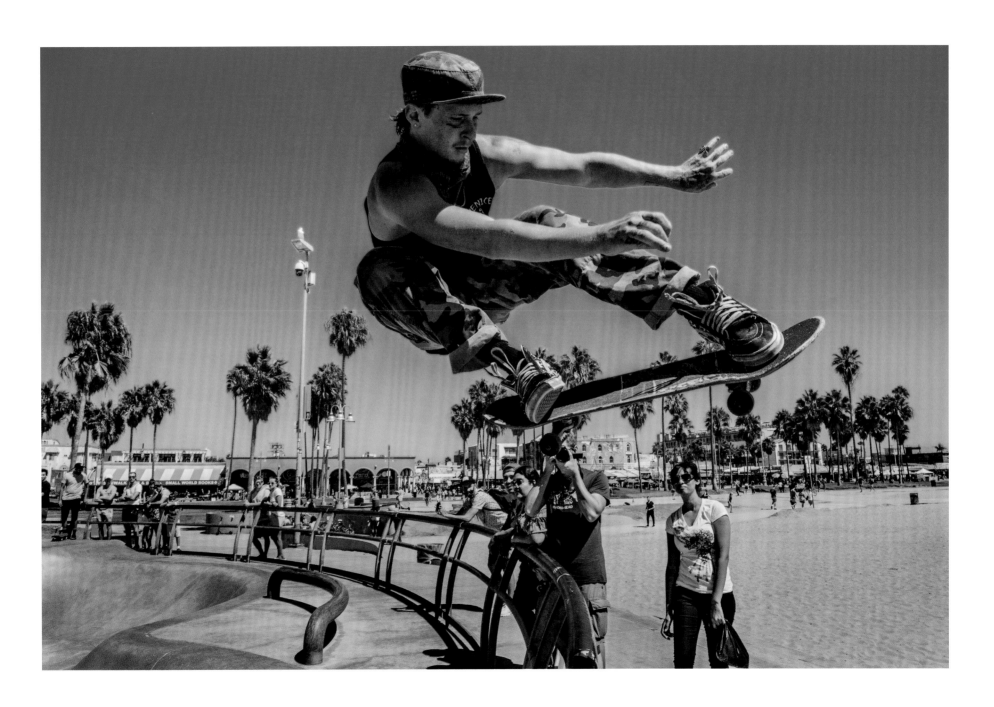

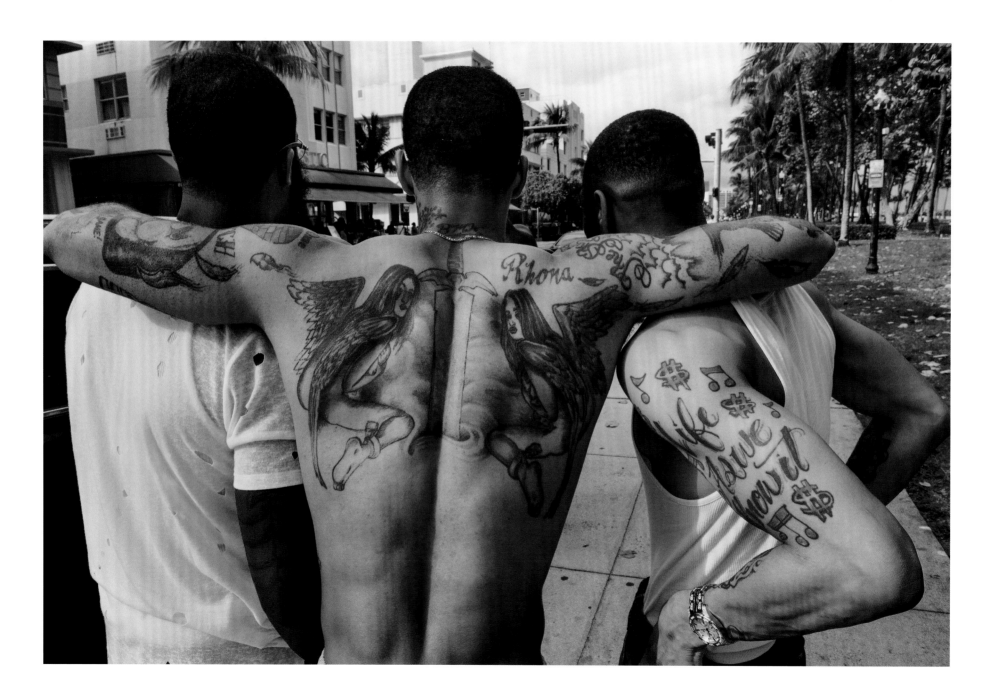

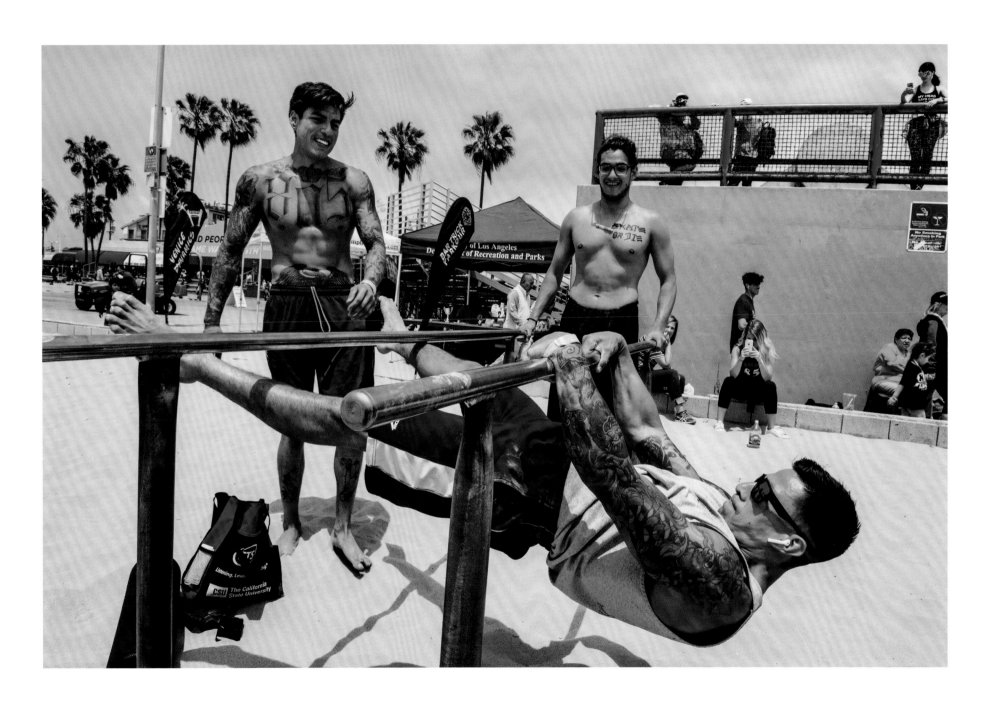

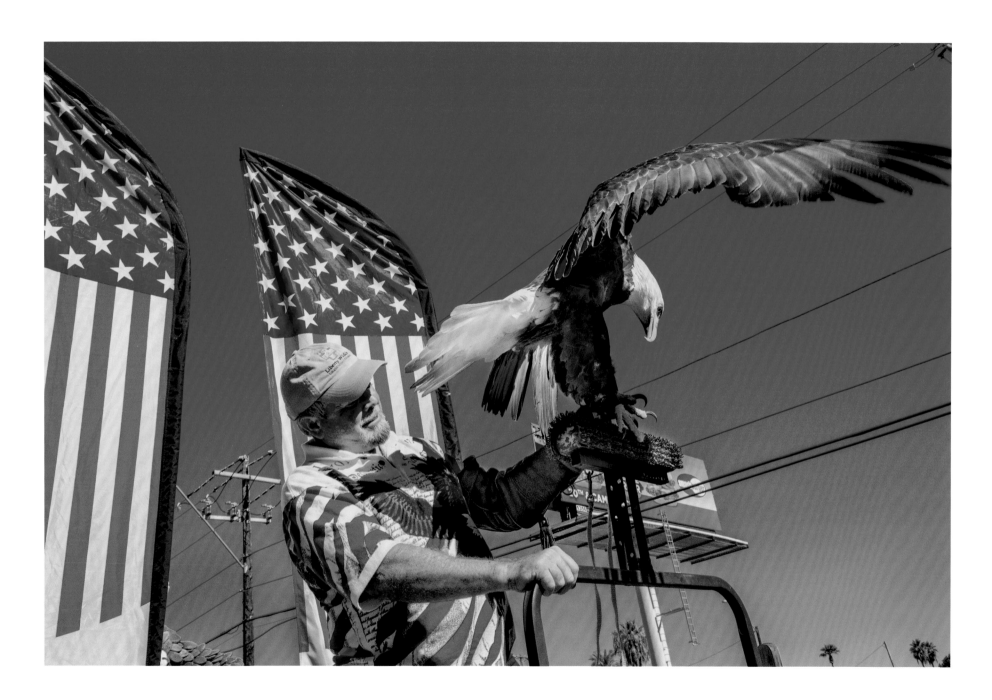

76 Phoenix, AZ

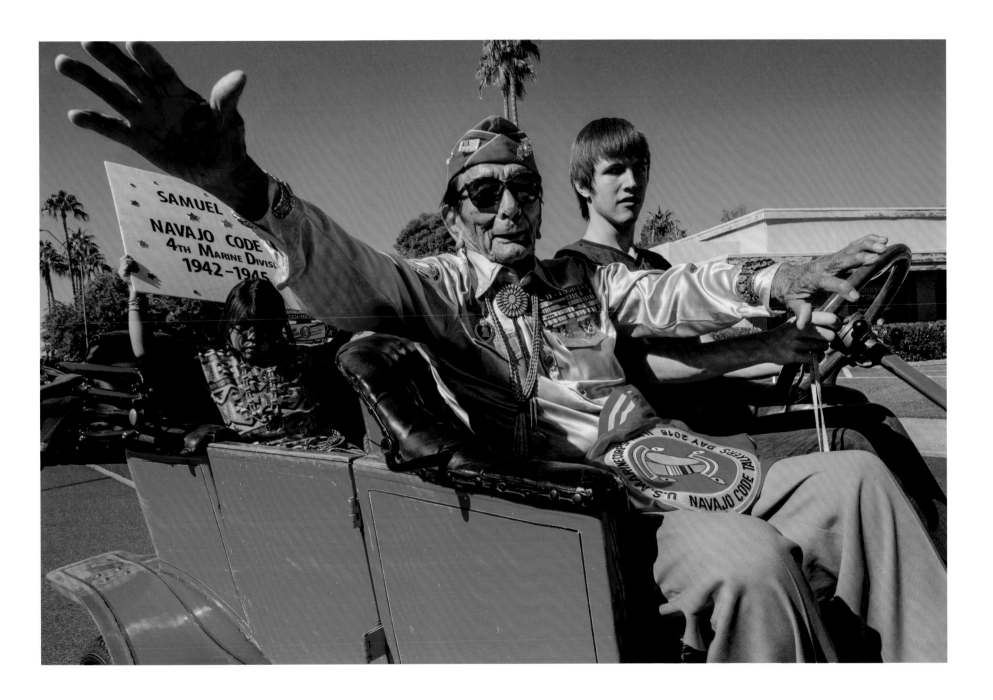

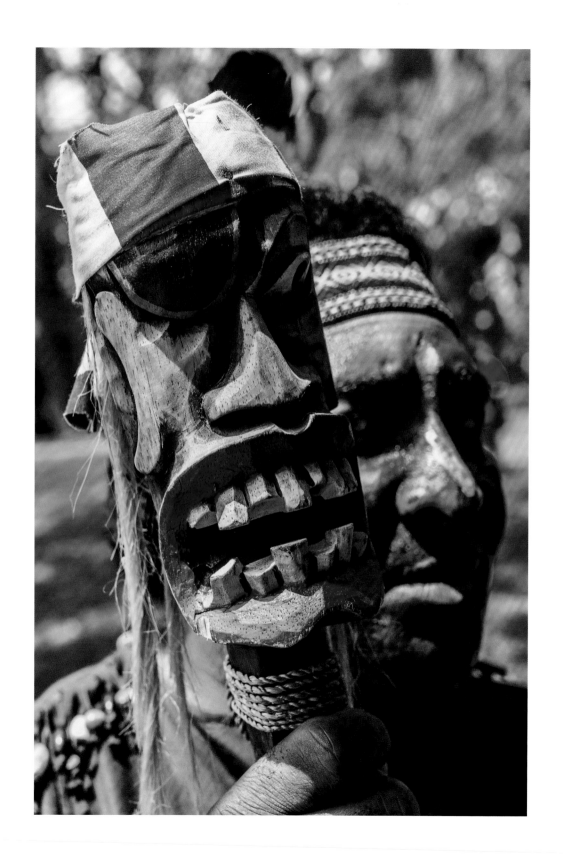

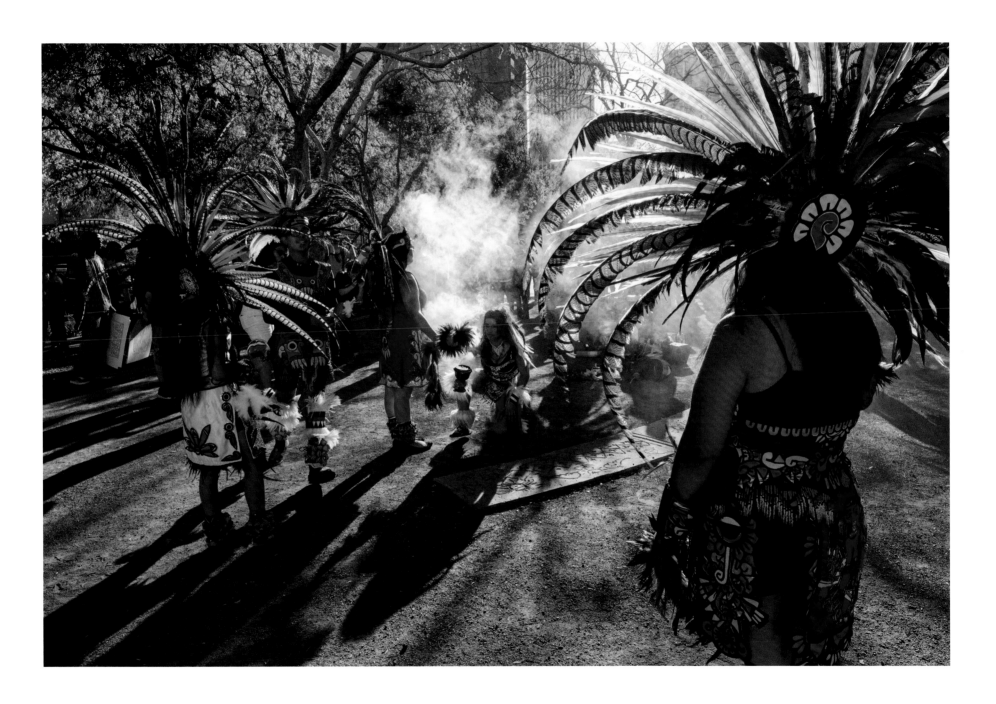

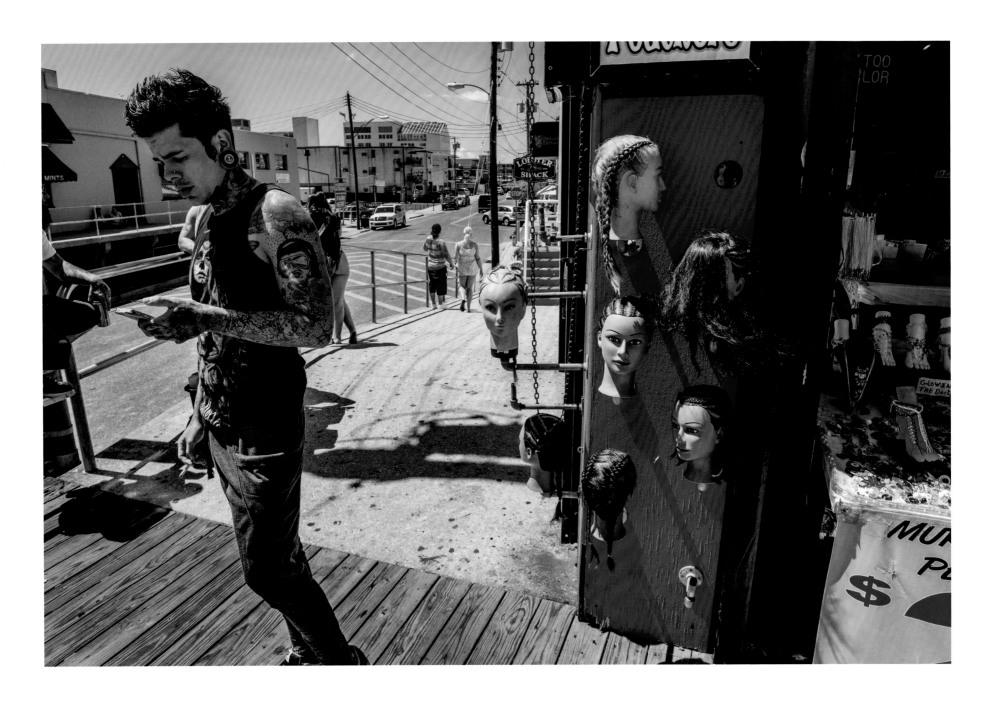

82 Wildwood, NJ

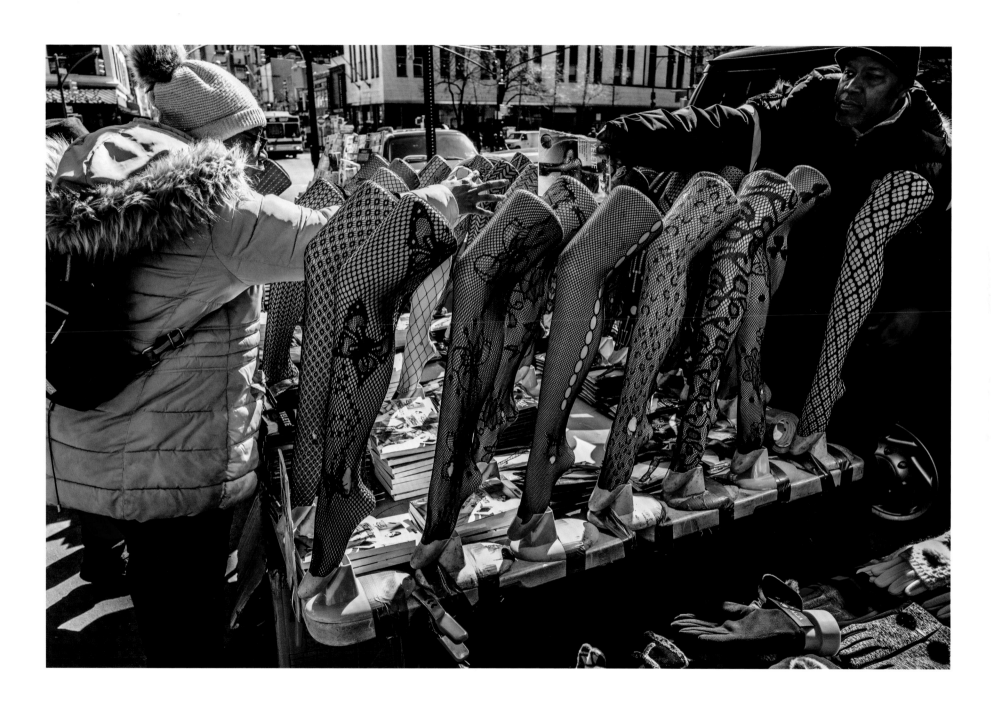

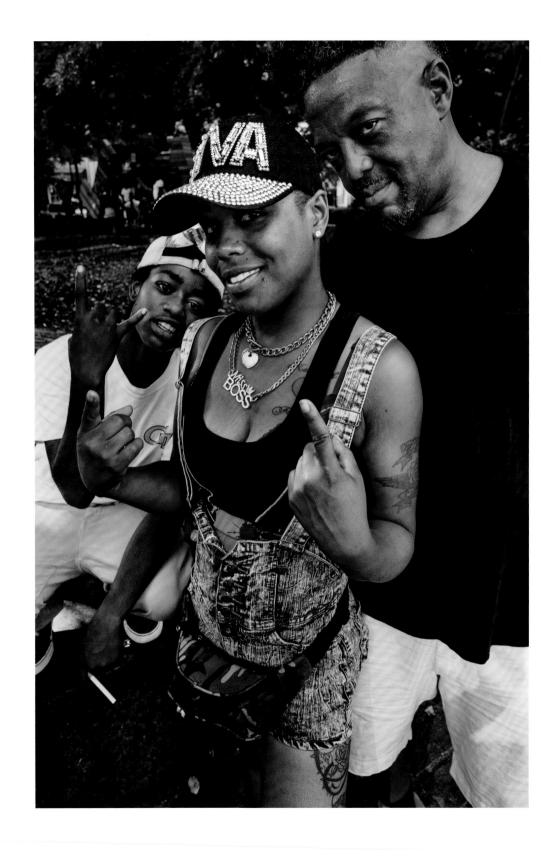

84 Atlanta, GA

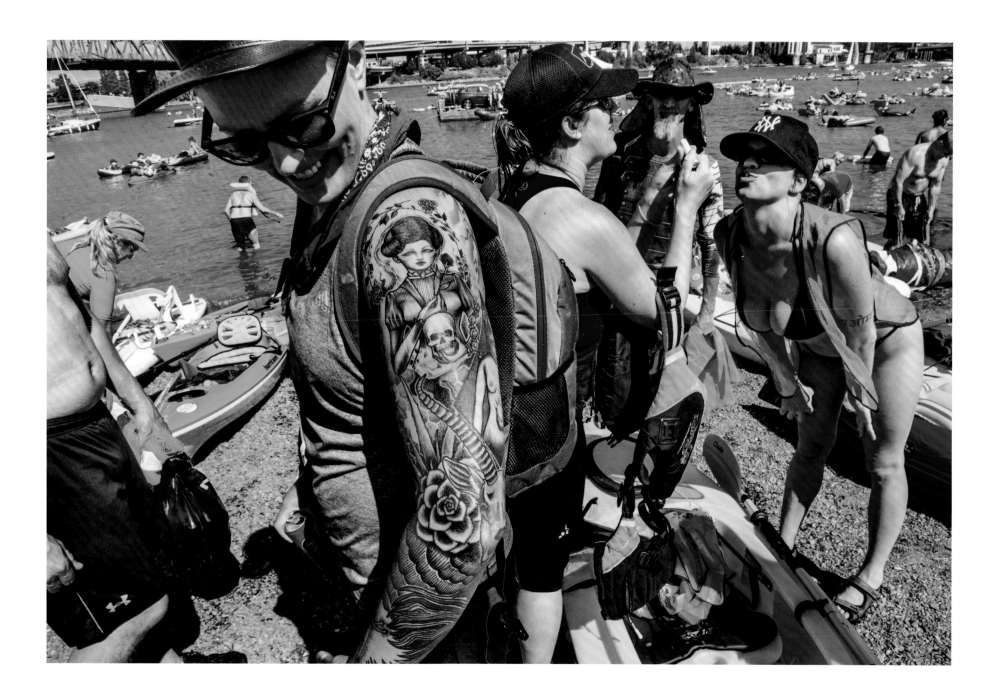

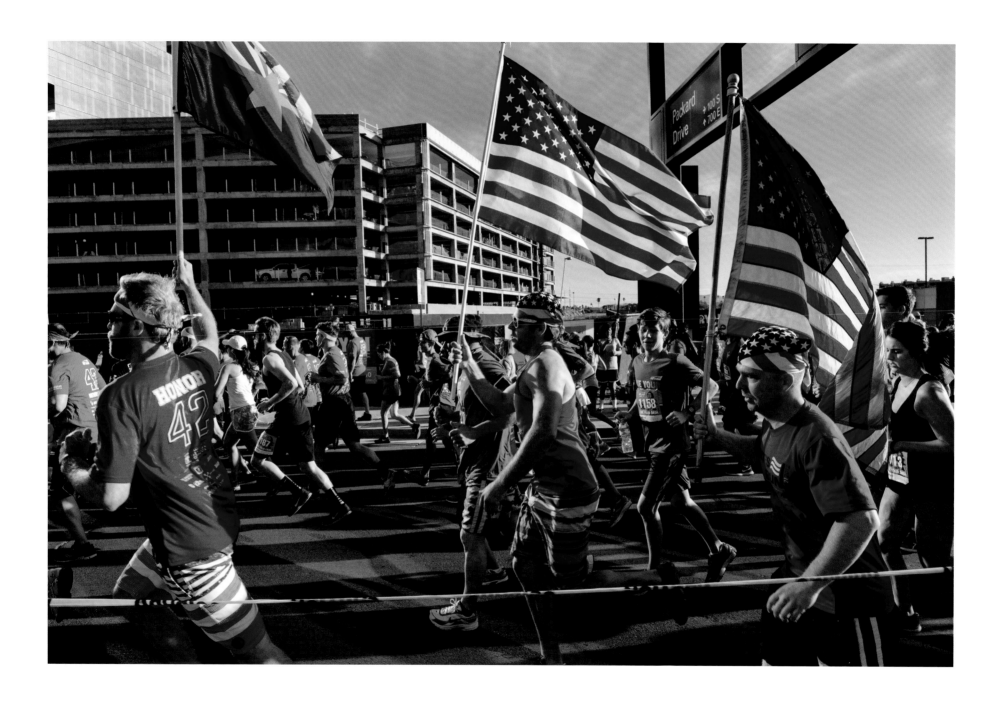

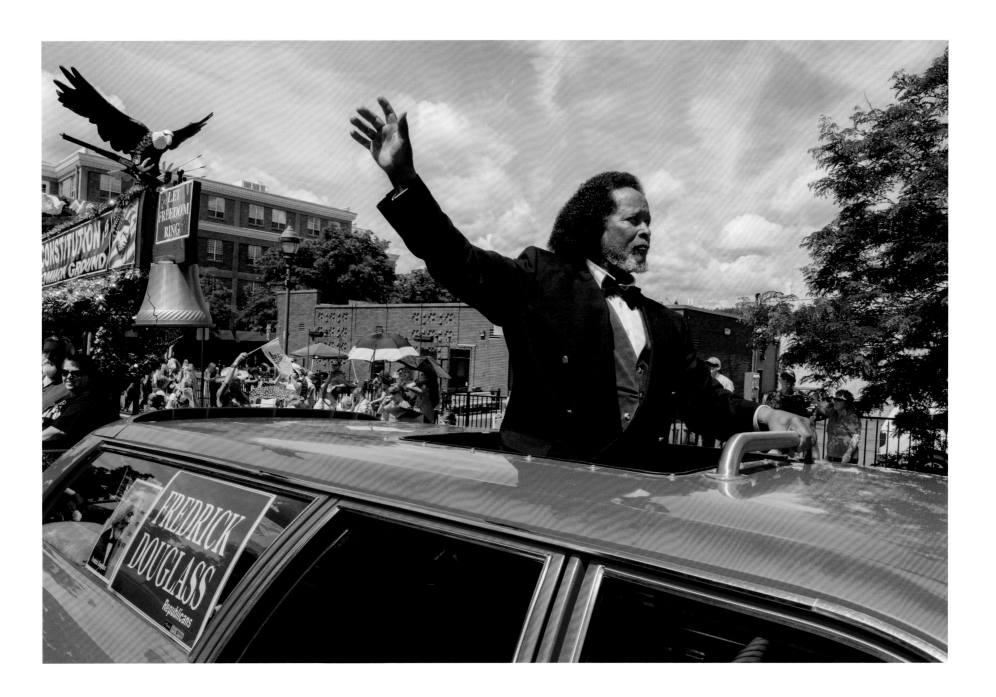

88 Flagstaff, AZ

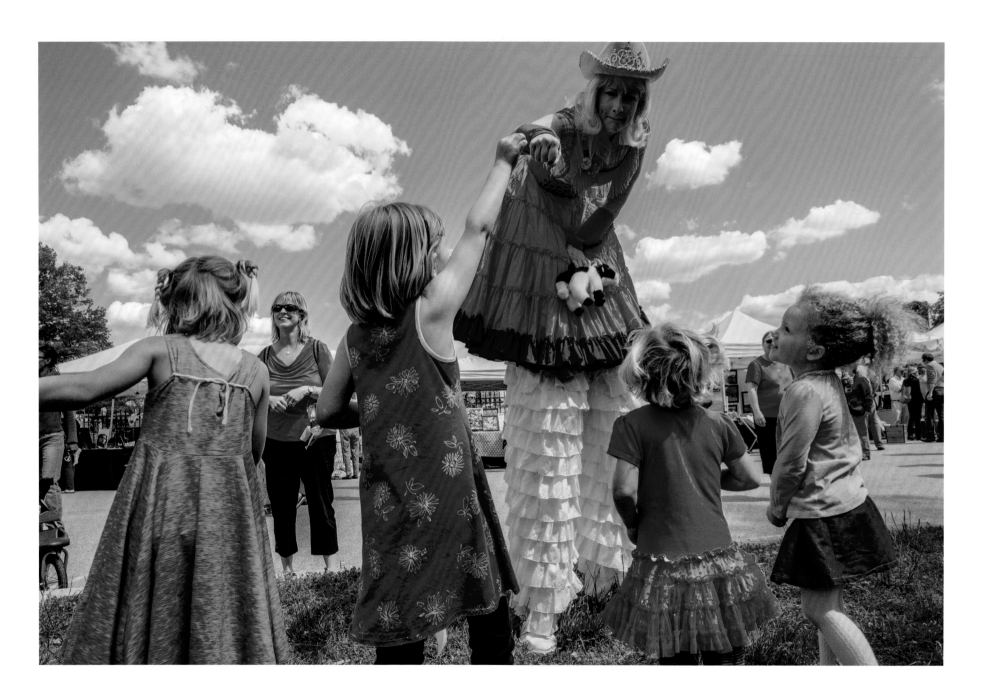

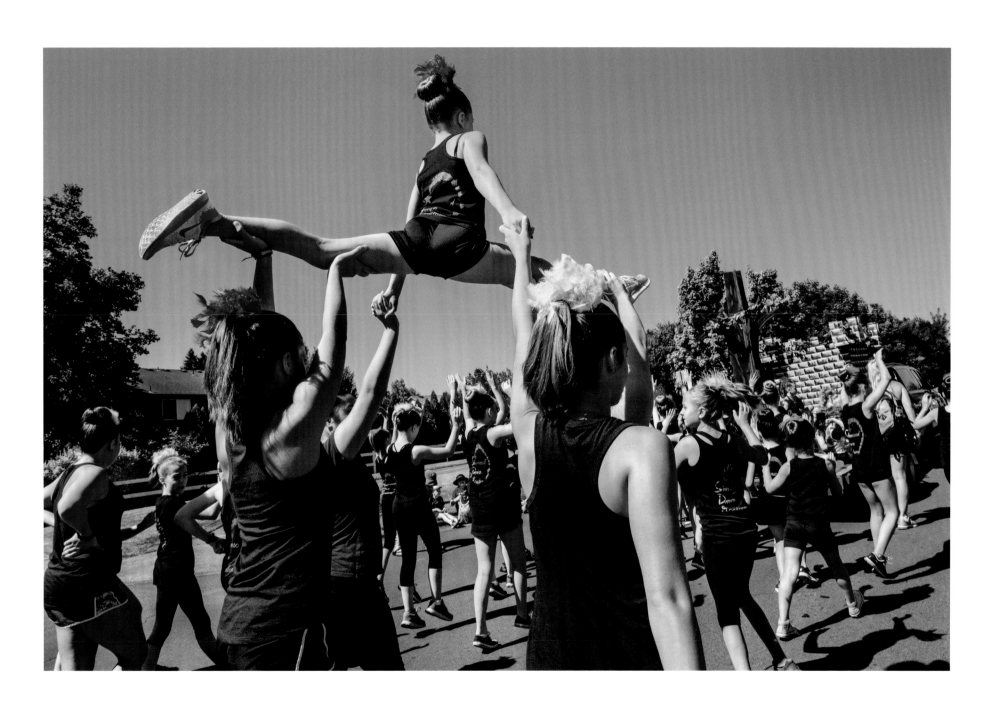

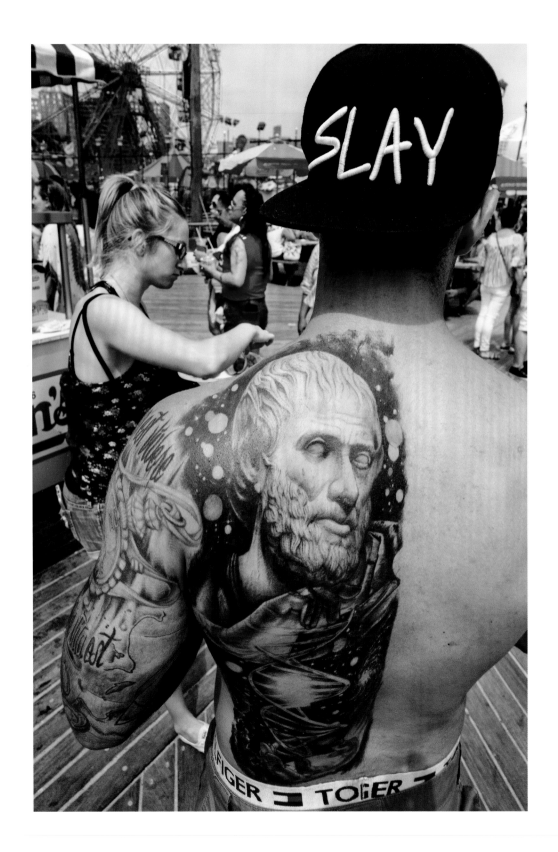

92 Brooklyn, NY

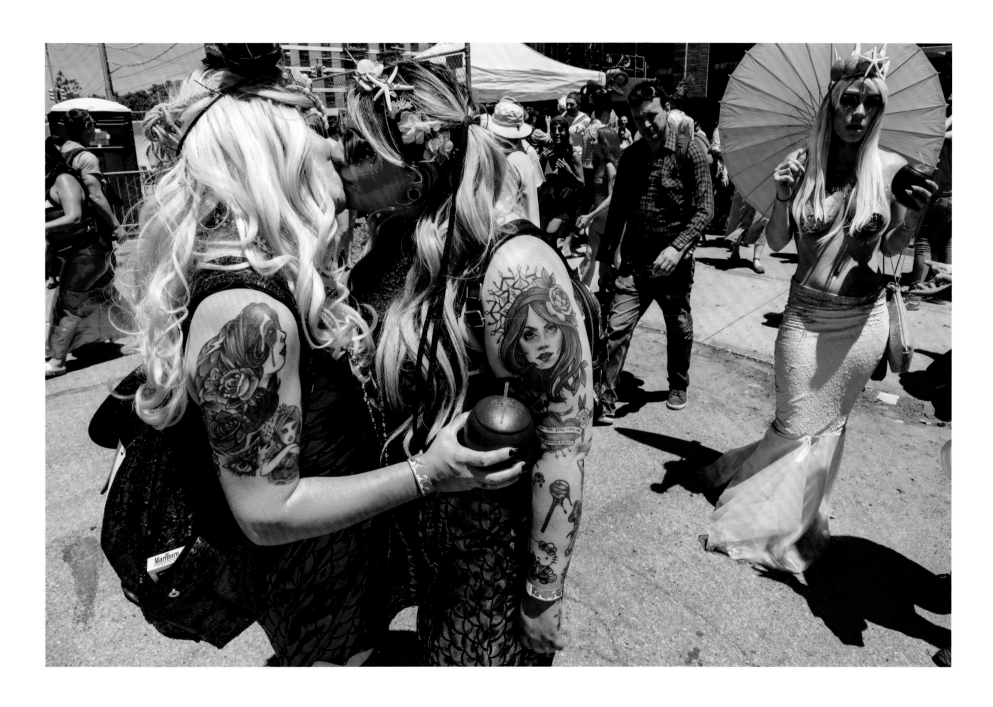

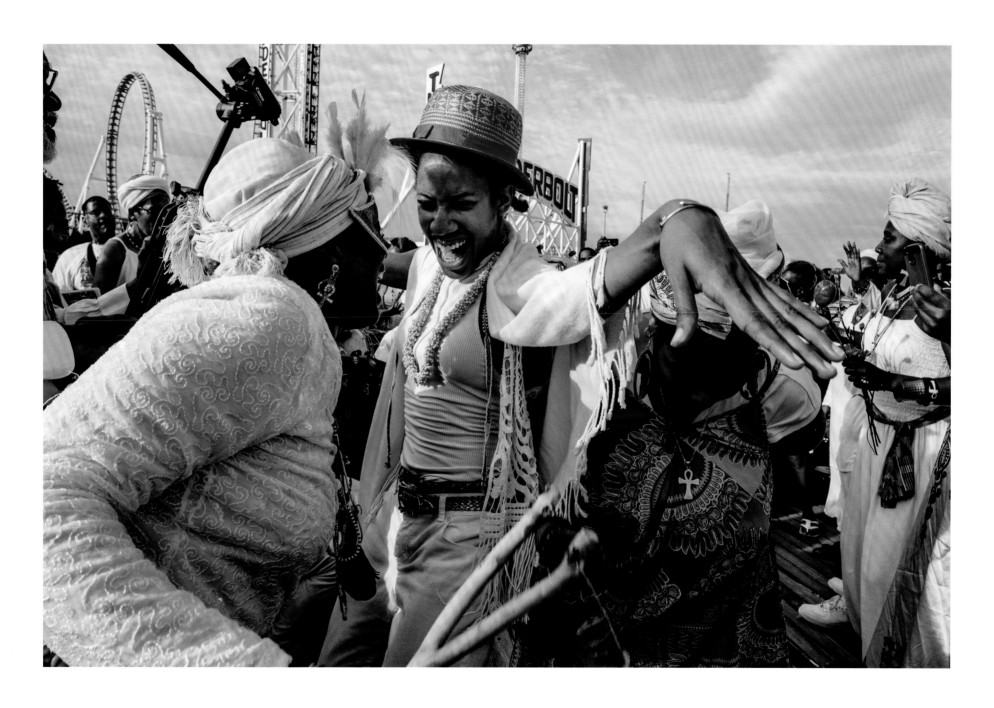

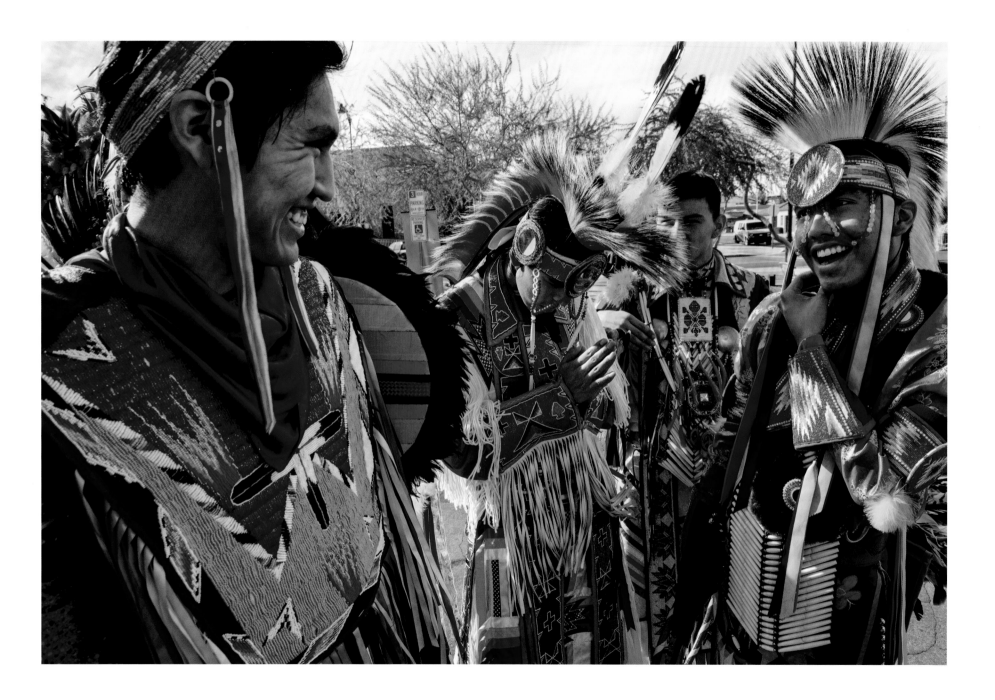

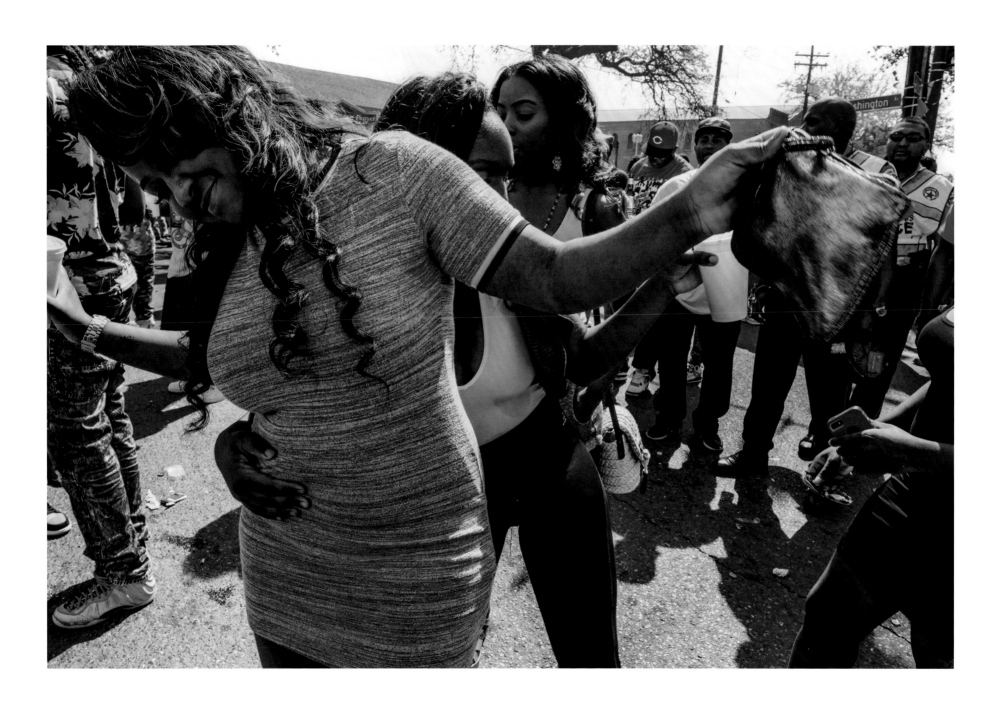

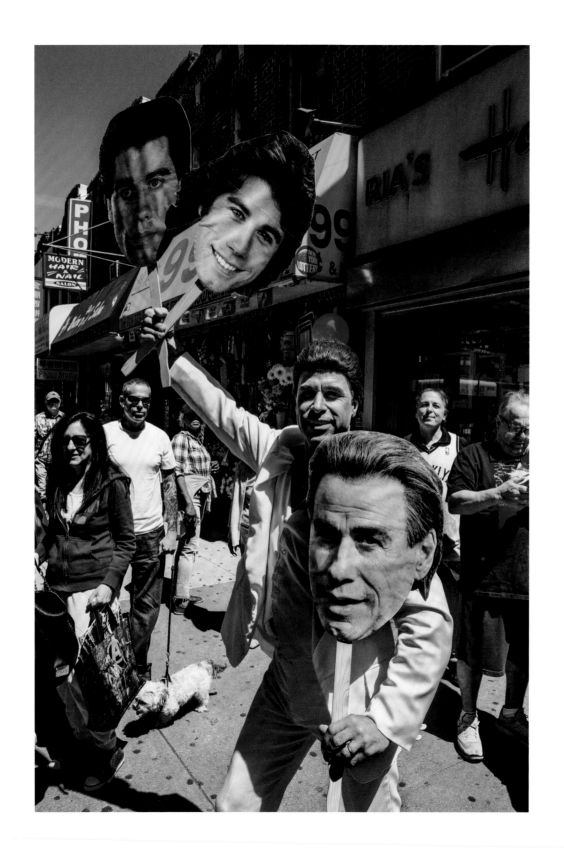

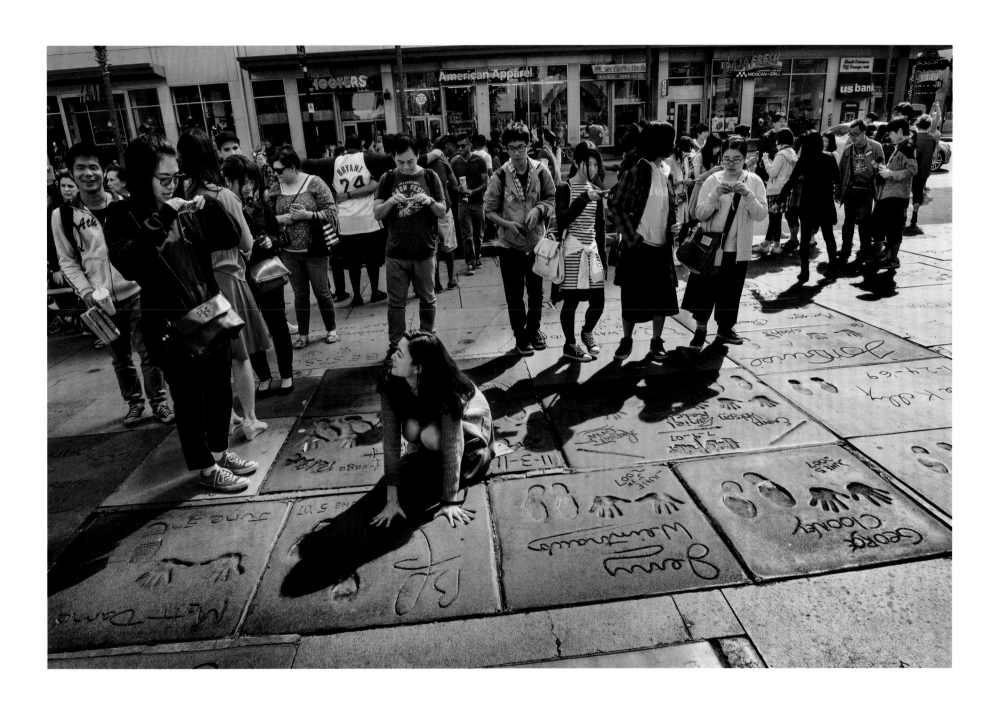

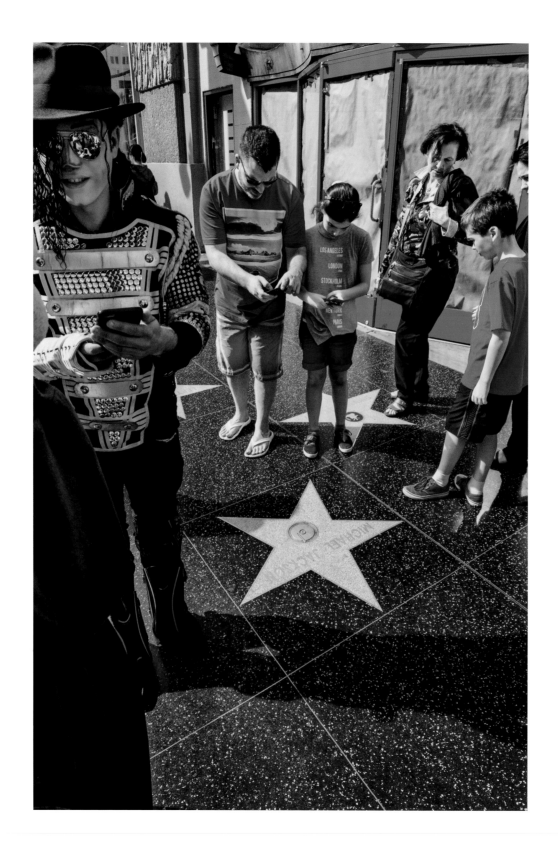

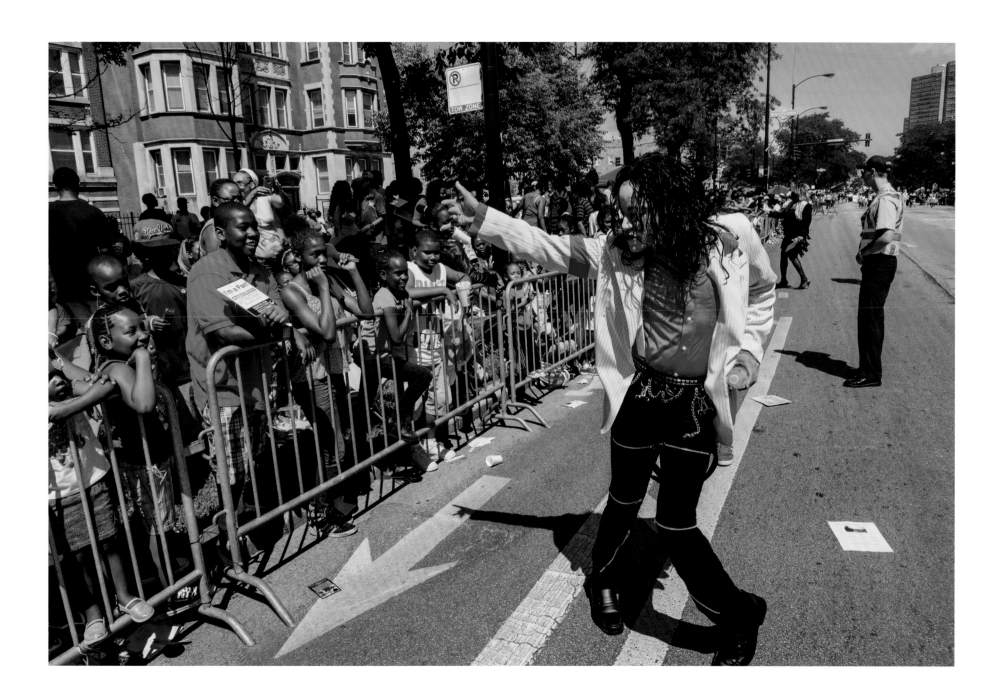

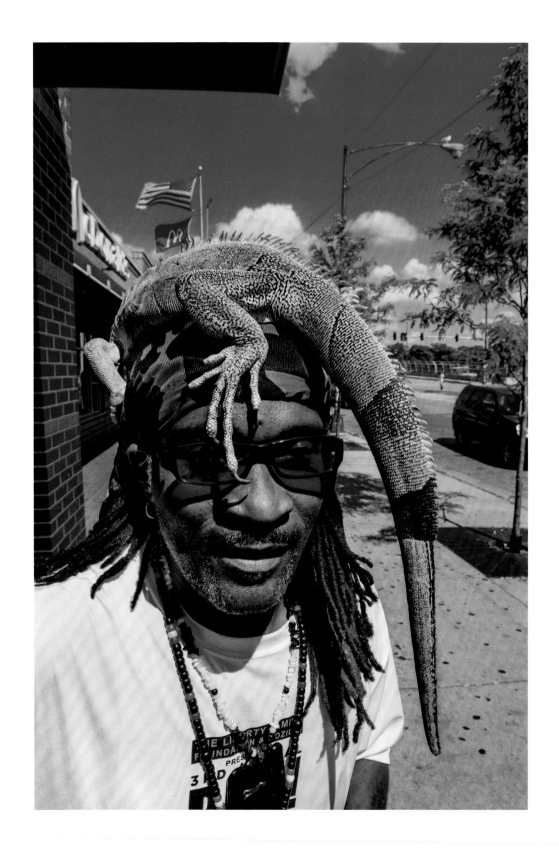

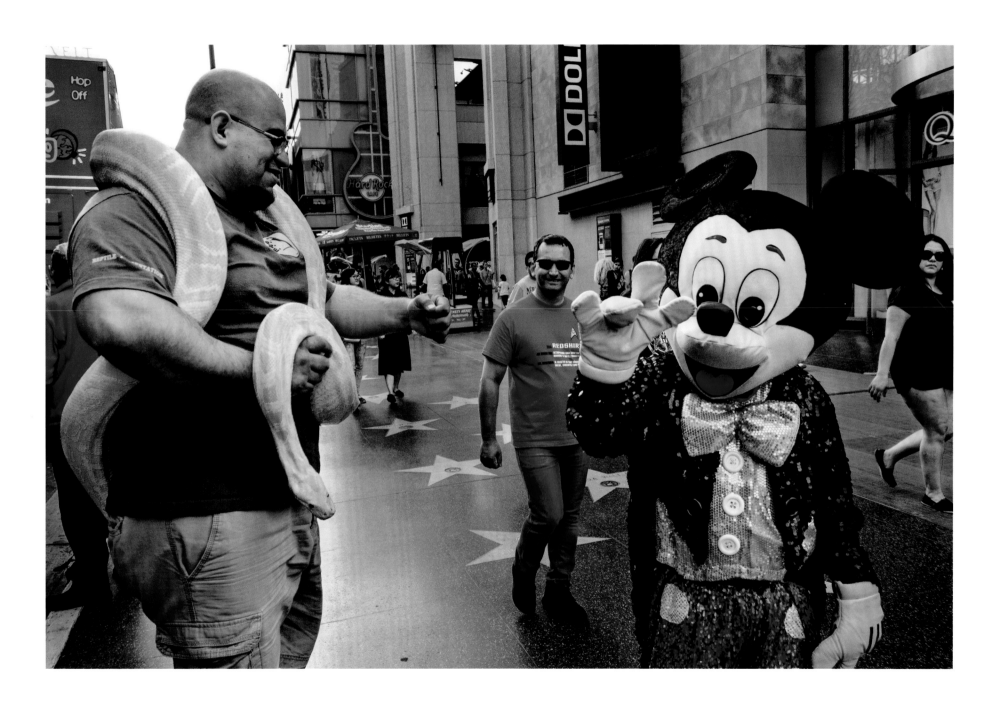

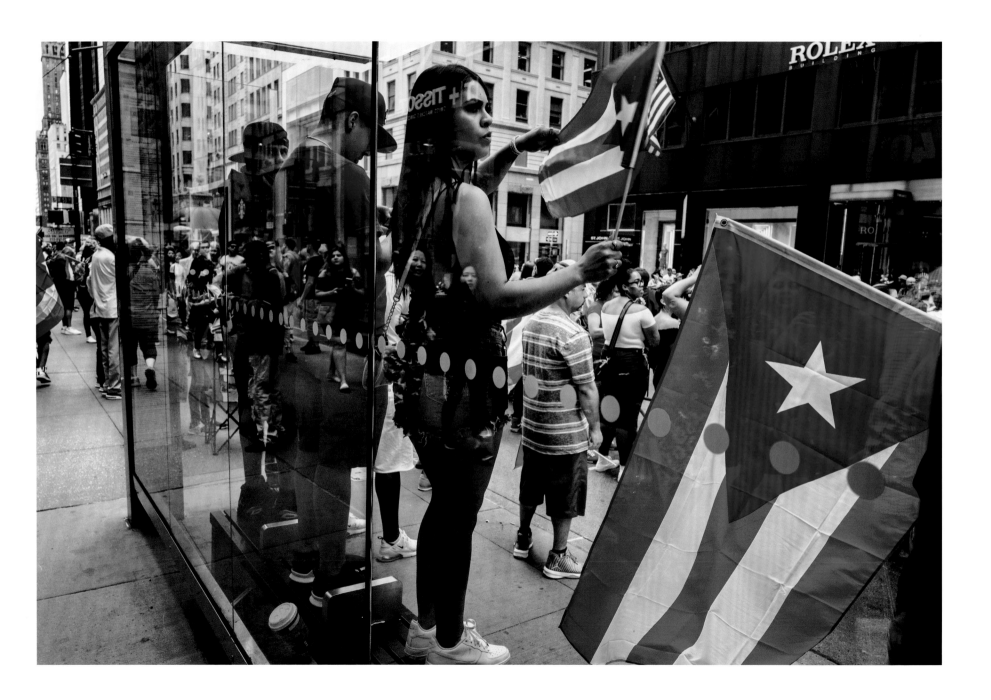

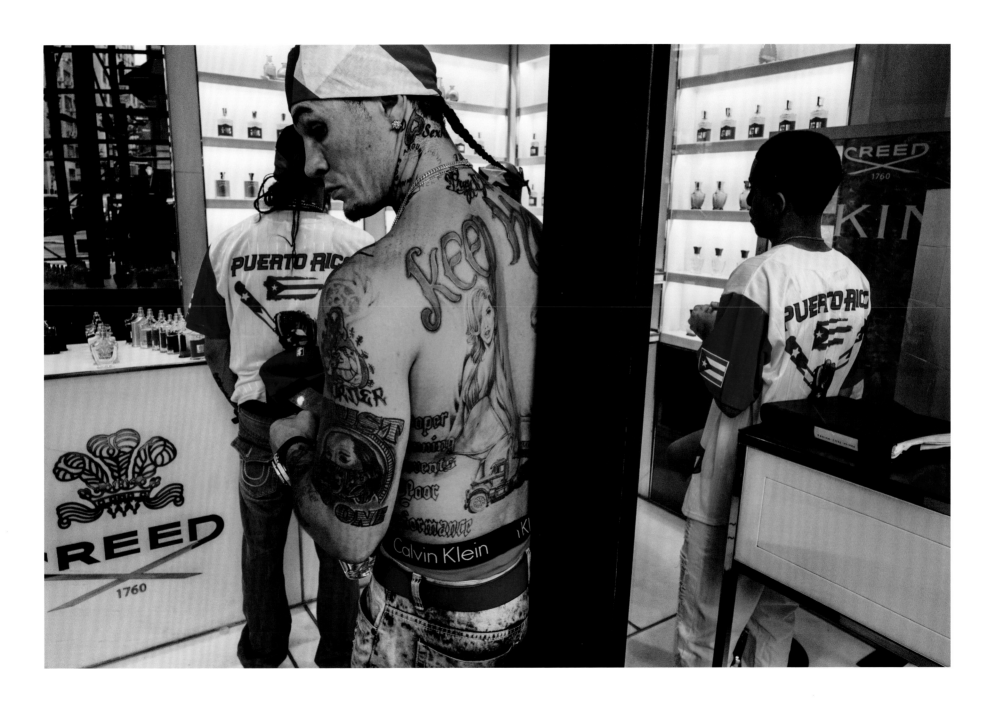

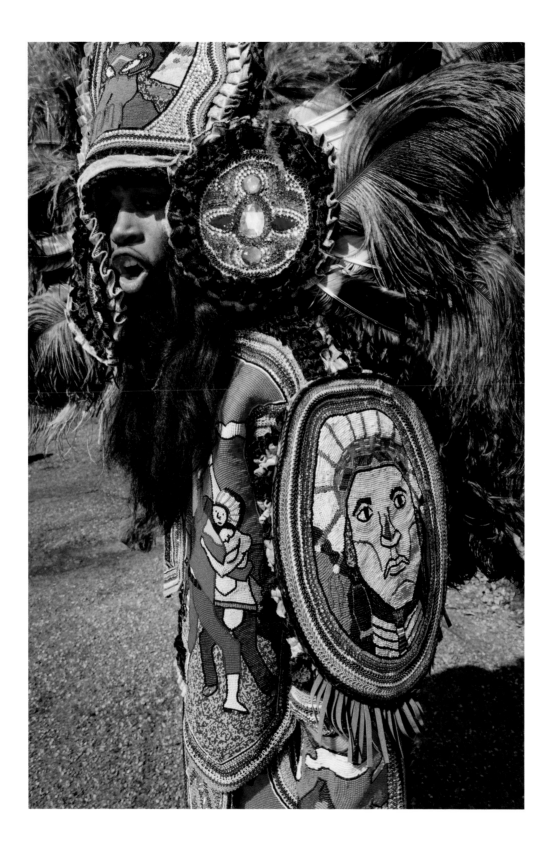

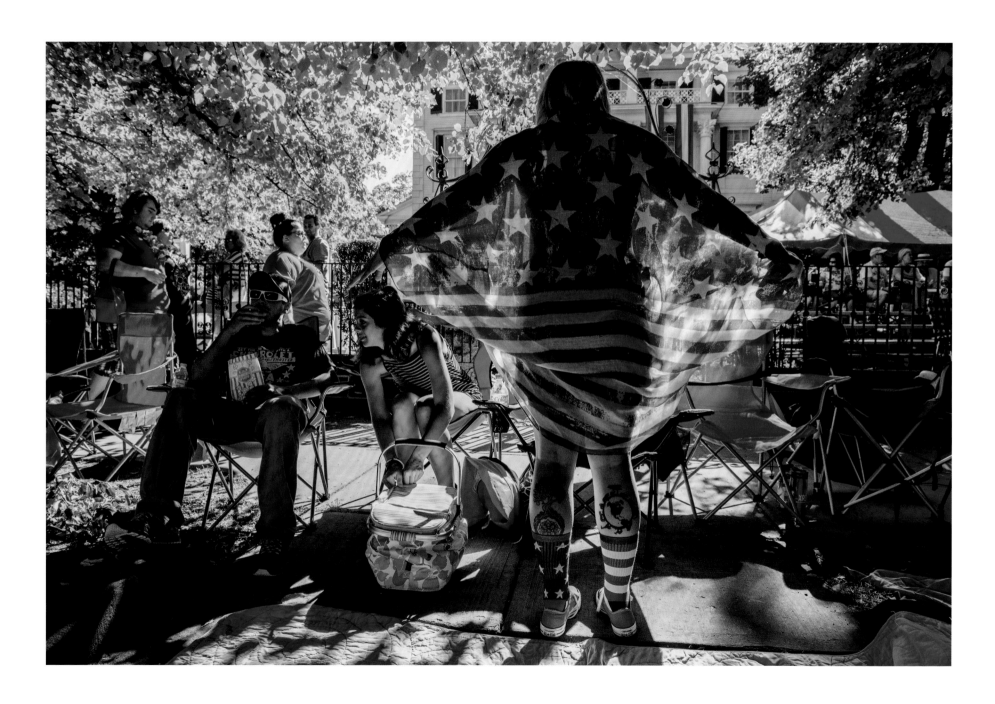

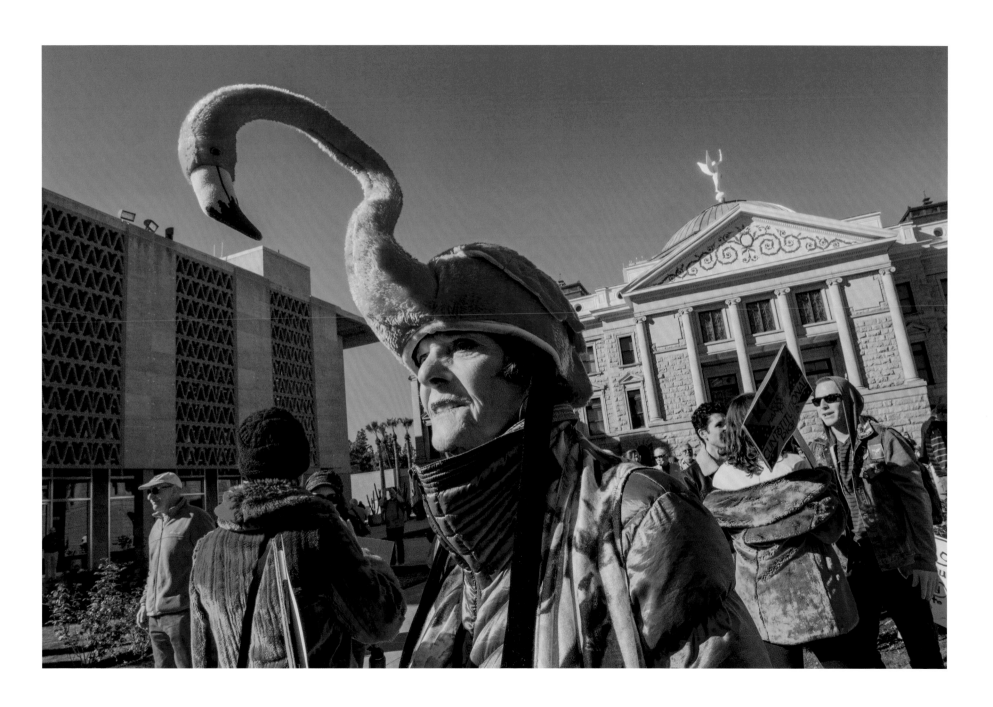

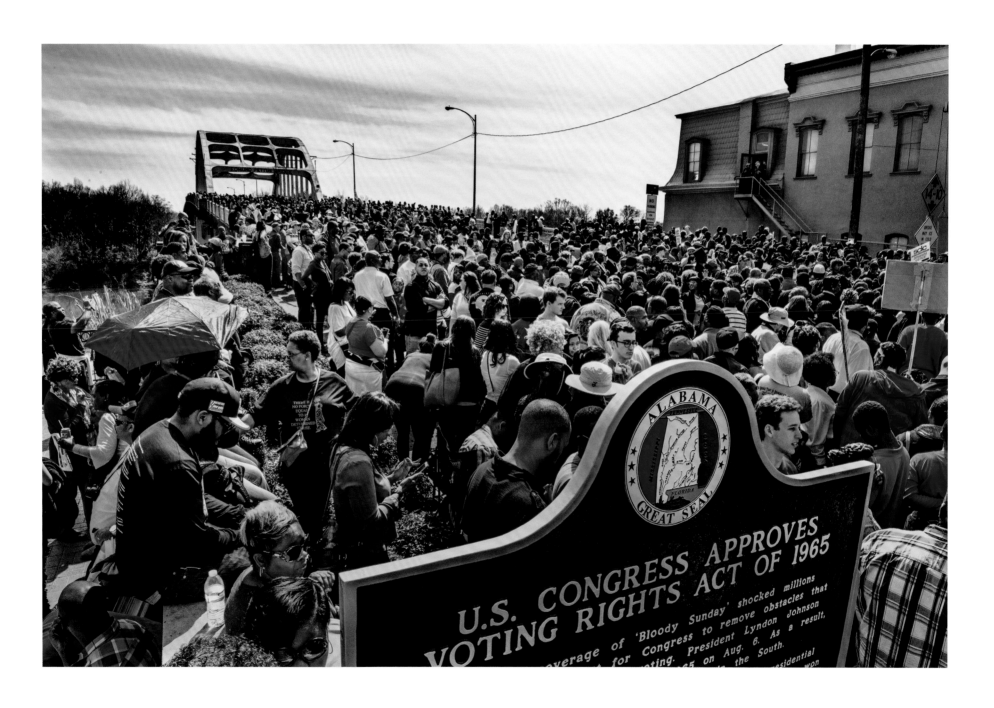

U.S. CONGRESS APPROVES
VOTING RIGHTS ACT OF 1965

... overage of 'Bloody Sunday' shocked millions
... for Congress to remove obstacles that
... oting. President Lyndon Johnson
... 65 on Aug. 6. As a result,
... in the South.
... residential
... won

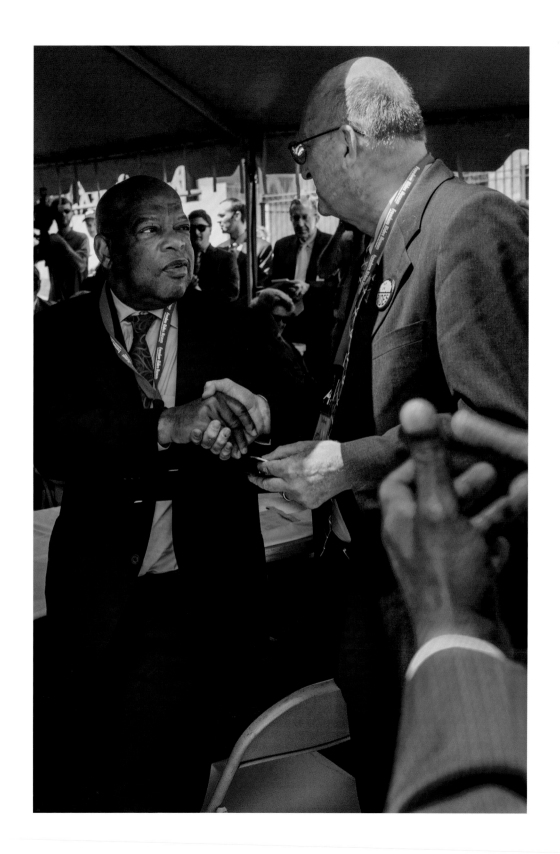

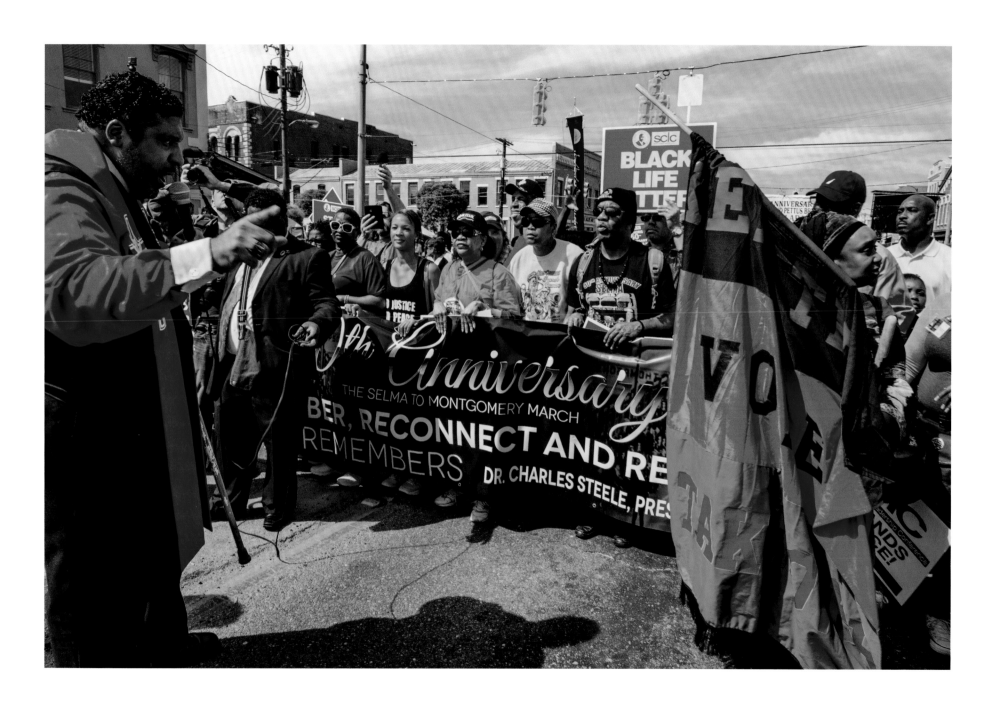

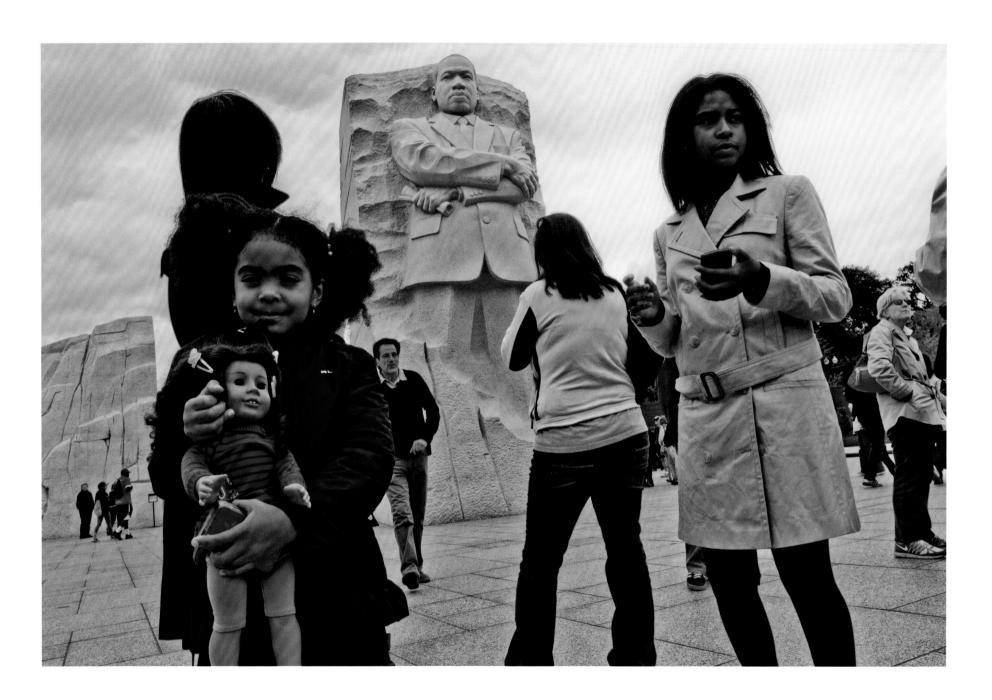

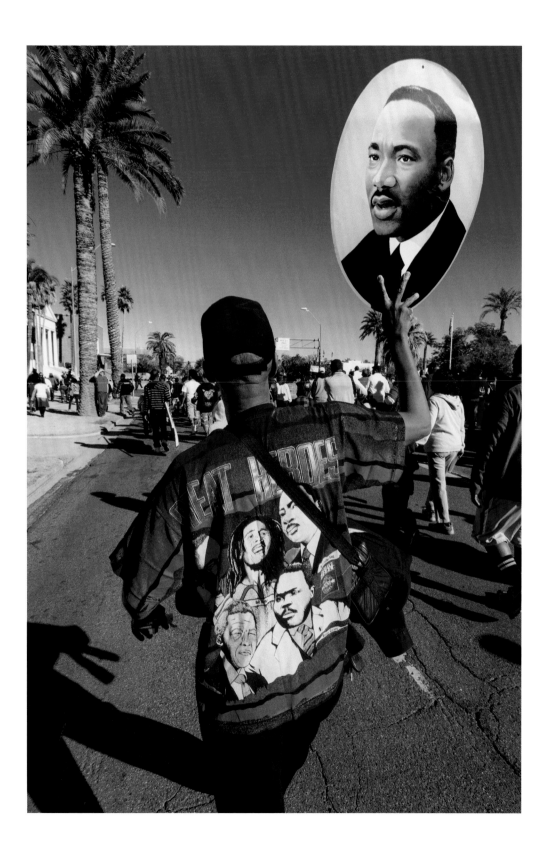

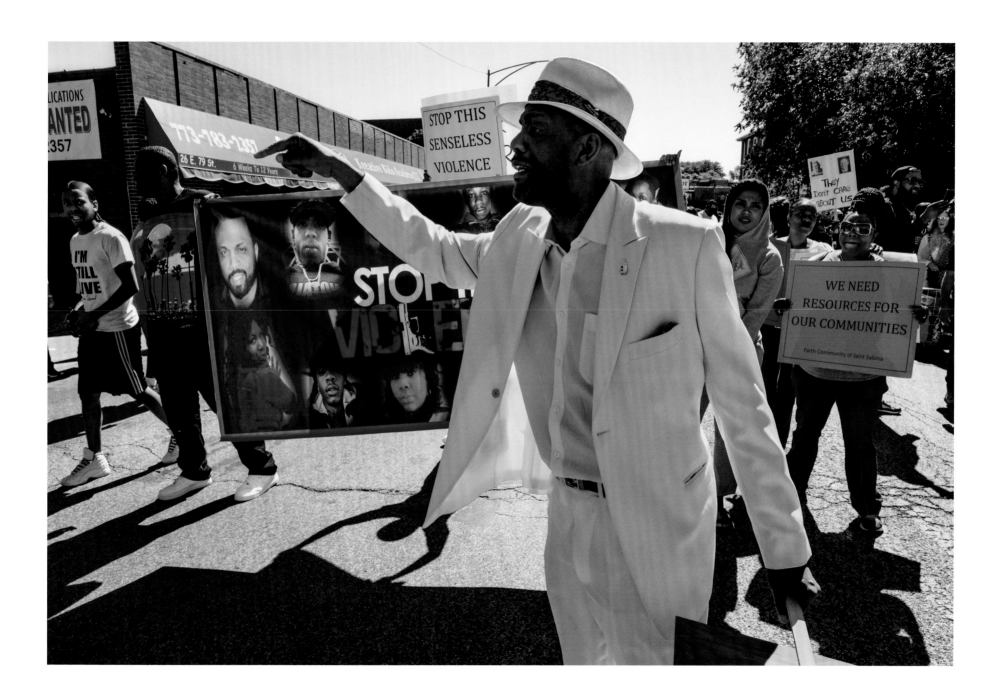

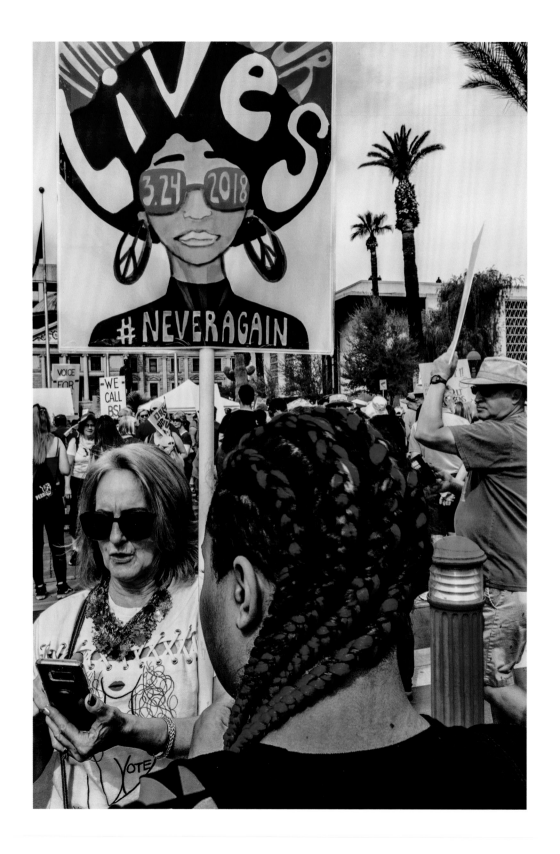

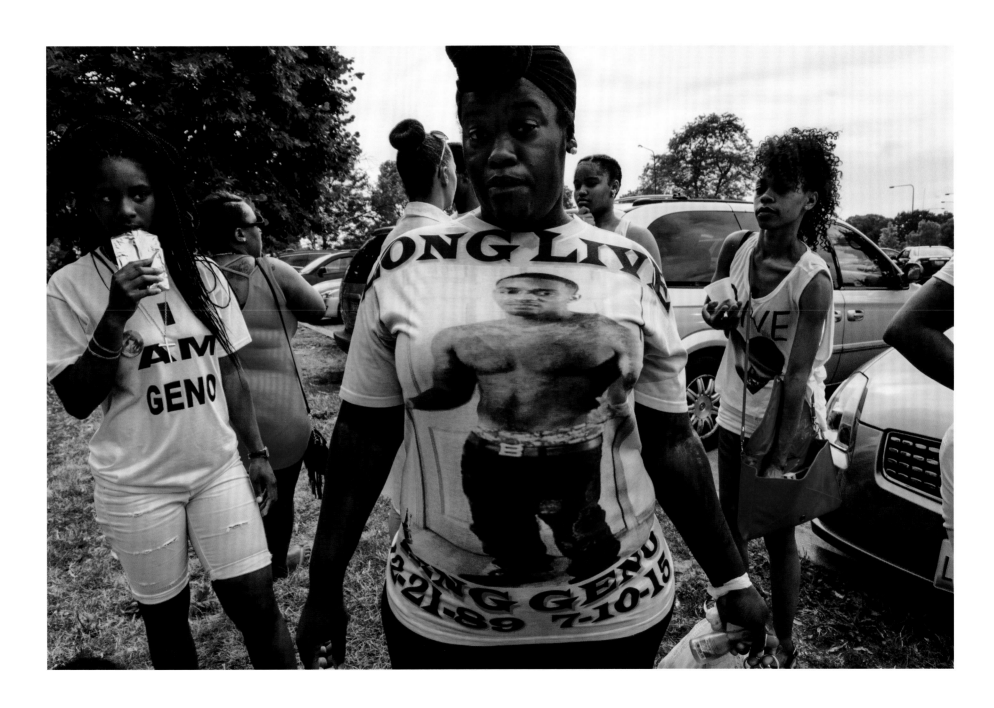

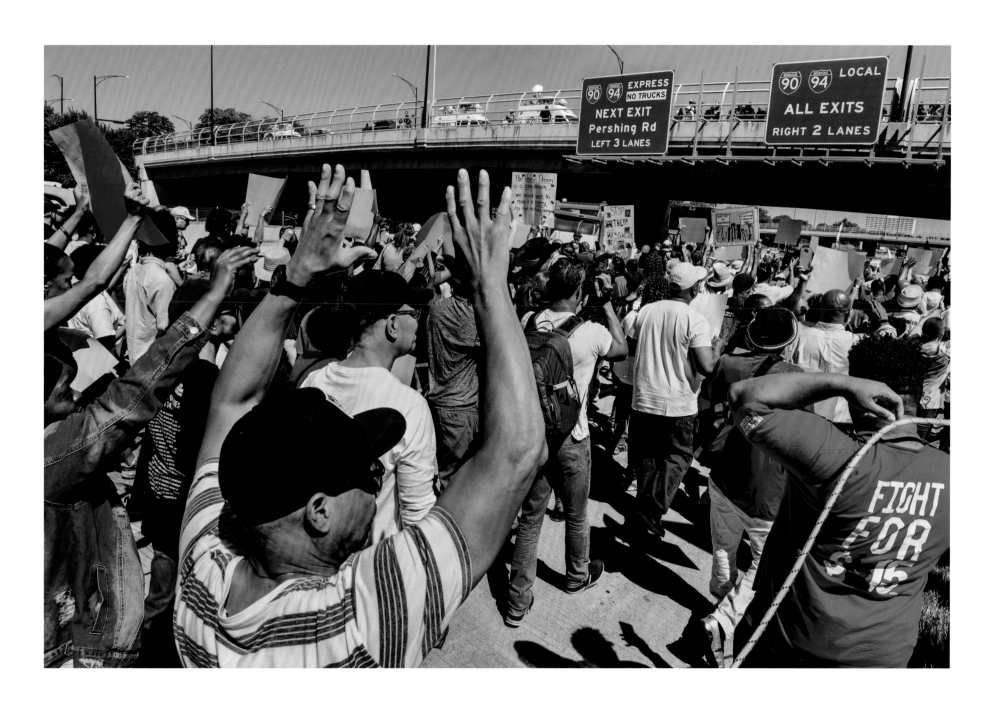

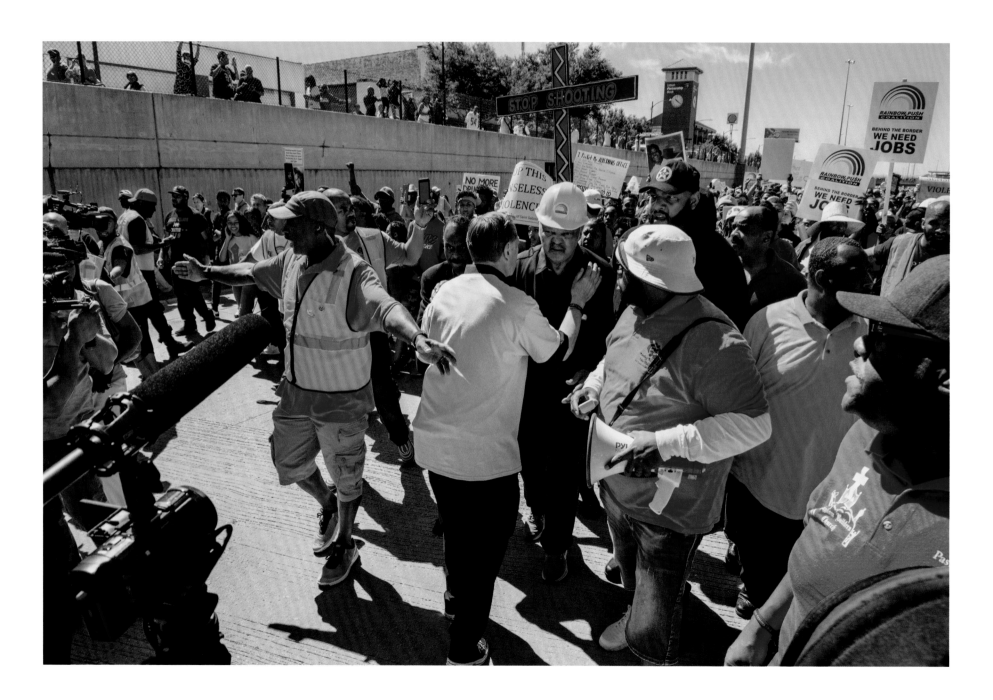

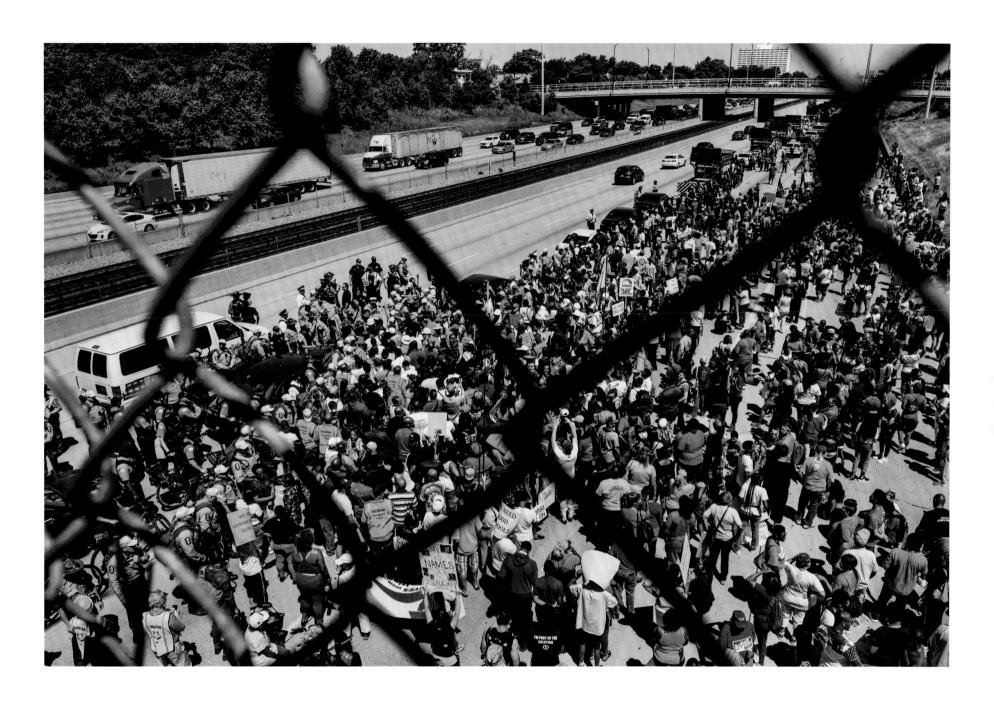

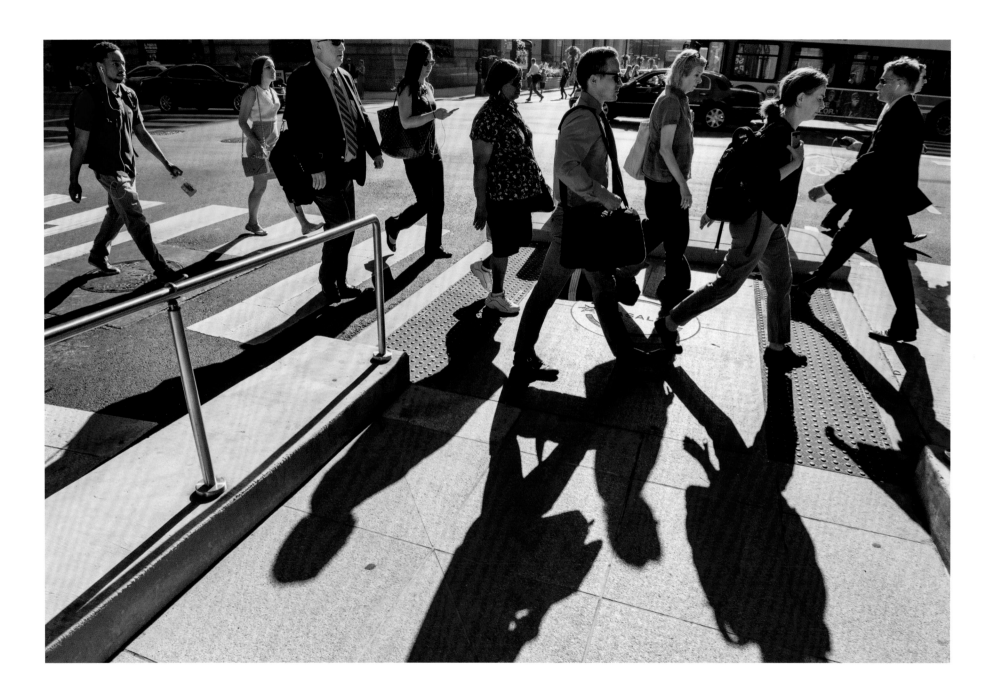

124 Chicago, IL

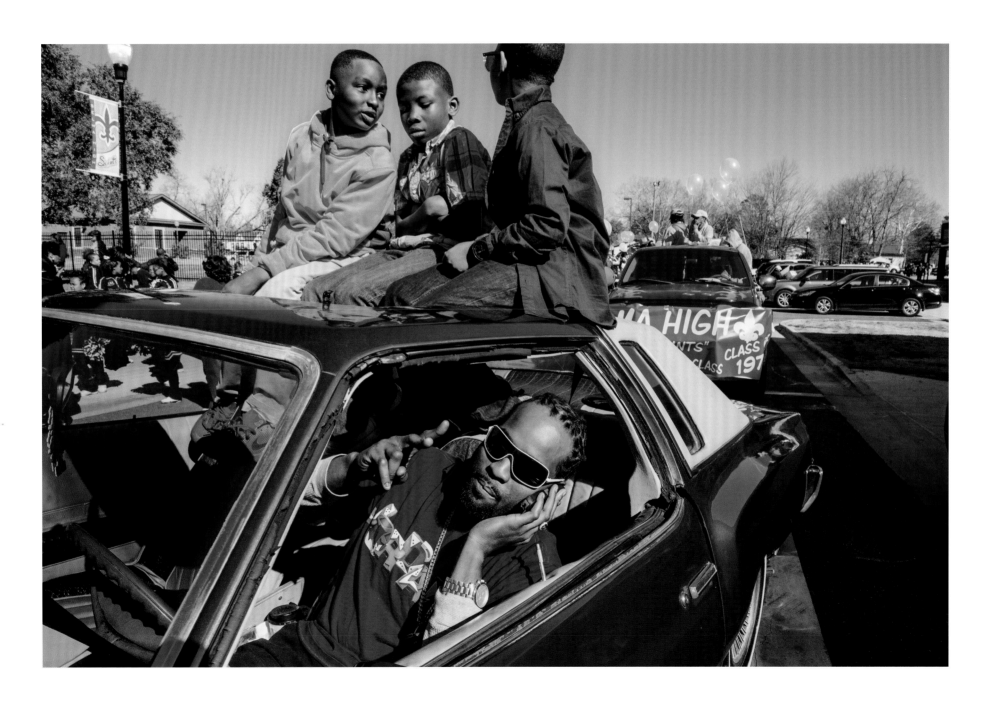

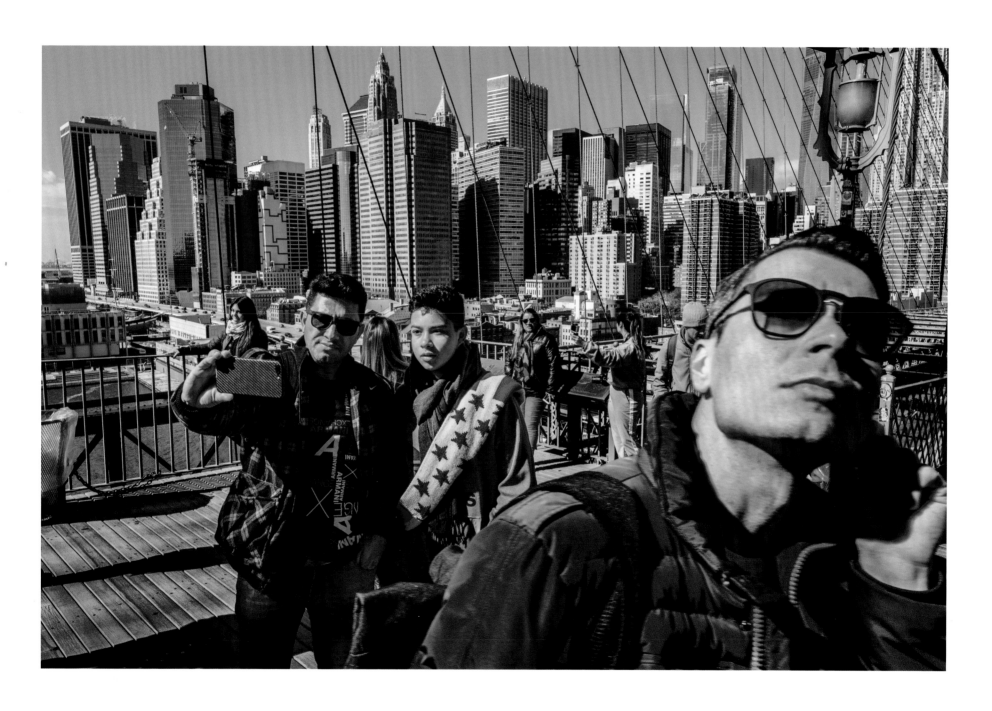

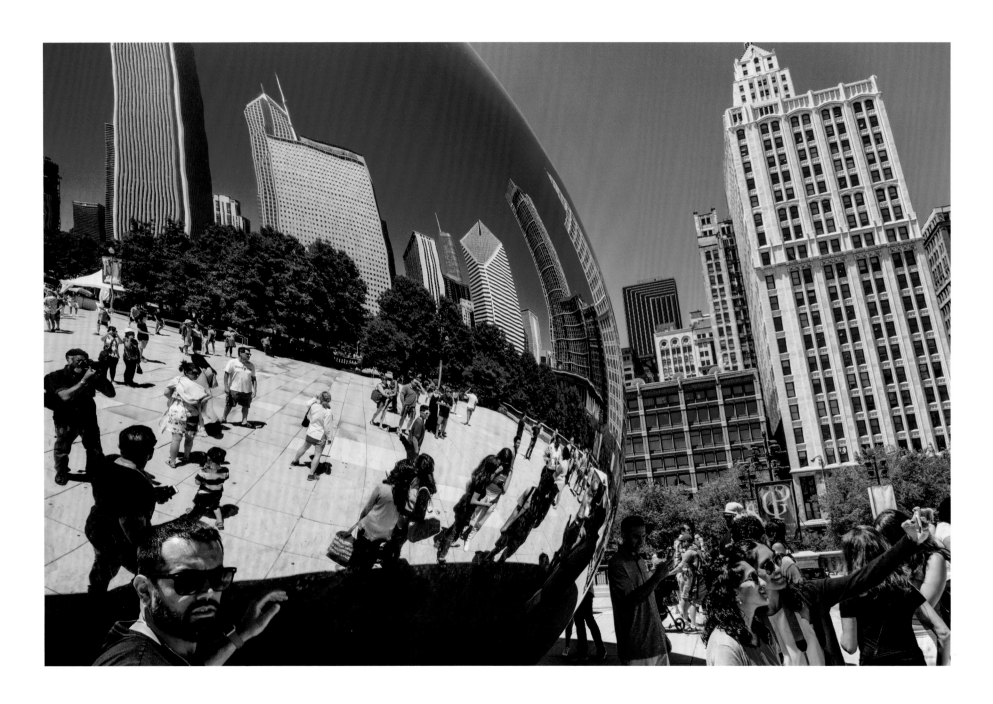

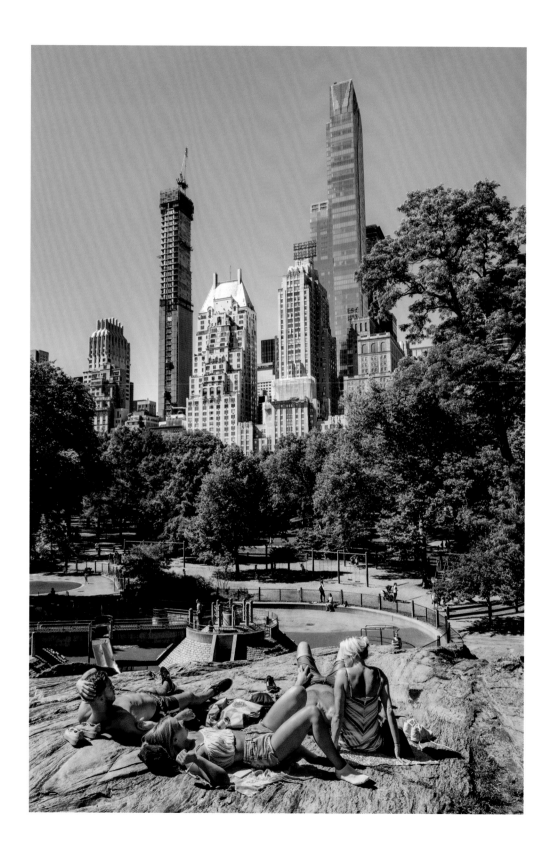

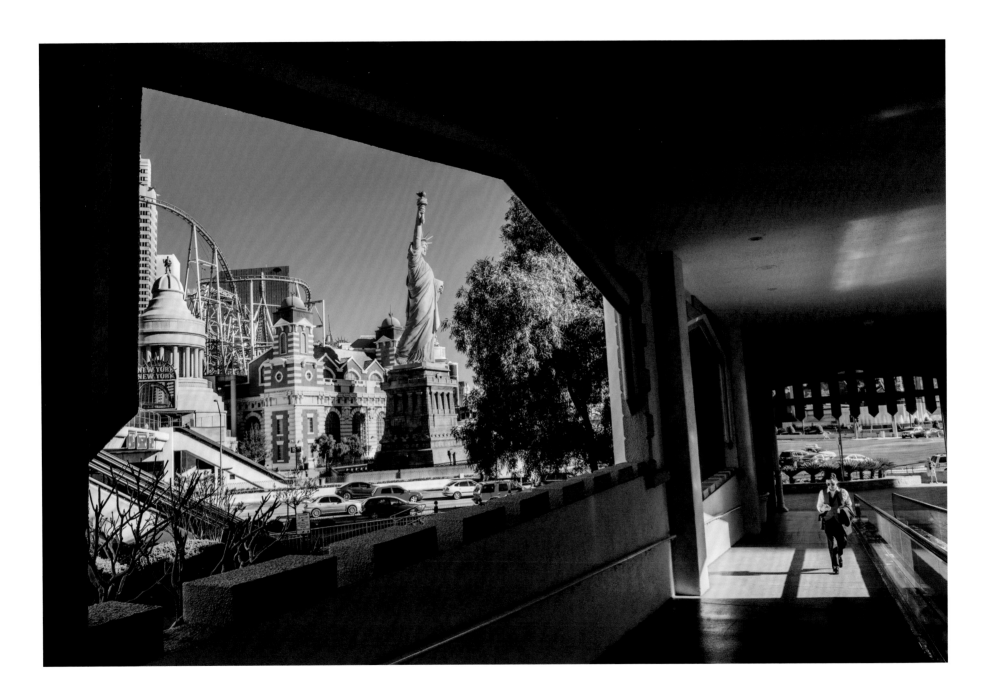

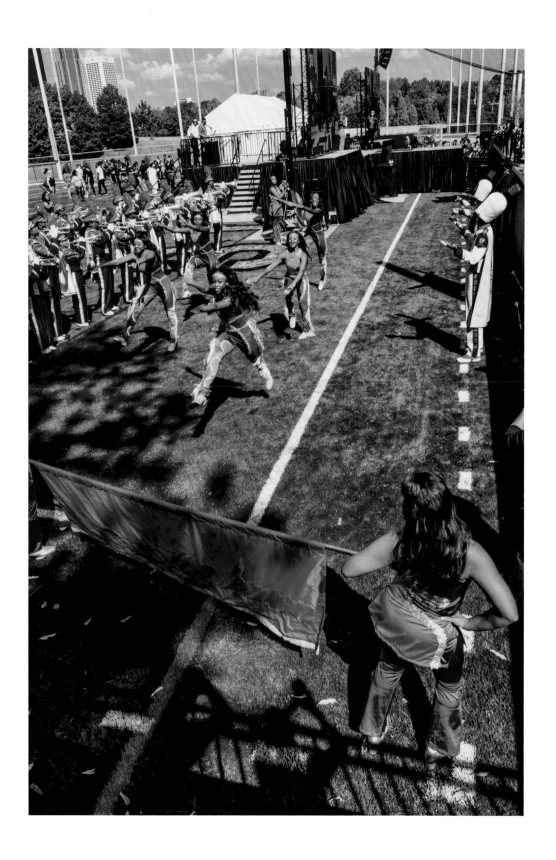

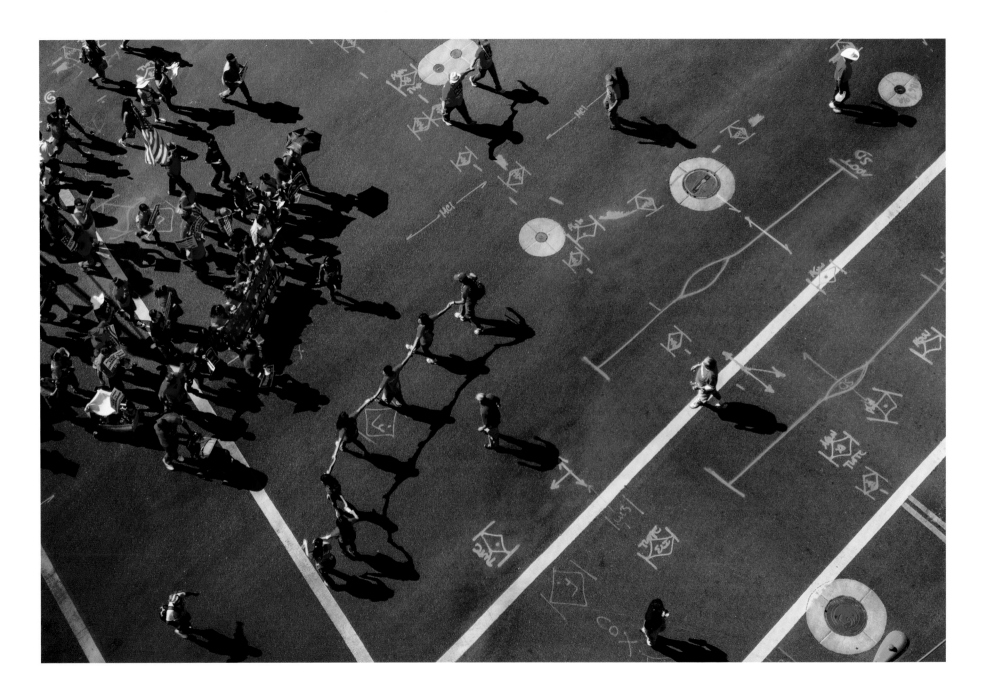

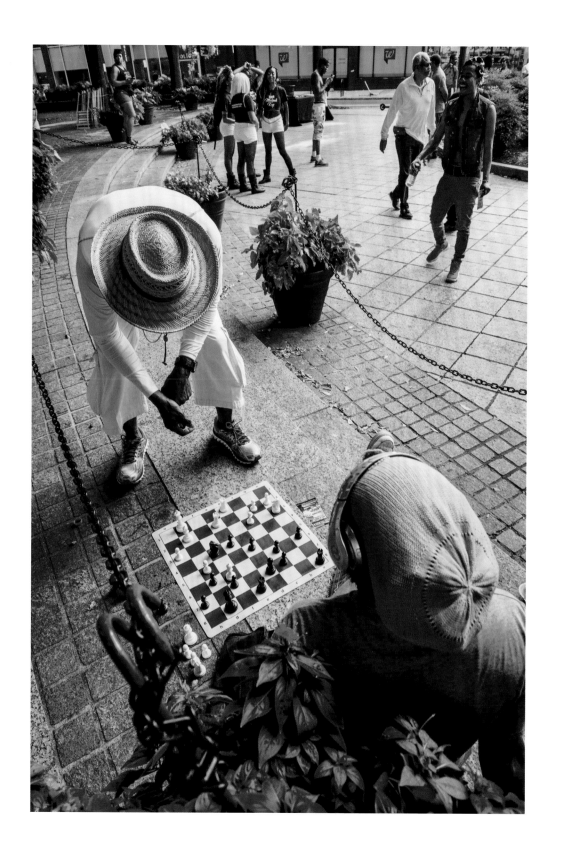

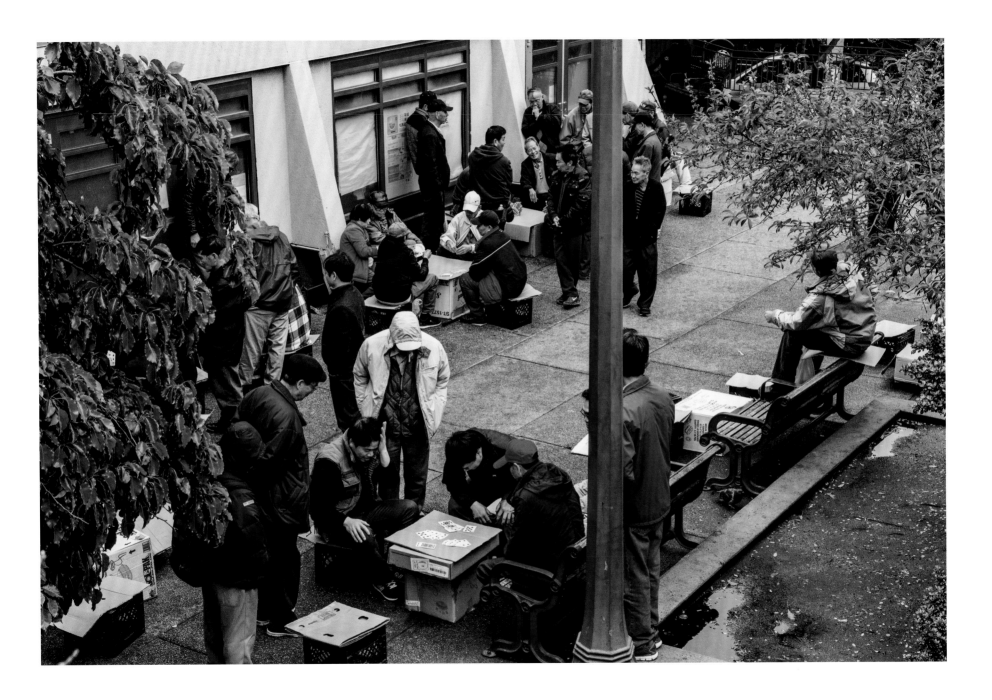

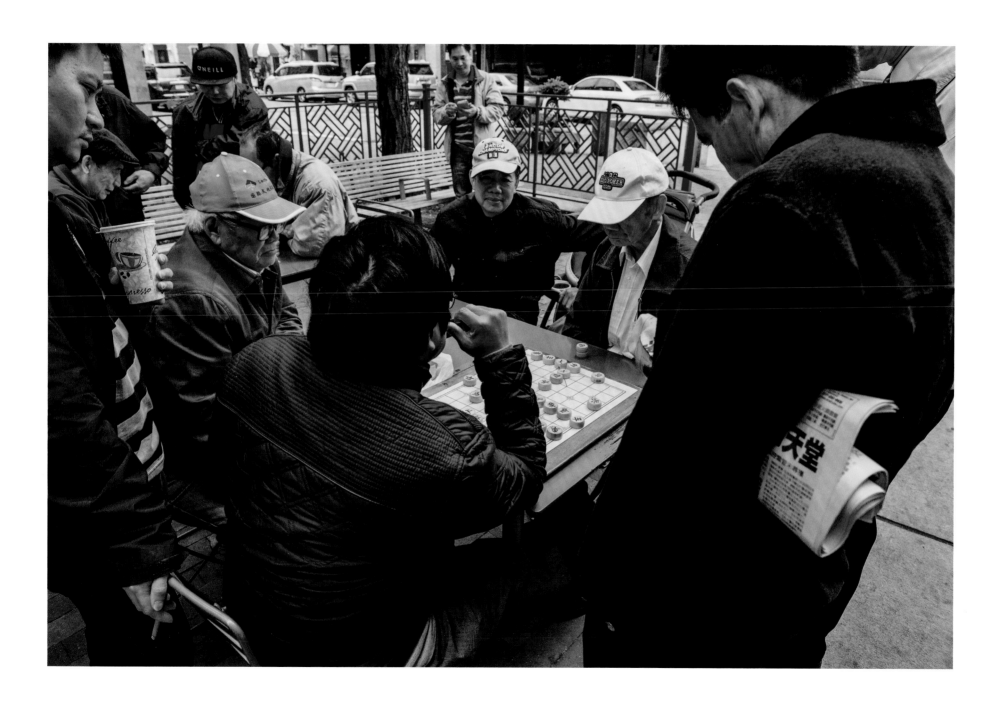

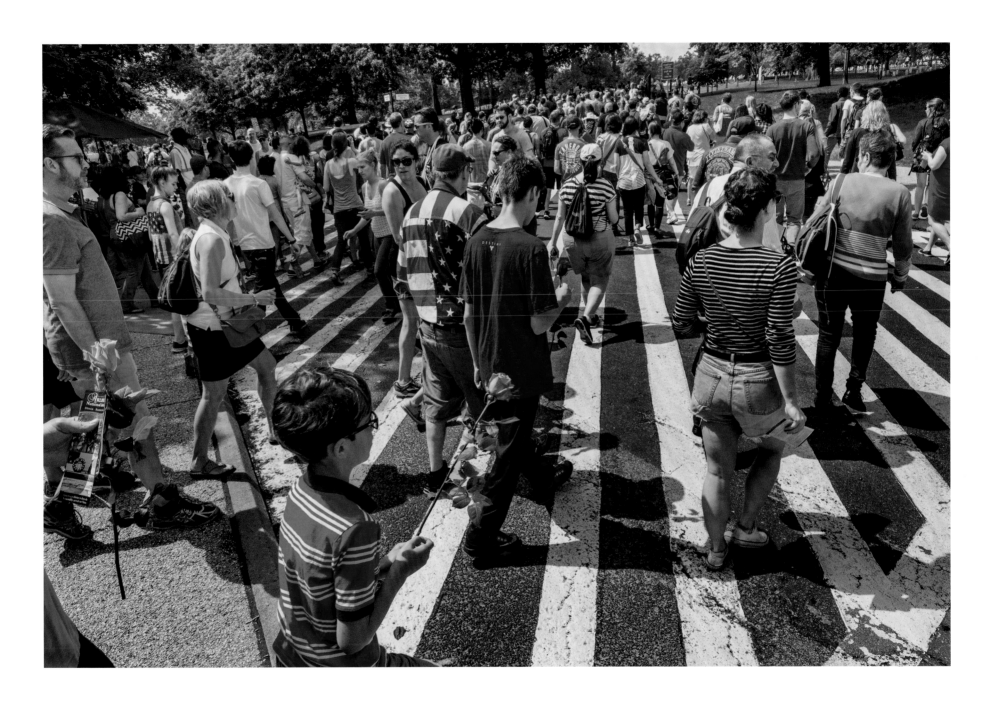

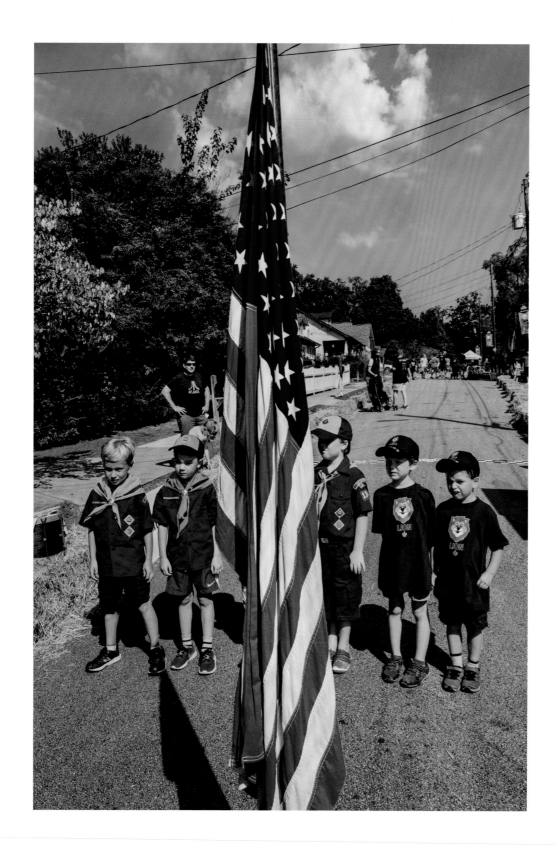

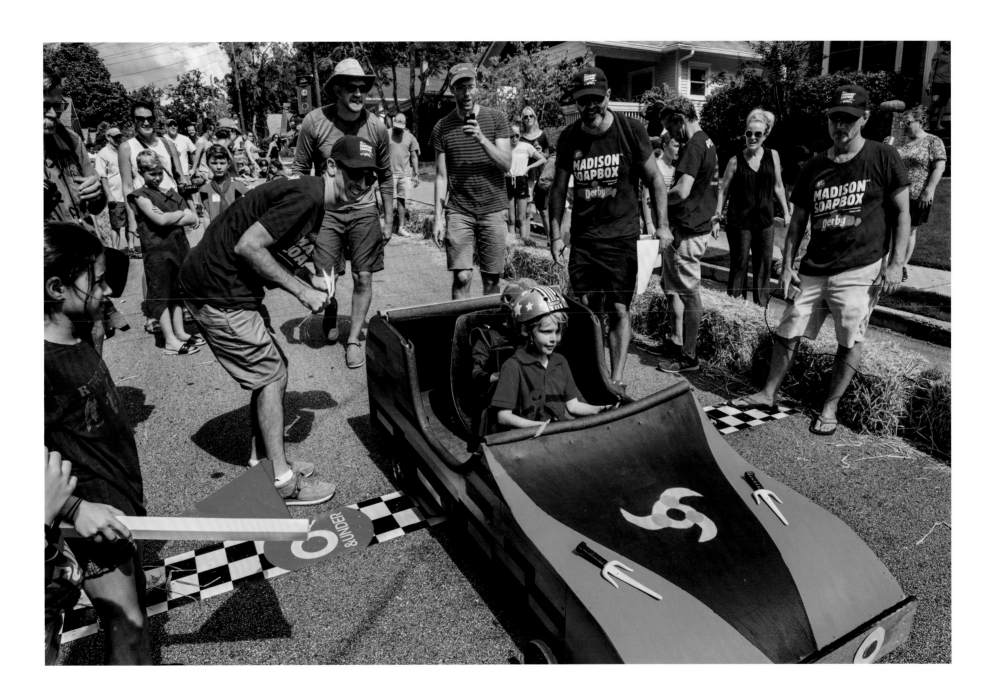

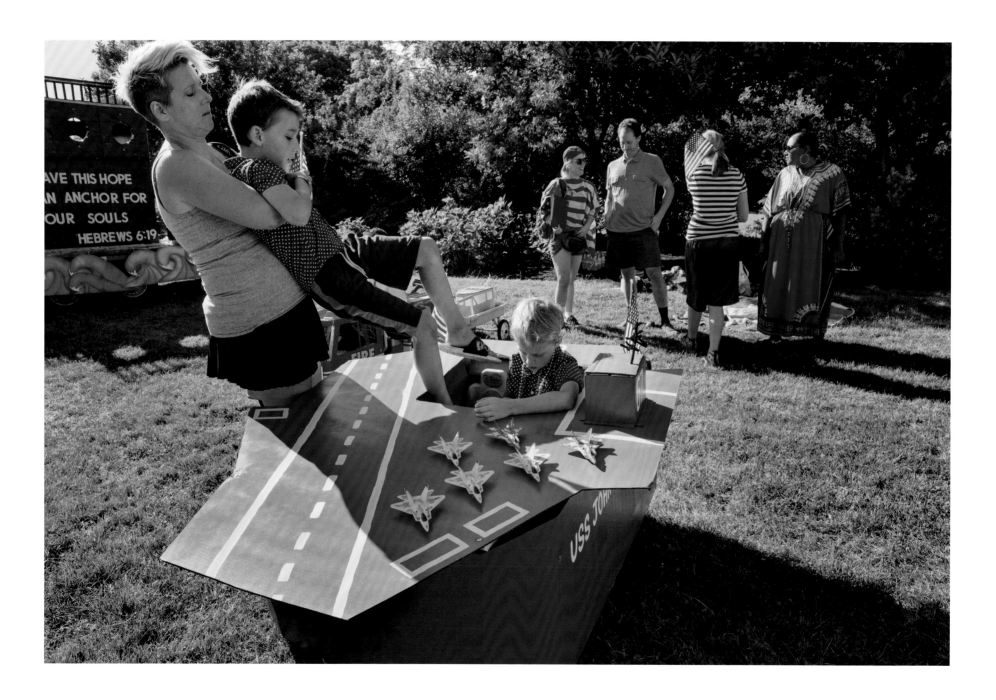

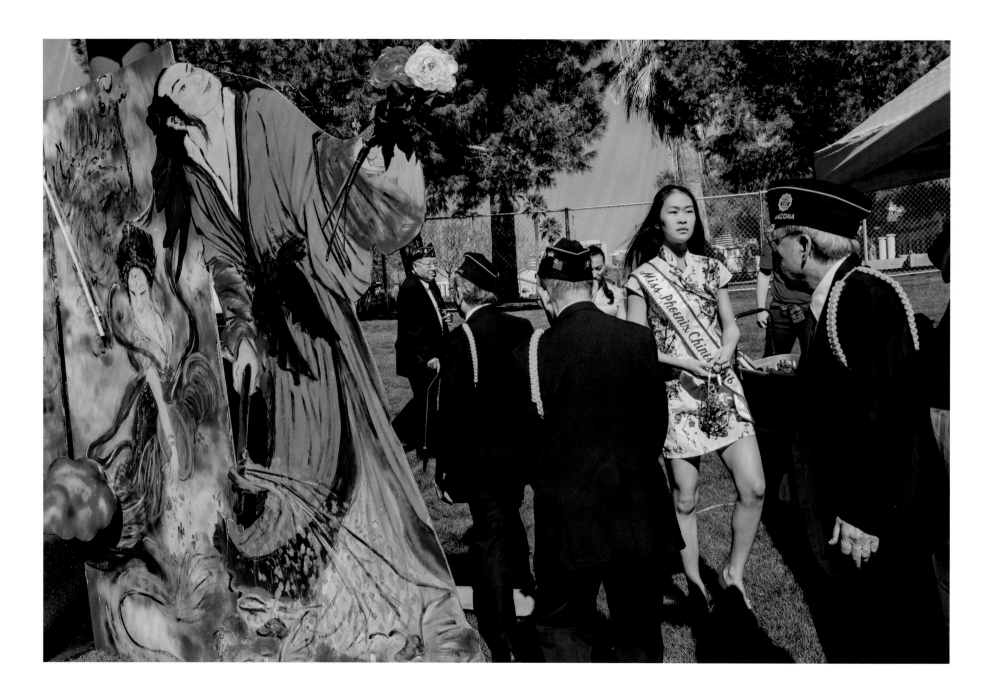

142 Phoenix, AZ

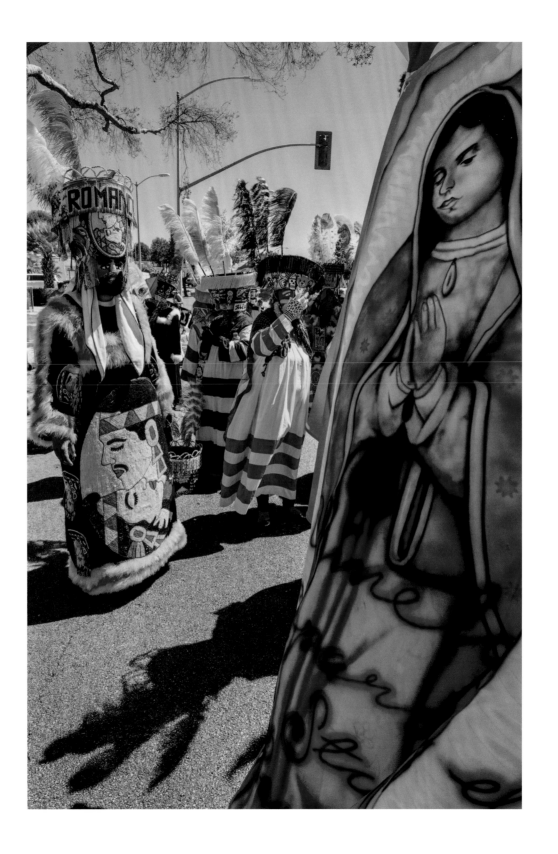

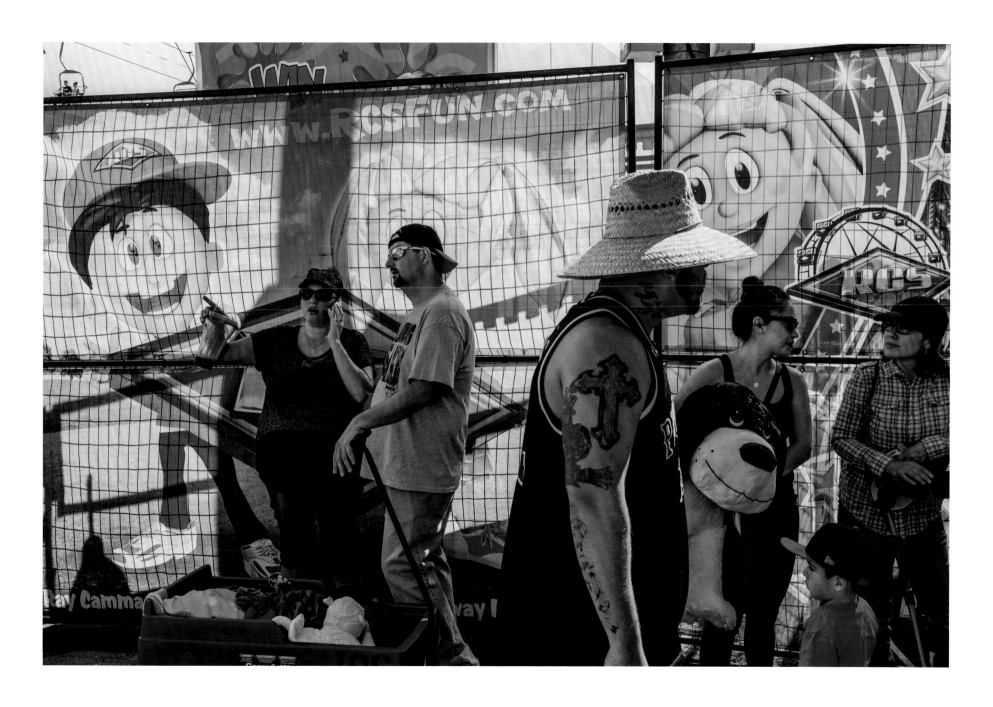

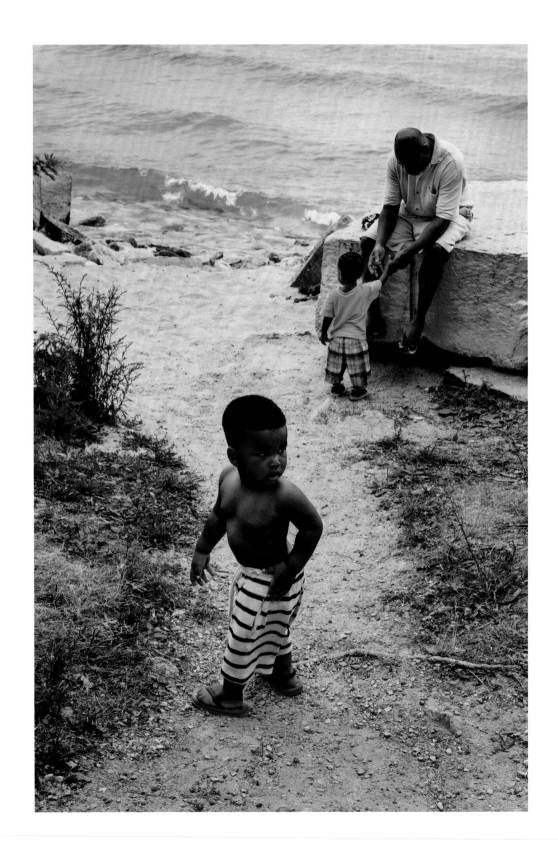

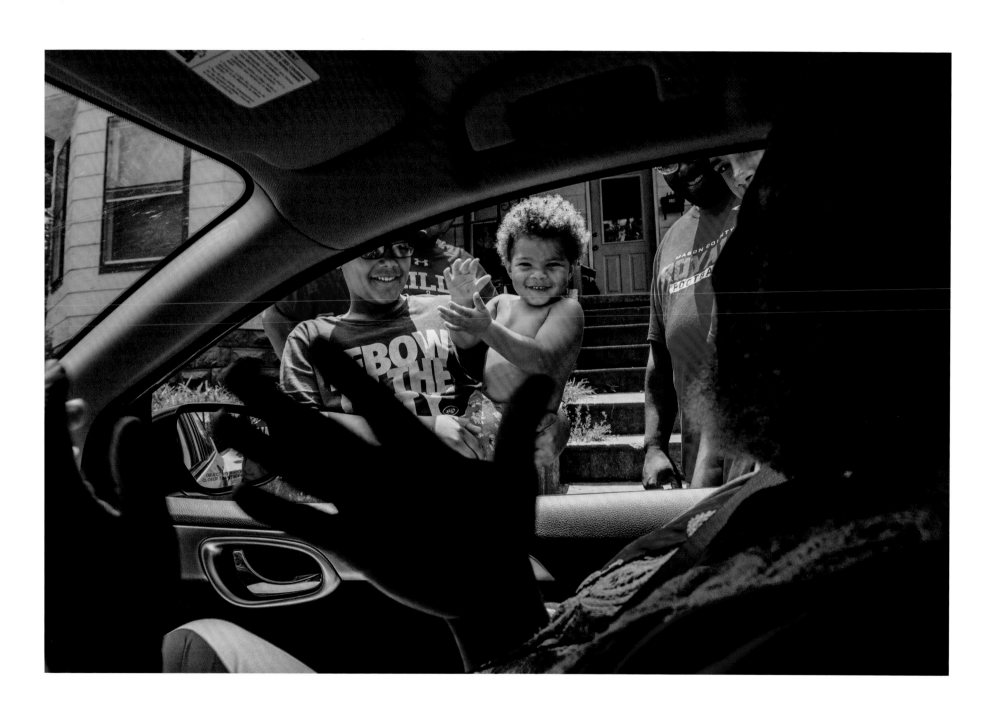

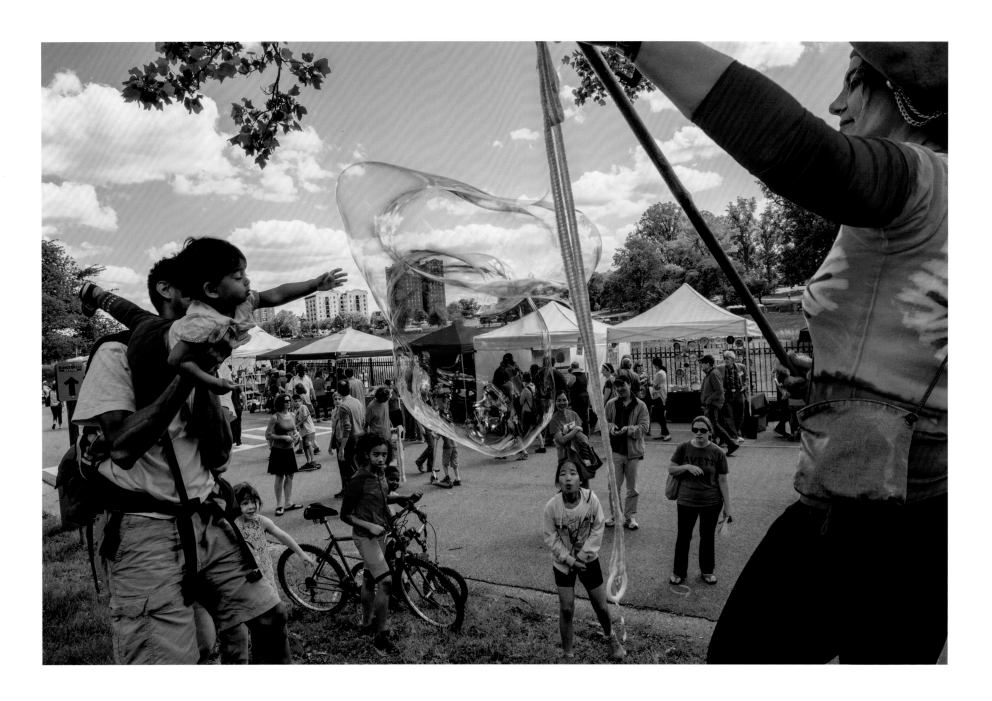

148 Baltimore, MD

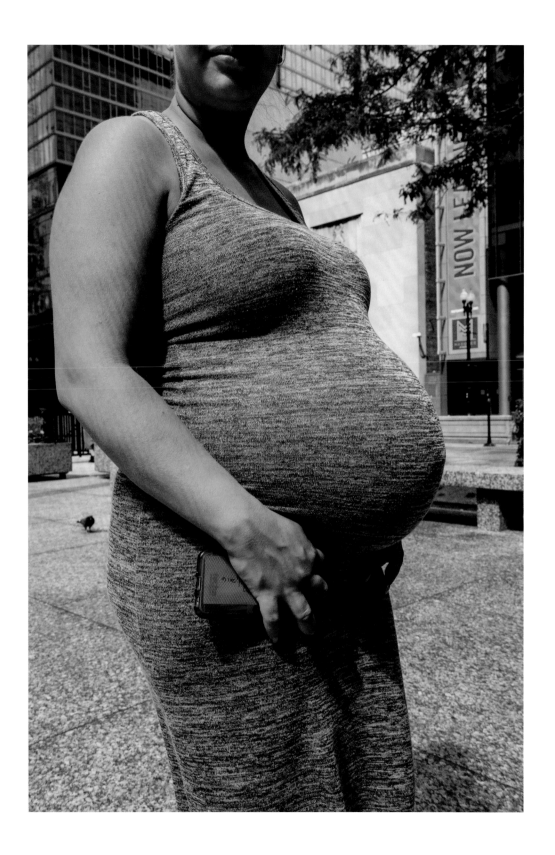

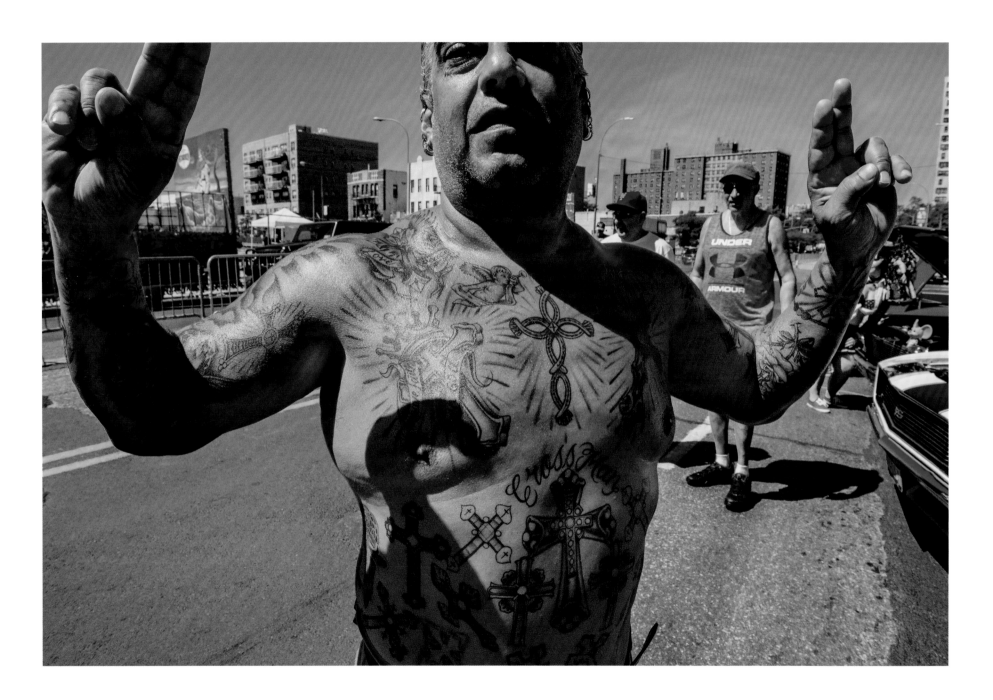

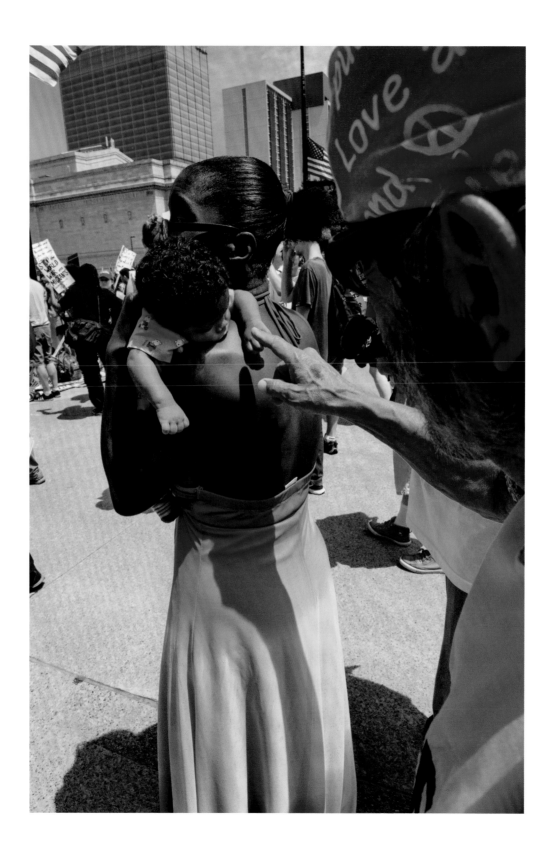

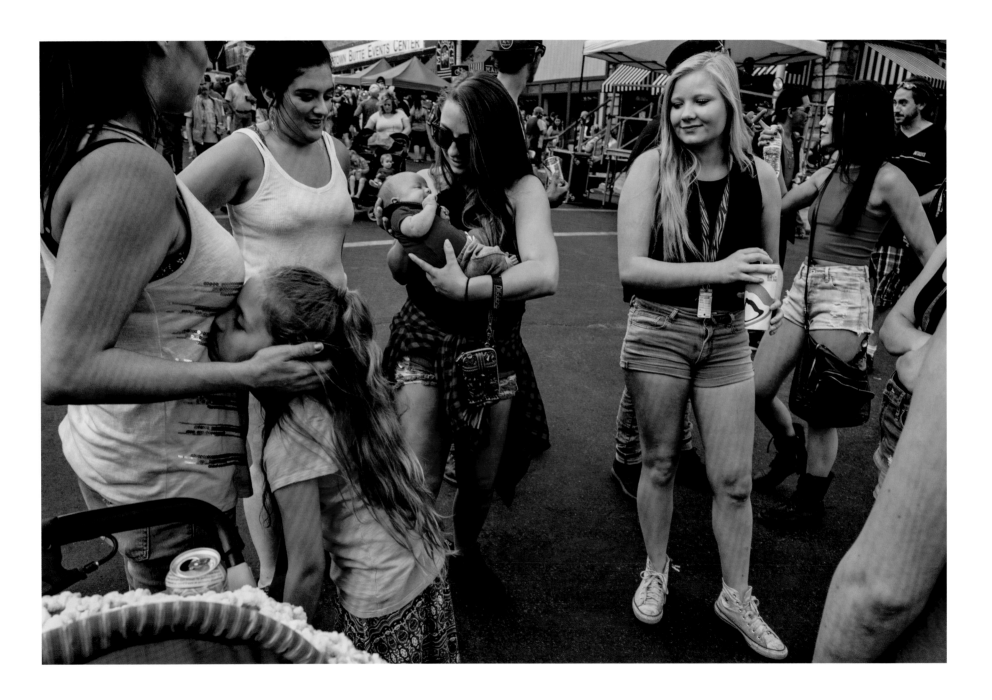

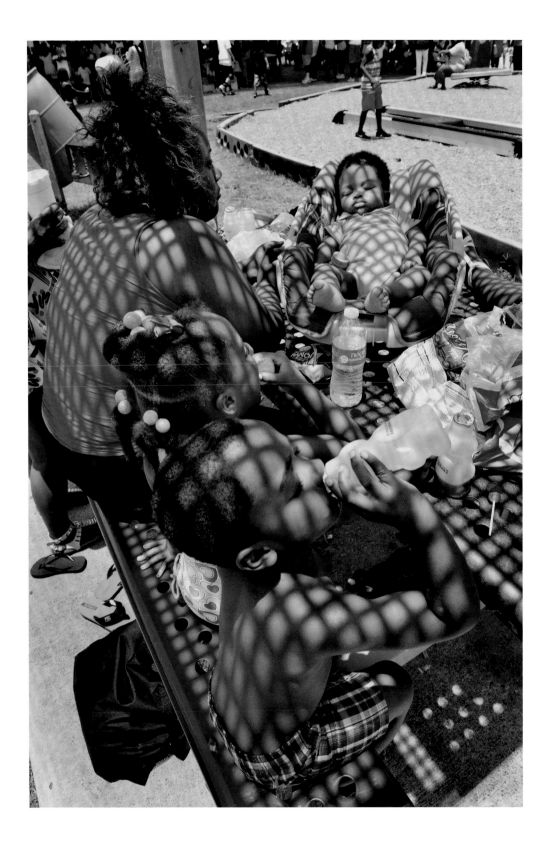

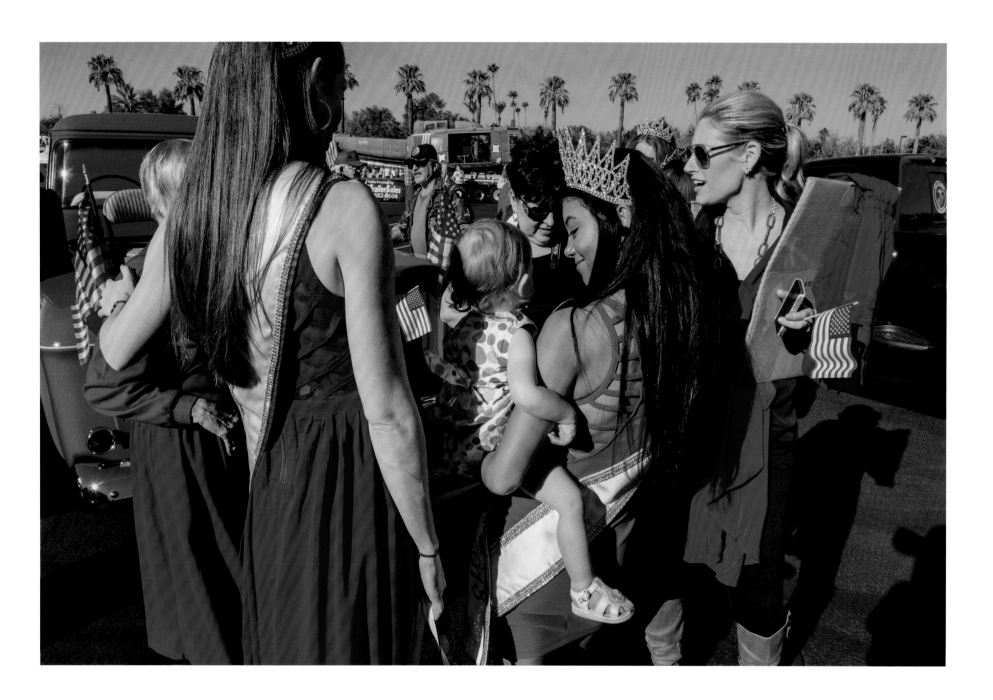

154 Phoenix, AZ

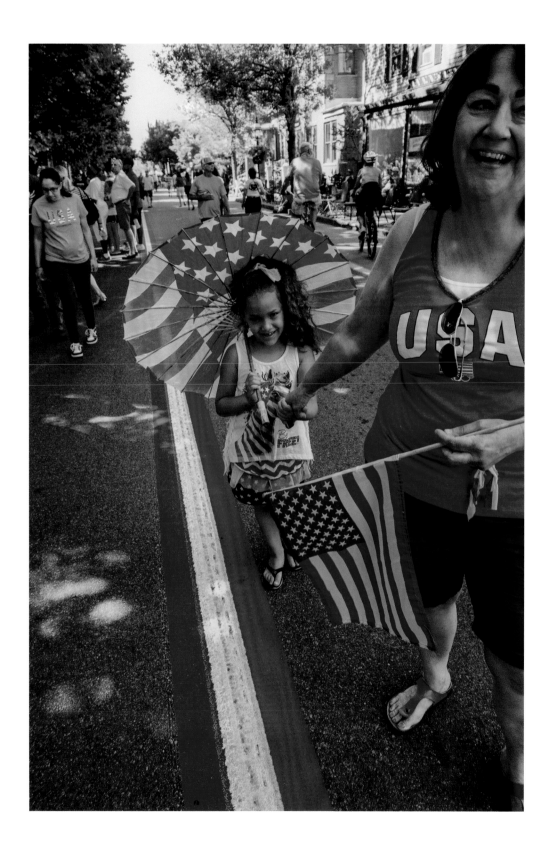

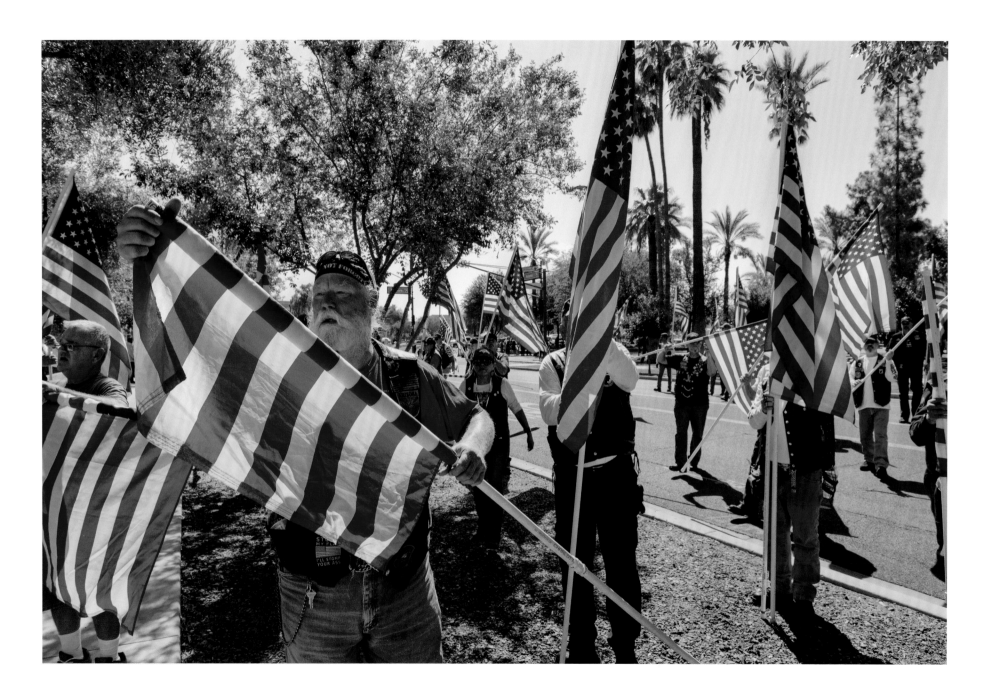

156 Phoenix, AZ

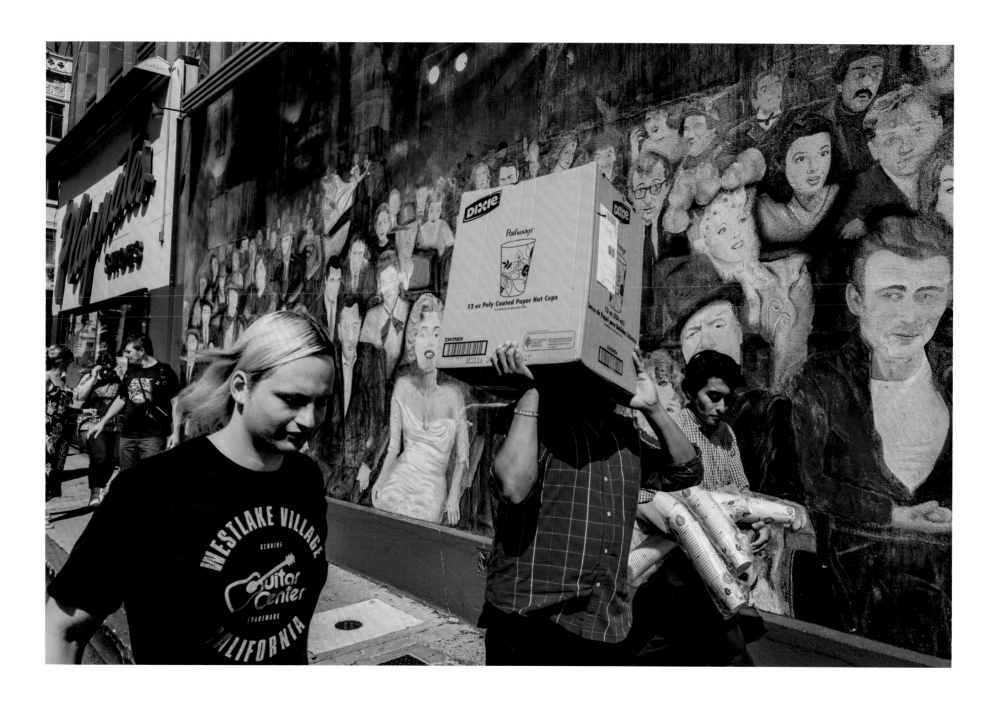

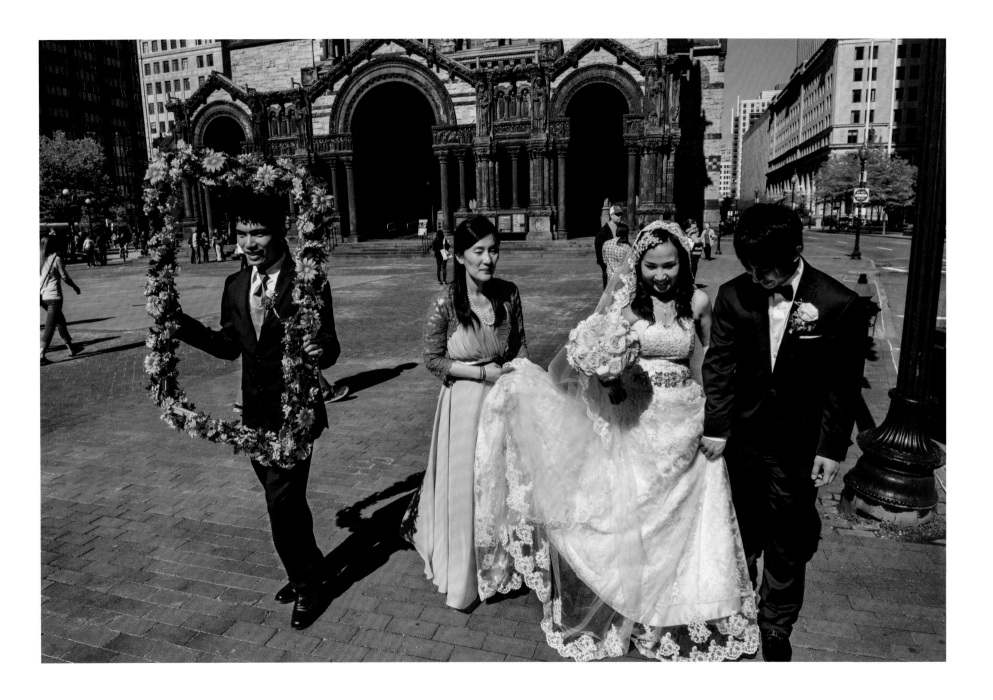

162 Boston, MA

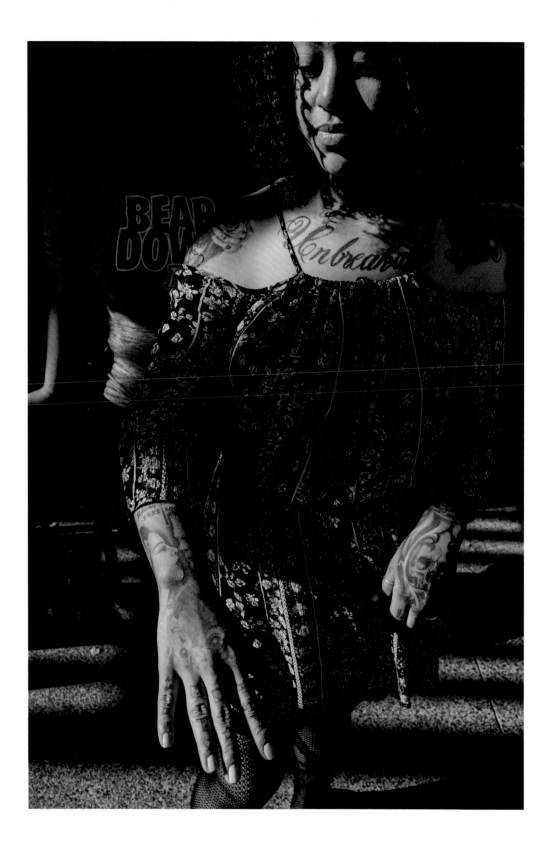

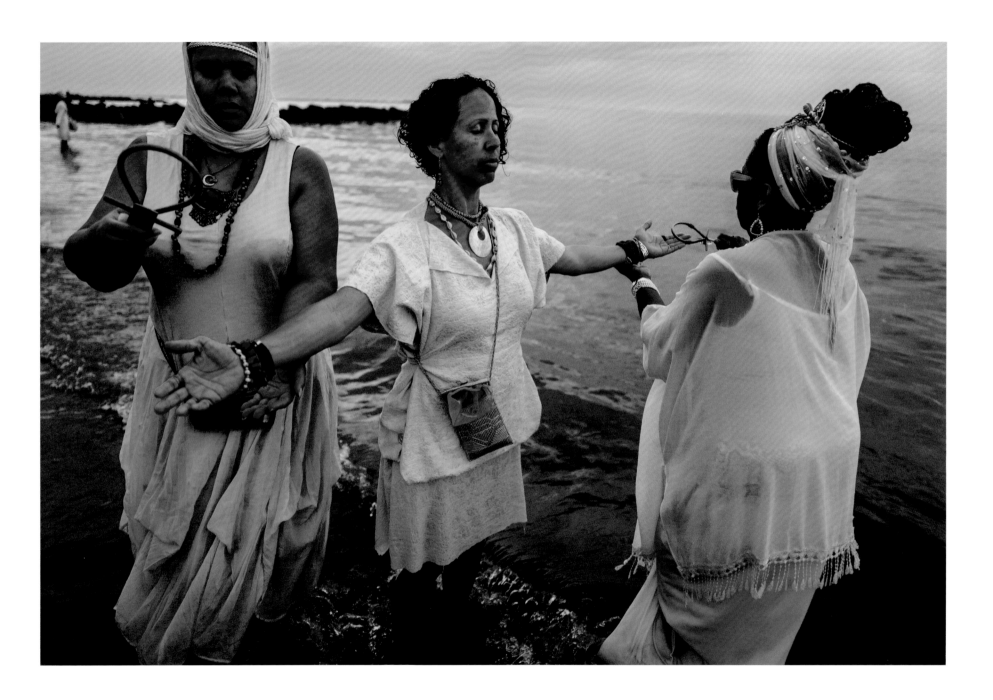

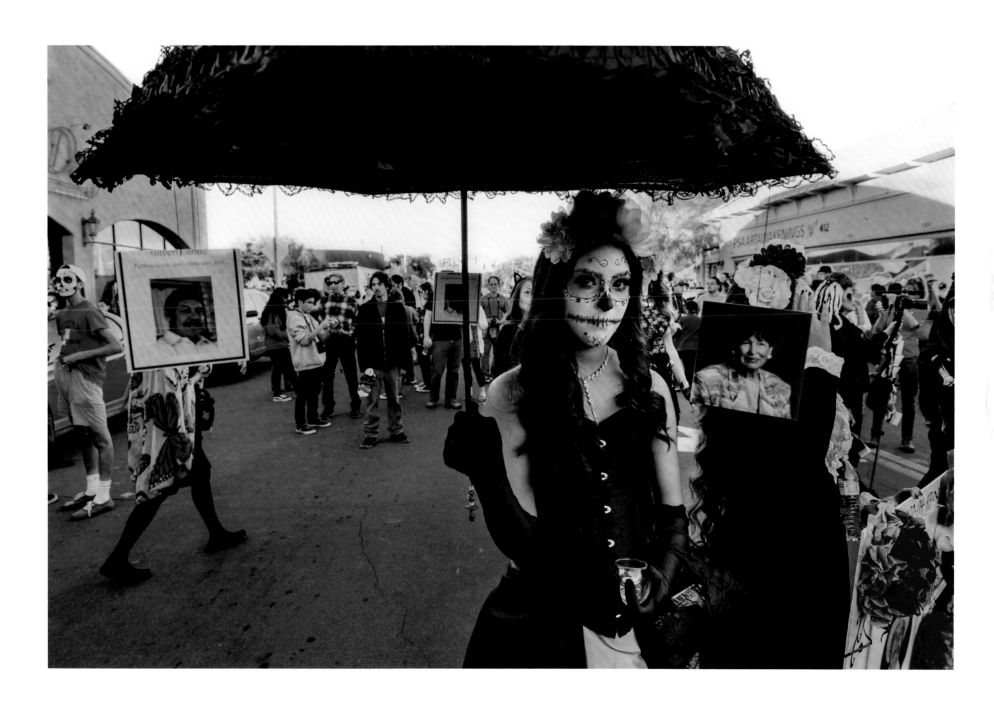

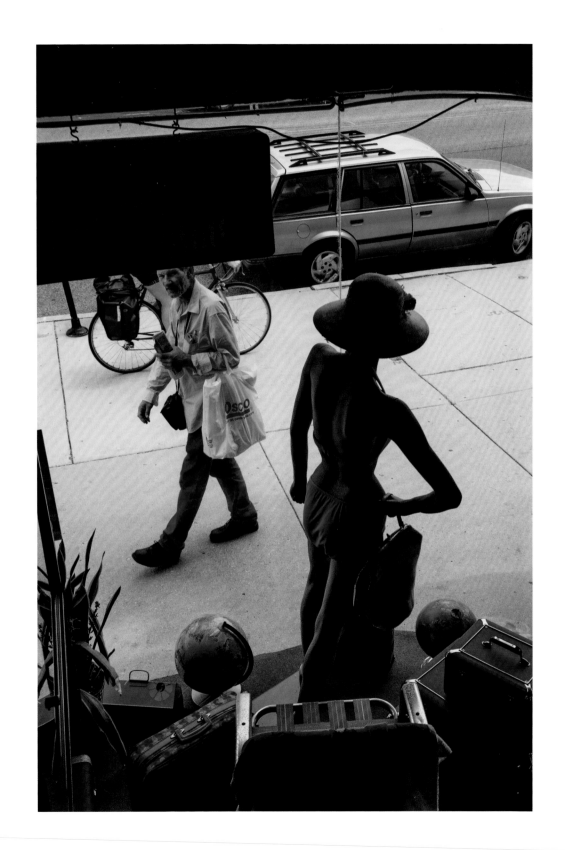

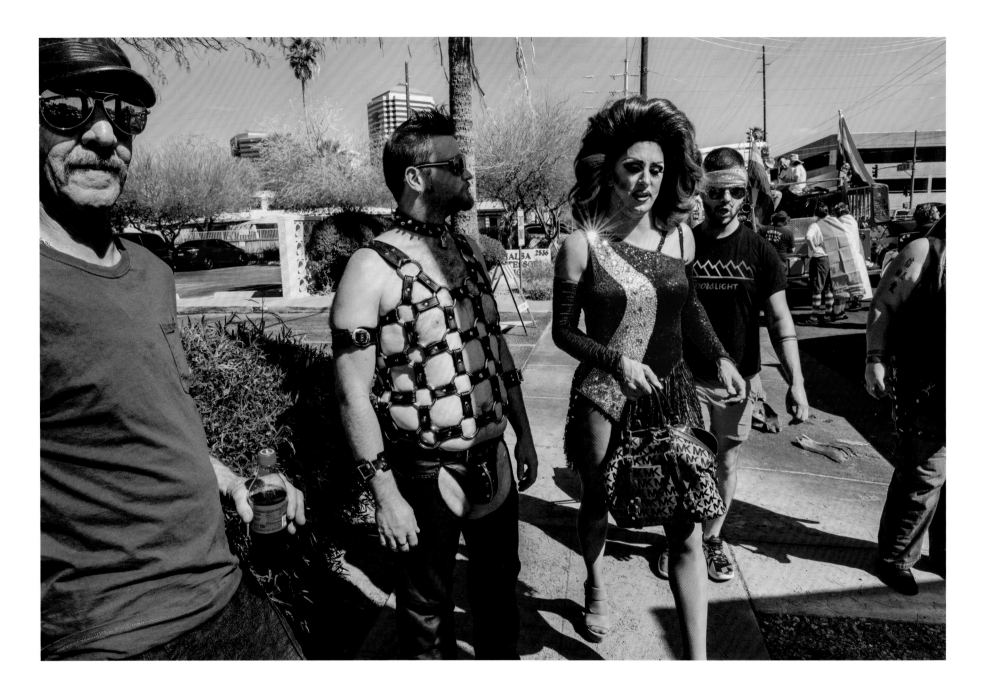

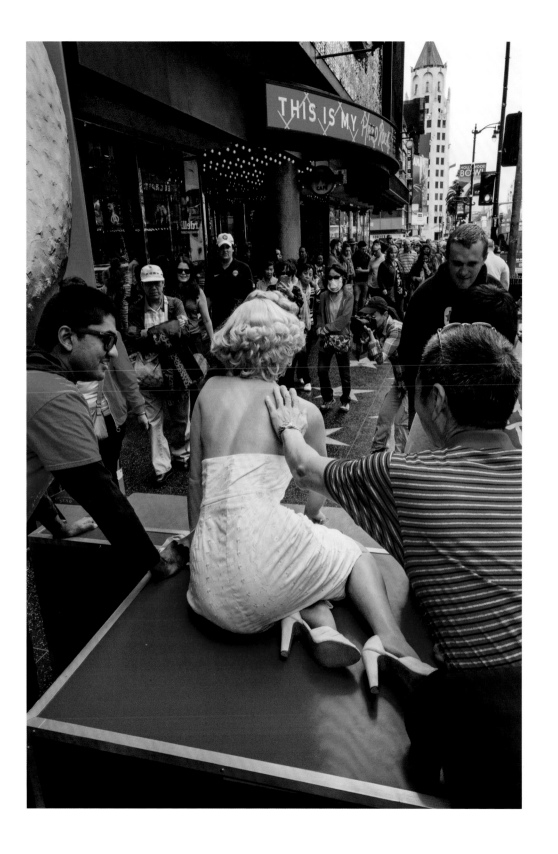

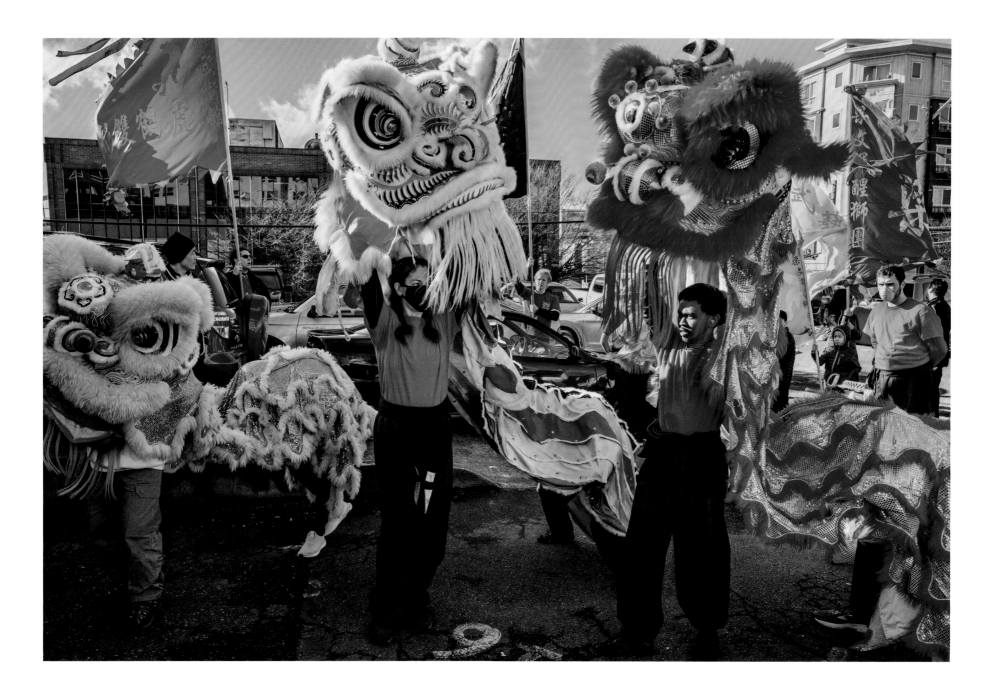

174 Seattle, WA

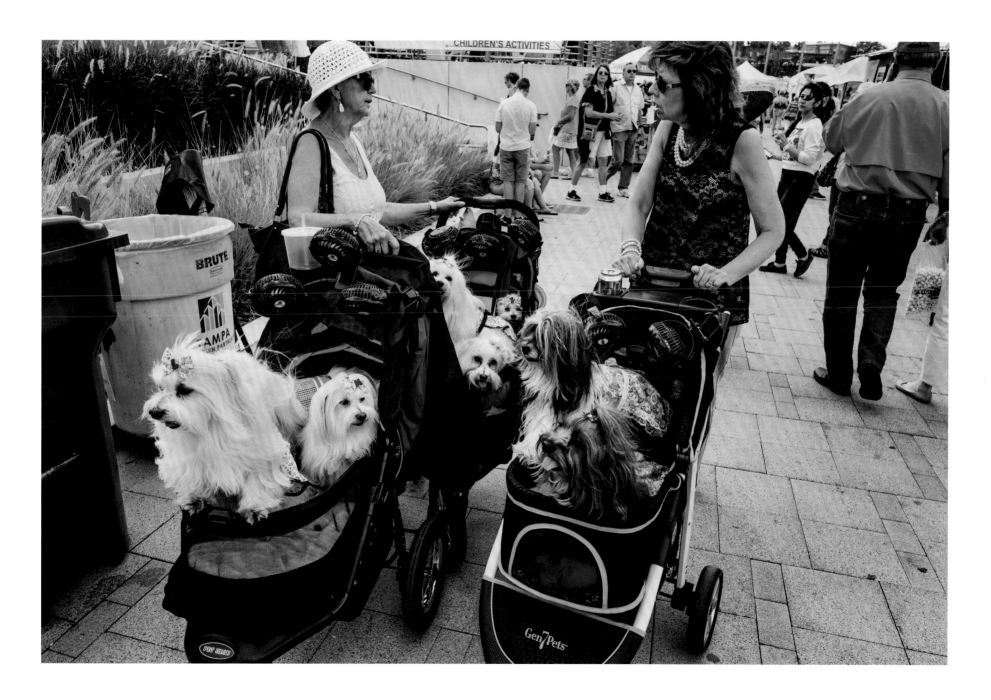

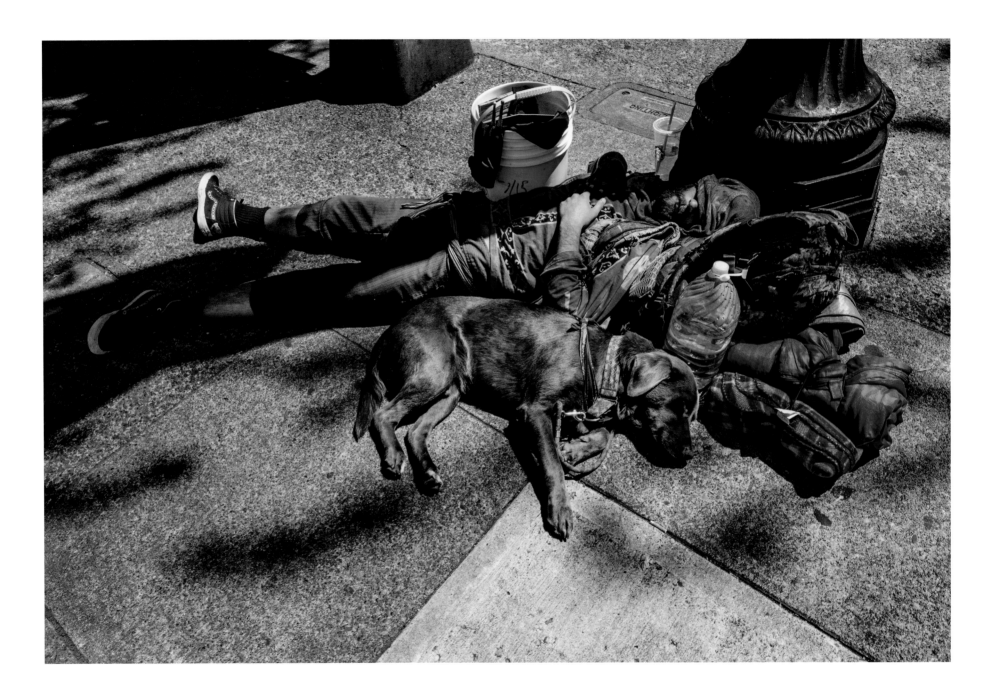

176 Portland, OR

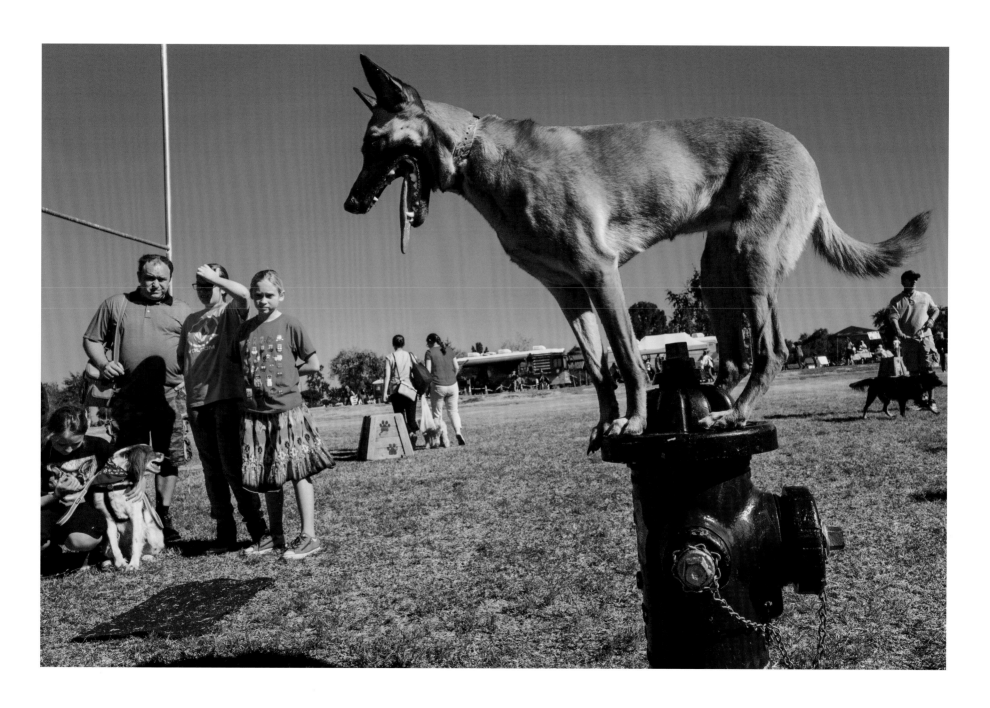

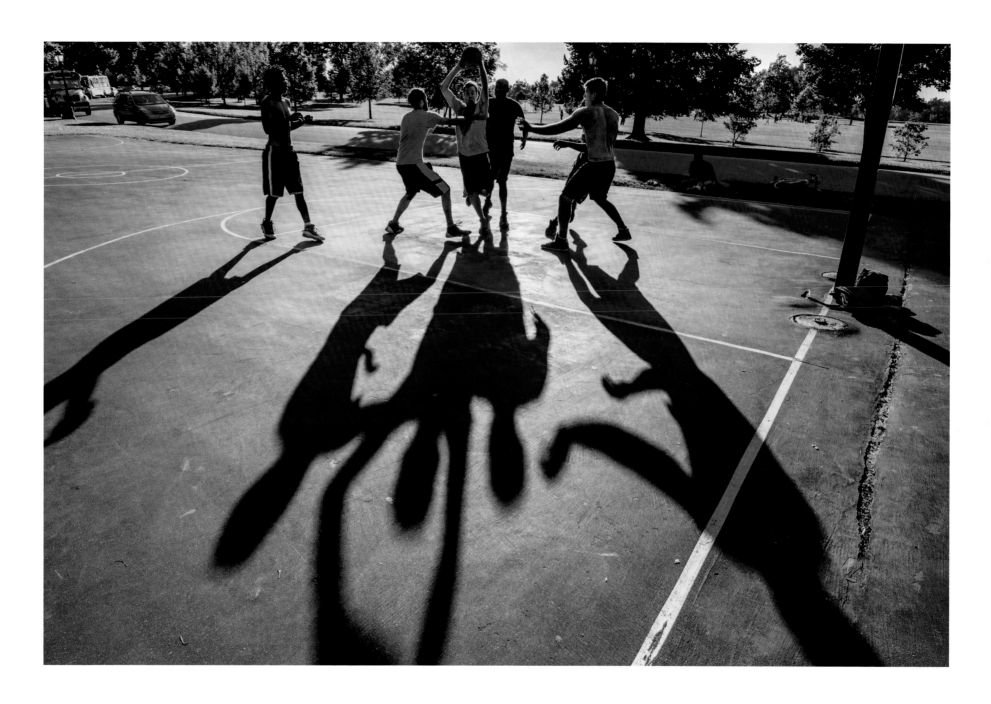

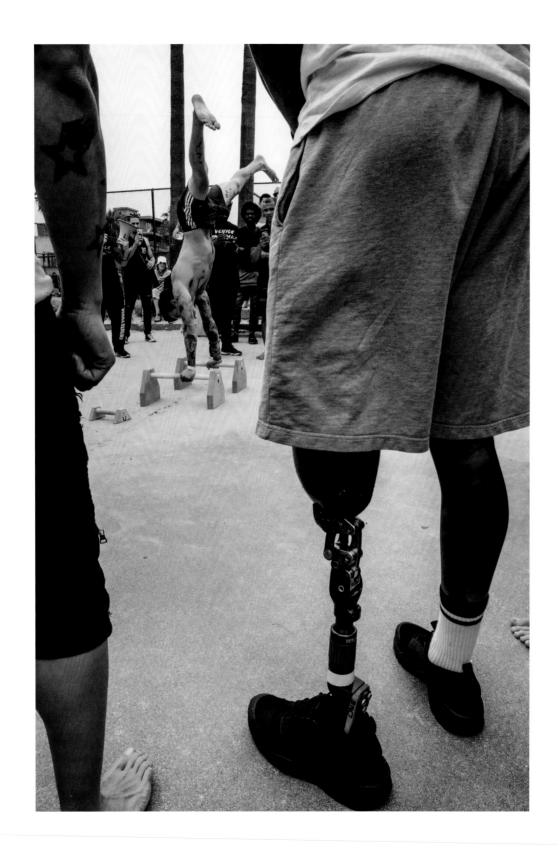

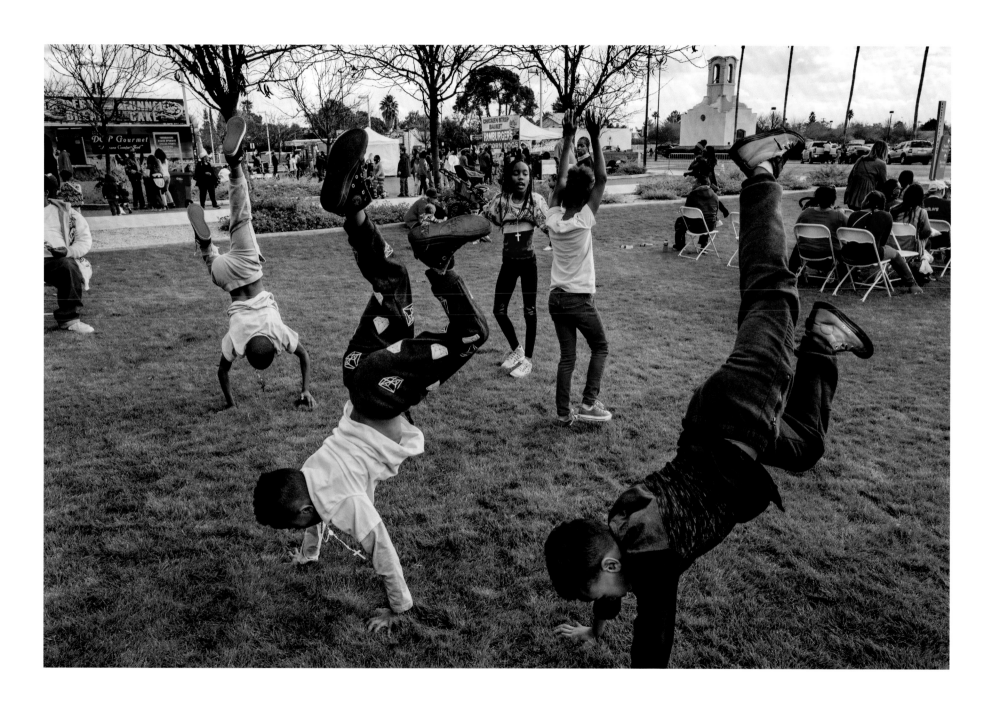

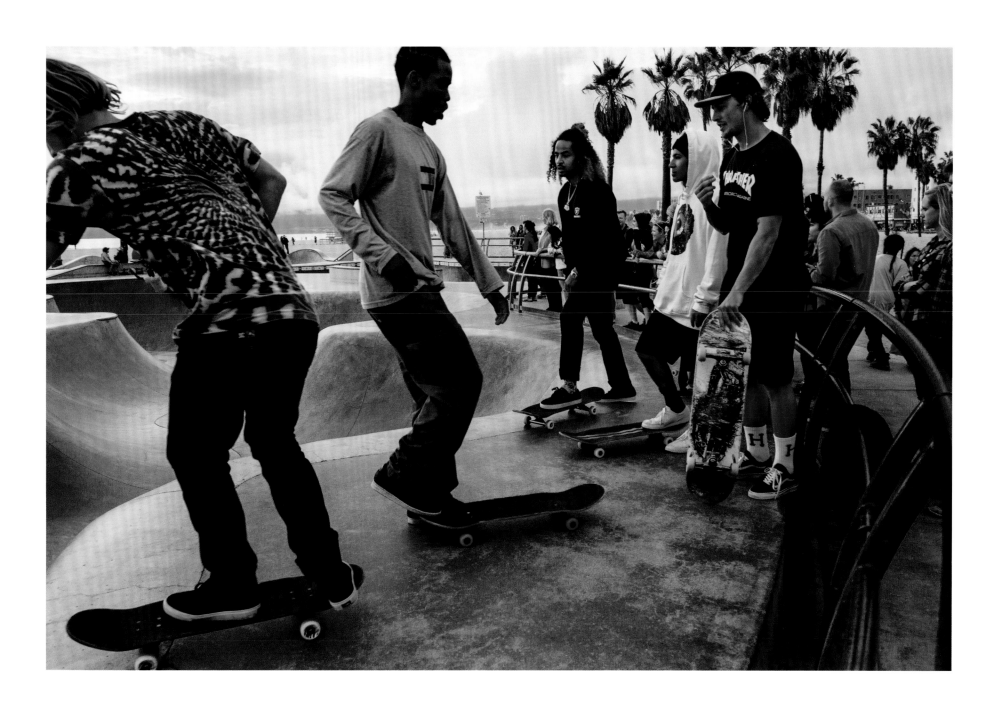

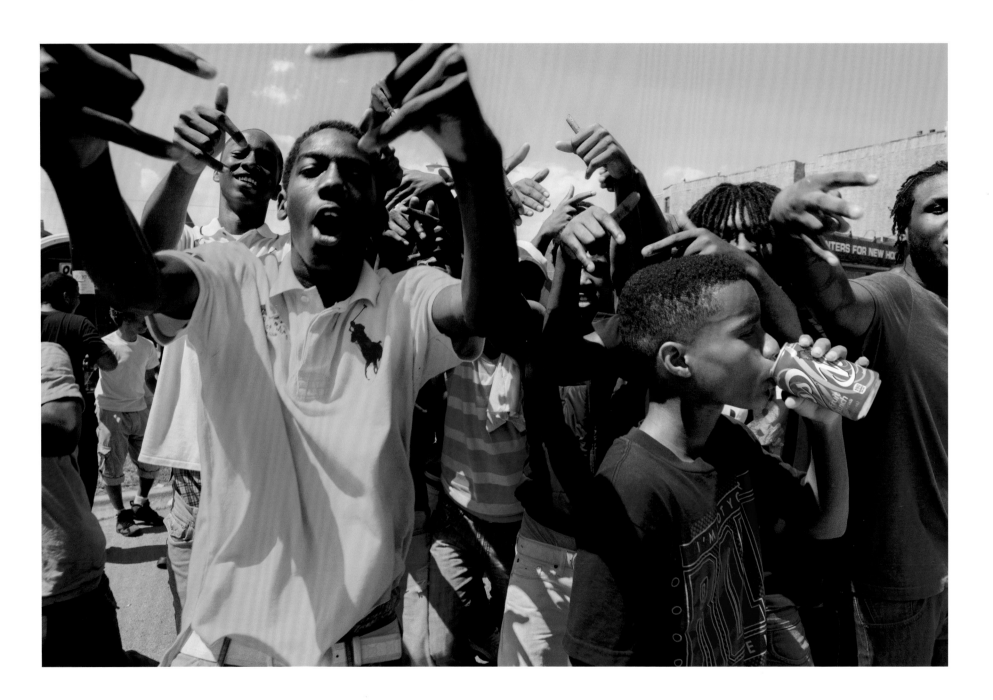

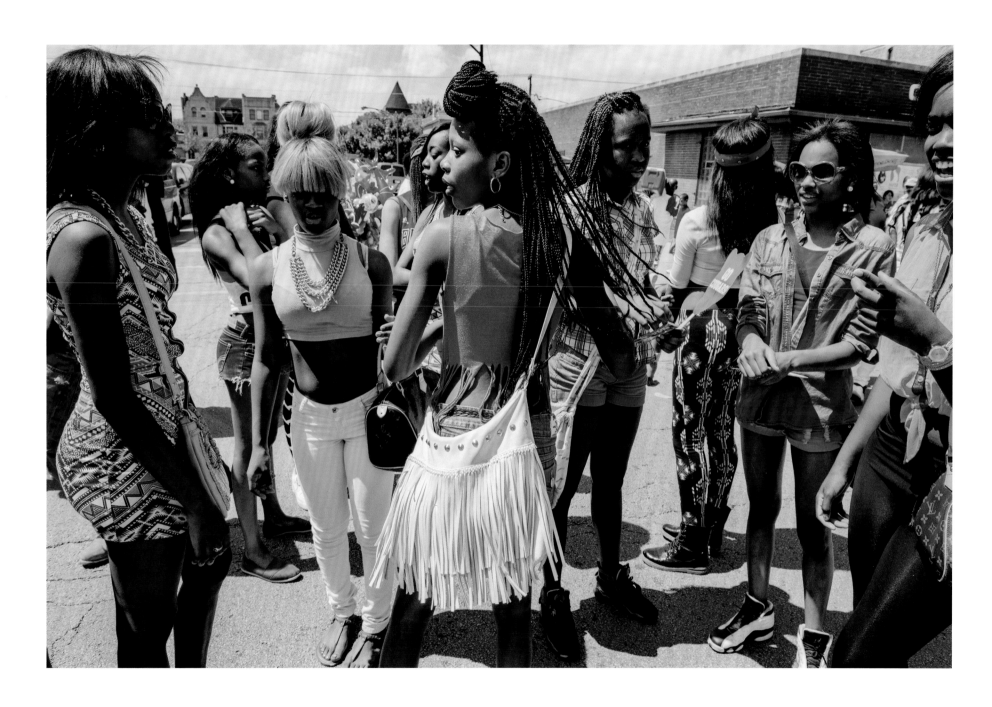

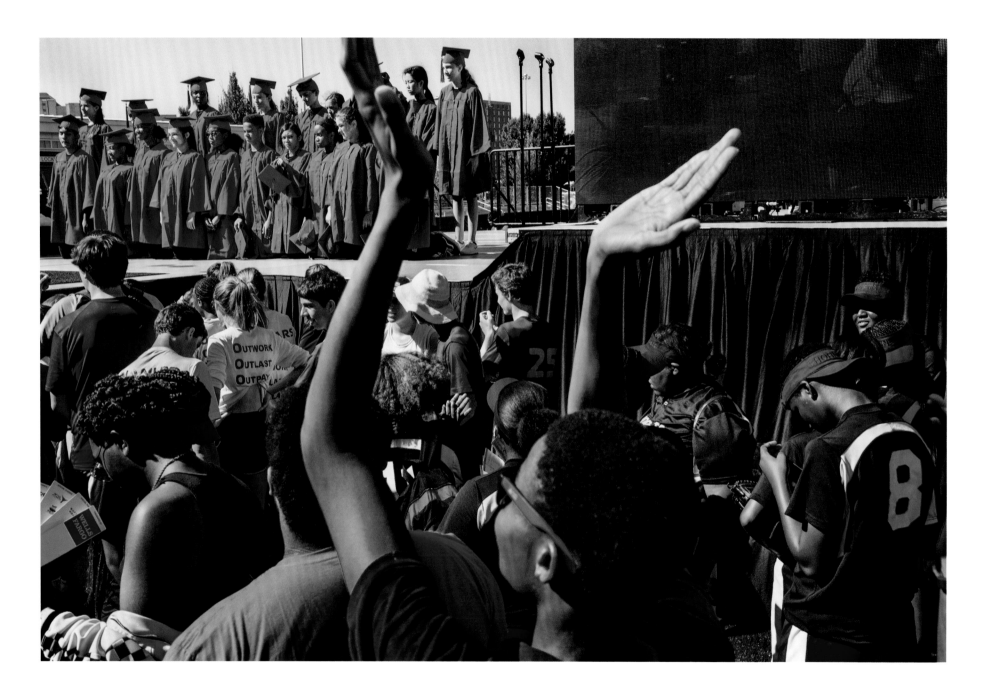

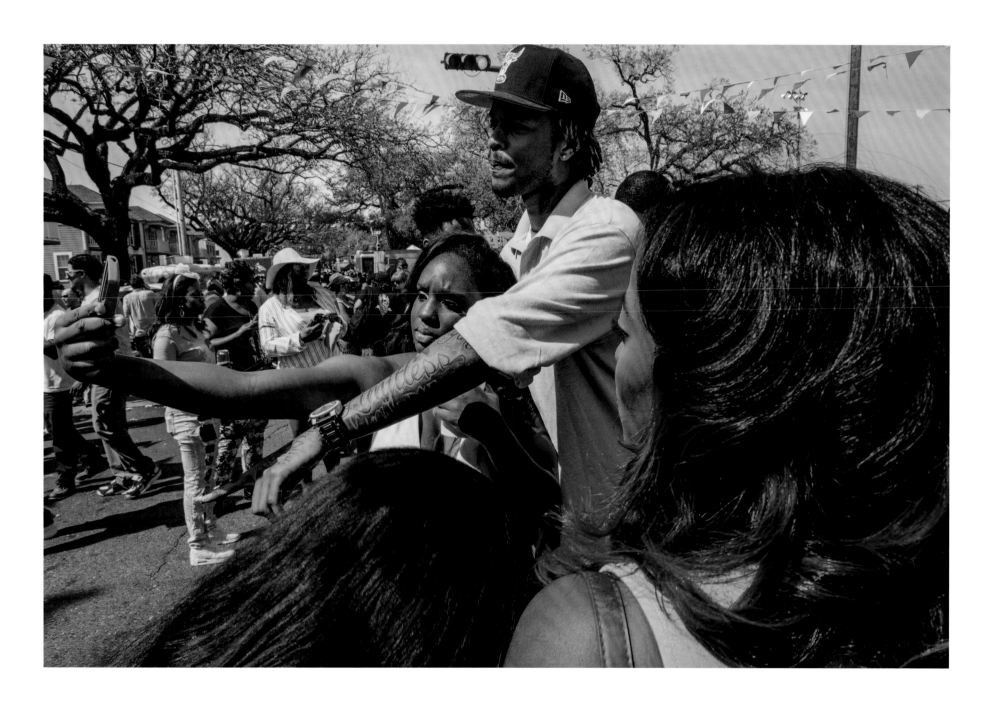

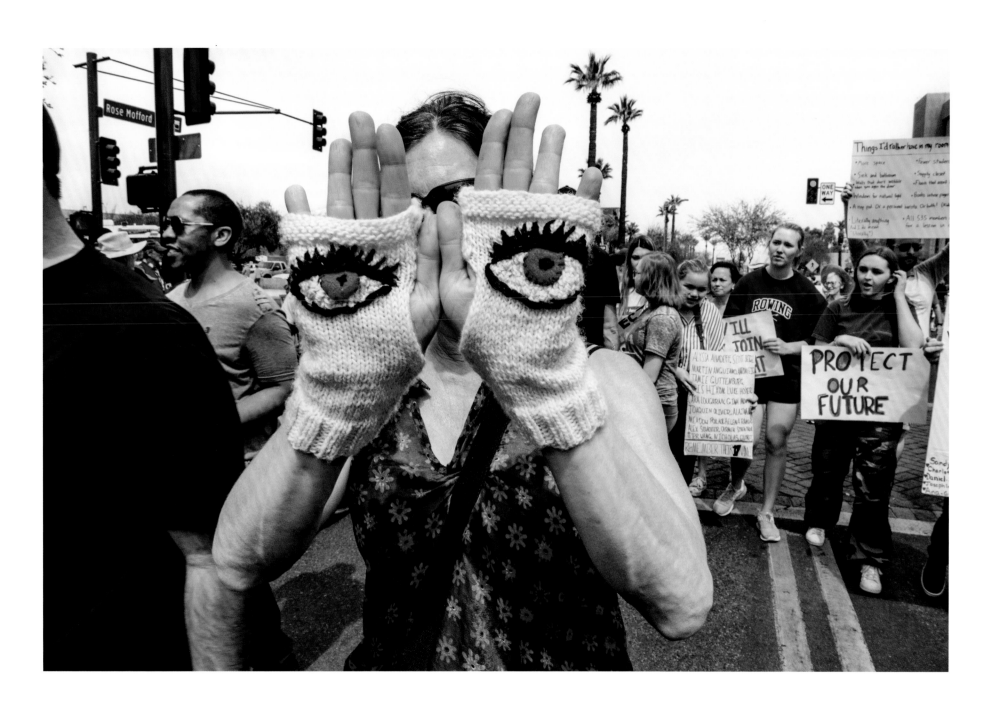

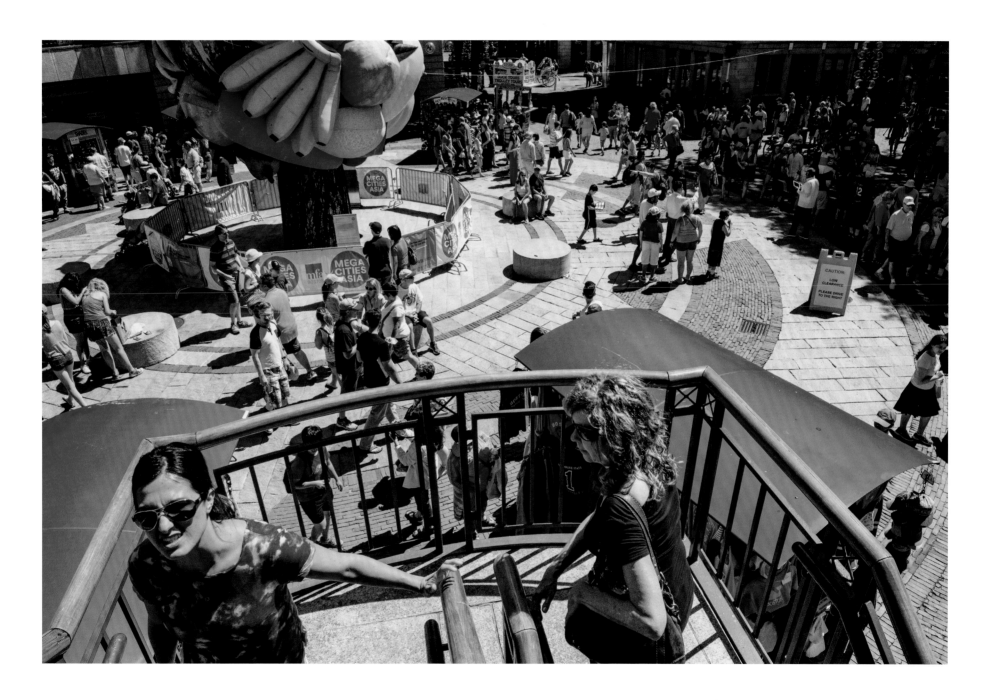

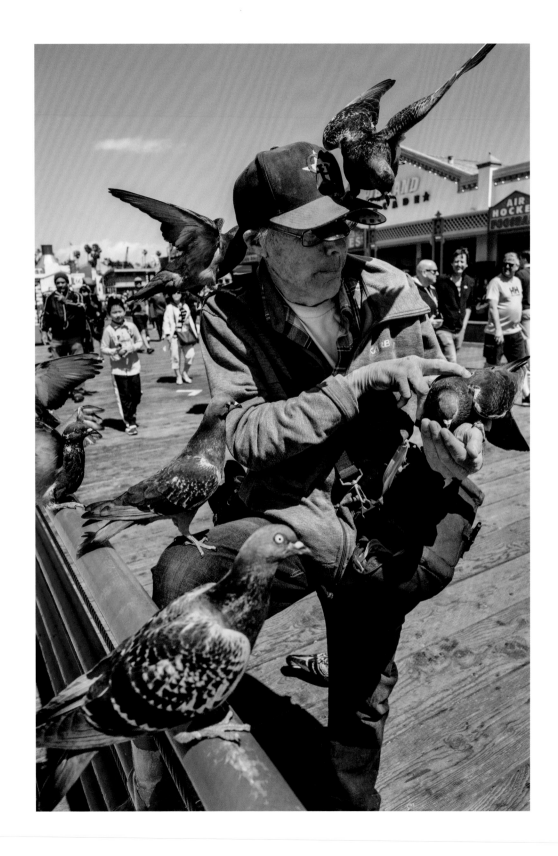

192 Santa Monica, CA

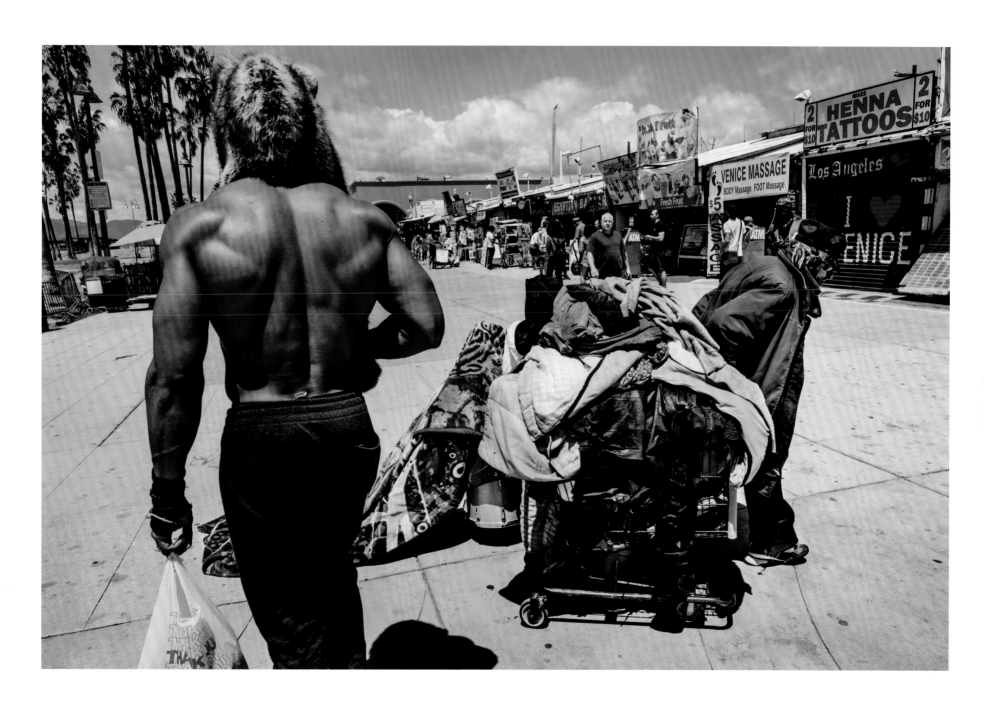

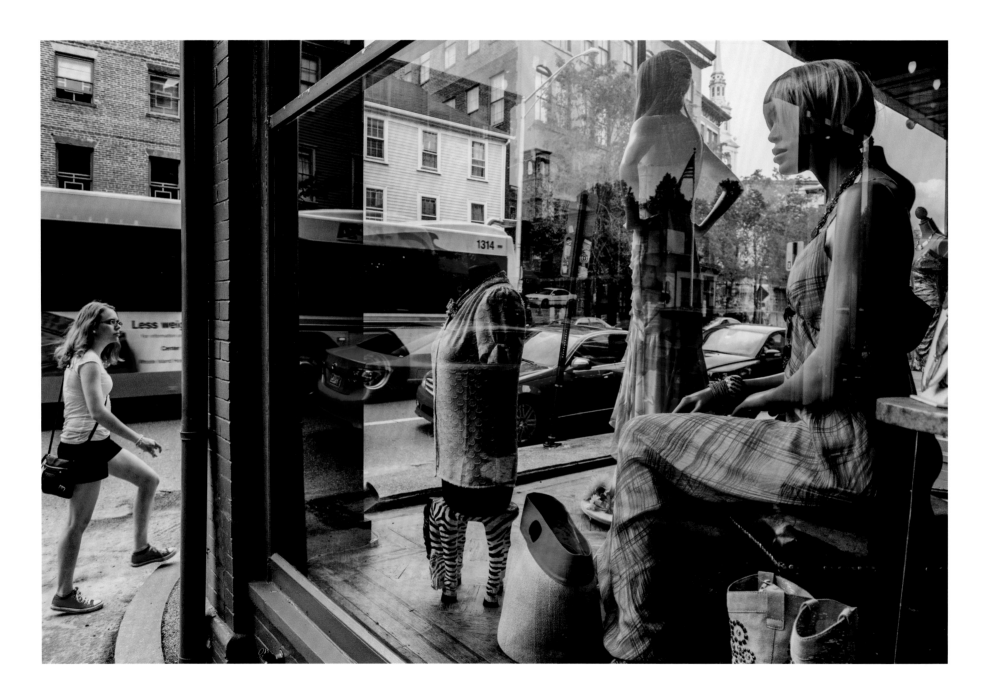

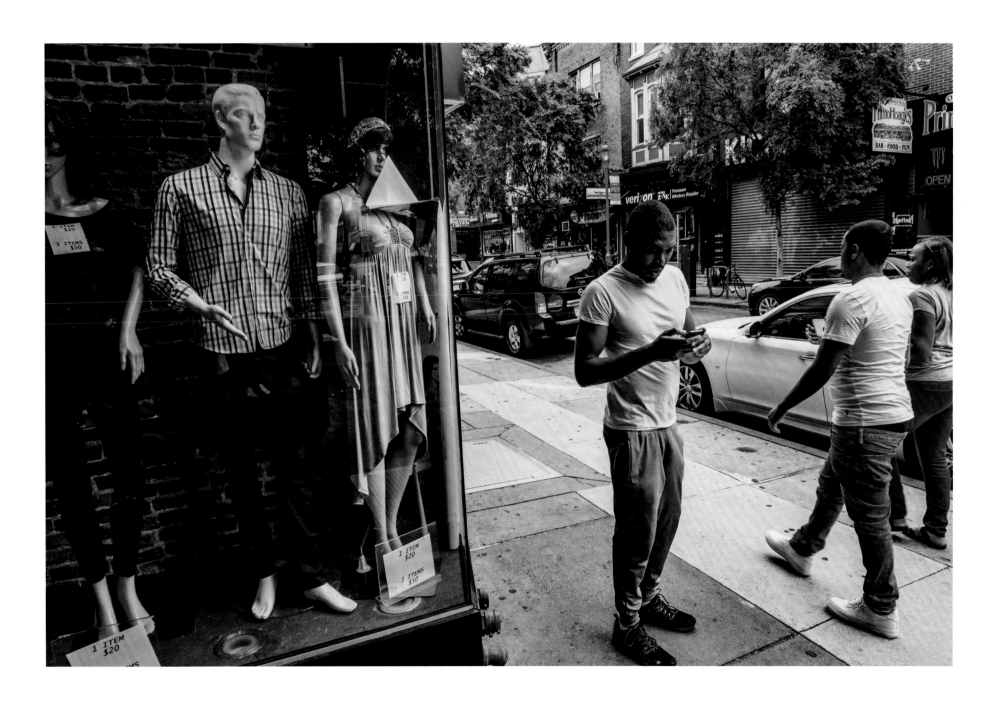

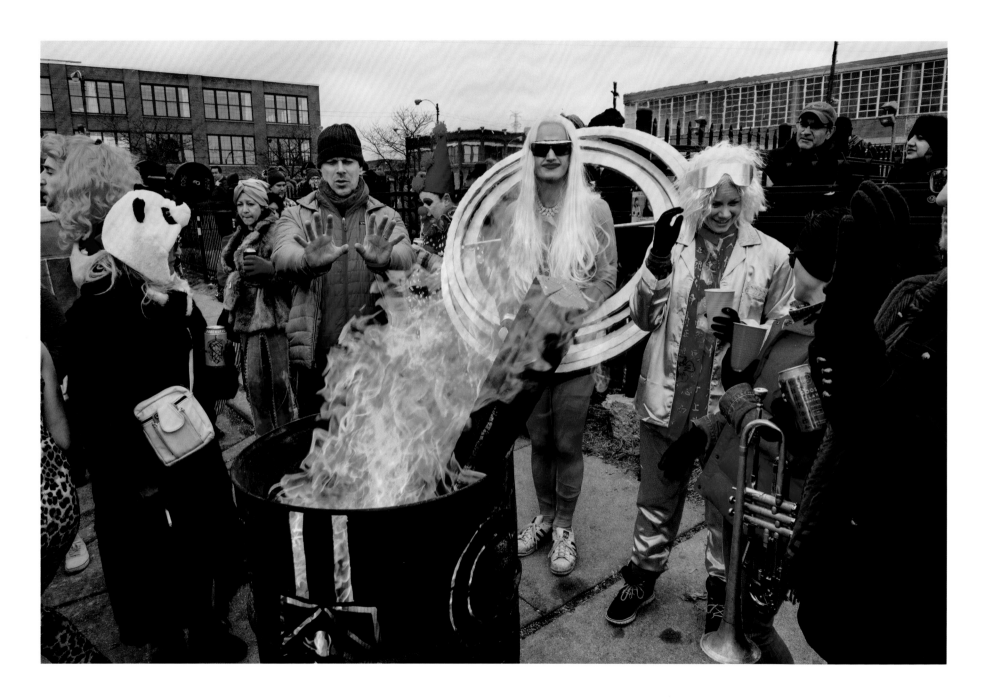

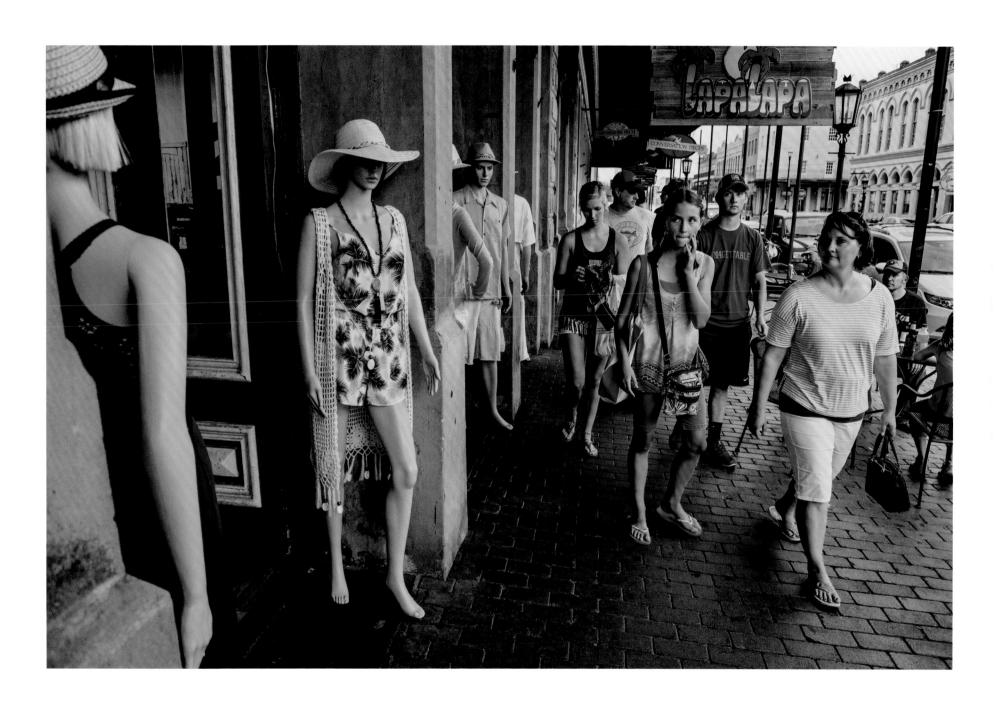

198 Boston, MA

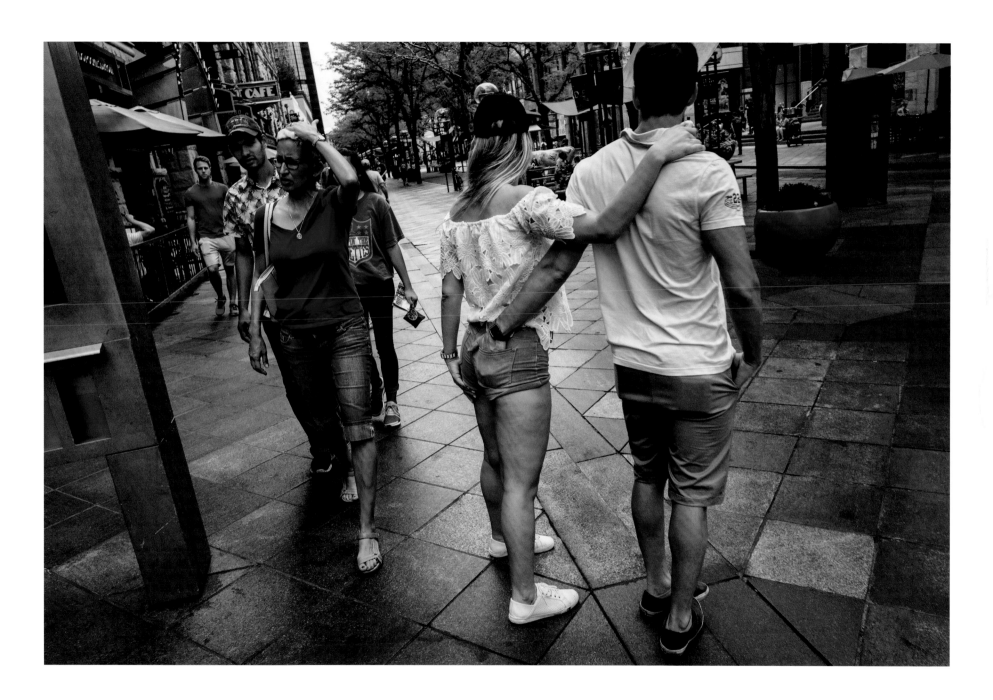

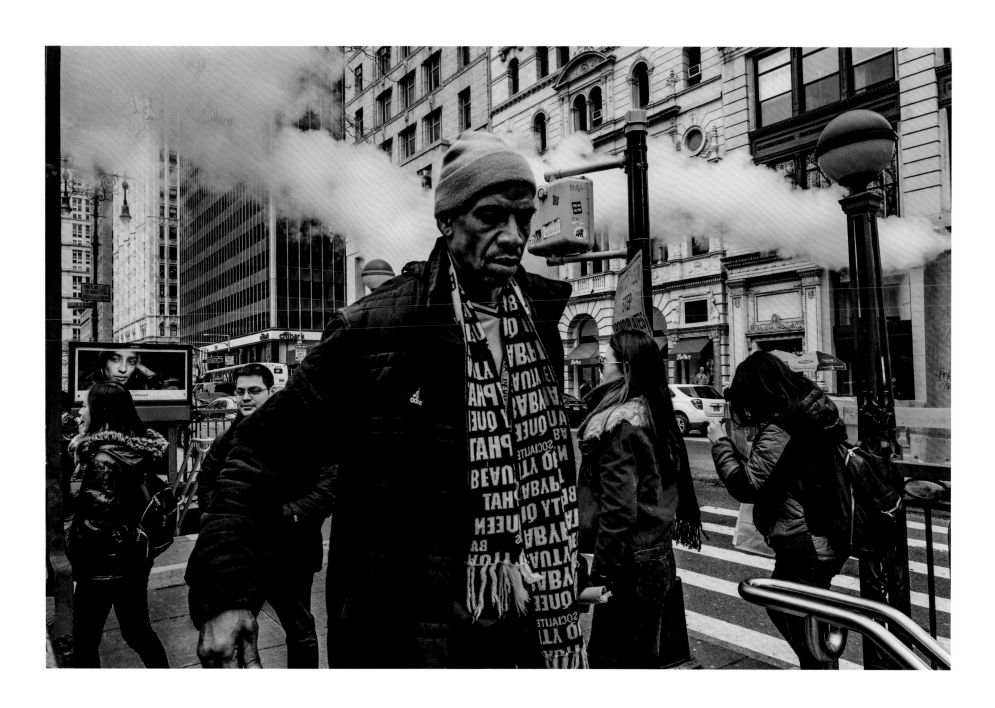

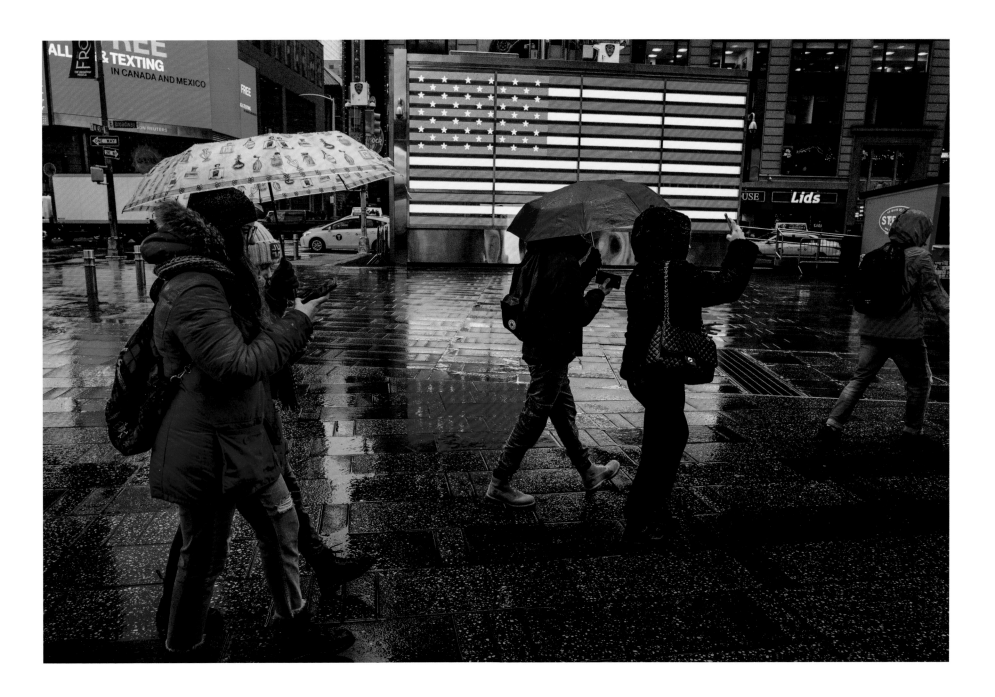

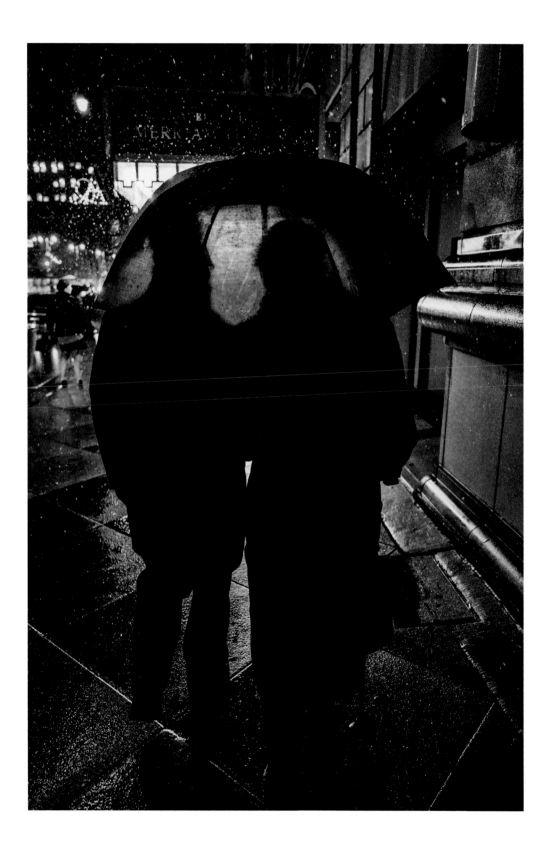

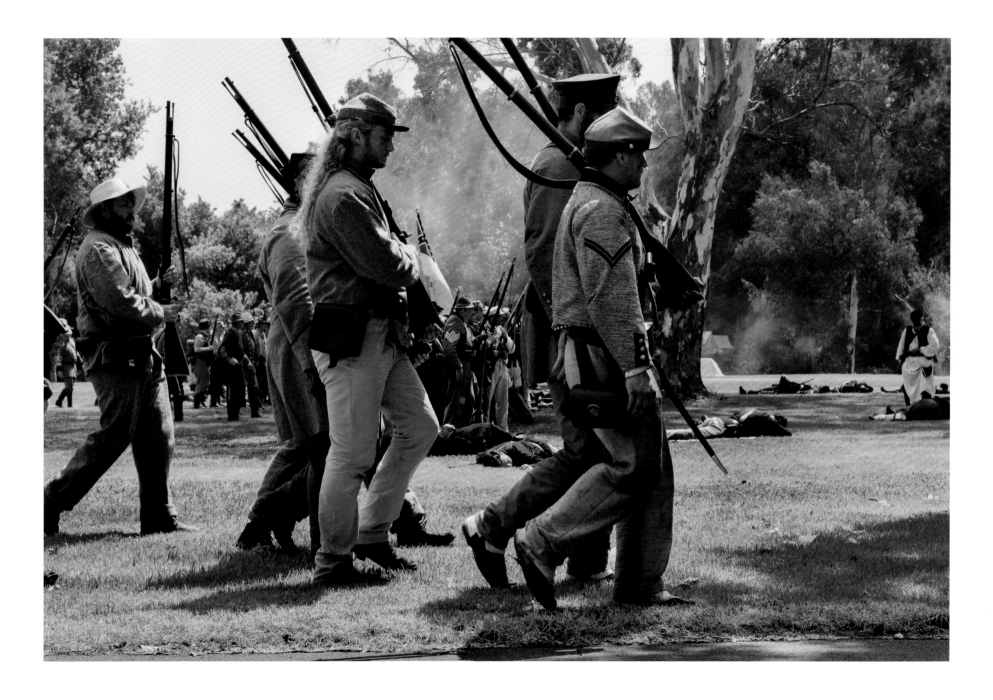

206 Huntington Beach, CA

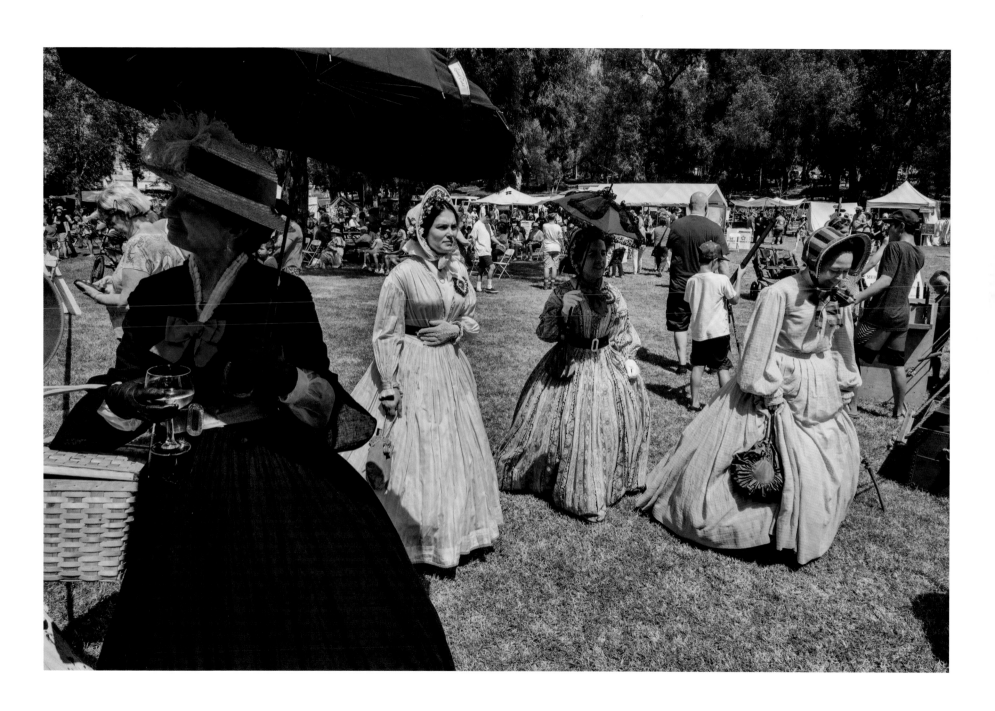

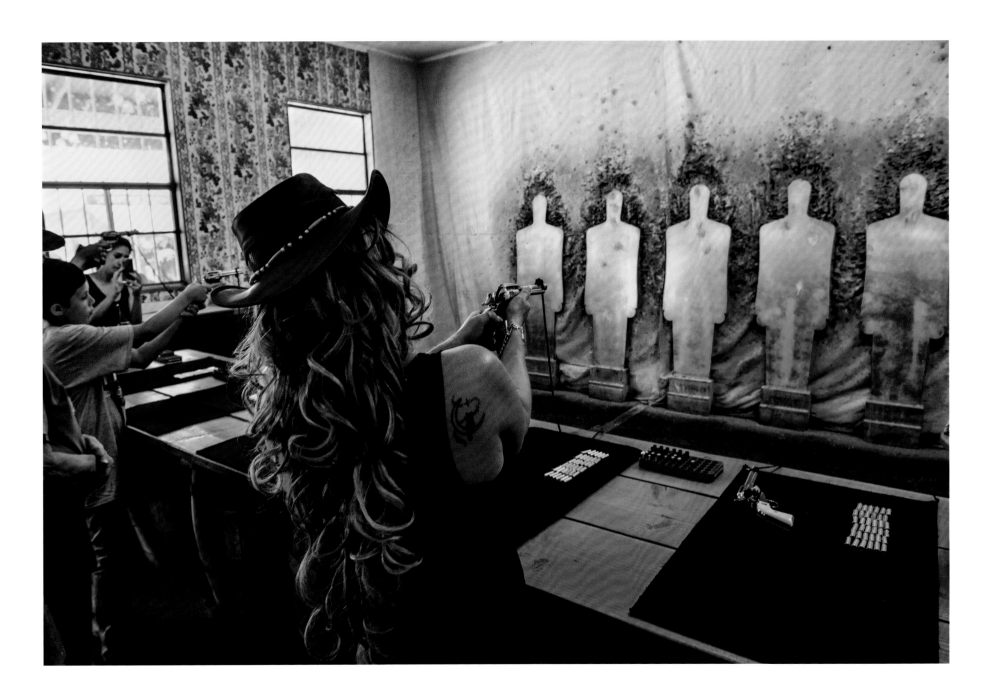

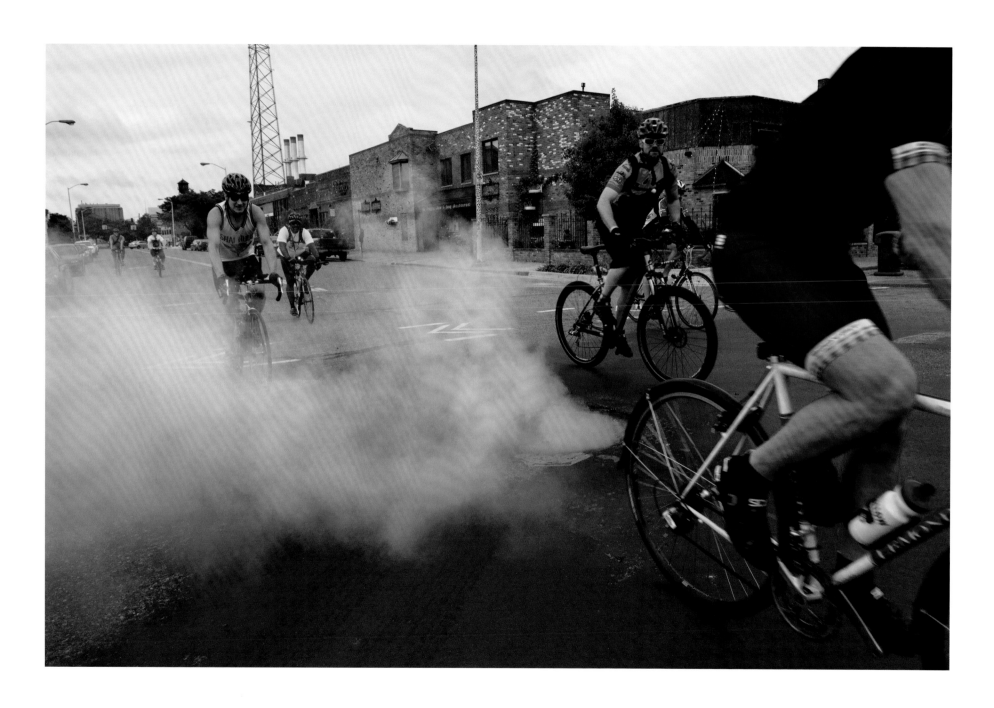

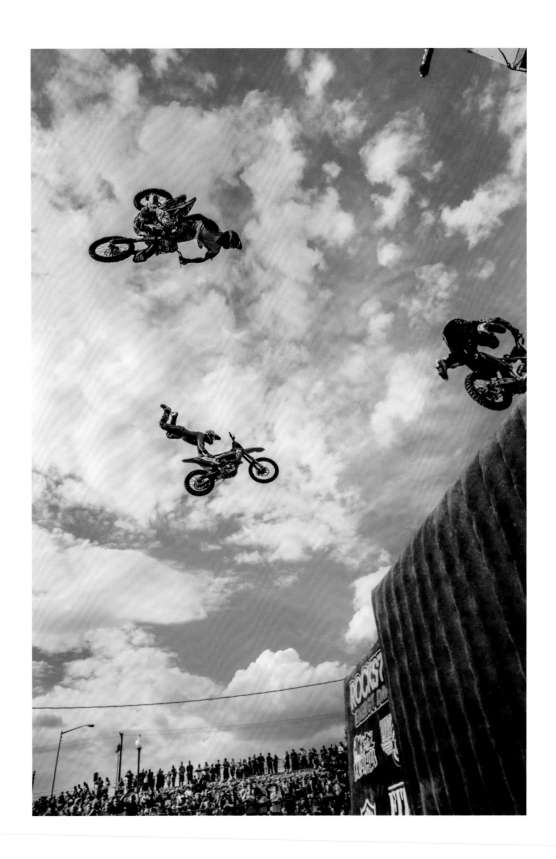

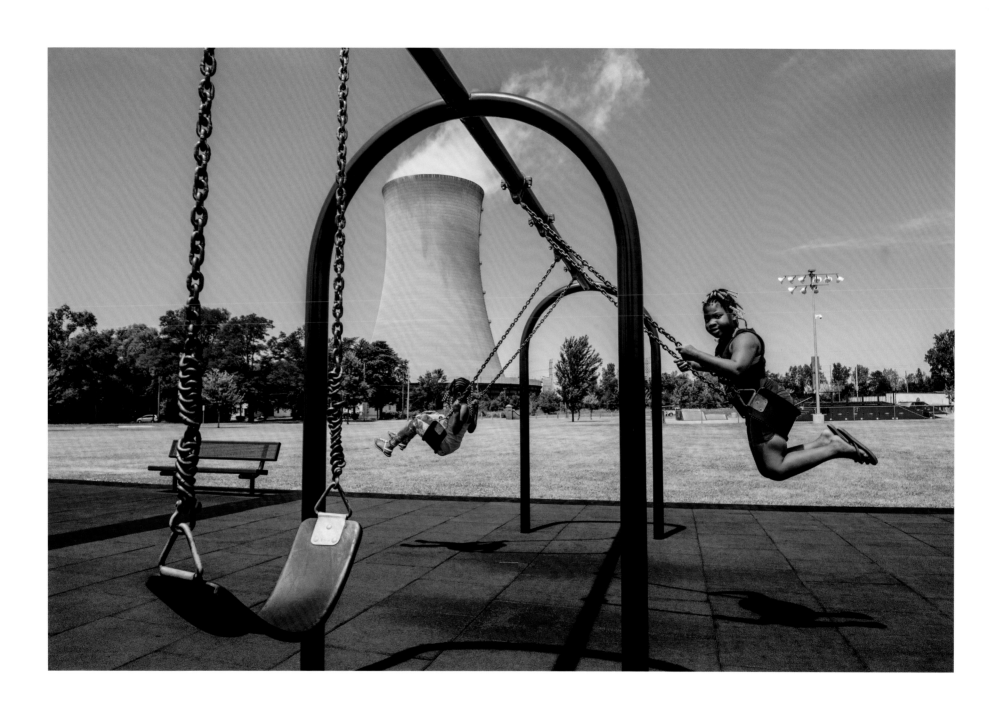

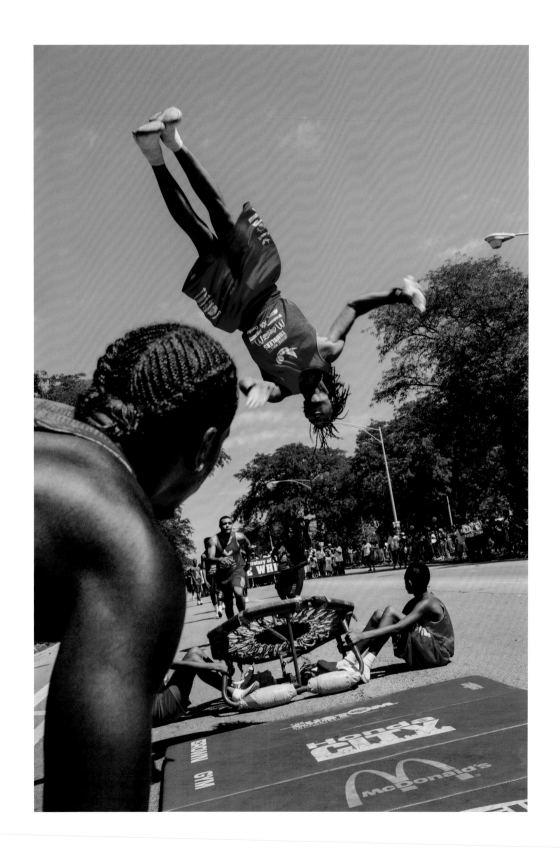

212 Chicago, IL

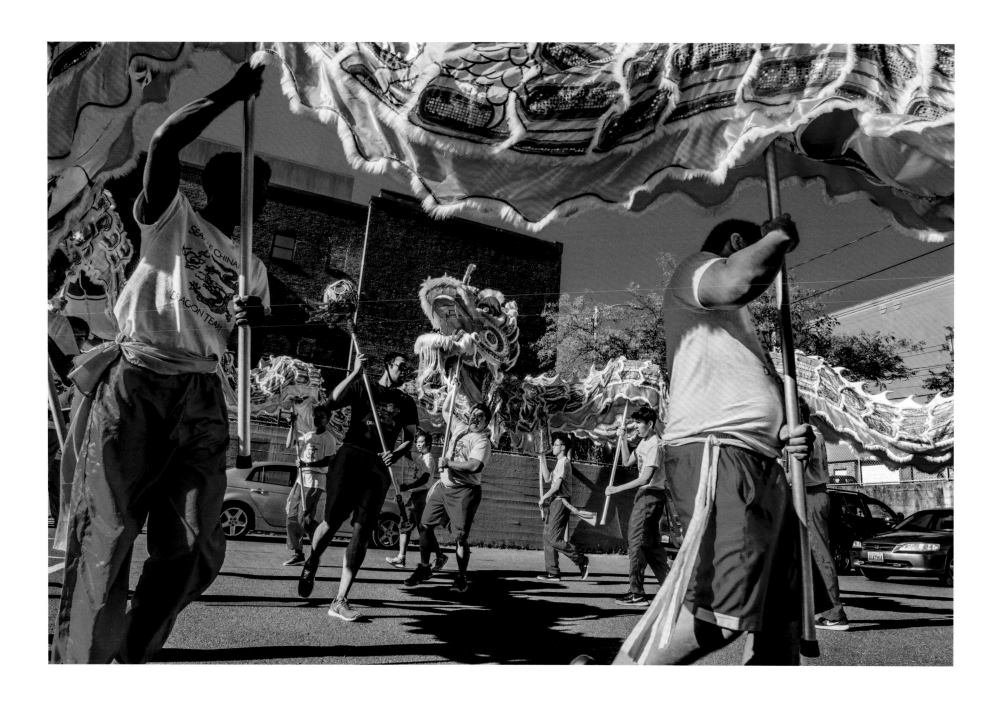

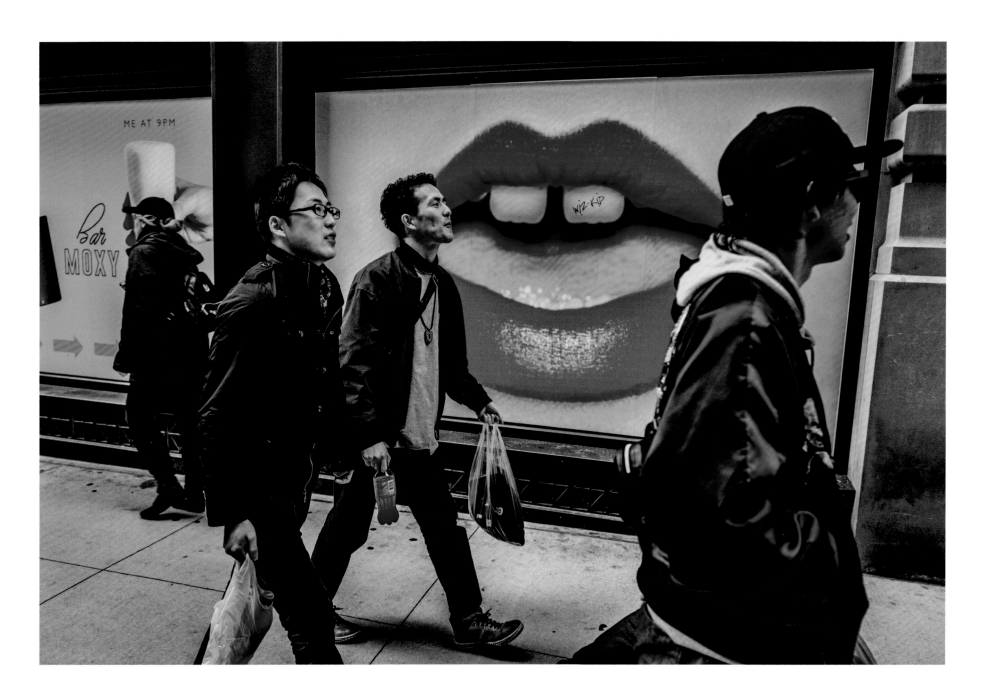

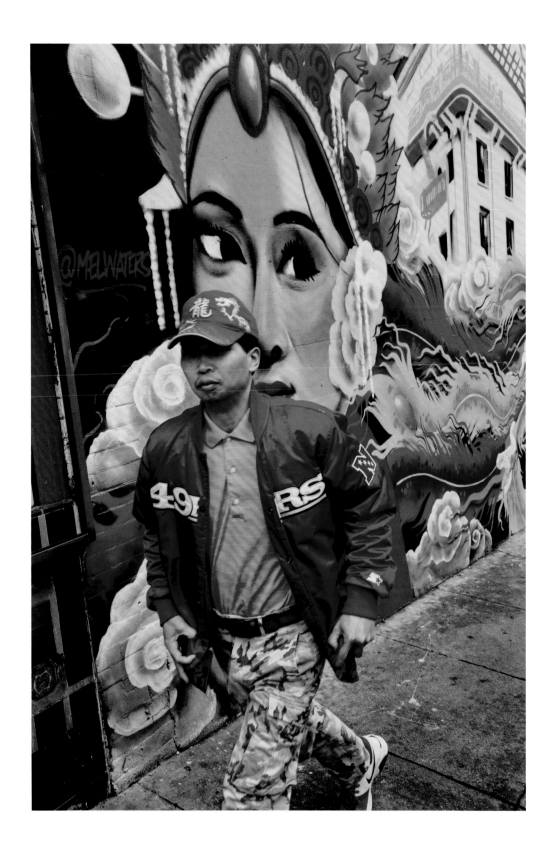

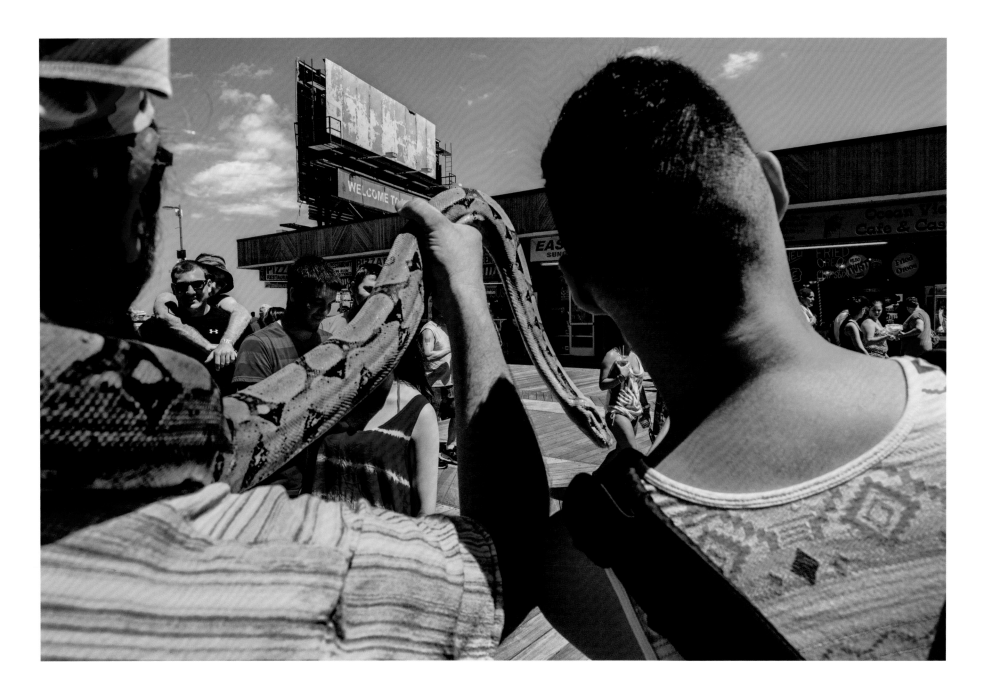

216 Wildwood, NJ

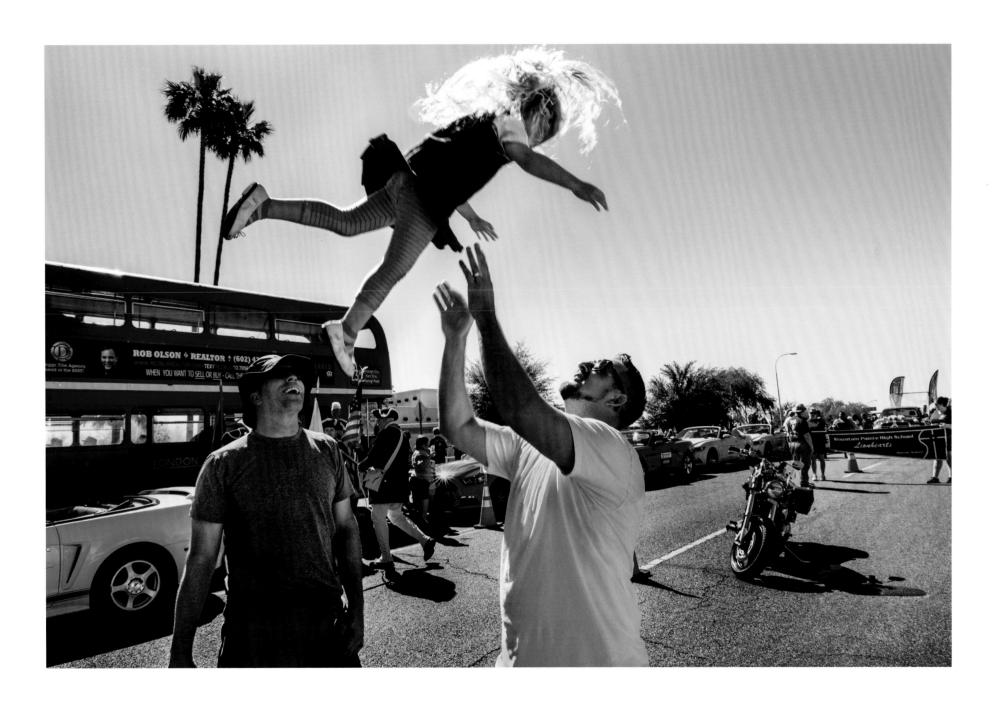

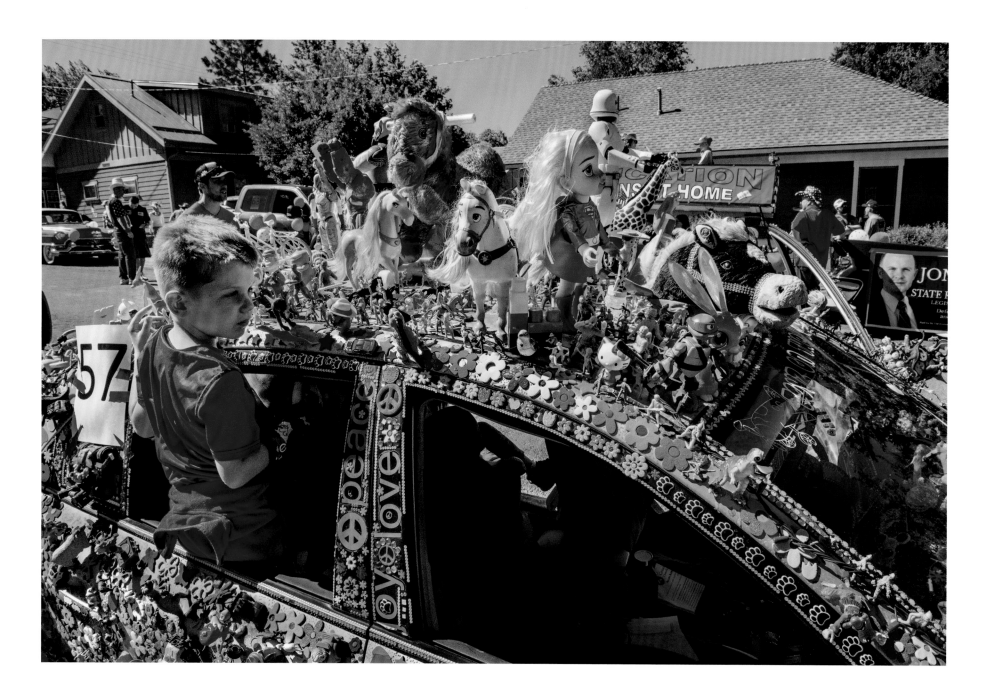

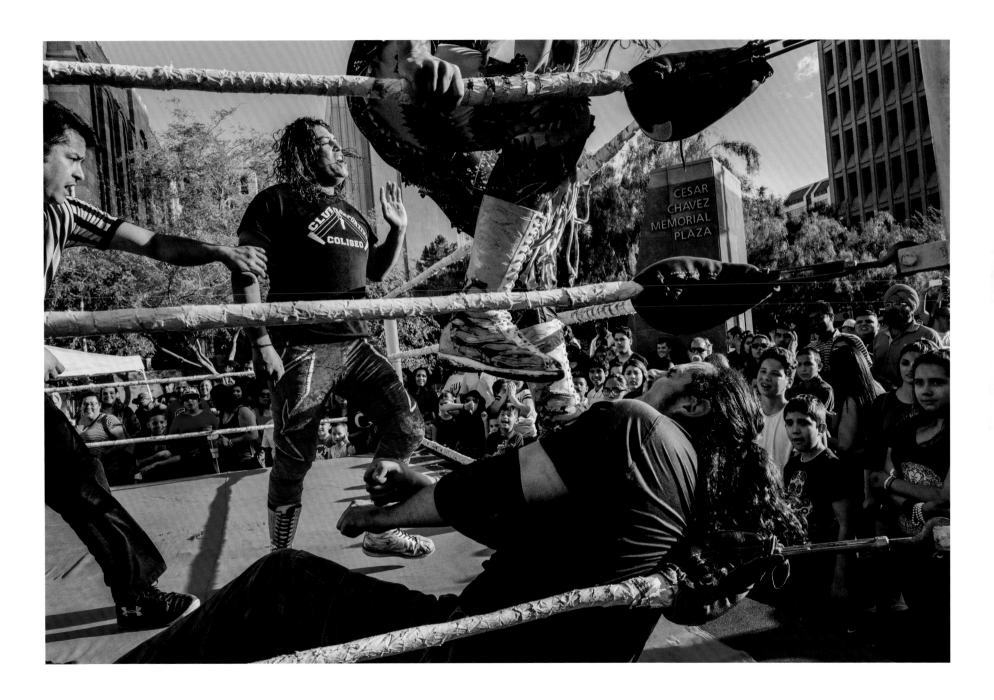

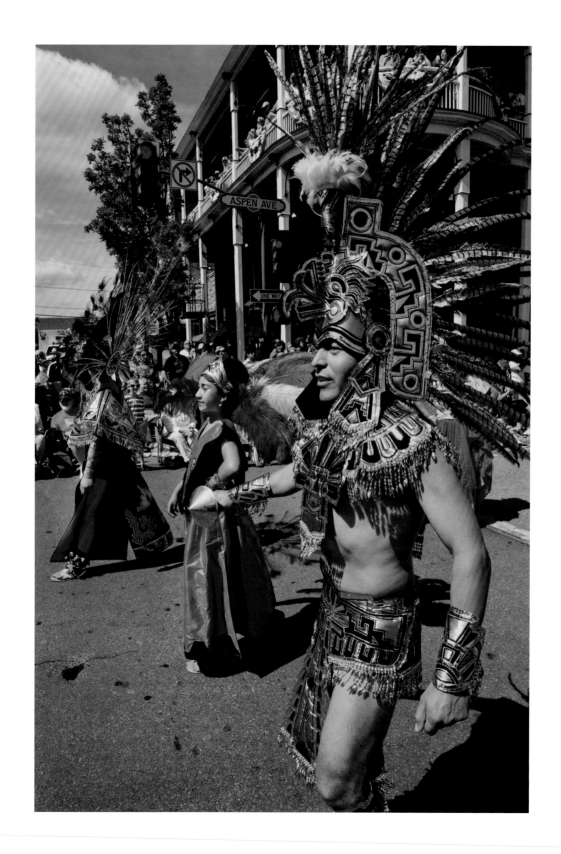

224 Flagstaff, AZ

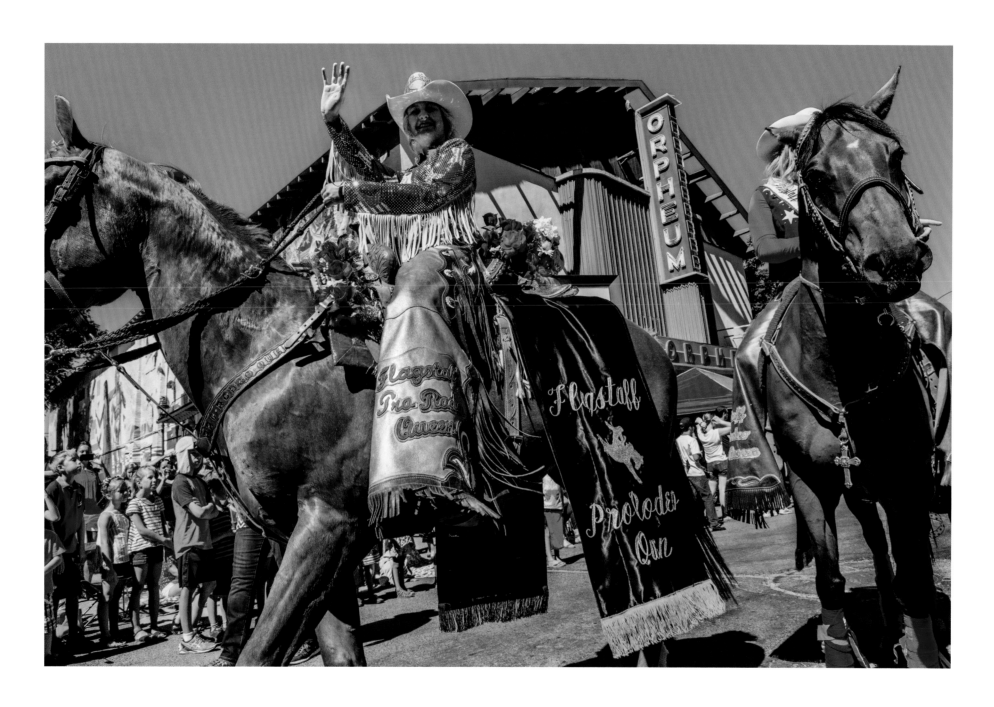

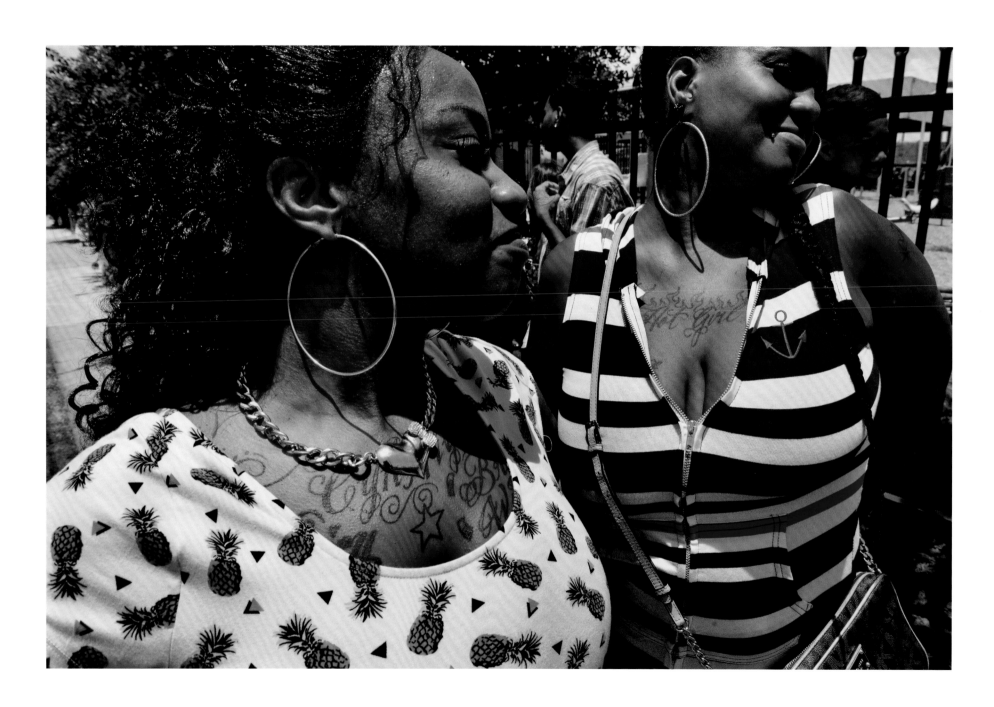

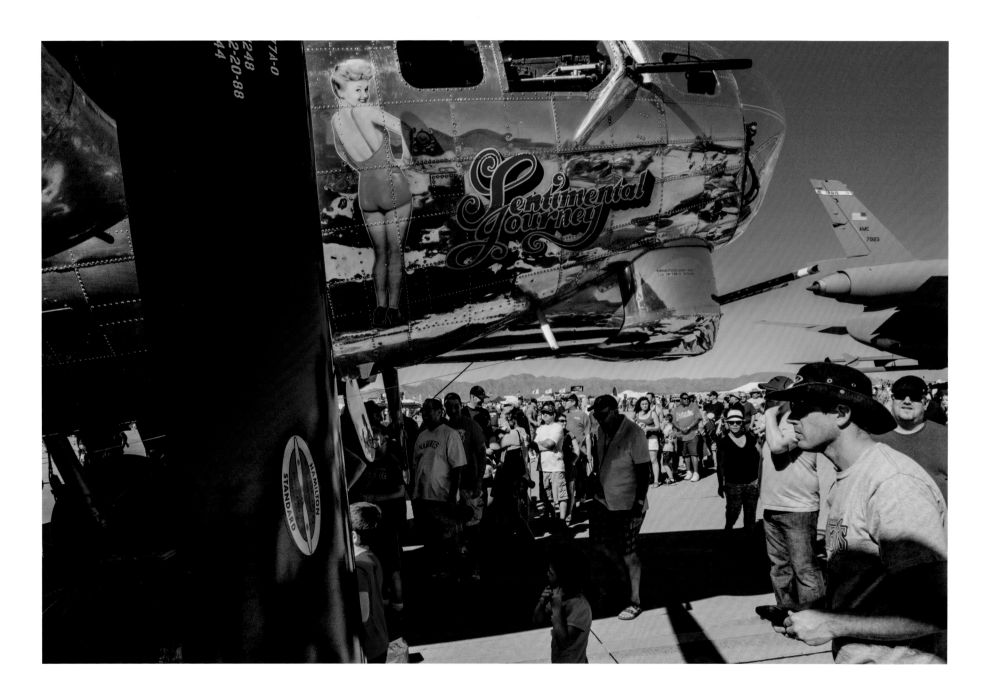

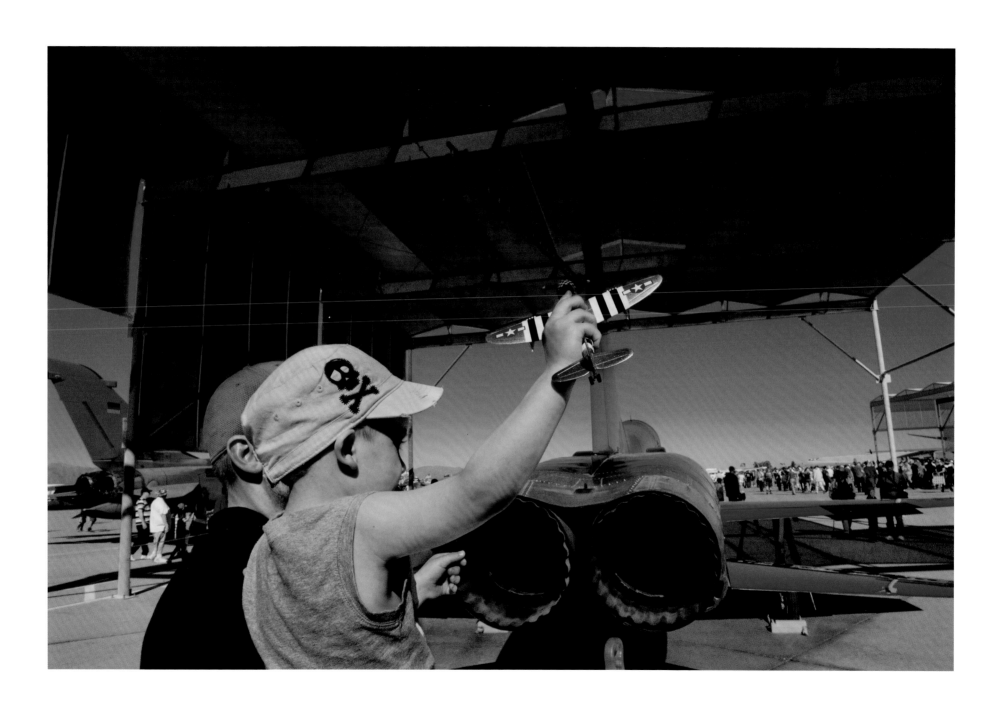

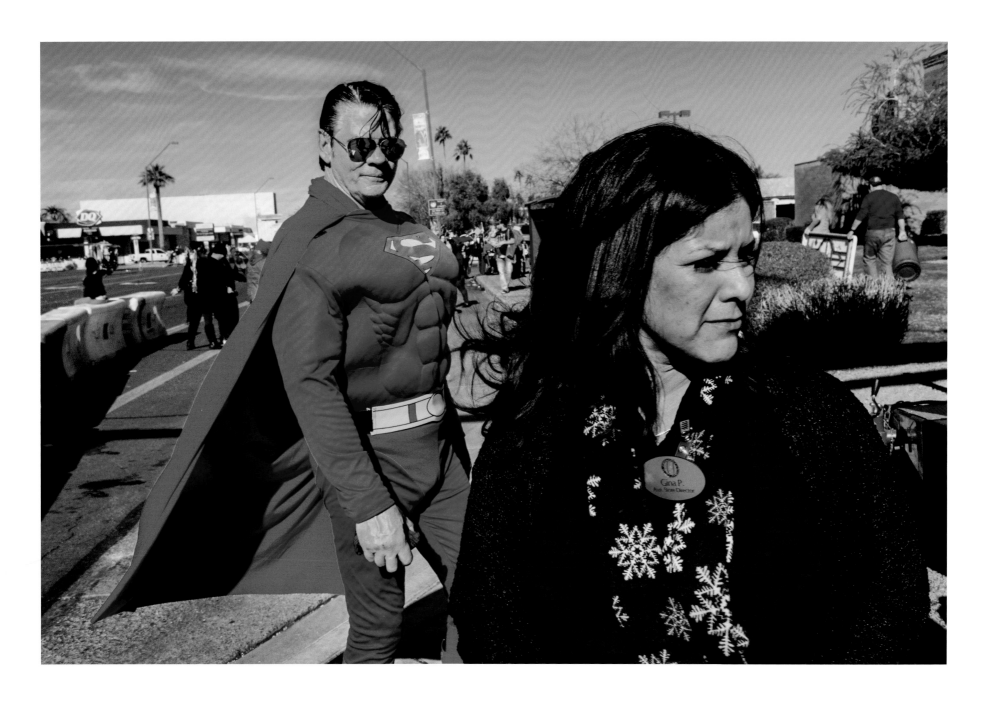

230 Phoenix, AZ

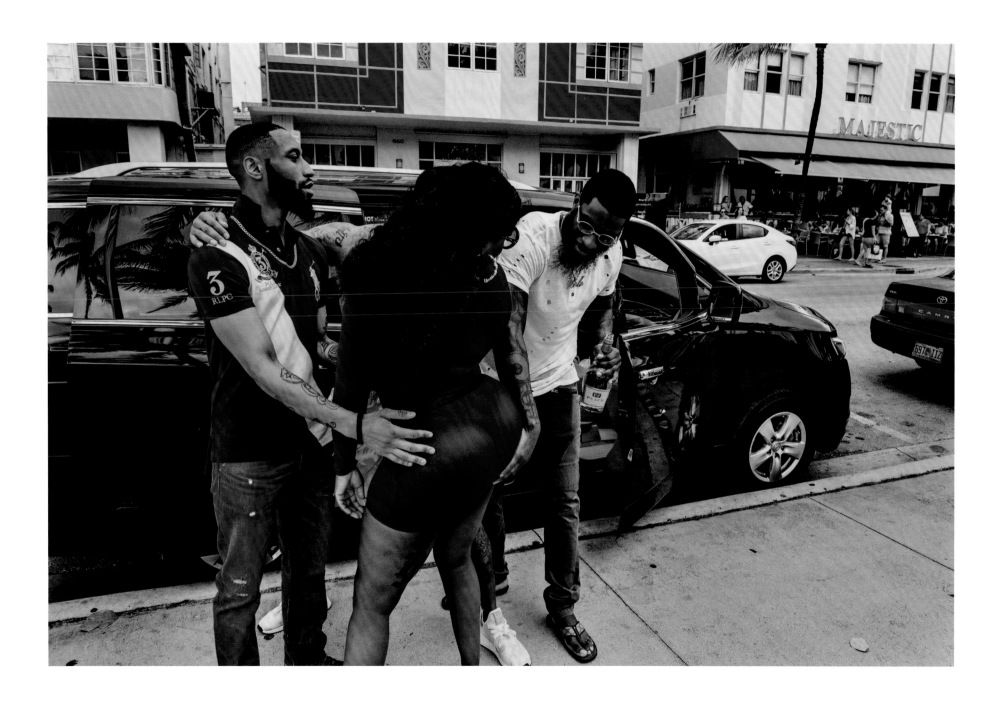

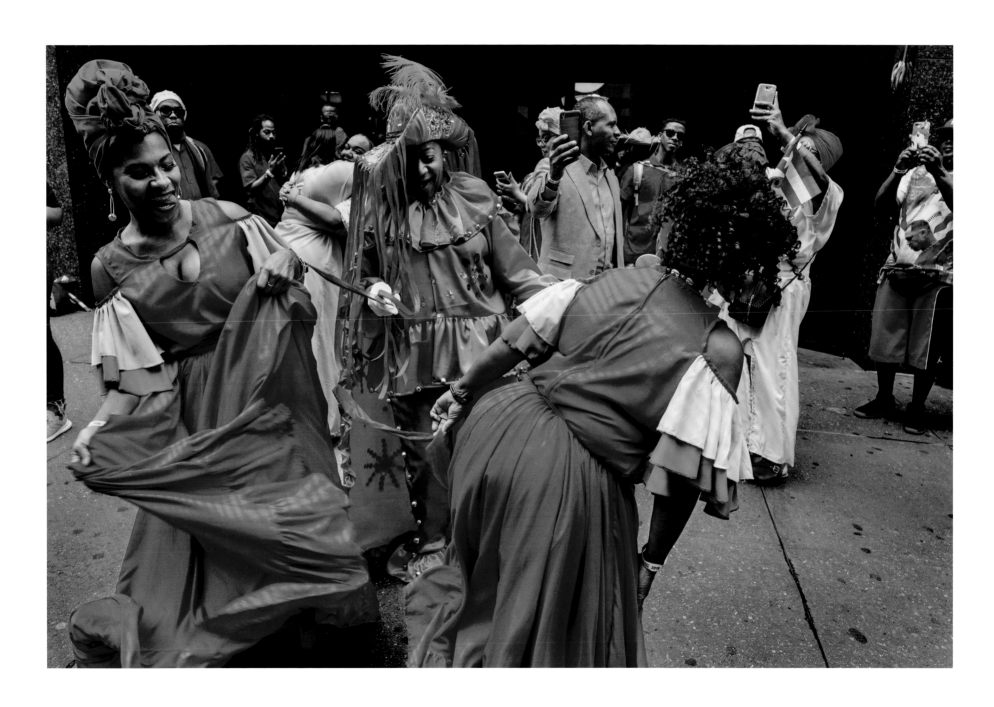

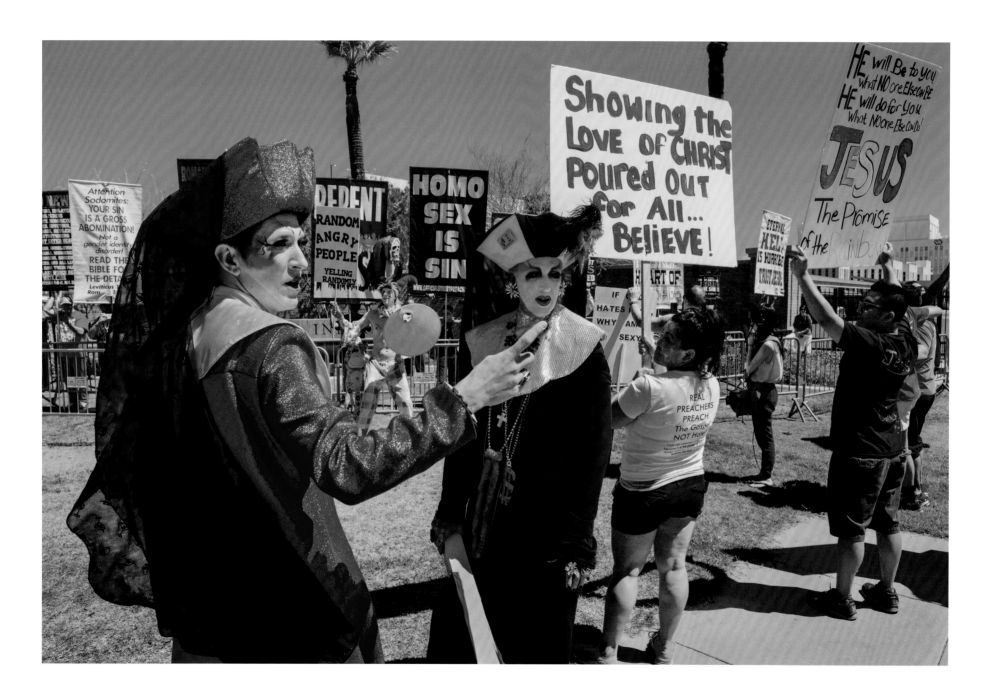

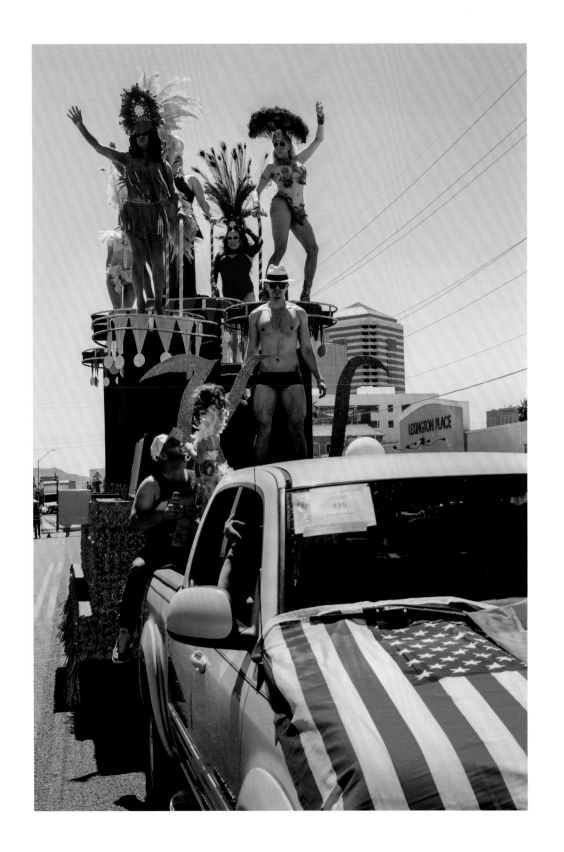

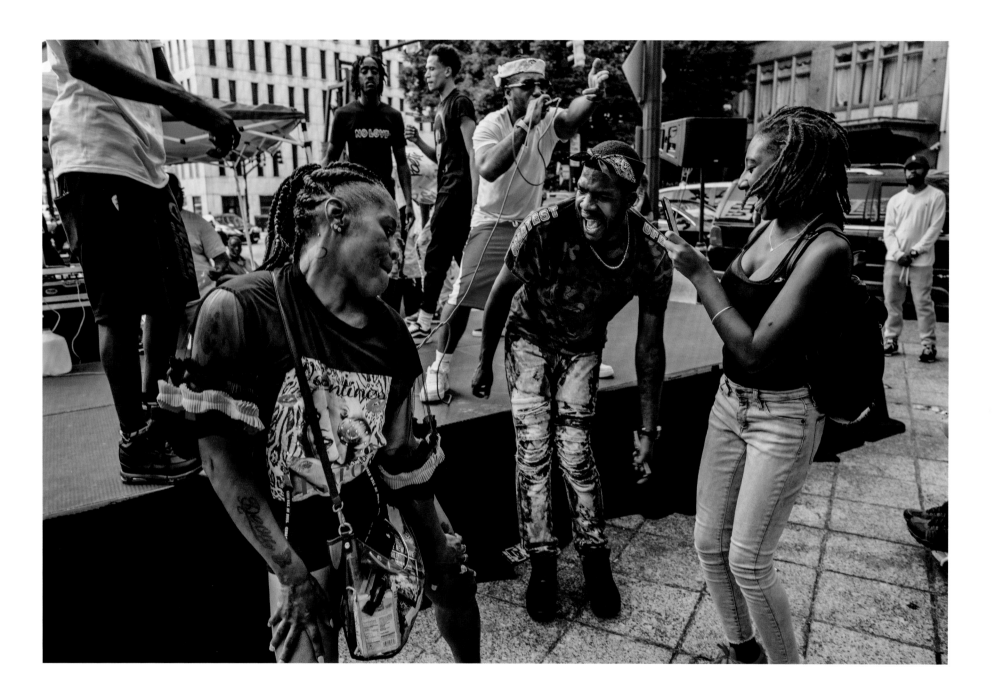

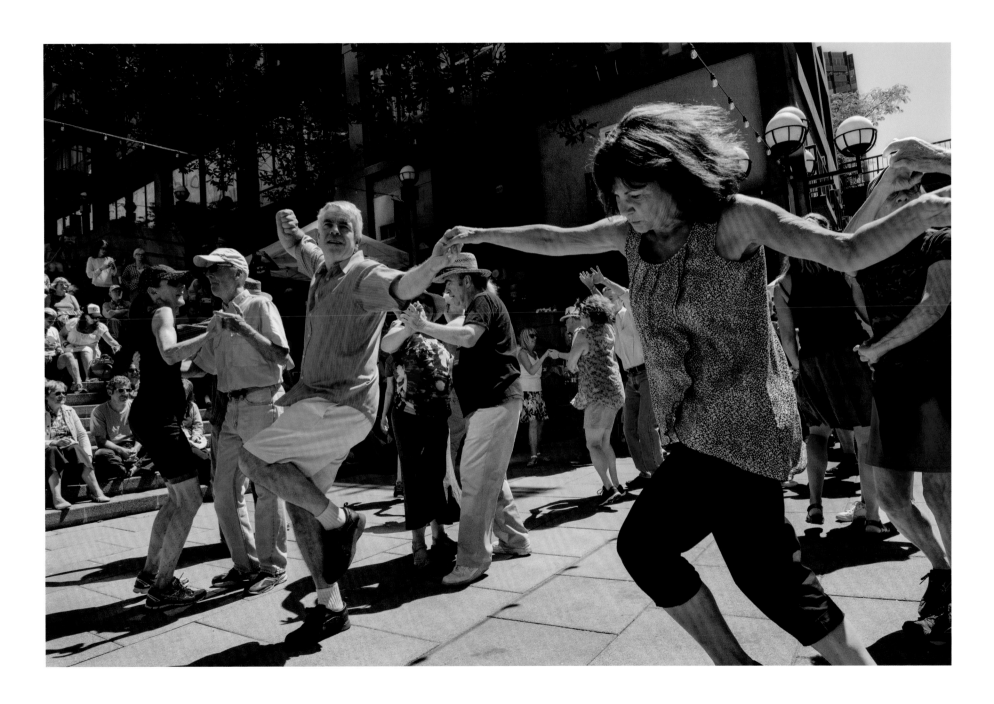

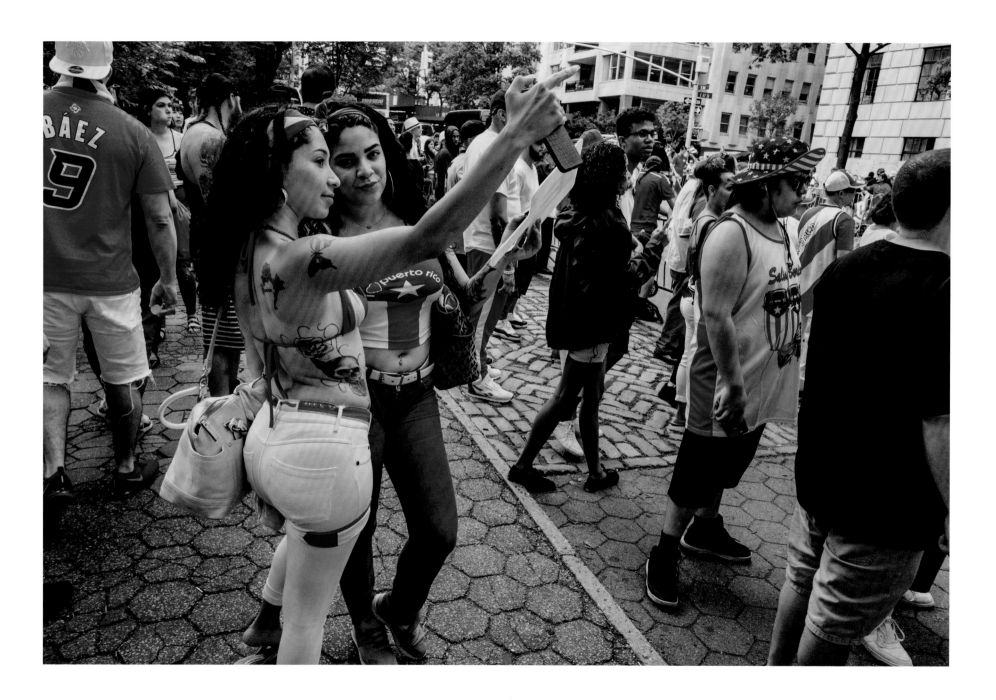

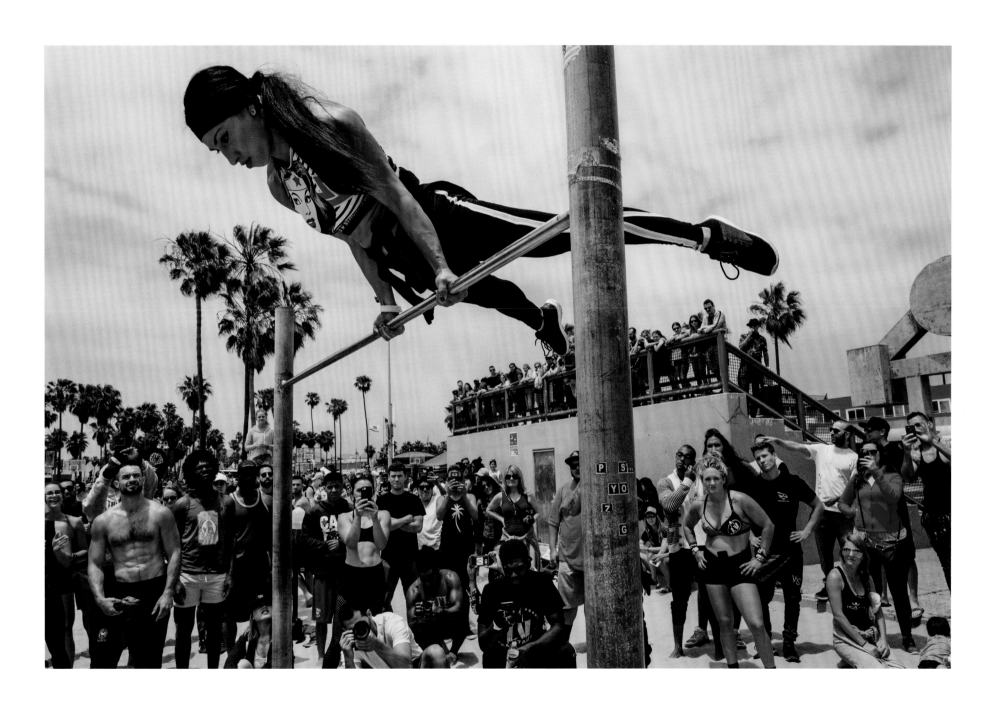

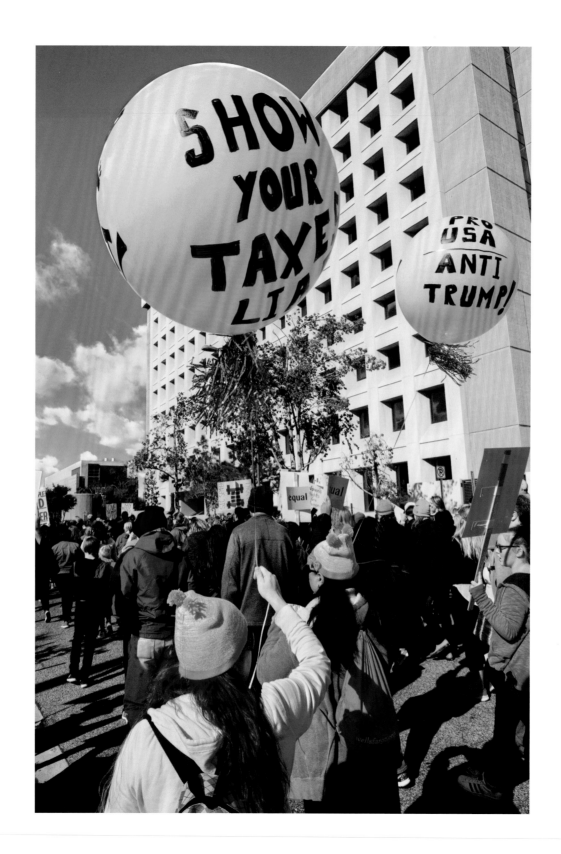

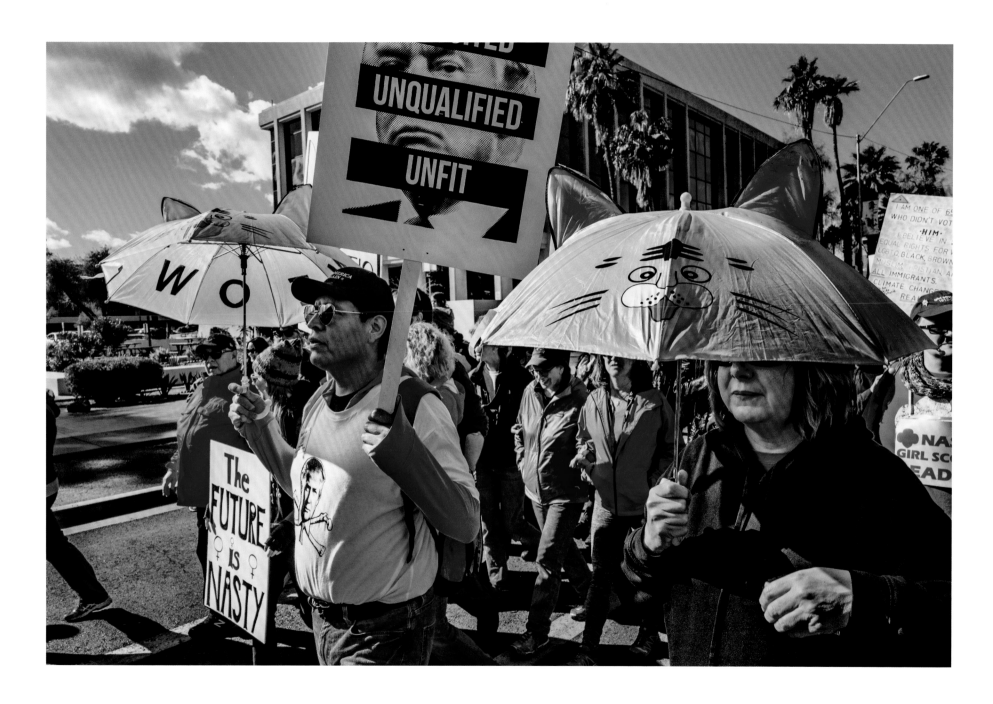

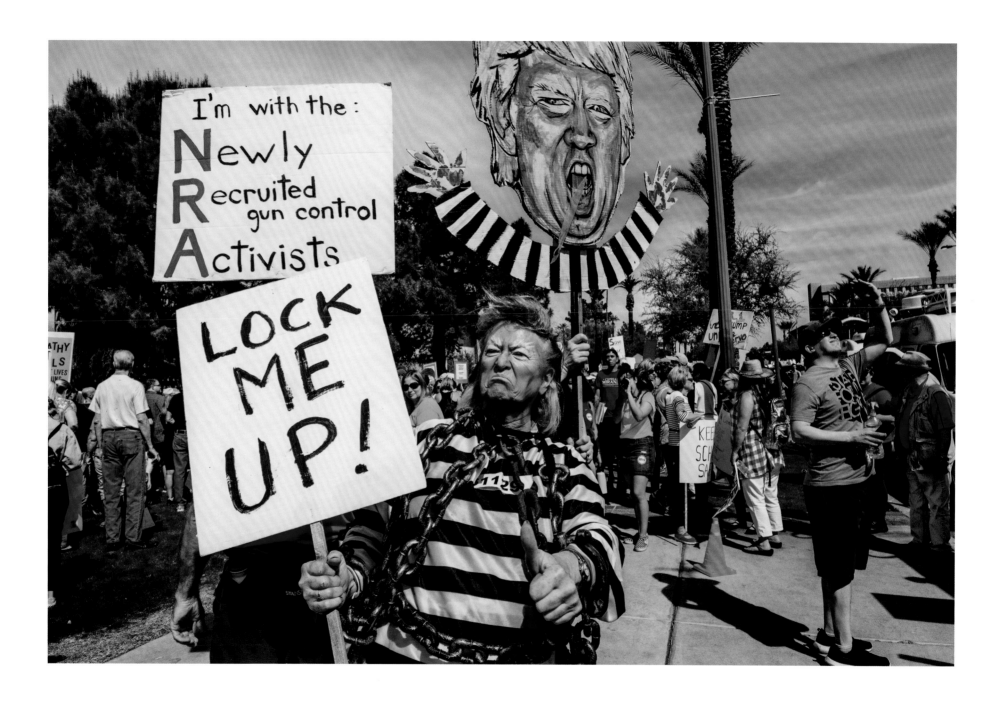

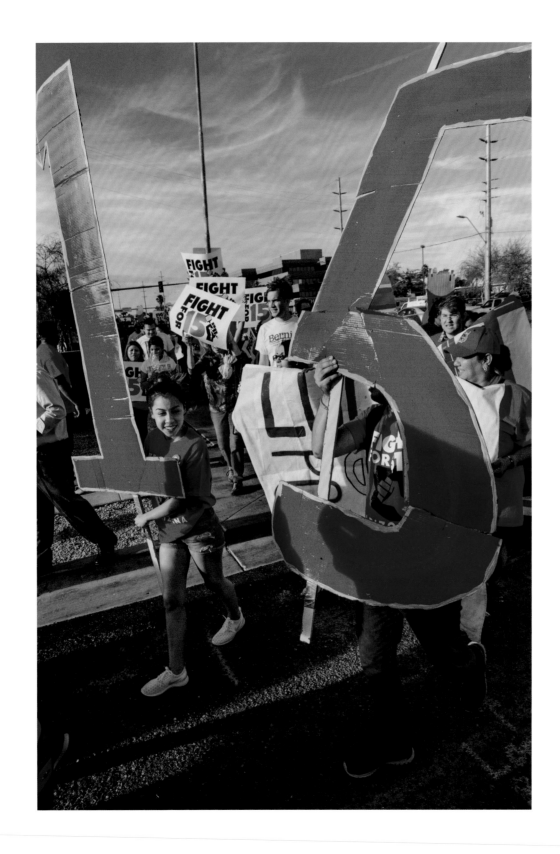

244 Phoenix, AZ

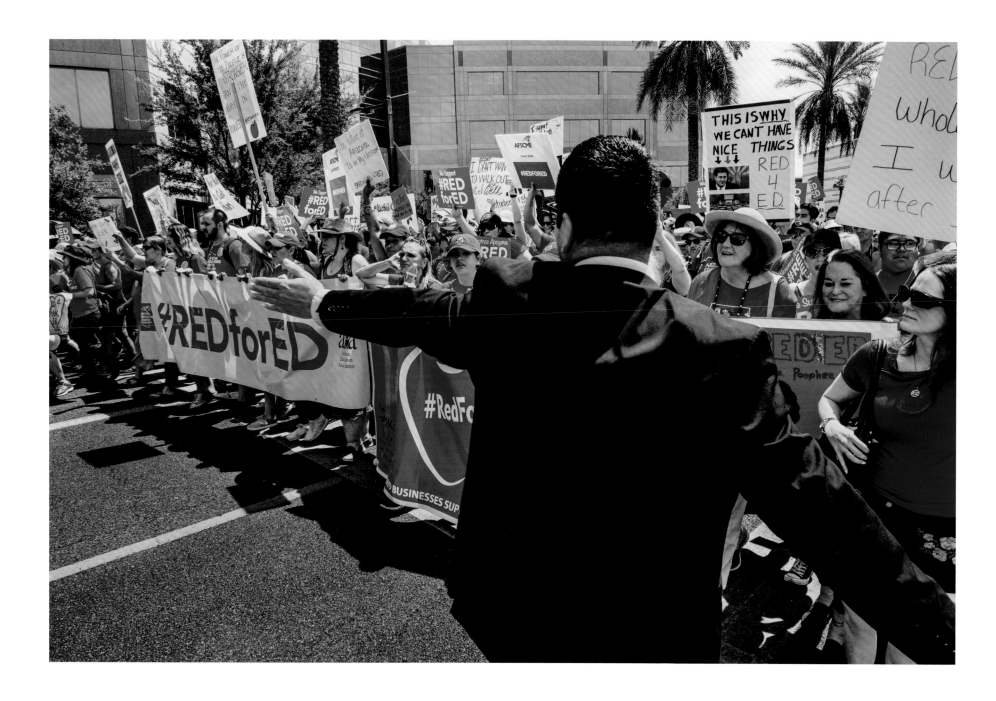

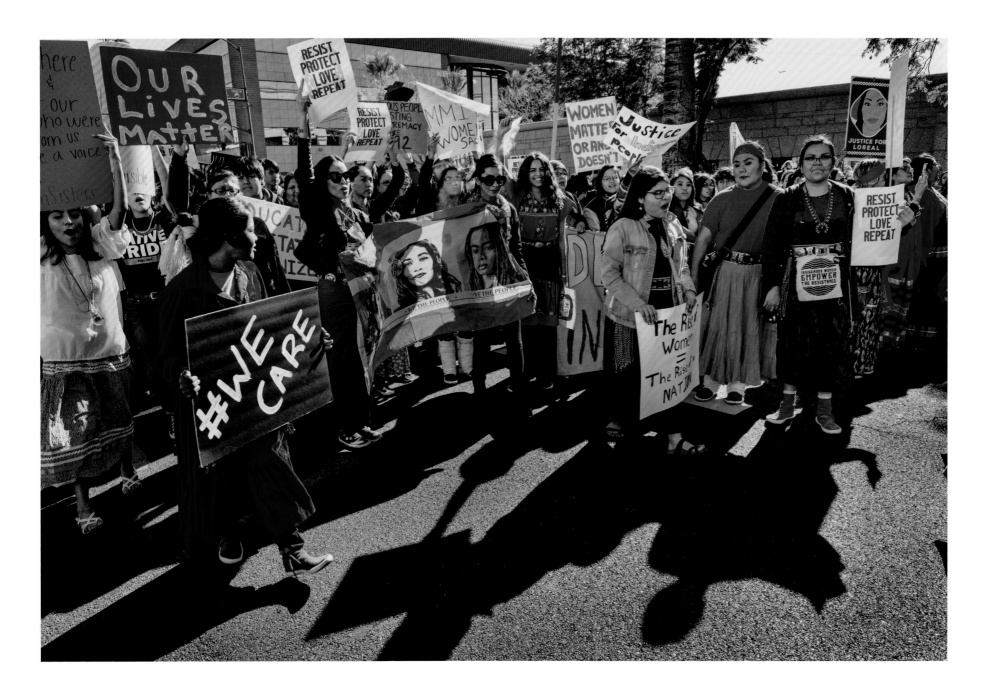

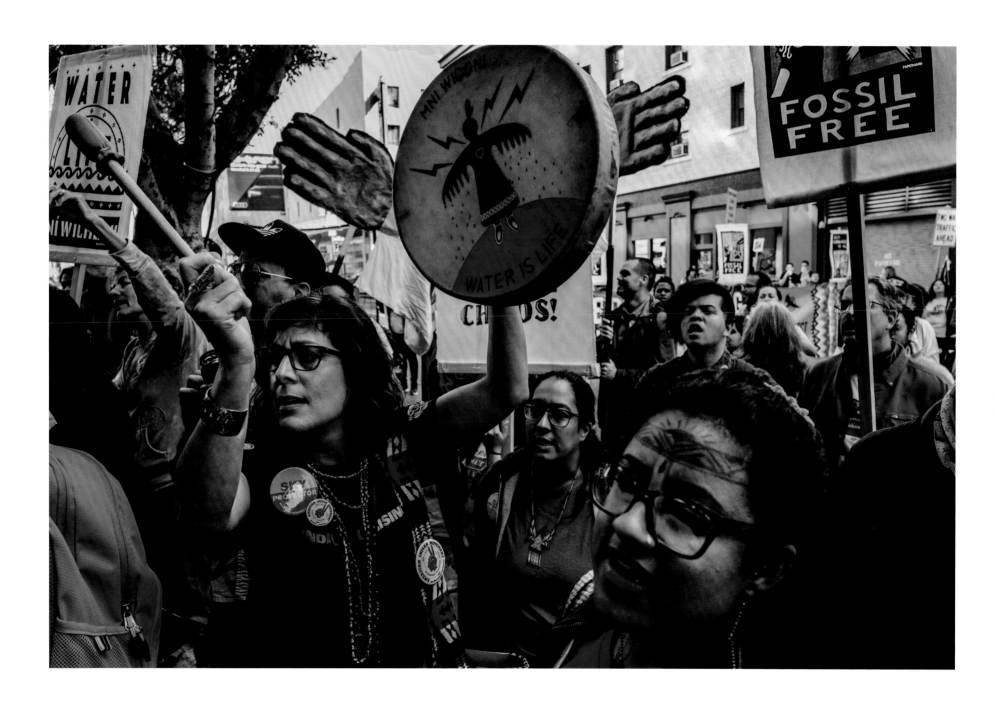

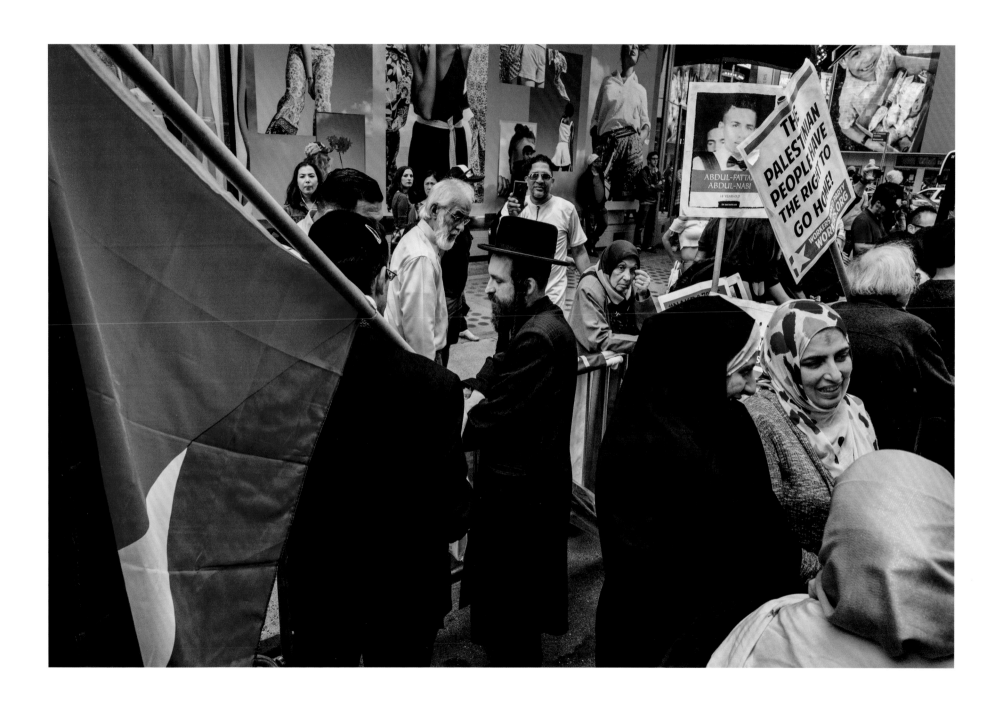

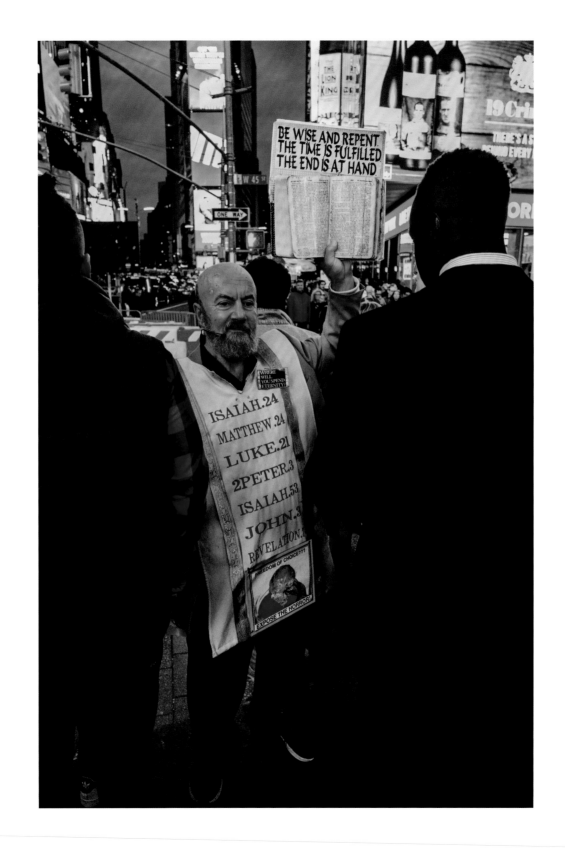

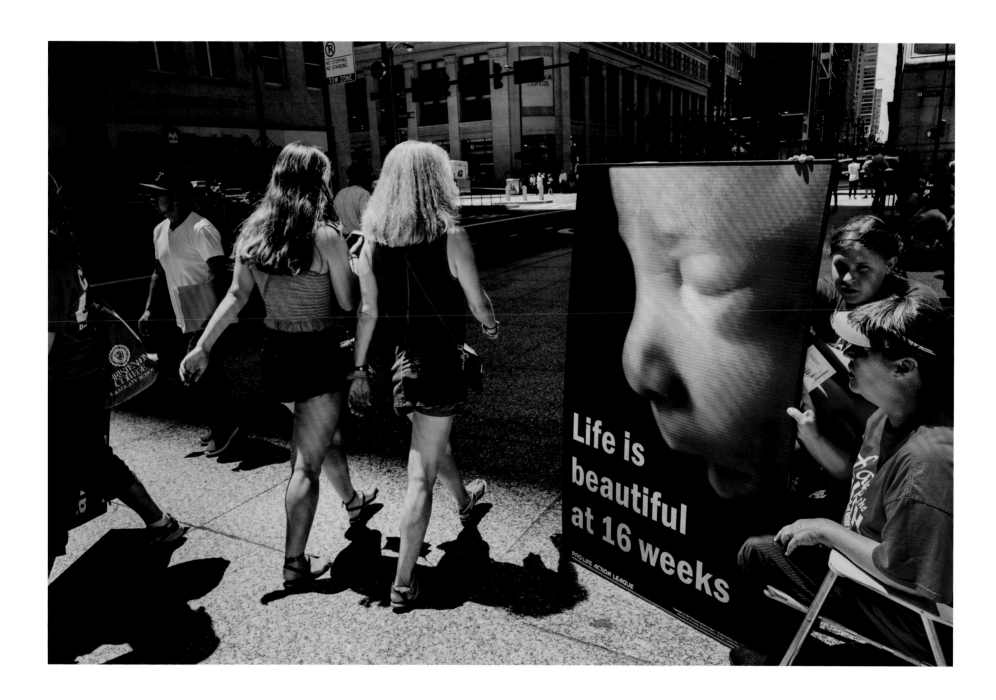

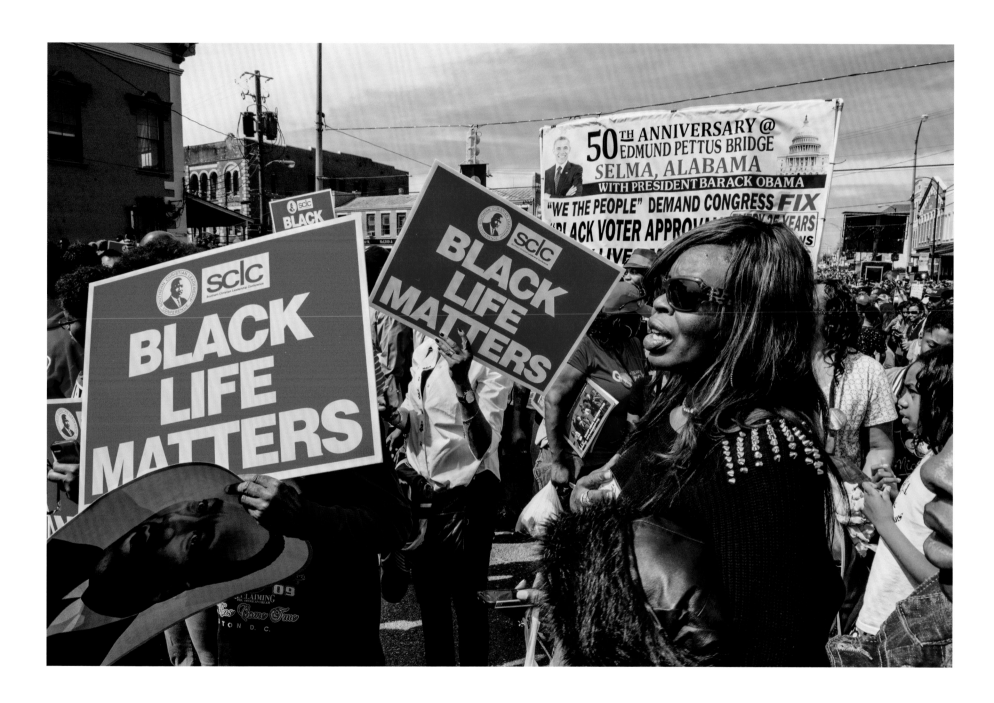

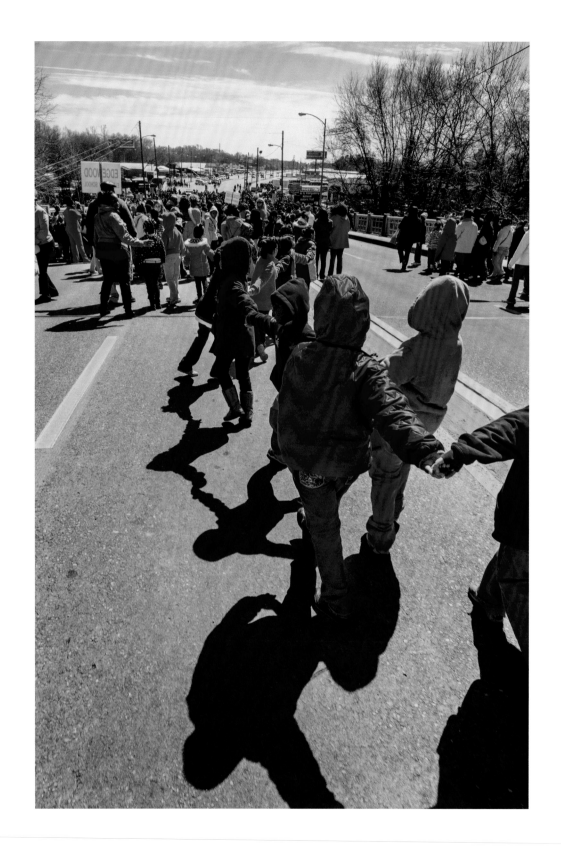

254 Selma, AL

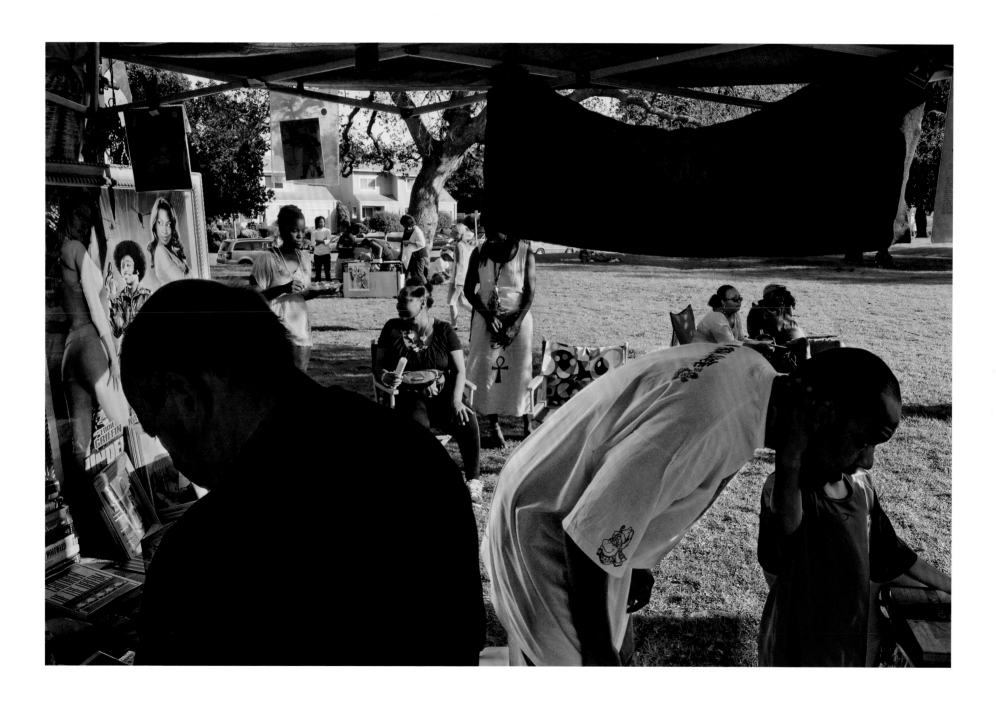

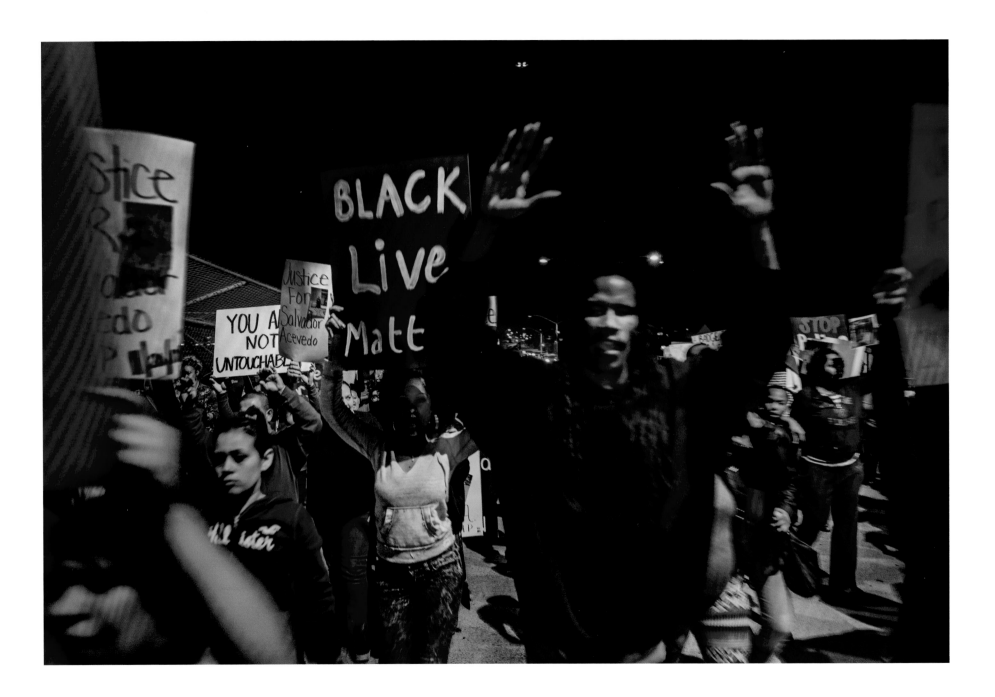

256 Phoenix, AZ

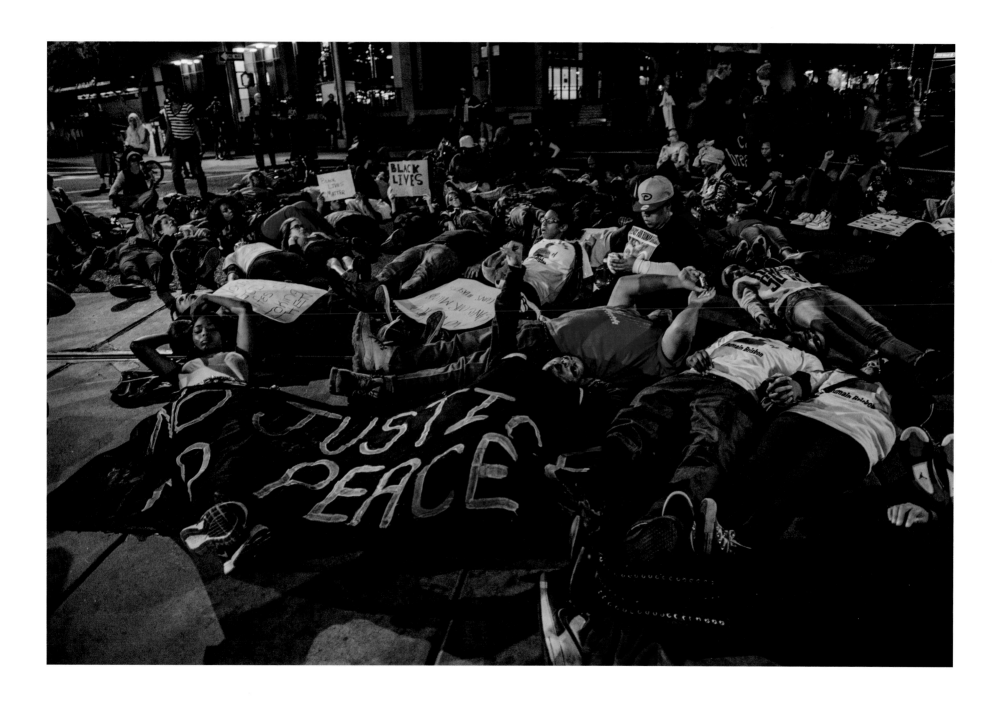

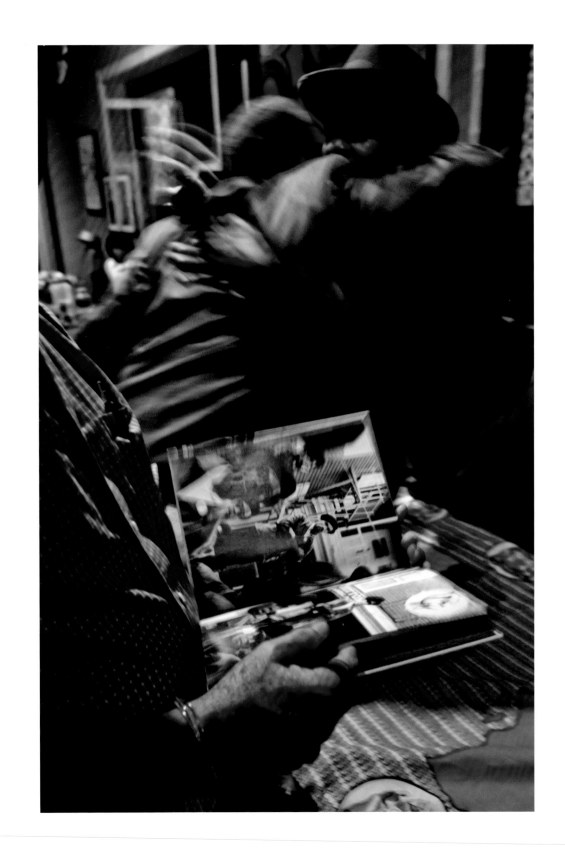

258 Oakland, CA

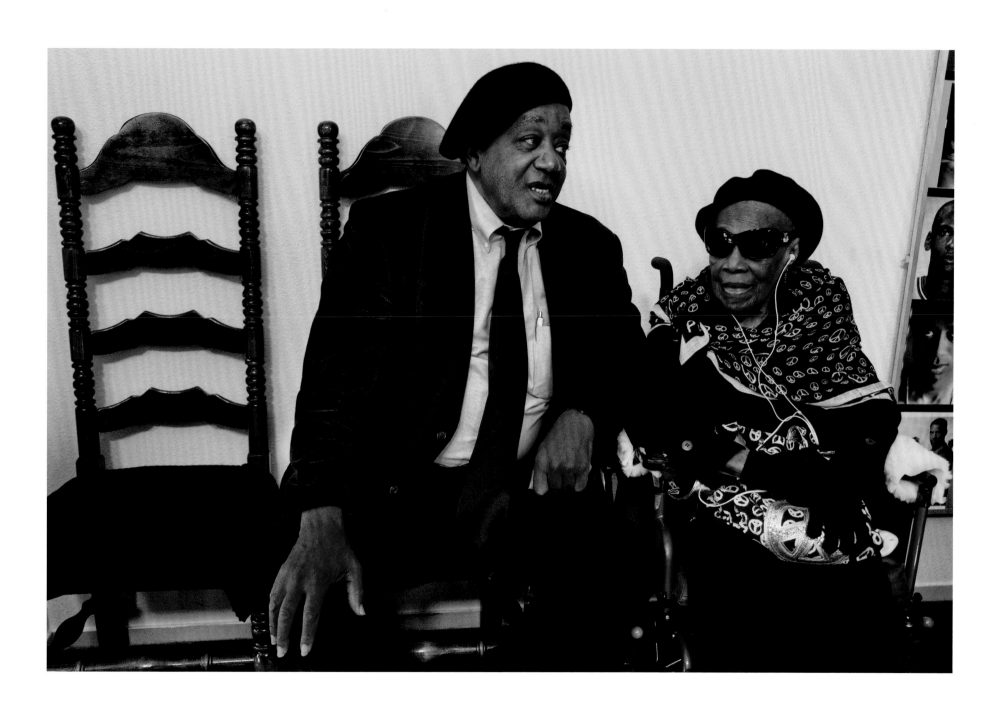

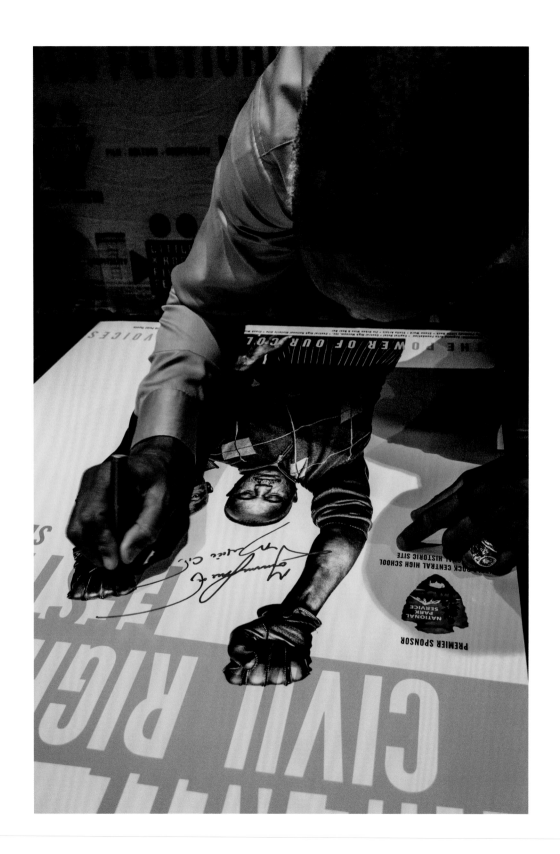

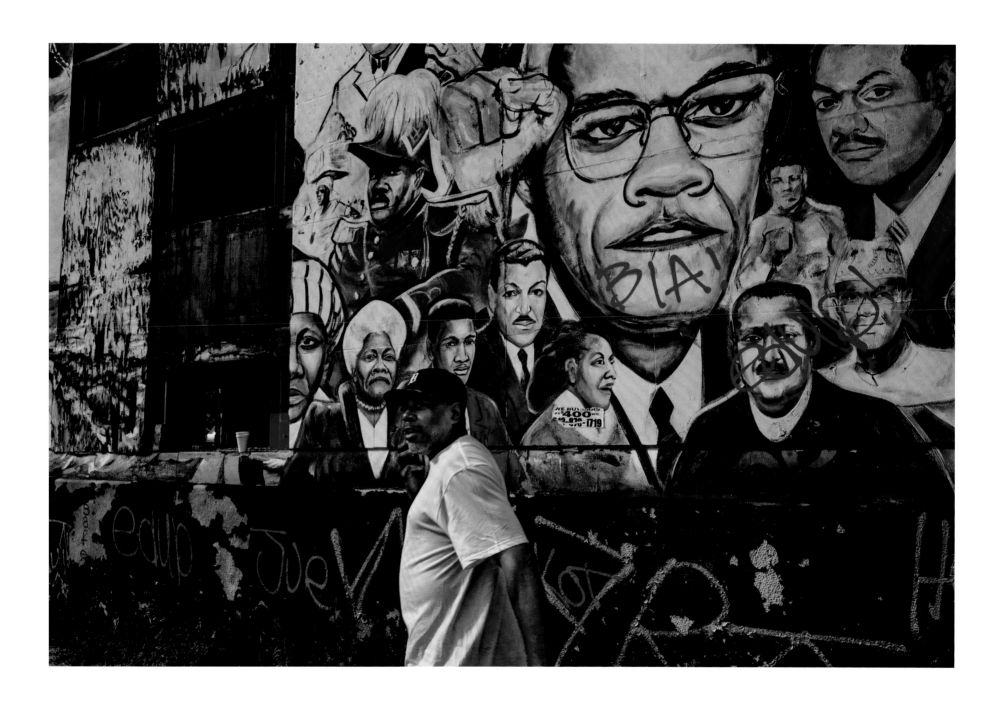

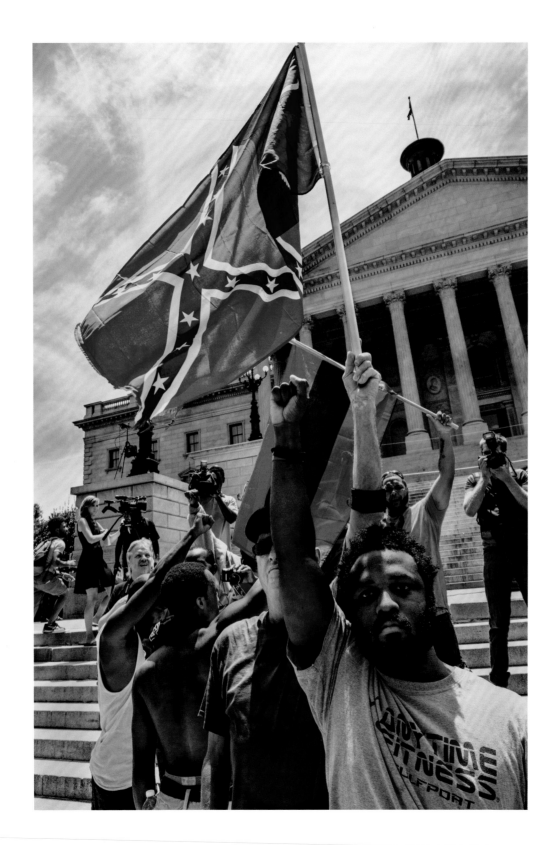

262 Columbia, SC

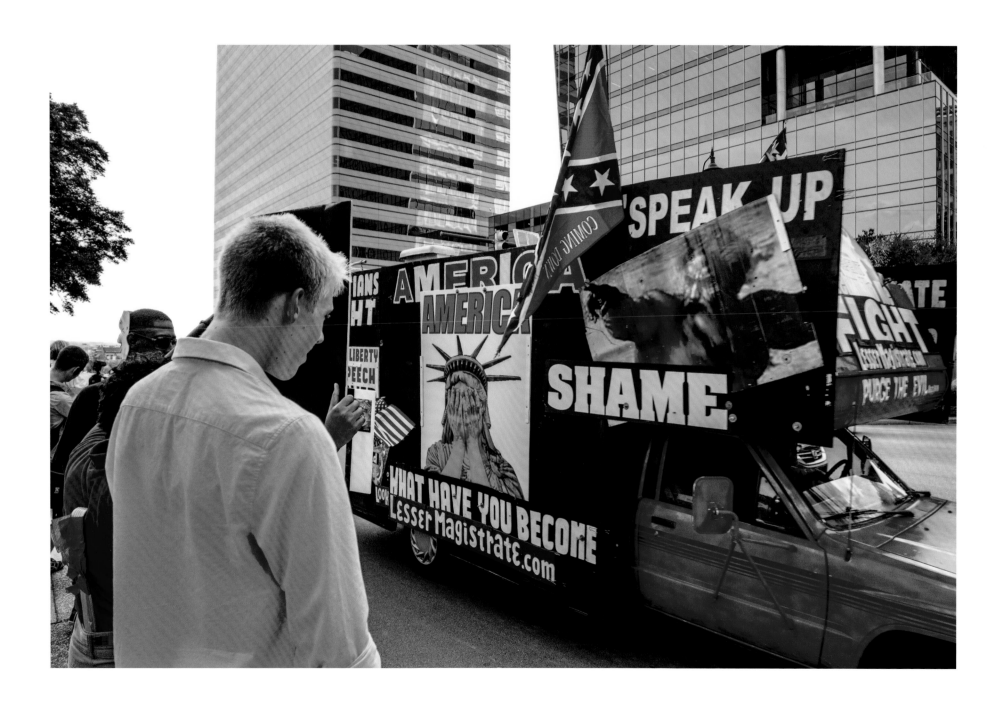

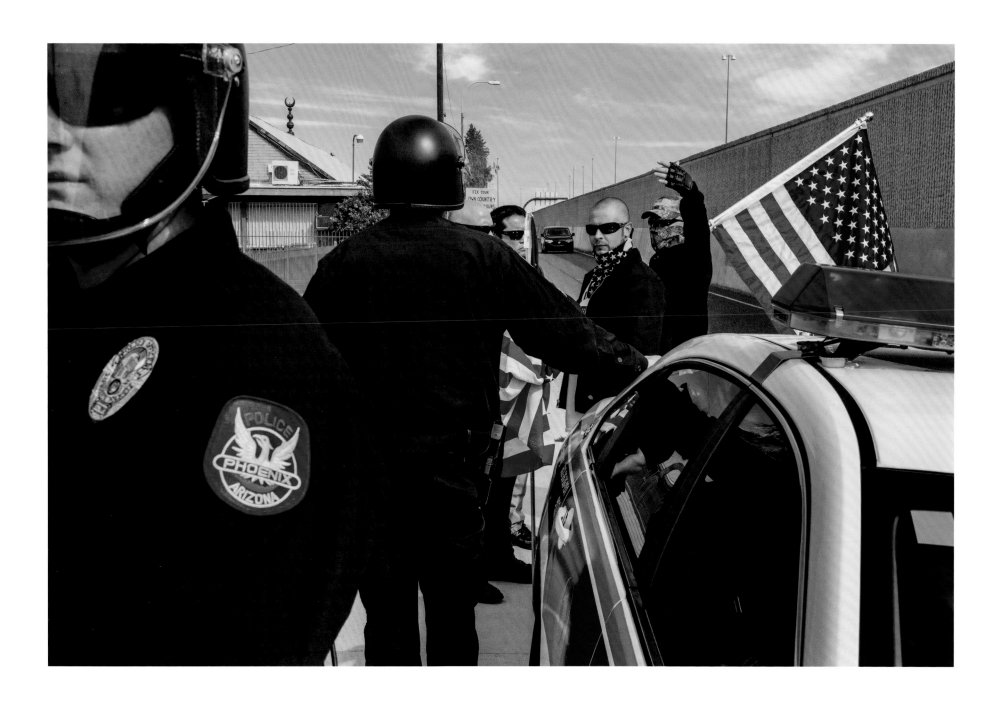

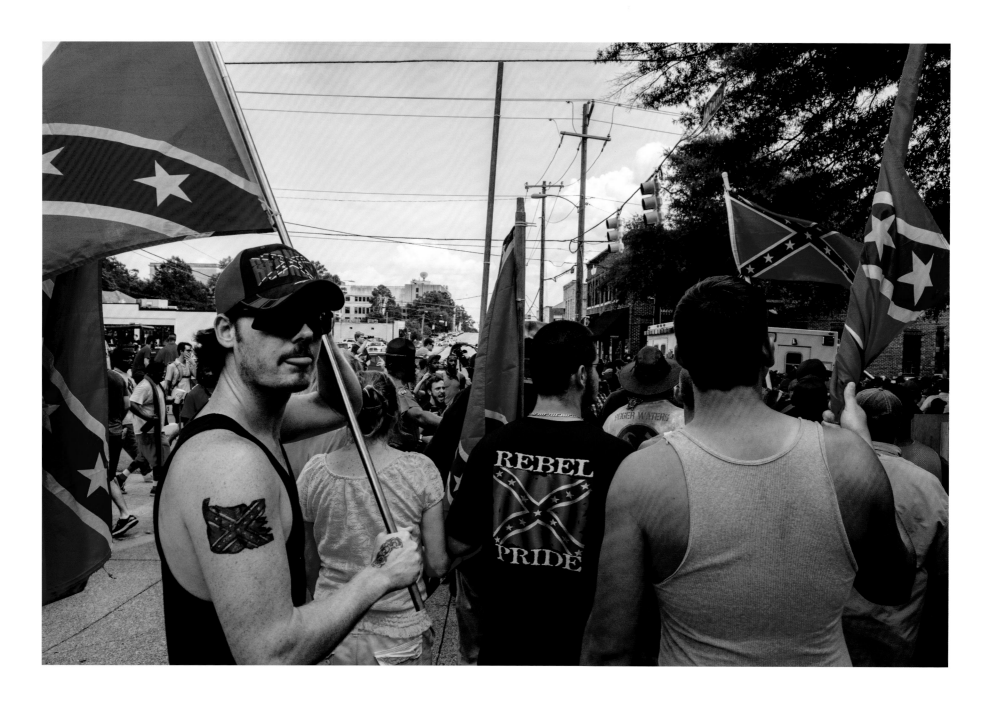

266 Columbia, SC

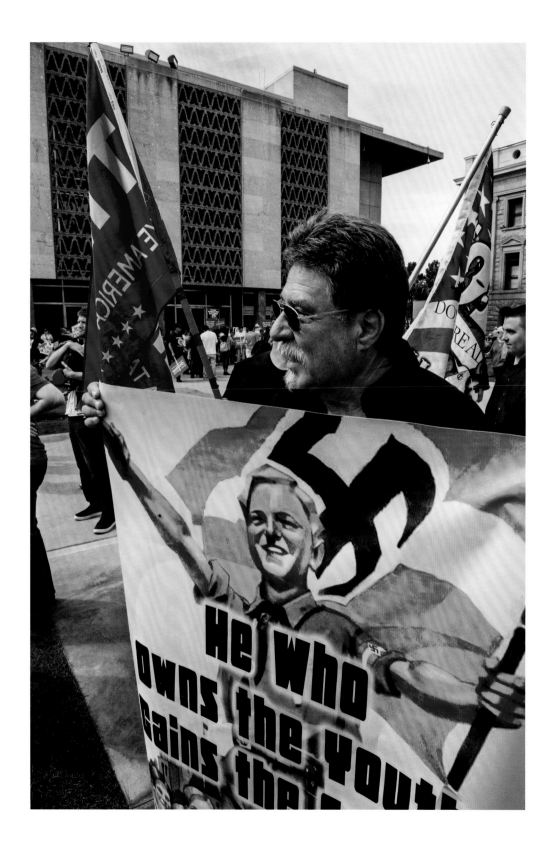

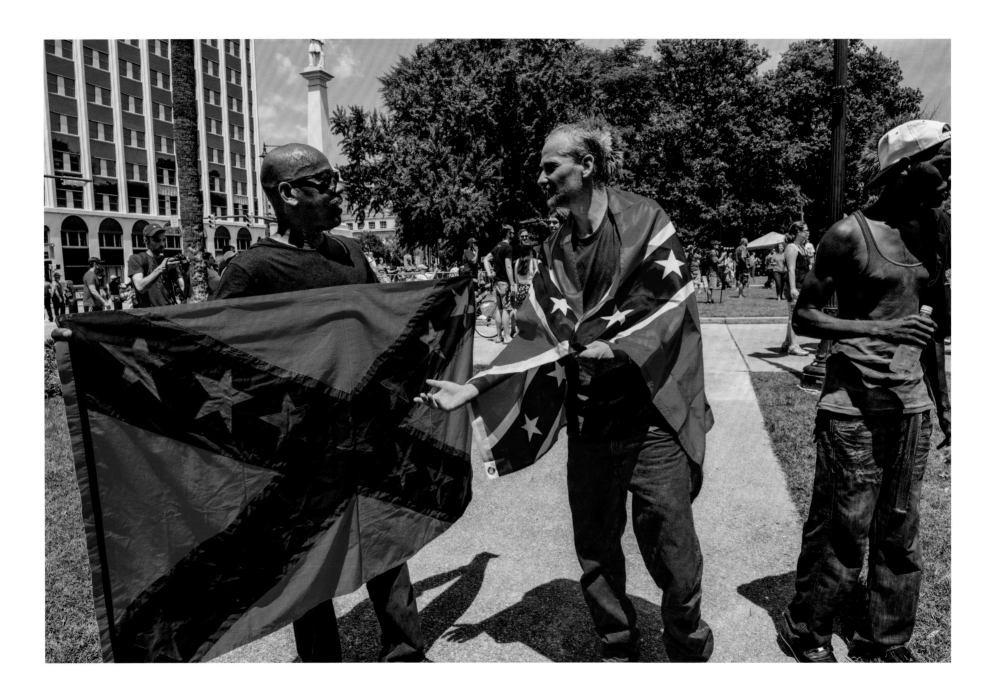

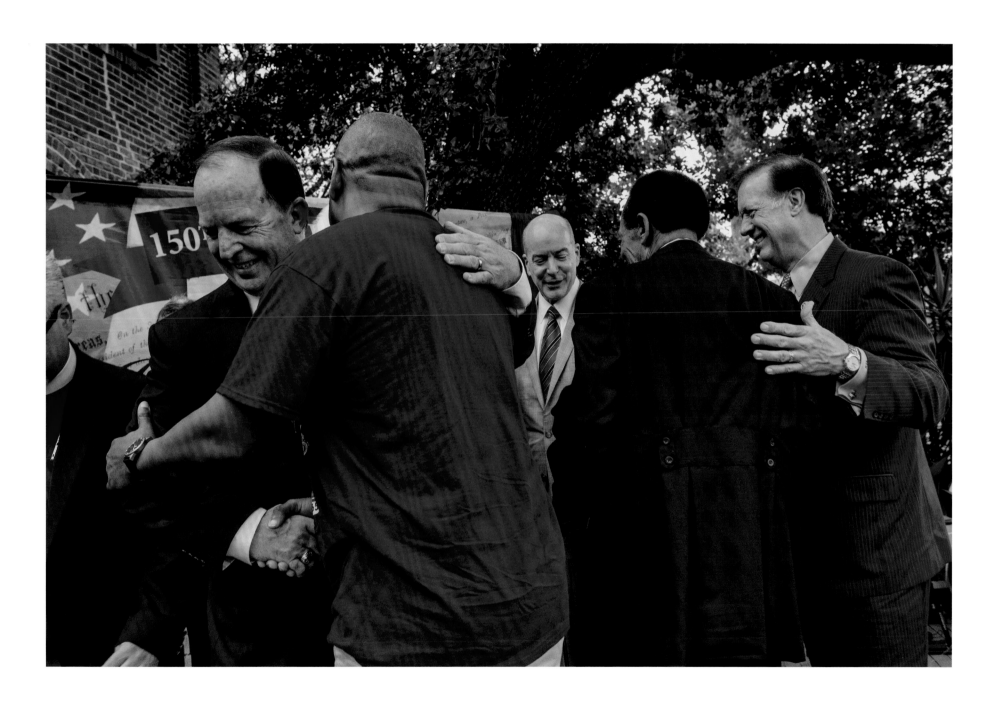

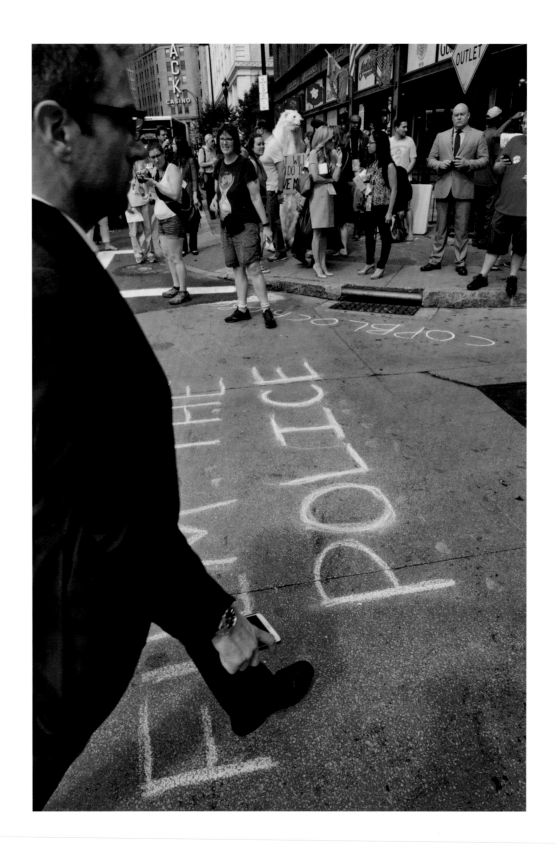

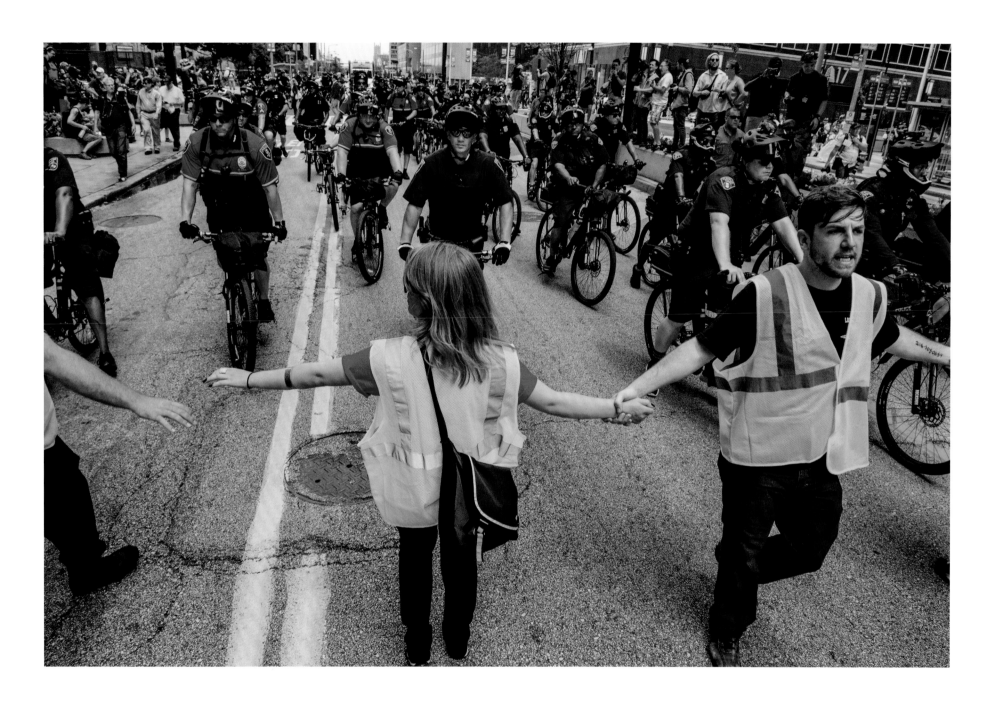

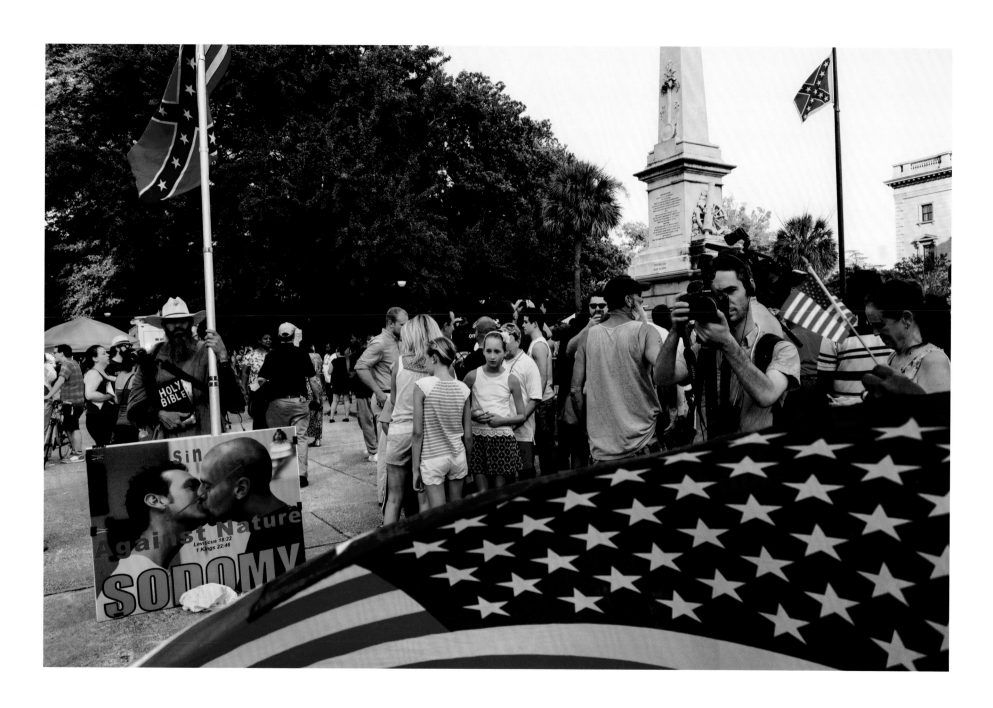

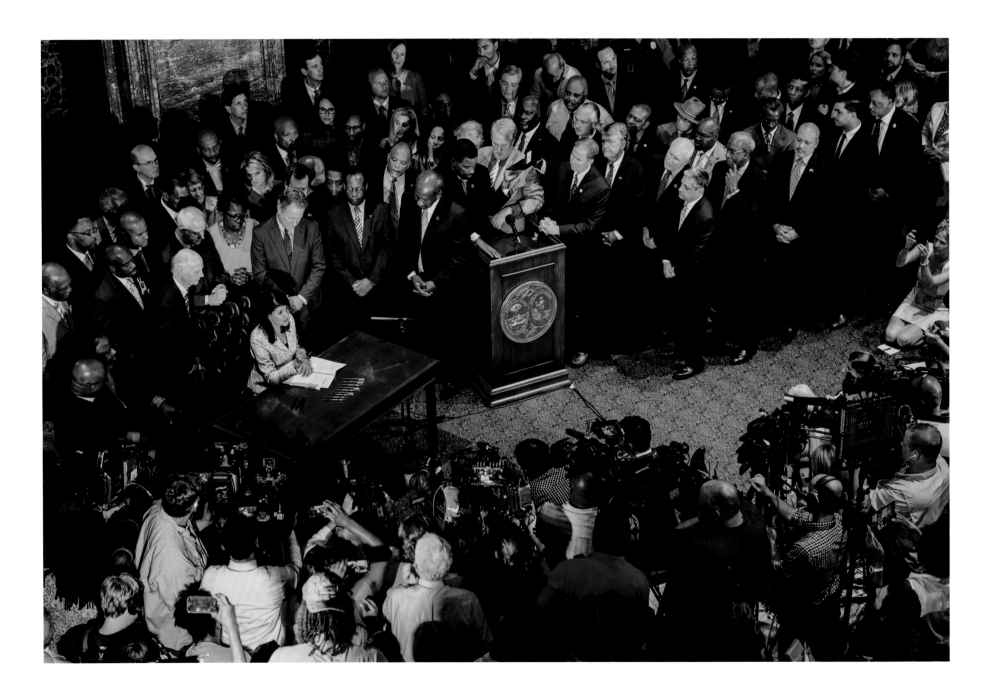

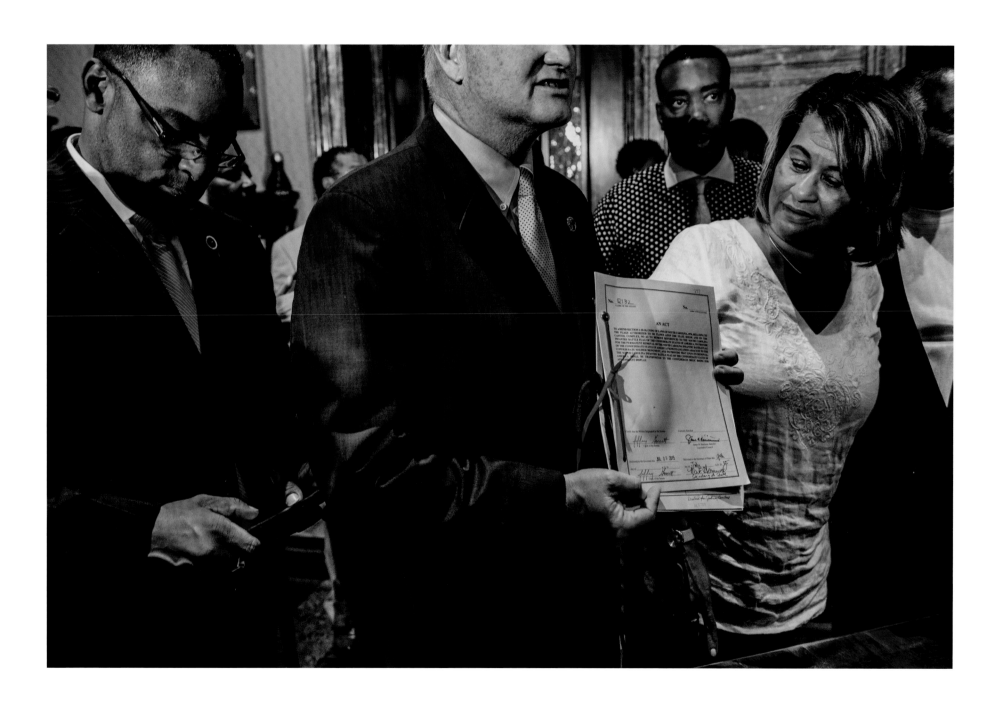

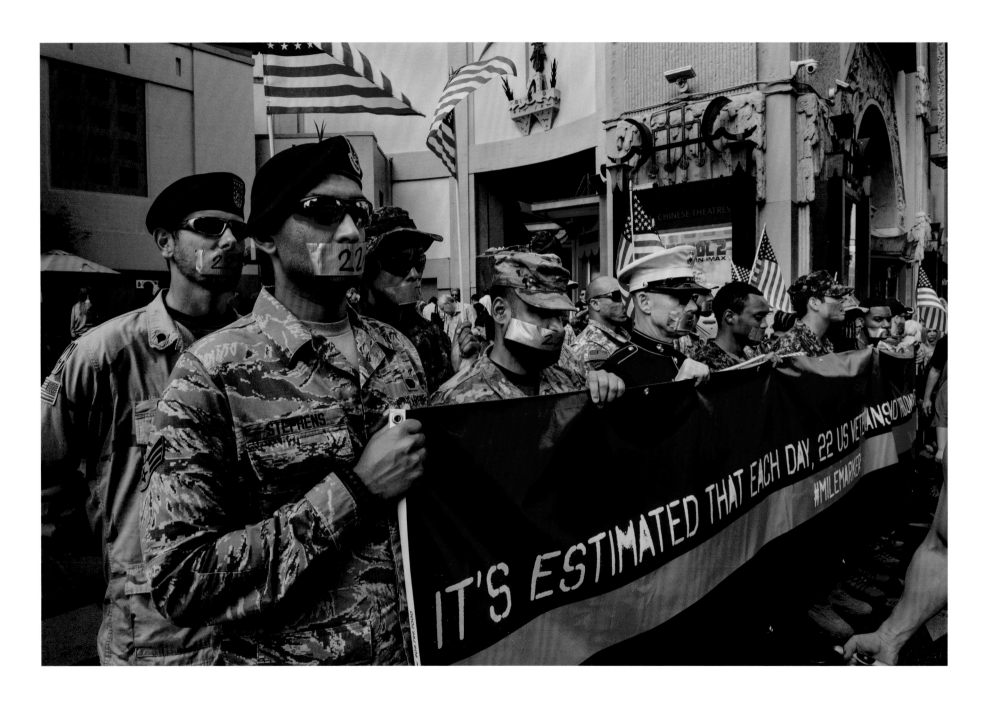

276 Los Angeles, CA

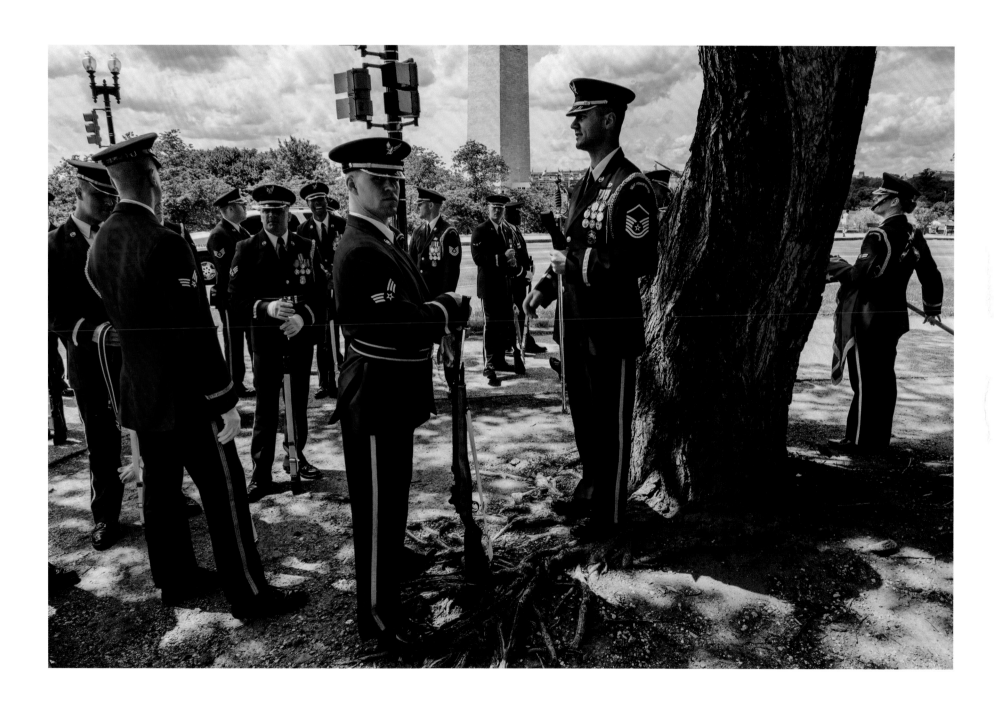

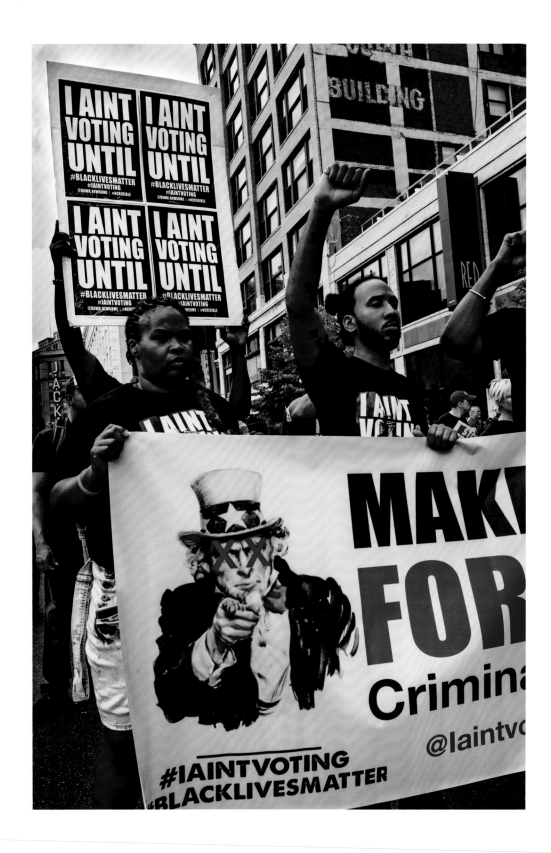

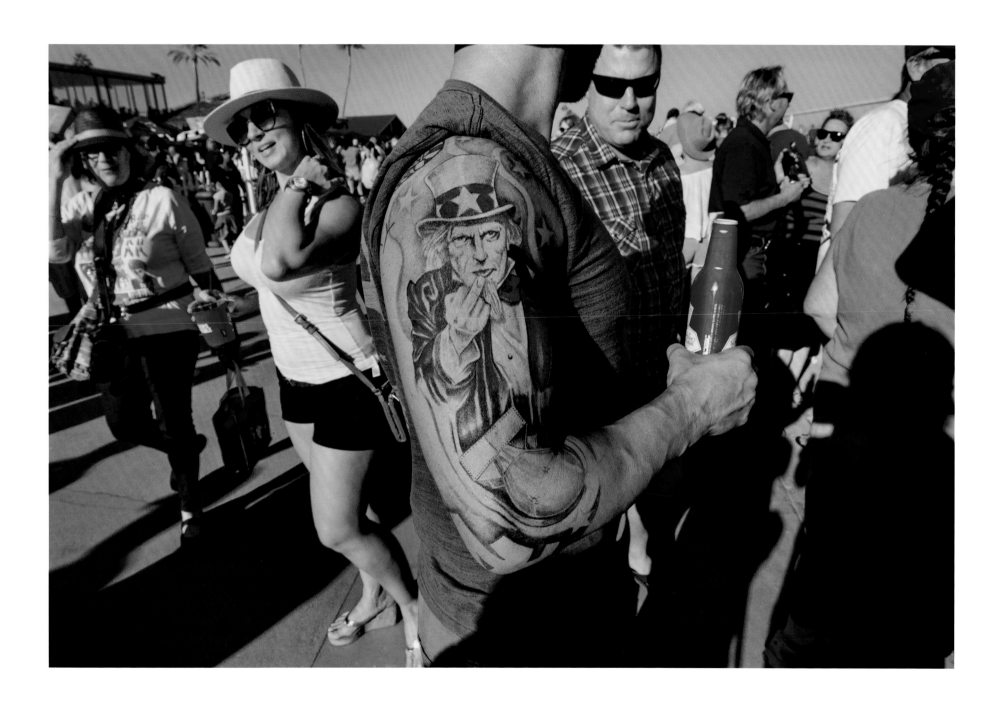

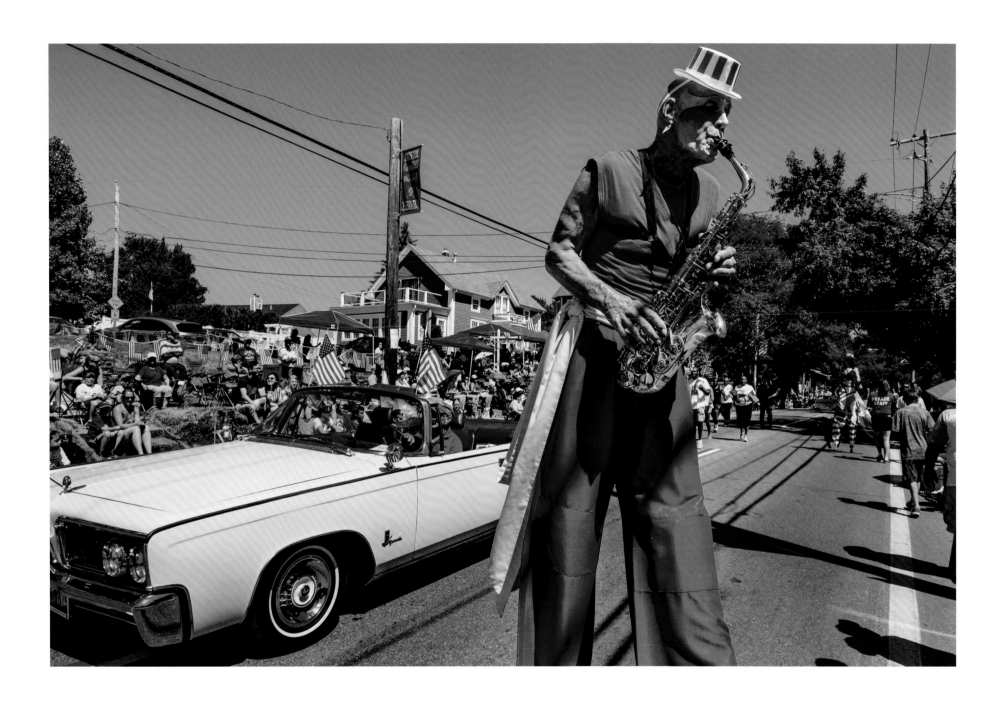

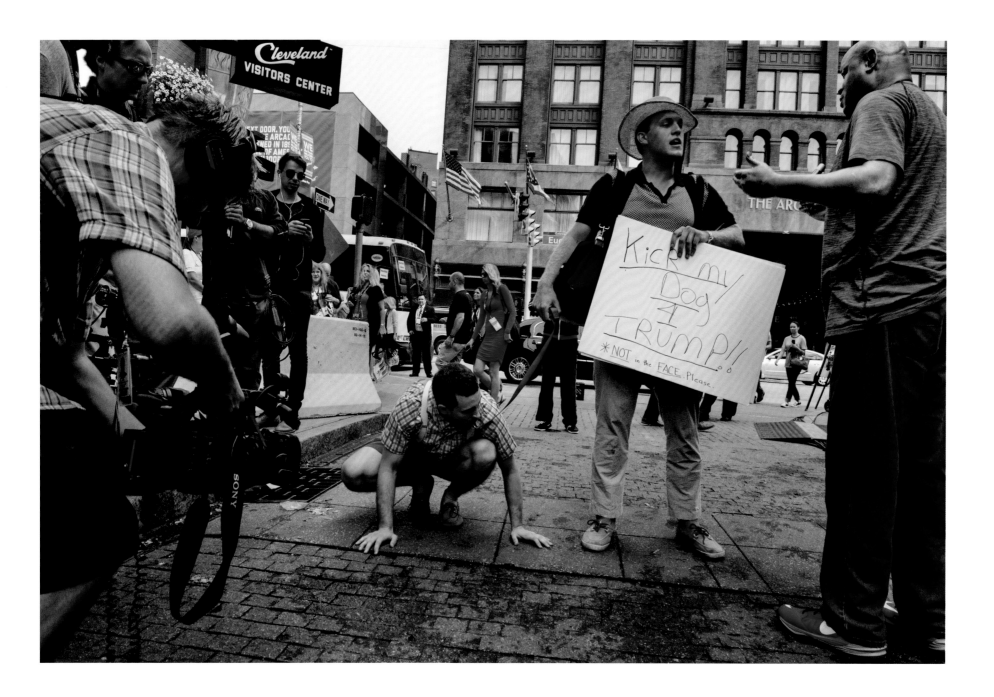

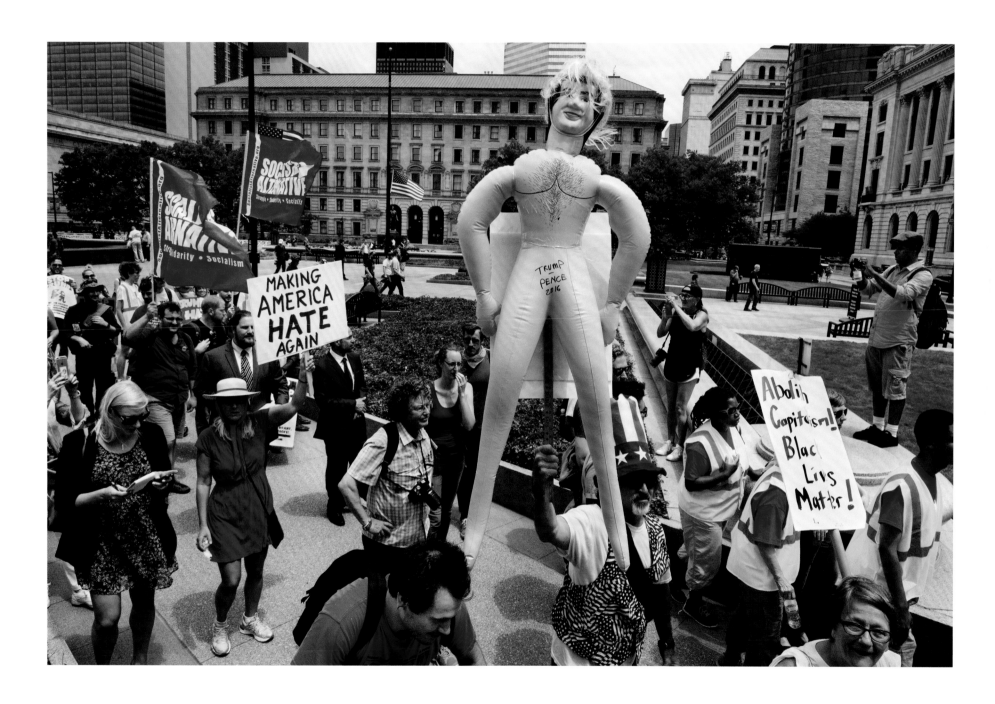

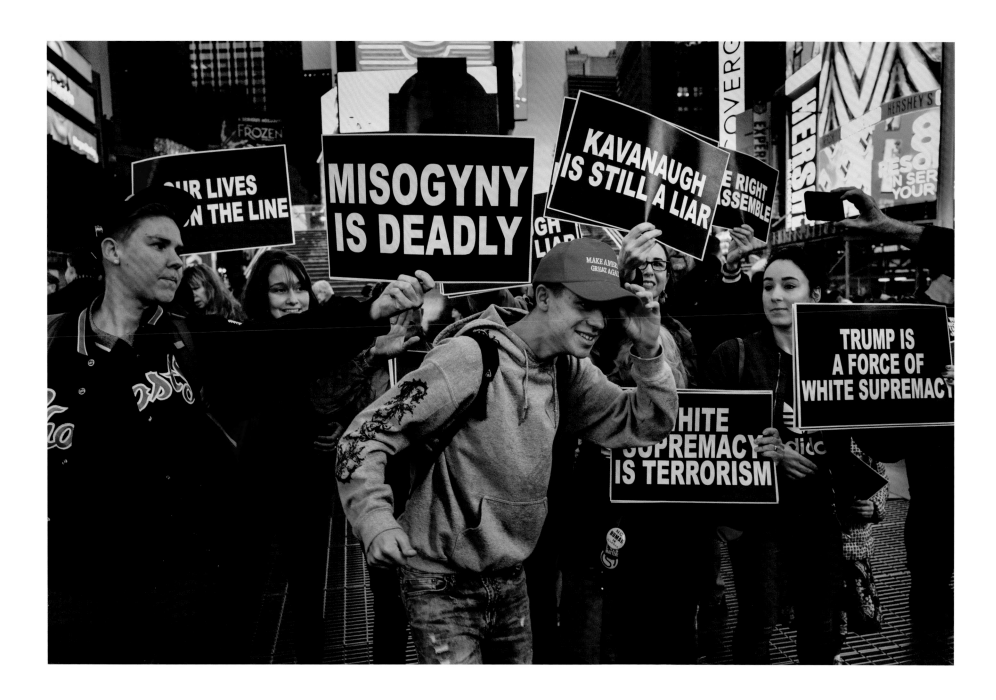

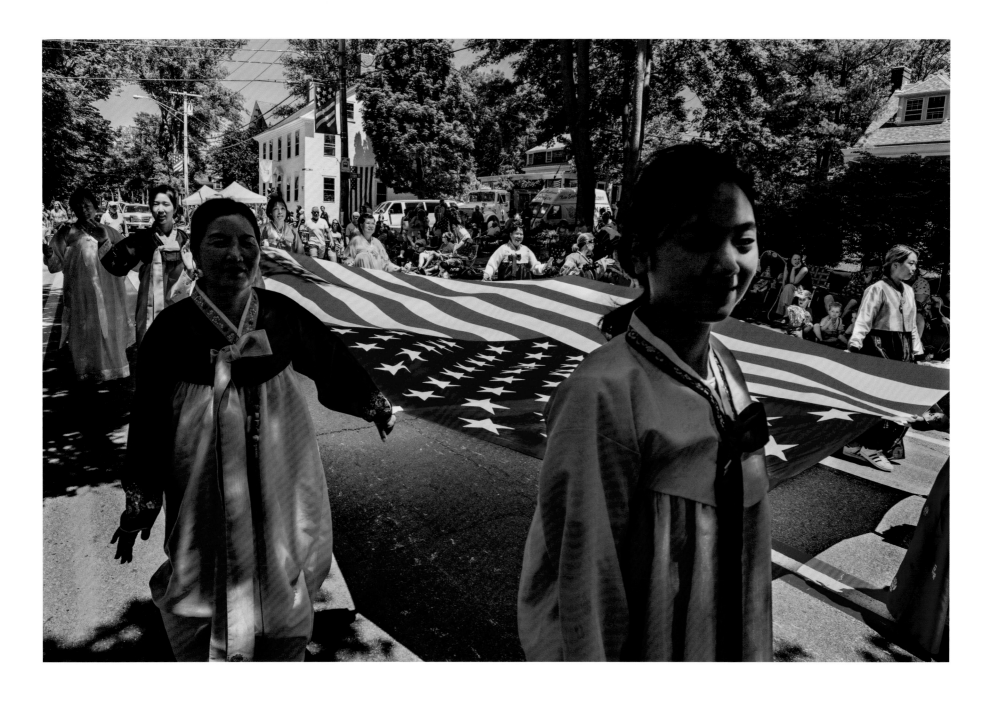

286 Bristol, RI

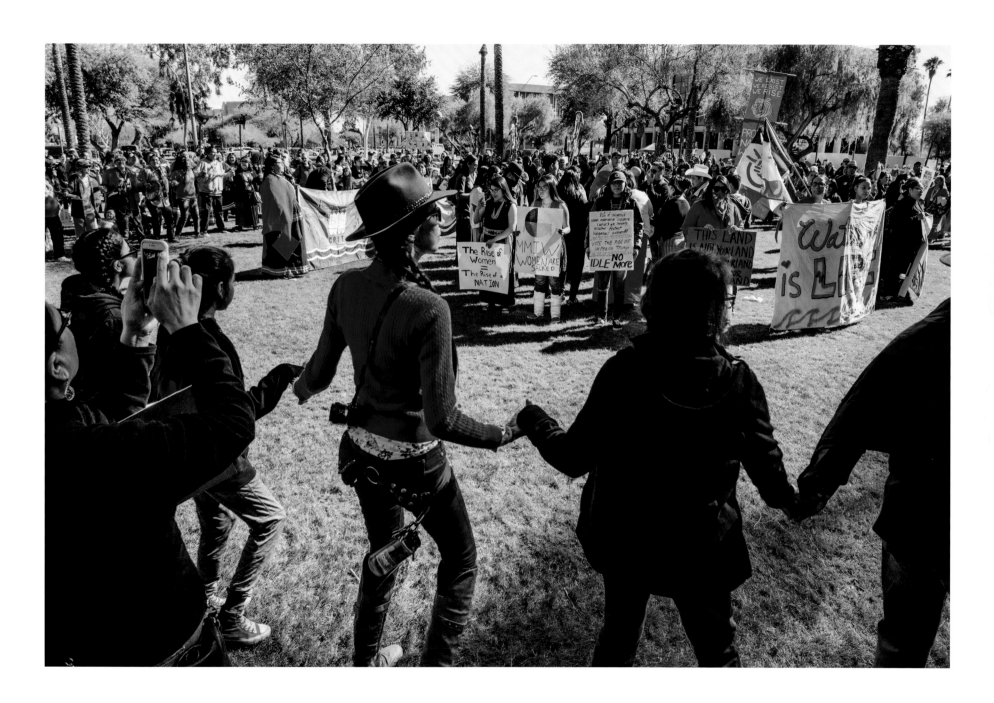

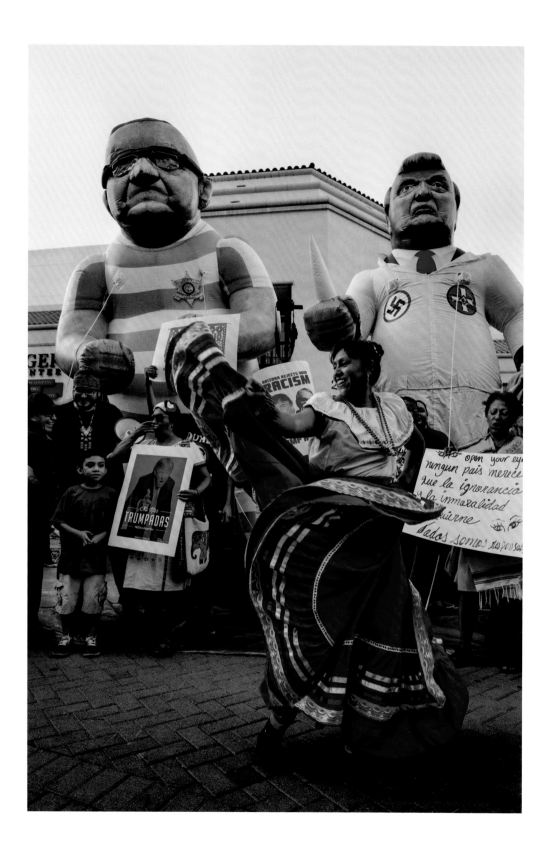

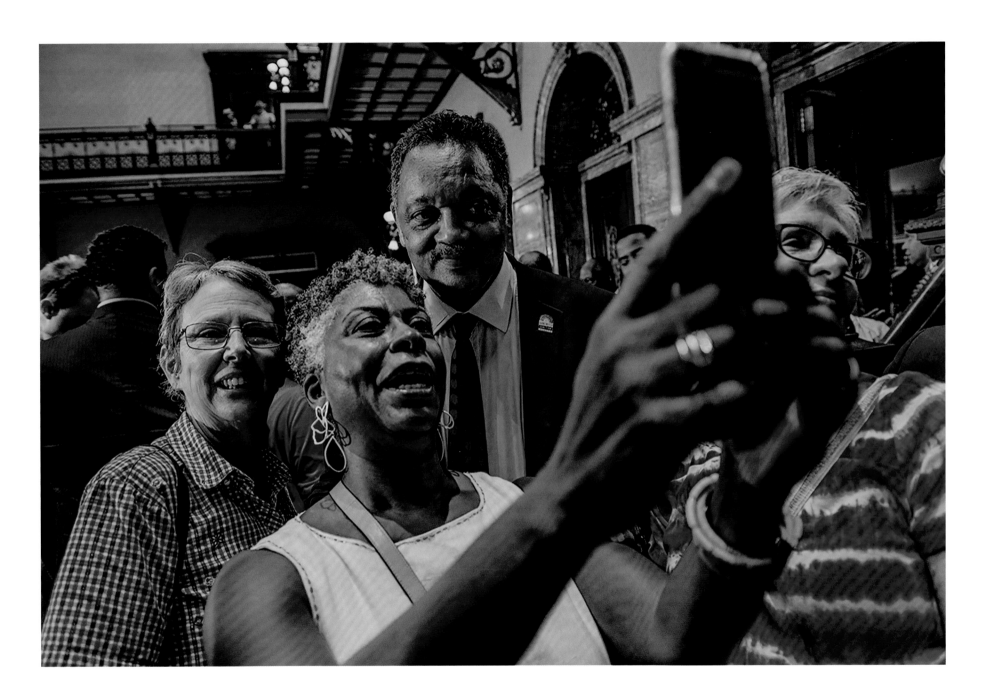

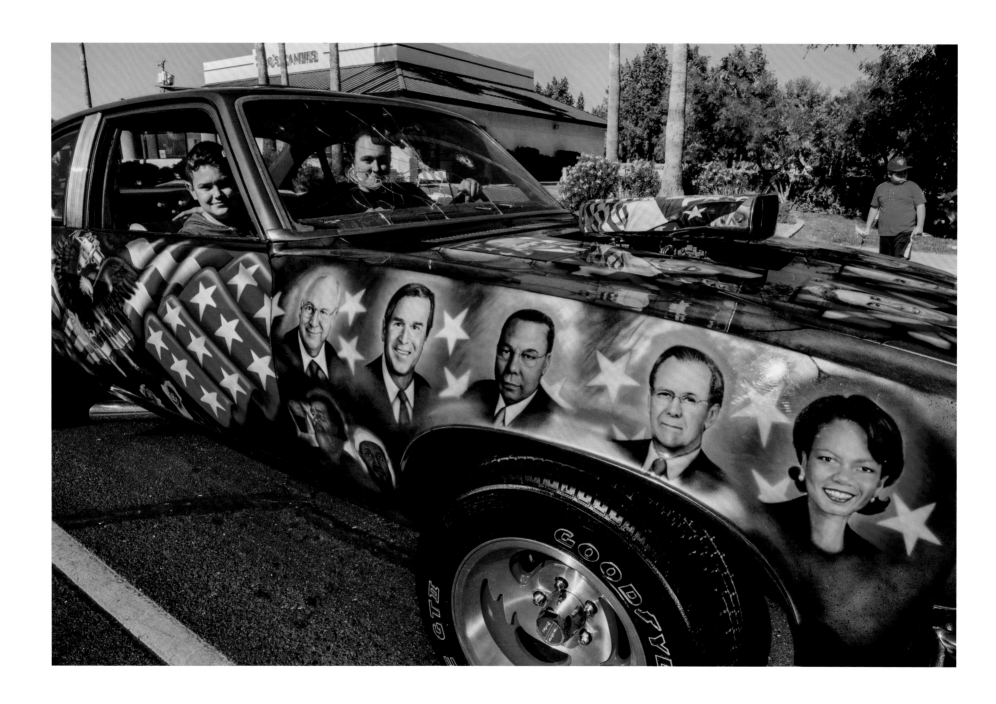

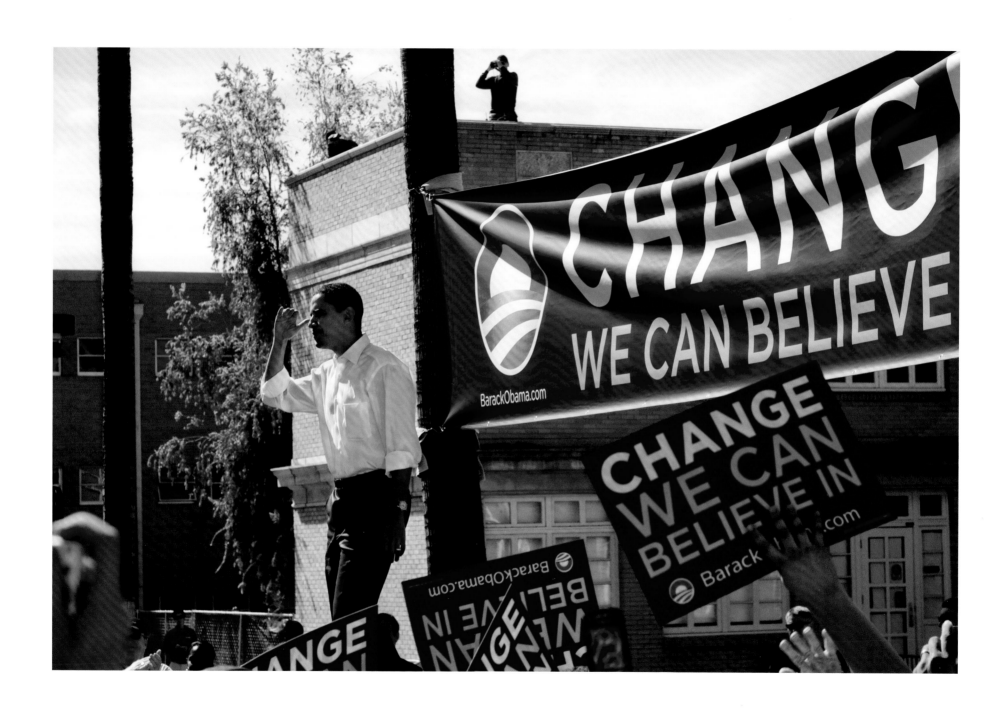

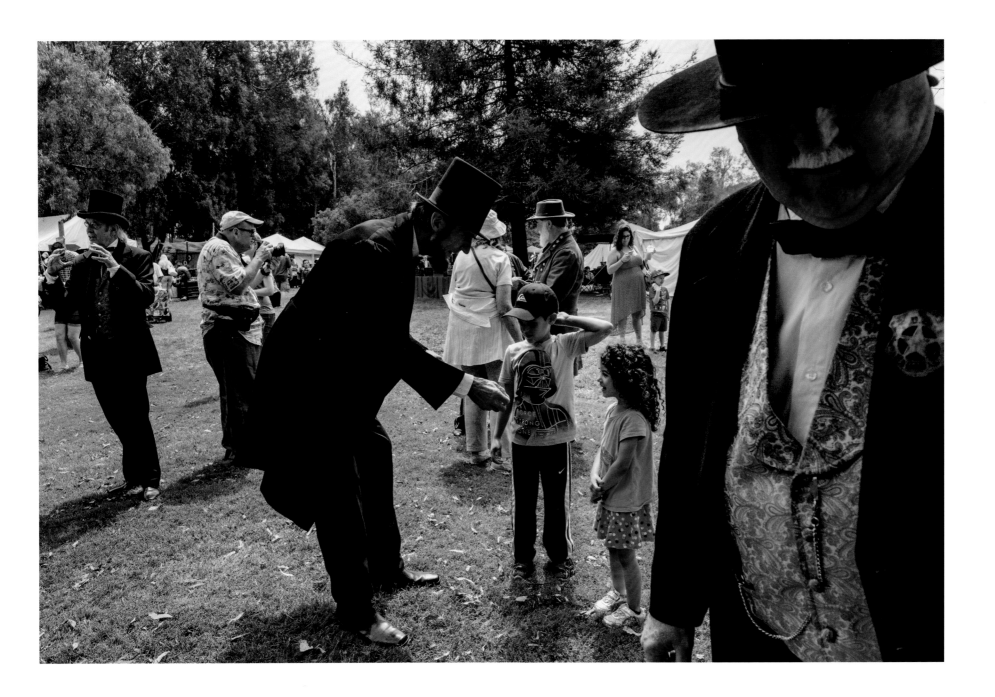

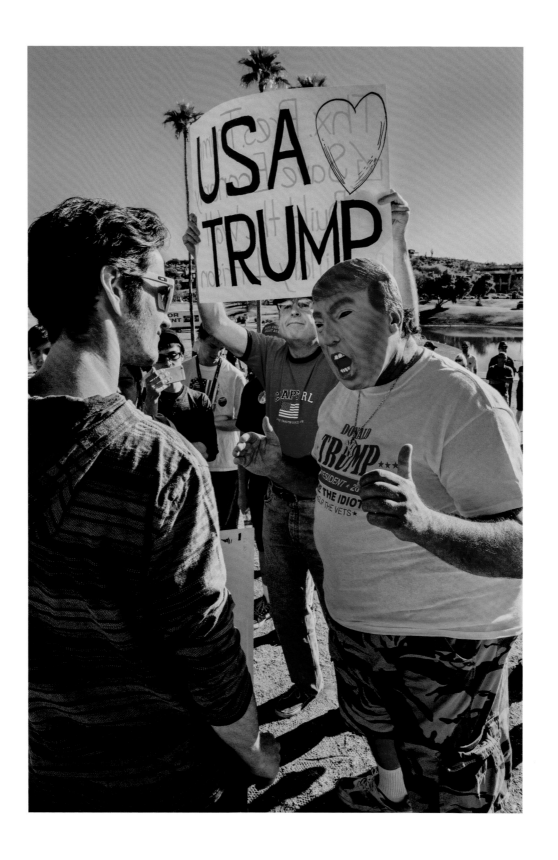

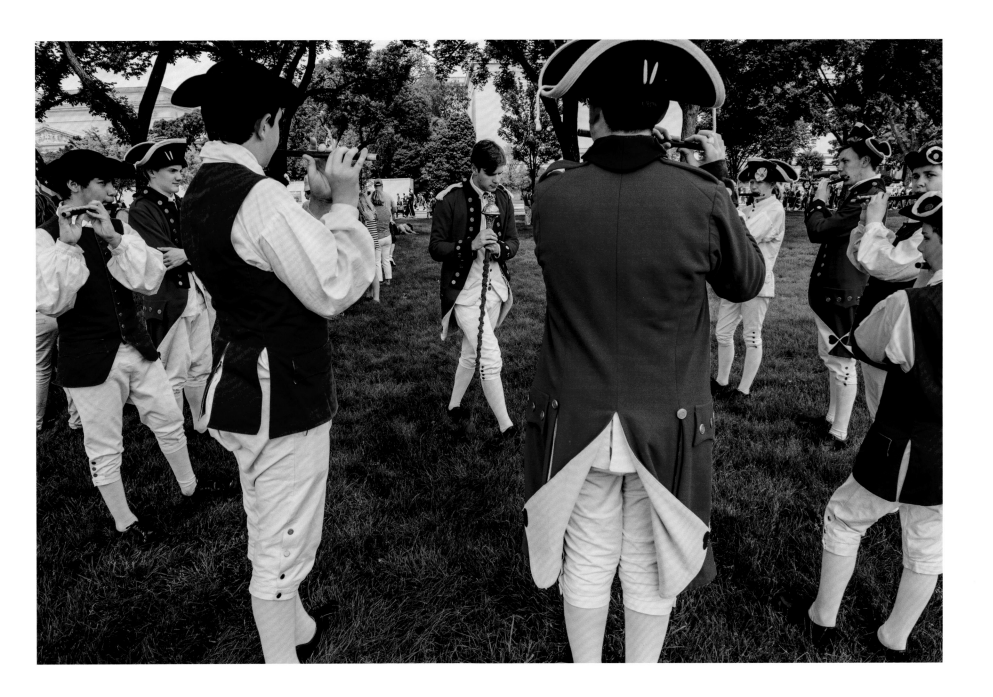

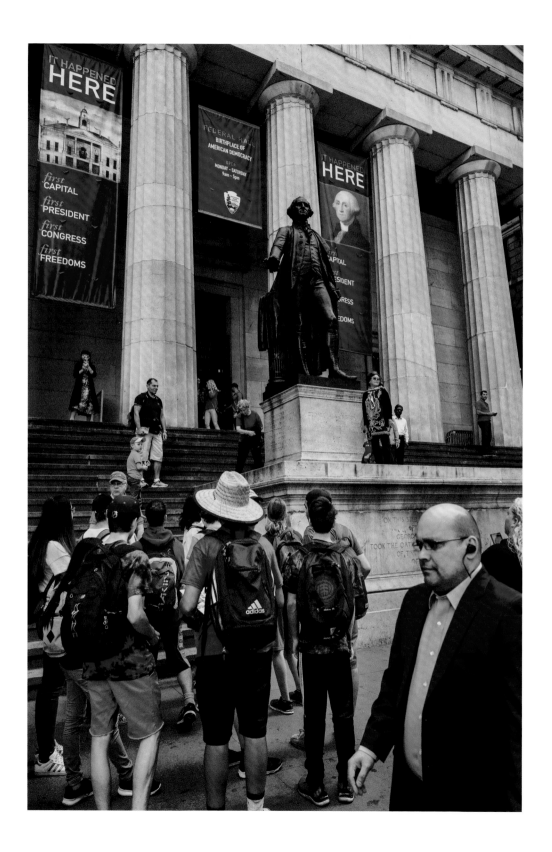

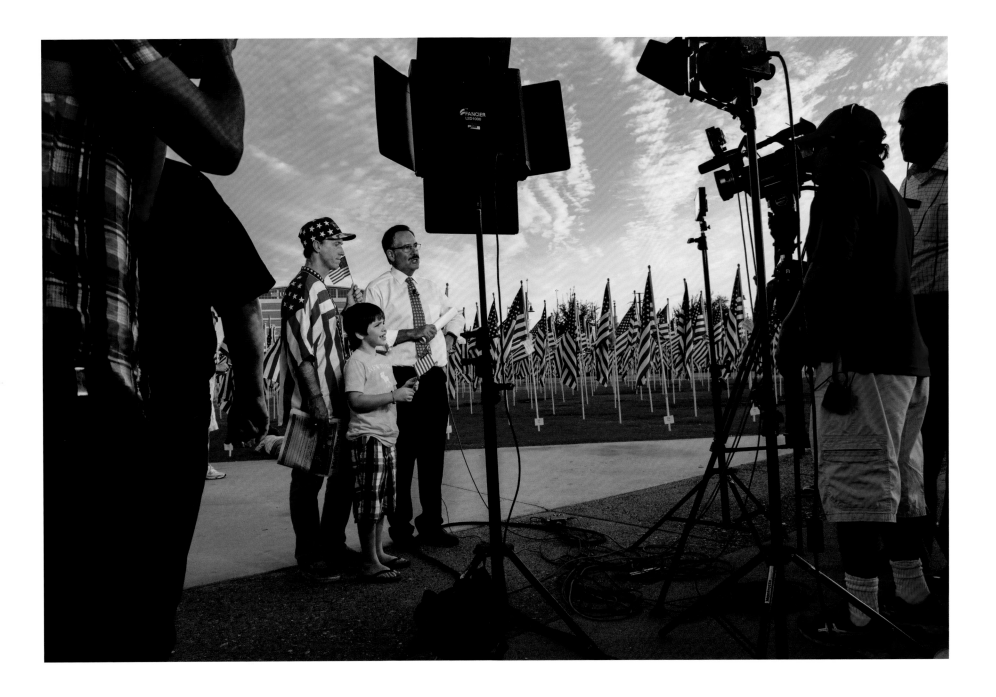

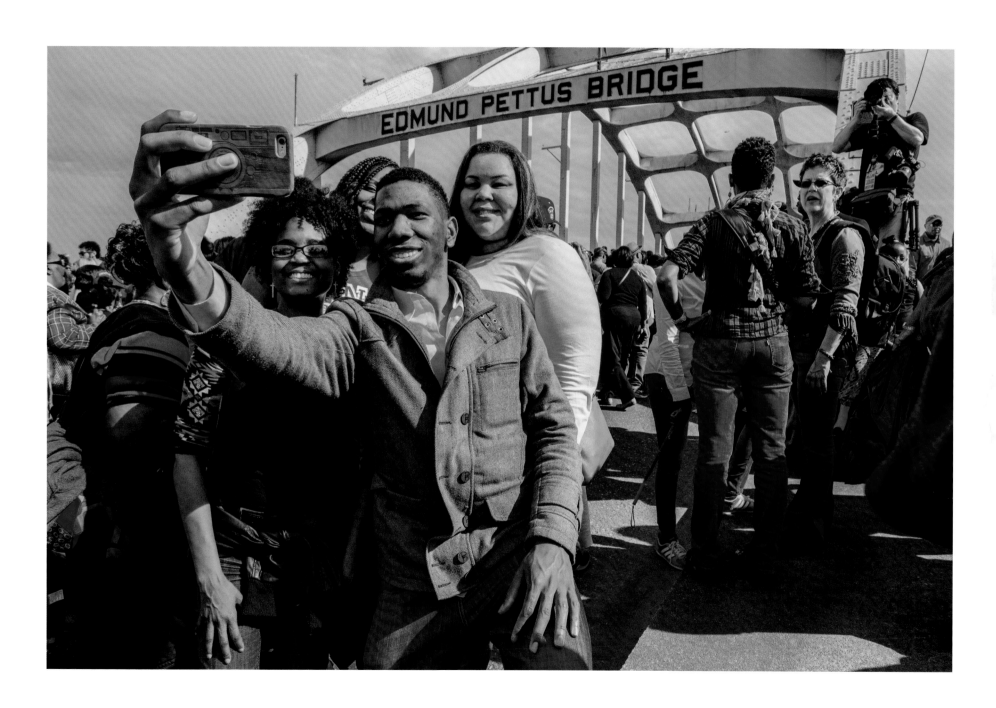

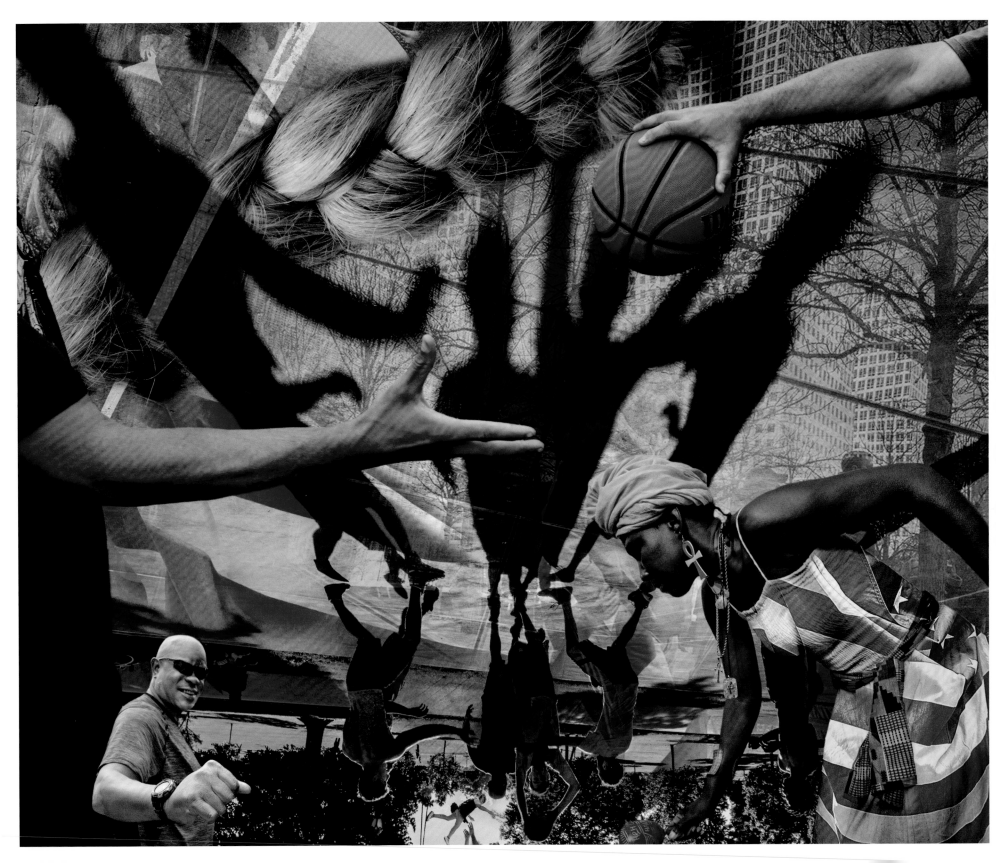

Neighbors in the Crowd:
An Interview with the Artist

BY REBECCA A. SENF, PH.D.

Rebecca A. Senf (RAS): *Can you tell us about growing up, since cultural identity and personal background provided a foundation for you to pursue the* American / True Colors *project?*

Stephen Marc (SM): I was raised on the segregated South Side of Chicago, during the Blackstone Rangers vs. Disciples warfare, and my formative years were also during the Black Power and Civil Rights Eras and the Vietnam War; with the heaviness of the times haunted by the assassinations of John F. and Robert Kennedy, Dr. Martin Luther King, Jr., and Malcolm X. (I still remember my draft number.) My parents were professionals: My mother was a social worker and, when she died, an associate professor in the School of Social Welfare at the State University of New York at Albany; and my dad was a mechanical engineer who served in the U.S. Air Force as a meteorologist and weather instructor and who, with a small group of friends, published *Tone* and *Marquee* magazines, where he served in a number of

positions, including executive editor. (An interview with James Baldwin titled "Is A Raisin in the Sun a Lemon in the Dark?" that was originally published in *Tone* in April 1961 was reprinted in *James Baldwin: The Cross of Redemption, Uncollected Writings* edited with an introduction by Randall Kenan, 2010.) We were both in the same fraternity (Alpha Phi Alpha), and since he was born and raised in Chicago, I learned a great deal from him concerning street sense and culturally navigating the city.

Champaign was my home-away-from-home, where I lived until I was three and later spent many summers and holidays. I was there enough that some people think I grew up there. Aunt Ruth and Uncle Frank served as surrogate grandparents on my mother's side. They lived on the segregated North End of Champaign, where Uncle Frank owned and operated Hendricks Auto Body Shop that was behind the house (he was also a specially appointed deputy sheriff and notary). Aunt Ruth worked in food service at the University of Illinois, where she

became the first African-American woman to head the large dining hall at the Illinois Street Residence Halls. She was church-going lady who could do a spot-on estimate for auto-body repairs and was the one who handled the money in the household.

Everybody spoke to each other, and if you didn't acknowledge someone (especially an older person) or took too long, people questioned what was wrong with you, who your folks were, and whether you had been "raised right." Uncle Frank's garage was a community hangout, so even at an early age I was exposed to people from all walks of life and spent a fair amount of time with the men who worked there, especially Brown, Slick, Jennings, and Smitty. Uncle Frank also had extensive mainstream business connections and friendships that required mutual respect. So I was exposed to the white community outside of the black North End, where my uncle frequented white businesses like Price Paint Store, Carr's Electronic Service, Mack's Auto Recycling, Twin City Junkyard, and numerous automotive-parts vendors not only in local towns, but neighboring states.

Riding through the countryside, we often stopped to see friends who were farmers, some whose property we hunted on in the fall. I used to ride my bike out on the old country roads, and there was a dairy-farming family with kids my age that I would visit. These varied socio-cultural and personal experiences during my formative years in Chicago and Champaign, visits to relatives in Springfield, and family road-trips, provided the background for my time as a student and my work as a photographer, where I utilize my academic interests and street awareness.

RAS: *You had the opportunity in a segregated community to watch your uncle interact in both white and African-American contexts and see that process happening in front of you. What did you learn and observe?*

SM: Because there is a wide range of skin tones in my family, at an early age I became aware of the biases regarding color and race (including within the black community). Uncle Frank was a short, powerfully built, cigar-smoking, dark-skinned black man who carried himself with a great deal of pride and confidence. Aunt Ruth, by comparison, was tall, good-looking, and light-skinned enough to pass.

There are different cultural codes: How you talked and carried yourself around the black community was different from how you carried yourself downtown and around white businesses. In order to navigate back and forth through both black and mainstream culture, you code switched while always remembering that you represented your family and the black community.

Although my uncle was very fluid in his relationships, I also understood that not everyone was able to do this. There was big difference in mainstream interactions between how we, as African Americans, can be treated as individuals where exceptions were allowed versus group encounters, even with the same people. Reading the situation was important, and maintaining the right balance was required. I learned the importance of building rapport with people and projecting your own individual sense of self.

Champaign and Chicago are a lot more Southern in attitude than most people realize. I heard the many

stories about black life and issues concerning race in the South. One of those was about one of my mother's brothers, who was killed in Helena, Arkansas, because of his alleged relationship with his white boss's daughter.

As a black American, I have had to learn the depth and context of what it meant when someone suggests that I need to "know my place" and the importance of reading what other people think they see when they look at me. I have also had to anticipate how much their preconceived view of me is based on the historical baggage associated with race. But, more importantly, I learned not to be content or limited by those stereotypes, assumptions, and systemic limitations. Forgetting who and where you are can be dangerous, and, yes, there are not only regional differences, but they can change from one neighborhood to the next. In Chicago (one of the most segregated cities in the nation), crossing a major street or going under a viaduct can transport you to a very different world. When I was in high school, I still remember my mother giving me "the going South" lecture before going to a family wedding in Helena, Arkansas, but by then it was just a reminder. I always stop to think about where I am going on each trip, especially when I travel south of the Mason-Dixon line, even today. It's kind of sobering to realize that growing up I was taught not only how to live with racism but how to "make a way out of no way" by navigating through it and finding a way to succeed in spite of it.

RAS: *You've mentioned the significance of car travels. Can you talk a little bit more about the role of the car?*

SM: For my Uncle Frank, who was raised in Columbia, Mississippi, it was the norm for kids to be taught to drive a car, operate farming equipment and to hunt and fish, so it was part of my early education, too. I was raised as a car-and-train kid moving back and forth between Chicago and Champaign; plane travel wasn't significant until my college years. Road trips were a family ritual, and as an adult, longevity behind the wheel was a rite of passage. When it came time to pick up car parts from another town, by the time I was twelve-years old, Uncle Frank often moved over to the passenger side and allowed me to drive his Cadillac on the highway, sometimes as he took a nap.

Of course, cars had a different significance to African Americans. I think it is underestimated how important the car is historically in black culture, during the migration north from the South and traveling back and forth, especially during the Jim Crow era. You could be run off your property (farm, house, or business) at any time, but a big car in good condition could move a family, and a large-capacity gas tank could carry you far enough to get to a gas station that would safely provide service. *The Green Book* [*Negro Motorist* by Victor Hugo Green], published from 1936–1966, identified businesses that welcomed black travelers.

RAS: *To what do you attribute your awareness and close attention to race and all these things that were happening around you? Lots of kids could be put in the same situations, but you were watching, listening, and learning from all of those interactions in ways that maybe another kid may not have been so acutely aware of what was going on.*

SM: To some extent, everybody had to be aware of what was going on, but I was raised as an only kid, so I was used to being around adults, without the distraction of siblings. Also, I came of age earlier enough to have experienced segregation but sheltered enough not to have been crushed by it, and I witnessed major changes in the country regarding civil rights.

I am old enough that one of the family stories was how my mother, after taking one look at the "colored only" restroom (separate, but not equal), marched pass the "white only" sign to change my diaper in a restroom in Tallahassee, Florida. I also witnessed "white flight" in Chicago, where whole blocks displayed "For Sale" signs like they were block-club holiday decorations. If memory serves me correctly, my neighborhood, Marynook, went from predominately white to almost all black in less than three years.

According to my dad, after attending the World's Fair in New York (1964), we were the first black family to check into the Howard Johnson's motel, across the street from today's Watergate Hotel in Washington, D.C., after the passage of the Civil Rights Act of 1964. On the way to the World's Fair in Montreal (1967) with my parents, I remember when my dad instructed us to keep our heads down as he drove through a burning Detroit riot.

I have had numerous life experiences in the communities where I have lived, schools I attended, summer camps, and activities, including running track. In college (at Pomona) I became a six-time small-college All-American hurdler and sprinter (NCAA Division III and the NAIA, where in 1976 I came in second place in the 110-meter high hurdles). I also played darts for two of the best teams in Chicago and represented Champaign-Urbana in its monthly matches against Decatur and Bloomington-Normal. Dart players are one of the warmest crowds possible (once they get to know you), but, being one of the few black players in Chicago during the 1980s when it came to "one-upmanship" in competition, racial taunts to throw your game off were common, not to mention the occasional rude comments from the bar crowd at an away game. Developing a different sense of humor and tuning out the nonsense, among other strategies, have greatly helped me out on the streets, especially as a photographer.

RAS: *How did you become a photographer?*

SM: Initially against parental advice, although my parents soon became my strongest possible supporters. Of course, initially they were just concerned about my future and if this was a career I would really commit to.

Ira, one of my closest friends, is a cartoonist and graphic designer who I have known since I was eleven. He was the only person who wasn't surprised when I committed to photography in college. His words were: "You've been a photographer as long as I've known you. It's about time you learned to use a camera."

I was a curious kid, and one babysitter quit because I asked too many questions. I also loved "show and tell" at school, so my experiences have always been important. Photography is a medium that allows me to share my interpretations of those experiences, and I come from a generation that loved to go outside, unlike today when being sent outside is a form of media-deprivation punishment.

I had a year of photography at the University of Chicago Laboratory High School with Robert Erickson.

During my first two years at Pomona College, I couldn't get into a photo class because I wasn't an art major or an upperclassman (so I missed my chance to study with Lewis Baltz). As a junior psychology major with only two classes, a thesis, and comprehensive exams left, I was finally able to enroll in a Photography I class with Leland Rice. After about five weeks, I had committed myself to photography.

I never finished the psych major, but I continued to run track, graduated on time as a Practice Art major, and headed off to grad school at Tyler School of Art (Temple University) in Philadelphia, where I studied with Will Larson and Michael Becotte. Fresh out of grad school, I was hired at Columbia College Chicago, where I taught (in the photo department) for twenty years. I joined the art department at Arizona State University in 1998, and I have been in Tempe ever since.

RAS: *Are there key experiences from your early career or student days that you remember as formative?*

SM: Where I went to school was very important to me not only academically, but geographically. Being from a car culture family, I made a pact with myself that I wouldn't go to school within 500 miles of home. But when a college catalog arrived from the University of Hawaii, my dad put his foot down and said, "Continental U.S. only." We had a good laugh, because he knew that I had ordered the catalog to make going to school in California—and Pomona College—the compromise.

Studying with Leland Rice was pivotal. He didn't treat me like a student but as a younger photographer who was hungry to make up for lost time now that I knew what I wanted to do. Leland and I still stay in touch. Of course, there's more to the story—about how what I learned in psychology, my accomplishments on the track, joining my dad's fraternity, and numerous road trips made such an impact on my life as a photographer.

Moving back to Chicago in 1978 and securing a teaching position at Columbia College Chicago was significant. Although I never planned to return home for more than a visit, being in a city and teaching at a college that embraced documentary photography was critical. This was especially true after going to school on the West Coast (Pomona College) and East Coast (Tyler School of Art at Temple University). Being on the two coasts provided me with an interesting hindsight-view of my formative years in Chicago and Champaign, and my return to Illinois provided me with an incredible opportunity to explore such insight in my own work. This included participating in the *Changing Chicago* and *City 2000* documentary projects.

RAS: *Let's capture the range of your projects.*

SM: *American/True Colors* is the fourth book I have published. The first three are: *Urban Notions* (1983), a study of the Illinois triangle (Chicago, Champaign, and Springfield), where I had family ties; *The Black Trans-Atlantic Experience: Street Life and Culture in Ghana, Jamaica, England, and the United States* (1992); and *Passage on the Underground Railroad* (2009). Between the book projects, I've also created digital montages relocating pre-1935 Black Americana postcards and trade cards, documenting historic African-American sites, figures, and commemorative events, "Soul Searching," my heavily patterned

self-portrait and extended-family album series; and a few public-art commissions, including works for the Chicago Transit Authority, Chicago Public Library, and two Jamestown Community College campuses in western New York.

I was part of three documentary projects that resulted in book publications and/or exhibitions: *Changing Chicago: A Photodocumentary* (1989), for which a group of thirty-three photographers documented the region for one-year period during 1987–1988; *City 2000* (2006); and the *America 24/7* project (one week in 2004), in which my work was featured in the state volume *Arizona 24/7* (2004).

As a student (at Pomona and Tyler), a few of my projects included photographing commercial and industrial landscapes at night (with a medium format on tripod, with exposures from fifteen seconds to one hour, taking into account reciprocity failure) and multiple-image flash 3D self-portraits, which were displayed in Wheatstone stereoscopic viewers, that I built. (The 3D self-portrait work was exhibited at Arizona State University in 1978, when I was a guest artist for Black Culture Week, while still a grad student at Tyler.)

RAS: *Can you explain your Underground Railroad project?*

SM: The history of the Underground Railroad (UGRR) and slavery is much more expansive and complex than what I had been taught. Most often people think of it as the routes that escaping slaves (enslaved people) took from various locations in the South to get to freedom in the North, aided by abolitionists, especially after the 1850 Fugitive Slave Act, which forced Northerners to help return slaves to the South. But it was more complex than that: Not to downplay the South's involvement, it has to be remembered that all thirteen original colonies had

slavery, and the Northern states had different policies for freeing the enslaved. (In the state of New York, manumission wasn't complete until 1827.) So I researched the different routes to freedom, which at different points in this country's history led to Canada, the Caribbean Islands, Central America, Europe, and areas of the United States that were then British, French, Spanish, Mexican, and Indigenous territories.

RAS: *Describe the look of the UGRR work.*

SM: There were two types of images in both the exhibition and the book, *Passage on the Underground Railroad*: composites (from 10" x 45" up to 18" x 81") that described individual UGRR sites and digital montages (from 9" x 26" up to 18" x 52") that incorporated historic sites that included safe houses, hideaways and freedom destinations, plantations with slave quarters, along with relevant documents and artifacts in order to provide an overview of the institution of slavery and context for the UGRR sites.

RAS: *Why did you choose the panoramic frame? Had you already been working with panoramas?*

SM: Although I own a panoramic camera, I still haven't done much with the photographs made with it. But, during an artist residency at CEPA Gallery in Buffalo (where the UGRR project began), I worked on a bus exhibition project where I was asked to create 9" x 26" digital montages that would fit in the space above the seats on public buses, a space usually used for advertisements. After that work became part of the gallery's series of exhibitions, "Paradise in Search of a Future," I have continued to work with that panoramic image ratio.

RAS: *Were you already collecting Black Americana and materials when you started the UGRR project?*

SM: Yes, to some extent. For years I have collected photographic stereo cards and "instant relative" portrait photographs, especially for my "Soul Searching" series, along with other odd curios. For the UGRR project, initially I only used materials found on location at UGRR sites, private collections, library archives, and history museum archives like the Avery Center in Charleston, South Carolina, which allowed me to photograph its Charleston slave tags and other significant artifacts.

Once I became more familiar with these items, I started to recognize them in antique stores. To make another long story shorter, I made the mistake of buying my first slavery document, and I unintentionally became a collector myself. While working on the UGRR project, I began to actively collect Black Americana, which has evolved into another digital montage series. Nowadays, as I travel around the country, I regularly "check my traps" (as my Uncle Jerry used to say) at the antique stores, especially looking for pre-1935 Black Americana postcards and trade cards for future digital montages.

RAS: *What was your goal with the UGRR photo montages?*

SM: Visiting the historic sites, for me, was always profound. Other books on the UGRR usually had photographs that showed the front of the houses like real estate for sale, with a few images that showed interior details of hideaway spaces. I wanted to create images that provided a more complete interpretation of each site inside and out, revealing its story as close as possible to what I had seen and learned. I also began to combine these views with those of commemorative events and relevant documents and artifacts, especially pulling together primary-source materials, which were sometimes located in different parts of the country.

RAS: *How did this work evolve beyond the UGRR project?*

SM: While I was finishing up the work on the UGRR, people mentioned other historic figures and events in their areas. I found myself going back to the same places but for different reasons. For example, in Ripley, Ohio, I was told about Colonel Charles Young, one of three black men who graduated from West Point in the nineteenth century. How does the saying go: "You have to be prepared to accept a gift?"

I wasn't ready until my friend, UGRR historian and collector Jerry Gore, took me to an old plantation in Mays Lick, Kentucky, not far from Maysville, the Mason County seat on the Ohio River. Behind the big house were the slave quarters, a two-story structure where Colonel Charles Young was born enslaved in 1864. The Young family ran away, across the Ohio River to Ripley, where they became close friends with John Parker, the black Underground Railroad conductor who ran a foundry and held at least one patent for a tobacco press. John Parker became a mentor to Colonel Young, shared his library, and helped prepare him for West Point.

Needless to say, this was the beginning of me following the long trail of Colonel Young. I created a series of montages about his life, which led me to his grave in Arlington National Cemetery for his ninetieth reinterment ceremony; his home (previously an UGRR site) near Wilberforce University (Ohio), where he taught military science; Sequoia National Park in California, where he

led the Buffalo Soldiers as they completed the roadway there; and to Fort Huachuca, Arizona, where he served and where there is a building named in his honor, which used to be the "colored" school on the base. This is just a brief piece of his story.

This led to further research, including more on the Buffalo Soldiers, the gold-mining Sugg family in Senora, California (William Sugg who bought his freedom in California), and James Beckwourth, the mountain man who discovered the route (Beckwourth Pass) to Marysville, California, that provided an alternative to the Donner Pass. Additionally, I documented milestone commemorations, including the fiftieth anniversaries of the Selma-to-Montgomery March and the Freedom Riders in Selma and Montgomery, Alabama; the fifty-fifth anniversary of the Little Rock Nine in Arkansas, the 150th anniversary of Juneteenth in Galveston, Texas, and the forty-fifth anniversary of the Black Panthers in Oakland, California.

There isn't just Black History but an under-told and sometimes denied American history. Without properly including the story of African Americans and other people of color, accounts of the history of the United States are, unfortunately and dangerously, inaccurate.

RAS: *Let's turn to the work for this project. How did you start making the street photographs found in this book?*

SM: Not only did I create montages from the black historic commemorations, but I also started to exhibit companion straight photographs from those events that became the foundation for the *American/True Colors* project.

Recognizing the significant changes happening in America, as a follow-up to my earlier project, *The Black Trans-Atlantic Experience*, I wanted to produce a photographic body of documentary work that provided an inclusive overview of America. Like other projects, I realized I had already started it, but there was no way to foresee how dramatic the changes would be, including how premature it was for some people to call this the "post-racial era."

The earliest photograph in the book was taken in 2007 (with then-Senator Barack Obama on the presidential campaign trail at Arizona State University). But the work became more recognized as a project and largely defined between 2011 and 2018, with the latest photographs made in early 2020, just before the country began its COVID-19 shutdown (March 16th), which restricted large gatherings. (During the week of March 7th, I was in the Houston area, and on March 12th I photographed the French Quarter in New Orleans.)

This is a critical, defining period in our country's history, spanning the presidencies of Obama and Trump: the two terms of the first African-American president, followed by an administration under Trump. We now are living in a turbulent period reminiscent of the 1950s and 1960s, in an extremely political atmosphere that has divided the country, where tribal fears and insecurities are being exploited. *American/True Colors* is a combination of celebrations, protests, and the everyday as rendered by the nation's shifting demographics.

RAS: *How are these photographs different from earlier bodies of work?*

SM: My earlier work alternated from straight photographs to experimental, from multiple exposures in the camera on film to digital composites that often addressed

black identity looking outward, at other times more personally. This work, *American/True Colors*, is comprised of photographs that document life beyond the black community, because I felt it is important to show African-American culture within an inclusive overview of American culture and to address the relationship between diverse communities and mainstream culture.

In *Urban Notions* and *The Black Trans-Atlantic Experience*, I used black-and-white film to make straight photographs, while *Passage on the Underground Railroad* was a digitally photographed and composited color project with an historical focus. *American/True Colors*, by comparison, is a more overtly political documentary project, where I photographed relevant commemorative events, festivals, protests, rallies, and everyday encounters. Many of the photos display and/or challenge ideas about mainstream patriotism and address collectively who we are as Americans.

RAS: *How do you decide what and where you will make photographs?*

SM: When I travel to other cities, I usually schedule my trips around large public gatherings (often on weekends), knowing that, on the other days throughout the week, I will encounter more everyday street life activity. These public events (from protests to parades) are sites of performance, participation, interaction, and dedicated attendance; spaces that encourage individual expression, special group interests, cultural homage, and support for socio-political issues; revealing and representing a wide range of who we are as Americans. For example, for the second of three trips to New York City, my advance research uncovered the Middle Passage Tribute to the Ancestors, the Puerto Rican Day Parade, and the Mermaid Parade and Festival. I had known about the Middle Passage event for years, so this was finally my chance to go. While in New York for this ten-day visit, I also discovered the Palestinian Rally in Times Square and "John Travolta Day" in Brooklyn, and I photographed extensively on the streets of Brooklyn and Manhattan. Throughout the project, I also made note of and sometimes visited the same cities or photographed comparable subjects to those found in the seminal American photographic surveys, especially Robert Frank's from the mid-1950s that resulted in *The Americans* (1959).

RAS: *What about photographing in Arizona?*

SM: Arizona is an interesting place to live. It's the forty-eighth state, culturally complex, and a political battleground state. Phoenix is now the nation's fifth-largest city and the largest city that is a state capital. As a result, many of the issues and events around the United States have their parallels in Arizona. National events like the Women's March, the Fourth of July parade, and the MLK March have happened here. Unfortunately, the national epidemic of African Americans killed by law enforcement under more than questionable circumstances—including Trayvon Martin in Stanford, Florida, in 2012; Michael Brown, Jr., in Ferguson, Missouri, in 2014; Freddie Gray in Baltimore in 2014; Eric Garner in New York City in 2014; Laquan McDonald in Chicago in 2014; Breonna Taylor in Louisville in 2020; Ahmaud Arbery in Brunswick, Georgia, in 2020; and George Floyd in Minneapolis in 2020—were mirrored in Phoenix with the loss of Rumain Brisbon in 2014 and Michelle Cusseaux in 2015, who are represented in this book.

When it comes to photographing protests and special events, even in the most contested situations, in my opinion Phoenix is the easiest large city to work in as a photographer. Since the Phoenix area doesn't have as active a street life as in cities like Chicago or New York, when I was at home I focused on public-space gatherings like parades, protests, rallies, and other special events, often looking more at what was happening around the events than the events themselves.

RAS: *When you're at an event or out in the world, how much are you looking for something specific to photograph versus how much are you responding to what's in front of you?*

SM: Both. If I already knew what I was looking for, it wouldn't be as challenging and rewarding. It's fun going to events I've been to before and enjoy enough to attend again. There is little or no pressure to photograph, because I don't need or expect to find something new, but when I do it's a wonderful thing.

Reading the mood on the streets is always a challenge, and that mood can quickly shift, especially when a camera is involved. The atmosphere, how a place feels, makes a big difference with regard to photographs I make. For this project, I focused on how an encounter represents American identity as a whole while also looking at the insights that different regions and cultural groups offer.

While reviewing and editing what I have already photographed, I am always looking to fill in the holes and editorial gaps in the work, identifying the places and events I felt needed to be included. If I am attending an event I already know something about, I may have an informal shooting script in mind or particular things to look for. The challenge is to not take the same

photographs but to find different ways and reasons to make images, to make sure that the images work in ways that are intended. (A good photograph may say the wrong thing and work against you.) Beyond that, it is a matter of responding to the situations and learning more about the context of those situations as I interact with those around me. Without the conversations, I would make photos and leave a place with only my preconceived ideas. It's important that I learn more about what I am photographing during the process. Besides, as you know, I enjoy talking.

RAS: *Yes, I do! About your identity as an African-American photographer, especially as it relates to your practice as a street photographer, how do you think your physical appearance plays into your role as a street photographer? Can you describe yourself? And when is how you look a hindrance and when is it a benefit? Or does it matter?*

SM: In my case, I definitely believe it matters that I am African American, because this country is still more race-conscious and biased than it is able to admit. It matters how you look, carry yourself, and where you are. Sometimes being black is an advantage, and other times it draws attention for all the wrong reasons. Anyway, on the streets, you have to play the cards you've been dealt.

Sometimes, I am personally accepted in a place, but carrying a camera is like bringing ~~in~~ a stranger. At other times, the camera is recognized as a mainstream instrument that provides my introduction. As a black man and a photographer, I know there are places where I'm not welcome and/or comfortable, but I often move forward and attempt to initiate conversation. Some of

my most meaningful and insightful encounters began this way. When faced with a challenging situation, how I responded made all the difference in the world. Each situation is different, and it's important to read other people's responses while being respectful and appropriately sociable, without being overly confident.

Describing myself: I am now (in 2020) a sixty-five-year-old African-American man with a semi-light skin tone and an Arizona tan, sharp featured, six feet tall, a thin build (not as thin as I used to be), a short gray ponytail (that used to be a brown Afro), and a salt-and-pepper mustache and goatee. In other words, I'm black. Like many African Americans, I don't know all the countries of my origin, but, in addition to the African, there is a little Irish. More than once I have been referred to as an "automatic search," including at a Custom Agents' party where six or seven officers each named two reasons why they would stop me. But that is another story that is too long for me to explain right now.

One of the first things I teach my students is this: Before they go out to photograph, they need to take a good look at themselves in the mirror. "Who will people think they are?" and "How will they respond to someone who looks and dresses like them, in that particular situation or community?" Also the type equipment a photographer carries makes a difference: a view camera with film versus DSLR, for example. Thinking about this in advance really helps to address the questions and challenges they may encounter as photographers, especially on the streets. To put it mildly, life on the street isn't always politically correct, and photographers have to be prepared for the unexpected, because people will often test you. Still, the positive things I've encountered far exceed the negative, and I look forward to what comes next.

RAS: *You are not a passive observer when photographing. Some photographers try to blend in to the background and observe, but that's not your M.O. Talk a bit more about how you work and how that style developed.*

SM: My experiences with people and places are more important than the photographs. Fortunately, the photographs are a byproduct I can share. If I don't make some kind of interaction, I feel like I wasn't really there, just passing through. As I've said, I learn a lot about what I'm photographing from the people around me. This doesn't mean that I talk to everyone, but it isn't unusual for me to quickly excuse myself to photograph something and return to continue an ongoing conversation. There are also times when I am photographing and moving too fast to personally connect, where I am responding to the flow of the situation. And there are photographs that have to be made without asking first and other photographs that can be made only after being given permission. Sometimes it's both, where I take a photograph or two, introduce myself and show them the digital images on the back of the camera, and then I am allowed to continue photographing. This is especially true when doing close-ups or detail shots. If someone doesn't want to be photographed, I leave them alone and wish them a good day. If I have already photographed someone and they are upset, I take the time to smooth over the situation by introducing myself and explaining what I am doing.

Bill Jay, who was an old friend and for a short time a colleague at ASU, said something that I always try to live by and pass on to my students: "Always leave a photographic situation so that it is as easy, if not easier, for another photographer to follow in your footsteps." I've

been at it long enough that, on several occasions, earlier interactions made it easier for me.

I realize and have been told that I'm not a photographer who just blends in, but I often find ways to connect with people and I also carry examples of my work (in a small flip book). It's surprising how much of a difference showing a few photographs can make, where people often follow-up by introducing me to other people or suggest other things that they think I might be interested in photographing.

It's not unusual for me to encounter people who look and/or think or act differently than I do. I greatly appreciate having been allowed to photograph what most people consider difficult situations for someone like me. Even at the South Carolina State Capitol, while photographing a KKK rally a week after the Confederate battle flag was lowered on Capitol grounds, I had an on-the-move banter going on with a couple of the Klan members, during both their entrance and exit. There have been numerous situations, where people who have significantly different perspectives from me have still interacted with me and/or allowed me to photograph. And, thanks to these "situational friends," I have a better understanding of where I was and what I was photographing.

RAS: *Are there key images for you in this body of work?*

SM: Yes, the first and last images are bookends: the man waving an American flag while riding in a convertible car at the Fourth of July parade in Flagstaff, Arizona (page 17), and the group posing for a selfie on the Edmund Pettus Bridge during the Fiftieth Anniversary "Bloody Sunday" commemoration in Selma, Alabama (page 299). For Bill Kouwenhoven, who wrote the introductory essay, the key photo is from the Bud Billiken Parade in Chicago (on page 184). In addition to photographs of specific events, there are reoccurring themes imbedded in the project, including flags and not just the American flag. They are symbolic references to our diversity, history, and culture. Without going into detail, other key photographs and facing-page pairs for me include:

President (then Senator) Barack Obama saluting the crowd in front of "CHANGE WE CAN BELIEVE IN" signs on Hayden Lawn at Arizona State University in Tempe, Arizona (page 293).

The KKK rally, looking over the shoulder of a black South Carolina State Trooper in Columbia, South Carolina (page 29).

Congressman John Lewis and James Zwerg shaking hands in Montgomery, Alabama (page 112).

"Hands up" marchers at the Dan Ryan Expressway in Chicago, Illinois (page 121).

The "Keep Families Together" rally, with a child standing next to the large family snapshot placard worn on his mother's back in Phoenix, Arizona (page 40).

A folkloric dancer in front of the Trump and Arpaio inflatables in Phoenix, Arizona (page 289).

An arrest at the protest to block Trump's arrival at his rally in Fountain Hills, Arizona (pages 39 and 41).

Governor Nikki Haley signing the bill to retire the Confederate battle flag (page 274) and the South Carolina Secretary of State holding the bill before handing it to Strom Thurman's black granddaughter (page 275), both in Columbia, South Carolina.

An Uncle Sam banner being carried by the "I Ain't Voting Until Black Lives Matter" protesters in Cleveland, Ohio and the modified Uncle Sam tattoo at Turf Paradise Racetrack in Phoenix, Arizona (pages 278 and 279).

A Navajo code talker riding in the parade car (page 77) and a bald eagle and handler riding on a parade float (page 76), both in Phoenix, Arizona.

RAS: *For me, this book is so much about flow, from one image to another, and the collective of all of these images. It's less about key images and what they do together.*

SM: I want the images be strong enough to stand on their own, but, more importantly, is the way they merge and come together to become a visual narrative.

RAS: *So what is the significance of the number of pictures (250) you include in the book?*

SM: First, it was important to me that the word "American" be in the title, not America or America's, thereby placing emphasis on people over place. Second, it was important to me that the book contain 250 photographs (excluding the five digital montages called *American Gumbo*). The number of photographs is a symbolic nod in advance recognition of America's 250th birthday (the Sestercentennial) in 2026. The challenge wasn't getting the number up to 250 but in editing down a large body of work to only 250 photographs and resolving the sequence.

There was a great deal of hype leading up to this country's bicentennial in 1976, the year I graduated from Pomona College, with a degree filled with red-white-and-blue patriotic graphics. Because of this, I was predisposed

to recognizing the milestones of the beginning of the twenty-first century, to be followed by America's upcoming 250th anniversary, which will also coincide with my fiftieth college reunion.

RAS: *What does it mean to see this group of pictures find expression in a publication?*

SM: It is important to me that my work is seen in exhibitions and publications, and, to some extent available, online. But books define the structure of the work, providing a way for the work to move around and allowing the work to have its own life and longevity. Flippantly, I like to say that I will do anything to get the work out of my house. With books, they stay away.

RAS: *You've talked to me about how you were drawn to other photographic surveys as this project developed. Do you want to mention those and their significance?*

SM: *American/True Colors* is, simultaneously, an homage, an update, and a hindsight critique and rebuttal of the canonized American surveys, from an African-American perspective that is both personally shaped and culturally informed. Although I appreciate the seminal American photo surveys of the past, they only partially show the America that is my lived experience. And I'm not only talking about race; my work is about trying to better understand and inclusively document the moods, cultural rhythms, and diversity of people throughout the country.

Of the numerous surveys, the most notable are the seminal projects of Walker Evans's *American Photographs* (1938) in the mid-1930s and Robert Frank's *The Americans* (1958 in France and 1959 in the United States)

in the mid-1950s. Most people don't know that Henri Cartier-Bresson also did an American road trip, with the intension of publishing a book about America in the 1940s, that would have bridged the gap between the projects of Evans and Frank. Cartier-Bresson was commissioned by *Harper's Bazaar* to make a portrait series of creative celebrities, and he traveled across the country with a writer, John Malcolm Brinnin, who dedicated a chapter ("Just Like Java") in his book, *Sextet* (1981), to their journey. It was during their trip that Cartier-Bresson made the photograph of the writer William Faulkner with his dogs at his home in Oxford, Mississippi, in 1947. The monograph didn't happen, but numerous photographs from the 1940s that were intended for the earlier publication appeared in Cartier-Bresson's book, *America in Passing* (1990).

Primarily straddling the 1960s and 1970s are the cumulative American publications of Garry Winogrand's work, including *Public Relations* (1977), *Women Are Beautiful* (1975), and the CCP's (Center for Creative Photography) posthumously produced *Winogrand 1964* (2002). While at Columbia College Chicago, I met Winogrand on a couple of occasions when he came to visit my old office partner, David Avison, and I attended one of his standing-room-only legendary lectures at a cathedral-size venue in Northwestern University's Thorne Hall.

Other influences? More than the American projects that feature many photographers with only a few photographers each, I am interested in the extended bodies of work by individual photographers. Other national documentary influences include the Farm Security Administration's (FSA) collective photographs by Walker Evans, Dorthea Lange, Russel Lee, Arthur Rothstein, Gordon Parks (as a Rosenwald fellow), and others; Mary

Ellen Mark's *American Odyssey* (1999); Leonard Freed's *Black in White America* (1968) and *World View* (2007); and the life-long work of Lee Friedlander, Bruce Davidson, Roland Freeman, and, primarily in New York, Helen Levitt and Roy DeCarava. More recent sources include: Eli Reed's *Black in America* (1997) and *Eli Reed: A Long Walk Home* (2015), Zoe Strauss's *America* (2008), and the work of Vivian Maier (primarily Chicago and New York City).

RAS: *How is your work different from these other surveys?*

SM: There are notable differences. Raised in the Midwest and now living in Arizona, I wasn't seeing America for the first time. I was a seasoned road traveler, trying to compare and contrast the America I was rediscovering with the memory of the country I already knew.

Robert Frank was Swiss and became a naturalized American citizen; Cartier-Bresson was French; Winogrand was raised in the Bronx and spent time in later life in Texas and California, but he was always a New Yorker at heart; and Evans spent his early years in the Midwest (born in St. Louis, Missouri, and raised in Toledo, Ohio, and the Chicago suburb of Kenilworth, Illinois), and his college years and adult life on the East Coast (New York, Massachusetts, and Connecticut).

According to family history (documents, photographs, and oral accounts) and additional historical research, members of my family experienced America differently than most previously accepted mainstream accounts recognize. Since the seminal works of Evans, Frank, Cartier-Bresson, and Winogrand, this country has greatly changed. My perspective of and relationship to this country is not the same as those photographers, and

how this country sees me isn't the same either. I could not have traveled to or photographed many of the people and places that they did during their times, due to the social and racial climate in this country. Even now, for someone like me, moving through America can still be a challenge.

Throughout my life I have crisscrossed the continental United States numerous times. When I returned to regions and cities, often several times during this project, I did so as a seasoned road traveler. I tried to compare and contrast the America that I already knew, with the current state of the nation. The seminal photographers were much younger when they documented America. I often joked that this was an AARP journey, and, unlike Evans, Frank, and Winogrand, my work was completed without significant outside funding. This project was pieced together from numerous trips made over approximately a twelve-year period of time. Frank's, by comparison, was two years.

Compared to the seminal American project photographers, due to life experiences and research as an African American (insider / outsider), I believe I am uniquely positioned and culturally informed about this country's history. I have an alternative take on its cultural baggage, the diversity and resilience of its people, and the reasons and strategies for maintaining hope in our two-steps-forward, one-step-back democratic society.

Of course, *American/True Colors* is also in color, utilizing digital technology, instead of black-and-white film. Starting off with film made it easy to shift to digital, because the ritual of film required an unforgiving awareness and control; that I carry over to digital. Color modernizes the project and brings another level of descriptive and emotive potential.

RAS: *With a project like this, how do you know when the body of work is complete?*

SM: In some ways, it will is never be finished; on the other hand, this is a significant intermediate point of closure that makes sense. After working on the project for twelve-plus years (from October 2007 to March 2020), it came to the point where the edited sequence seemed right; and although I have continued to photograph, it has become more and more difficult to edit out old photographs to replace them with new ones. Even with photographs that I liked, they just didn't fit. Over time, the narrative of the work developed its own character and personality.

From track and other sports I learned to trust the process after putting in the work. There are ways that the work can take on a presence beyond what is intended, and I try to recognize, learn from, and welcome this when it happens.

RAS: *What do you hope people will get from experiencing this group of pictures now? How do you imagine that takeaway will change over time?*

SM: This book is a time capsule, a record of this pivotal time in American history, straddling the presidencies of Barack Obama and Donald Trump: the time when Americans elected their first black president in 2008 and the radically different choice that was made in 2016. In the same way it is important that historians and other artists, scholars, writers, and activists offer their takes on significant historic figures, events, or periods of time, I would like for *American/True Colors* to be among the interpretations that

provide meaningful insight into who we are as Americans as we approach the nation's 250th birthday.

RAS: *How does this project reflect current issues related to racial identity in America? Was that a particular goal at the start?*

SM: Yes, it was intentional, but race was also imbedded in the project because race is imbedded in the foundation of America. And, as mentioned earlier, we are not living in a post-racial society. America is multi-ethnic, with a heterogeneous culture, like a stew or gumbo, but it's definitely not a smoothie. You can't address American identity without confronting race, unless it is avoided on purpose or someone is so sheltered they don't recognize it.

Since America has been my family's home for many generations, there is no going "back to where I came from," which has been suggested to me on more than one occasion. Beyond citizenship due to birthright, members of my family have, in numerous ways, earned the right for us be in this country. I am also part of the first generation in my family granted the freedom to pursue individual goals and careers without having to defer and sacrifice so much in life for the next generation. As a result, reevaluating American identity through an African-American perspective as a photographic artist is both a privilege and a responsibility.

Like earlier generations, I have seen a great deal of progress, but sometimes that progress seems fragile, tentative, and too often temporary. I know that I won't see the issues of race and equality fully resolved in this country. But, then again, I never thought I would live to see a black president either.

America holds a great deal of promise, but in order for it to live up to its ideals and potential, it will have to take acknowledge the impact that its history continues to hold. This conundrum of coexistence will require us as a people to reevaluate ourselves and recognize and ideally embrace (or at least tolerate) in each other the diversity of who we are as Americans.

Coda

COVID-19 broke America out of its everyday rhythm, making it possible for more of us to realize some of the things that have always been part of this society. It has accelerated our reliance on social media to stay in touch. But it has also drawn attention to the value of face-to-face interactions, physical mobility, and the need and desire to travel (temporarily high-risk) as indispensable freedoms and humanistic needs that we have somehow begun to take for granted. Apparently, we need each other, and we need to be there in person. More than many people thought, social distancing and isolation greatly affect our mental well-being. It has become even more evident how important public-space gatherings, special events, and holidays are as cultural revivals and manifestations of national identity.

The double pandemics of COVID-19 and systemic racism have been wake-up calls that have shown not only how small this country is as a village, but how interconnected the world is. These events have served as reminders of how politically divided we are in the United States but also how a more diverse, younger generation is ready to effect change. But moving beyond the moments and symbolic gestures, there's still a lot of work that remains to be done, without forgetting the conflicted history of America.

There is a difference between changing laws and changing hearts and minds. Changing laws can be accomplished through protest, the vote, and working inside the system; changing hearts and minds requires conversation, building trust and rapport, and developing mutual empathy. Although these events are currently significant and overwhelming, only time will tell how much of a lasting impact they will really make on the unfinished business of this nation.

One thing I believe most of us can agree on: We Americans can do better! And, at this time, it seems most appropriate to end by honoring John Lewis with his own words:

> When we seek justice, we must come to that point to realize in the final analysis we are one people, we are one family, one house—the American house—and we all live in that house.*

*John Lewis, interview with Mariana Cook (n.d.); online at www.cookstudio.com/gallery/justice.

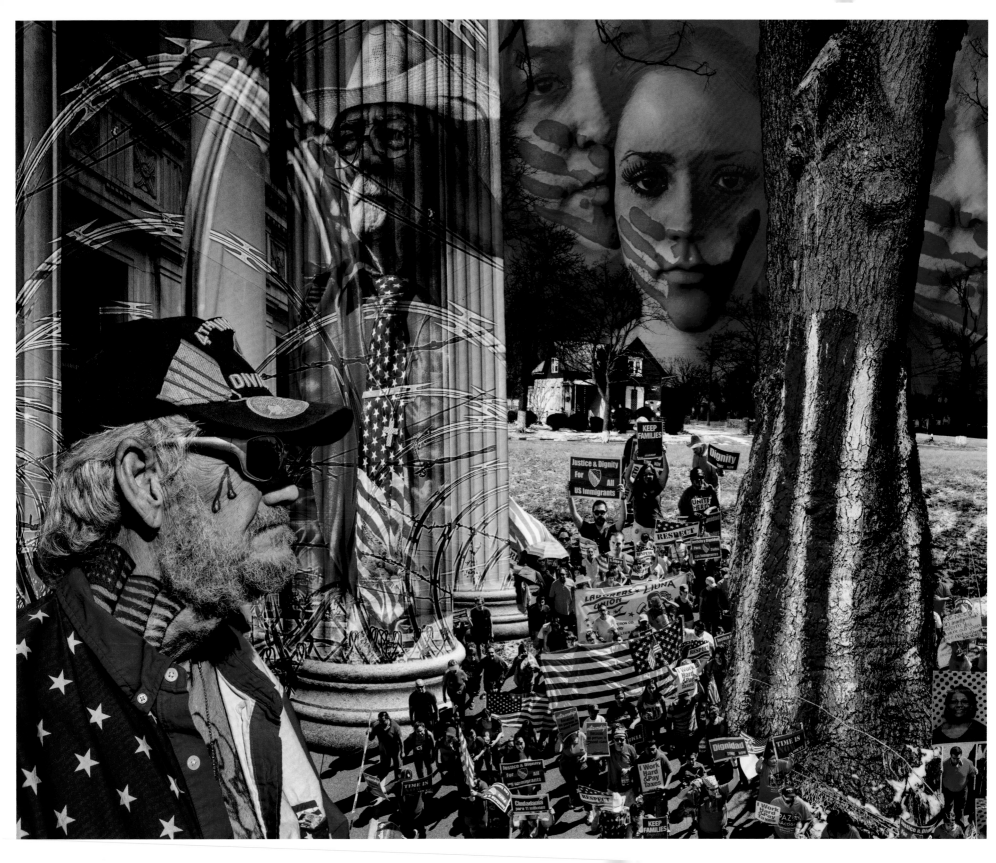

Notes on the Photographs

2 *American Gumbo.* Photographs from 2013–2018 were used to create this digital montage from locations in Chicago, IL, Phoenix, AZ, and Tempe, AZ (2019).

8 *American Gumbo.* Photographs from 2020 were used to create this digital montage from locations in Phoenix, AZ, Baton Rouge, LA, Galveston, TX, and New Orleans, LA (2020).

17 Patriotic cheer at the Fourth of July Parade (Independence Day). (Flagstaff, AZ, 2013.)

18 An Arizona Black Rodeo flag bearer holding the Pan-African liberation (Black Liberation) flag at the Rawhide Rodeo Arena at Wild Horse Pass. (Chandler, AZ, 2013.)

19 Veterans folding an American flag before the 231st Bristol Fourth of July Parade, the oldest Fourth of July parade in the United States. (Bristol, RI, 2016.)

21 Stars haircut at the Super Sunday Parade celebrating Mardi Gras Indian culture. (New Orleans, LA, 2015.)

22 A protestor draped in an American flag during the "Stop Trump" rally and march outside of the Republican National Convention. (Cleveland, OH, 2016.)

23 Veterans Day Parade featuring Miss World America. (Phoenix, AZ, 2015.)

24/ An immigration march to the local ICE (U.S. Immi-
25 gration and Customs Enforcement) office, protesting against the deportation and separation of families. (Phoenix, AZ, 2013.)

26 A Second Amendment supporter holds a *State of Arizona* "Bite Me" flag while counter-protesting the March for Our Lives rally at the Arizona State Capitol. (Phoenix, AZ, 2018.)

27 Head bowed to show a "Southern Bred" Confederate flag hat, in front the South Carolina State Capitol. (Columbia, SC, 2015.)

29 One week after the Confederate battle flag was removed from the north side of the South Carolina State Capitol grounds, a State Trooper stands guard at a Ku Klux Klan rally on the south-side stairway of the Capital. The KKK banner, illustrating a burning cross and white-robed figures, identifies them as "The Original Boys N The Hood." There was a moratorium on wearing hoods and robes and carrying weapons for the event. (Columbia, SC, 2015.)

30 A shrine in front of the Emanuel AME Church recognizes the hate-crime massacre, which claimed the lives of nine members. (Charleston, SC, 2015.)

31 The end of the City Hall protest for Michelle Cusseaux, a fifty-year-old mentally ill black woman who was shot and killed by a Phoenix police officer. (Phoenix, AZ, 2014.)

32 A family member at an informal memorial gathering for Rakin J. Vineyard, a twenty-two-year-old gunshot victim. (Champaign, IL, 2014.)

33 The sidewalk shrine for Rakin J. Vineyard, marking the site where he was killed two days earlier. (Champaign, IL, 2014.)

35 Hebrew Israelites preaching at an Occupy Wall Street rally. (Phoenix, AZ, 2011.)

36 Ceremonial dancers during the day-long boardwalk celebration at the People of the Sun Tribute to the Ancestors of the Middle Passage event on the Coney Island boardwalk before the evening procession and water's edge rituals, with people facing ancestral homeland of Africa across the Atlantic Ocean. (Brooklyn, NY, 2018.)

37 The "March against Gun Violence" where protesters blocked the Dan Ryan Expressway. The posters and a T-shirt portray images of Matthew Rogers, who was killed by gunfire. (Chicago, IL, 2018.)

38 Protesting against the deportation and separation of families at an immigration rally. (Phoenix, AZ, 2013.)

39 A protester being arrested for locking herself to the doorframe of her van, that was used to block the Shea Boulevard route to a Trump Rally. She is being restrained by police, while an approaching officer equipped with bolt cutters prepares to remove the U-lock fastened around her neck. (Fountain Hills, AZ, 2016.)

40 People gathering at an immigration rally and the march to the local ICE office to protest the deportation and separation of families. (Phoenix, AZ, 2013.)

41 The arrest of one of the three protesters who blocked the Shea Boulevard route to a Trump Rally. (Fountain Hills, AZ, 2016.)

42 Spectators at the Mexican Independence Day Parade in front of the "Raza Adelante" mural by John Zender Estrada. (East Los Angeles, CA, 2018.)

43 Reenactors at the Mexican Independence Day ceremony. (East Los Angeles, CA, 2018.)

45 "Obrewercare" protesters at Governor Brewer's Medicaid expansion rally. (Phoenix, AZ, 2013.)

46 Anti-Islam rally in front of the Islamic Community Center. (Phoenix, AZ, 2015.)

47 Jon Ritzheimer displaying his "HARD KNOCK LIFE" American flag tattoo. He was the head of the anti-Islam rally in front of the Islamic Community Center (and later played a significant role in the anti-government armed occupation of Malheur National Wildlife Refuge in Oregon. (Phoenix, AZ, 2015.)

48 Reenactors (Spanish and black soldiers along with Yamasee Indians) who defeated the British at the commemoration of the 272nd anniversary of the Battle of Bloody Mose, Fort Mose Historical State Park. (St. Augustine, FL, 2012.)

49 Veterans at the opening ceremony for Evel Knievel Days. (Butte, MT, 2017.)

50 H. K. Edgerton, a Southern heritage activist and member of the Sons of Confederate Veterans, debating with the crowd to defend the display of the Confederate battle flag on the SC Capitol Grounds. (Columbia, SC, 2015.)

51 Reenactor as Union Army Major General Gordon Granger, waiting to go out on the Ashton Villa balcony for the ceremonial reading of General Order Number 3 that freed the enslaved on the 150th anniversary of Juneteenth. The actual historic site was in downtown Galveston at 22nd Street and The Strand (now a parking lot), where, on June 19, 1865, Texas became the last Confederate state to grant freedom to blacks. (Galveston, TX, 2015.)

52 A reenactor showing off the details on an antique shotgun at the 36th Annual Wyatt Earp Days. (Tombstone, AZ, 2016.)

53 A reenactor standing next to a wooden "cigar-store Indian" during Wyatt Earp Days. (Tombstone, AZ, 2016.)

54 At the Arizona Black Rodeo, a bull rider is preparing in the bucking chute. (Chandler, AZ, 2017.)

55 A bull with rider storming out of the chute at the Arizona Black Rodeo. (Chandler, AZ, 2017.)

56 Cowboys gather after the Jubilee Days Parade during the White Center Community Festival. (Seattle, WA, 2017.)

57 Conversation at the Indian Village during *Cheyenne Frontier Days*. (Cheyenne, WY, 2017.)

58 Officers of the Los Angeles Police Department's mounted platoon on duty. (Los Angeles, CA, 2016.)

59 Navajo Lodge neon sign on display in an antique store. (Prescott, AZ, 2013.)

61 Marilyn Manson tattoo being flashed at the Venice Beach Skatepark. (Los Angeles, CA, 2018.)

62 Swimmers at Promontory Point on Lake Michigan. (Chicago, IL, 2016.)

63 Staging area for the 37th Annual Mermaid Parade at Coney Island. (Brooklyn, NY, 2018.)

64 The Big Float 7 on the Willamette River. (Portland, OR, 2017.)

65 Venice Beach. (Los Angeles, CA, 2018.)

66 Canoes and kayaks on one of Belle Isle's interior lakes. (Detroit, MI, 2016.)

67 First annual MaskAlive! Festival of Masks in Pioneer Park, hosted by master mask and puppet maker, Zarco Guerrero. (Mesa, AZ, 2018.)

68 The weathered and partially demolished Pilsen mural, "Familiar," by Jeff Zimmerman on Ashland Avenue. (Chicago, IL, 2013.)

69 A family walking on the South Side's 47th Street. (Chicago, IL, 2013.)

70 Street scene in the downtown Loop. (Chicago, IL, 2016.)

71 The "Pharaoh's Fury" ride at a traveling community carnival. (Providence, RI, 2013.)

72 A pickup basketball game on Venice Beach. (Los Angeles, CA, 2018.)

73 An exit ritual at Venice Beach Skatepark. (Los Angeles, CA, 2018.)

74 Hanging out on South Beach's Ocean Drive. (Miami Beach, FL, 2017.)

75 Warming up at the 3rd annual Muscle Beach Calisthenics Jam on Venice Beach. (Los Angeles, CA, 2018.)

76 An American bald eagle on display at the Veterans Day Parade. (Phoenix, AZ, 2014.)

77 Samuel T. Holiday, one of the last surviving World War II Navajo Code Talkers (Marine Corps), waving to the crowd at the Veterans Day Parade. (Phoenix, AZ, 2015.)

78 A participant at the commemoration of the 272nd anniversary of the Battle of Bloody Mose, Fort Mose Historical State Park. (St. Augustine, FL, 2012.)

79 Dancers in traditional Aztec attire conducting a smoke-purification ritual during a protest of Trump's immigration policy, across the street from his rally at the Phoenix Convention Center. (Phoenix, AZ, 2016.)

81 On the campus of Arizona State University. (Tempe, AZ, 2017.)

82 Hanging out on the ocean boardwalk. (Wildwood, NJ, 2014.)

83 A street vendor's stocking display. (Brooklyn, NY, 2018.)

84 At the Atlanta Hip Hop Festival in downtown Woodruff Park. (Atlanta, GA, 2018.)

85 Participants at the Big Float 7 on the Willamette River. (Portland, OR, 2017.)

87 Patriotic runners at the twelfth annual Pat's Run, honoring the legacy of Pat Tillman. He was a professional football player who gave up his NFL career to enlist after the September 11th attacks. Tillman became an Army Ranger and was killed in Afghanistan by friendly fire in 2004. (Tempe, AZ, 2016.)

88 A Frederick Douglass reenactor in the Fourth of July Parade. (Flagstaff, AZ, 2015.)

111 An immense crowd gathering on the Edmund Pettus Bridge for the Fiftieth Anniversary Commemoration of the Selma-to-Montgomery March. This bridge was the symbolic historic site for three marches: the "Bloody Sunday" March (March 7, 1965) that was derailed by law-enforcement violence (where Congressman John Lewis was severely beaten); "Turnaround March," led by Dr. Martin Luther King, Jr. (March 9th); and the successfully completed Selma-to-Montgomery March (March 21–24) that led to the passage of the 1965 Voting Rights Act. This was a three-day weekend anniversary event, followed a small group that completed the journey to Montgomery, reenacting of the final four-day march. (Selma, AL, 2015.)

112 The greeting of Congressman John Lewis (left) and James Zwerg (right), survivors of the Greyhound Bus Station assault, Freedom Riders Fiftieth Anniversary commemoration. (Montgomery, AL, 2011.)

113 Reverend William Barber II (left) leading his group across the Edmund Pettus Bridge during the Fiftieth Anniversary Commemoration of the "Bloody Sunday" and Selma-to-Montgomery March. (Selma, AL, 2015.)

114 Visitors at the Dr. Martin Luther King, Jr. Memorial. (Washington, DC, 2011.)

115 A man carrying an oval portrait of Dr. Martin Luther King, Jr. at the end of the MLK Day March. (Phoenix, AZ, 2013.)

117 Activist Eric Russell leading a group during the March Against Gun Violence on the way to the Dan Ryan Expressway. (Chicago, IL, 2018.)

118 March for our Lives AZ (#Never Again) on the Arizona Capitol grounds. This was part of a nationwide, student-led anti-gun demonstration following the 2018 mass shooting at the Marjory Stoneman Douglas High School in Parkland. (Florida, Phoenix, AZ, 2018.)

119 A gathering at 63rd Street Beach on the first anniversary of Geno's passing. (Chicago, IL, 2016.)

123 Protesters on the Dan Ryan Expressway during the March against Gun Violence. (Chicago, IL, 2018.)

124 Rush-hour pedestrians in the downtown Loop. (Chicago, IL, 2018.)

125 Riding in the annual parade from Selma High School to downtown during the Fiftieth Anniversary of the Selma-to-Montgomery March. (Selma, AL, 2015.)

127 Standing on the Brooklyn Bridge. (New York City, NY, 2018.)

121 "Hands up, don't shoot" gesture at the March Against Gun Violence protest on the Dan Ryan Expressway. (Chicago, IL, 2018.)

122 Protestors in the March against Gun Violence that blocked the South Side's Dan Ryan Expressway. The march was led by Reverend Jesse Jackson and Father Michael Pfleger (shown conversing with Jackson, who is wearing a yellow helmet). (Chicago, IL, 2018.)

128 Visitors at "the Bean" (officially known as Cloud Gate) in Millennium Park. (Chicago, IL, 2018.)

190 Waiting for theater tickets in Times Square. (New York City, NY, 2018.)

191 Faneuil Hall Marketplace (also known as Quincy Marketplace). (Boston, MA, 2016.)

192 "Pigeon man" at Santa Monica Pier. (Santa Monica, CA, 2018.)

193 On the Venice Beach Boardwalk. (Los Angeles, CA, 2018.)

194 Storefront mannequins. (Providence, RI, 2013.)

195 South Street. (Philadelphia, PA, 2017.)

196 Keeping warm in the staging area for the CHIditarod, where costumed groups race shopping carts from bar to bar. (Chicago, IL, 2019.)

197 Visitors to The Strand Historic District. (Galveston, TX, 2015.)

198 A wedding party outside of Faneuil Hall. (Boston, MA, 2017.)

199 A wedding party in front of the James Scott Memorial Fountain, Belle Isle. (Detroit, MI, 2016.)

200 Congresswoman Shelia Jackson Lee (shown from behind) being hugged at the *150th* anniversary celebration of *Juneteenth*. (Galveston, TX, 2015.)

201 A couple walking arm-in-arm along the 16th Street Mall. (Denver, CO, 2017.)

203 A man entering a Metro Subway station near City Hall. (New York City, NY, 2018.)

204 A rainy day in Times Square. (New York City, NY, 2018.)

205 A couple sharing an umbrella on a nor'easter night. (Philadelphia, PA, 2018.)

206
207 Reenactors in Central Park during HB Civil War Days. (Huntington Beach, CA, 2018.)

208 A shooting gallery on Allen Street during Wyatt Earp Days, only a couple of blocks away from the site of the 1881 shootout at the O.K. Corral. (Tombstone, AZ, 2016).

209 Cyclists riding through steam rising from the sewers. (Detroit, MI, 2014.)

210 Freestyle motocross (FMX) riders performing during Evel Knievel Days. (Butte, MT, 2017.)

211 Playground near the shore of Lake Michigan, with the cooling tower of a coal and natural gas-fired power plant looming in the background. (Michigan City, IN, 2016.)

212 Jesse White Tumblers performing at the Bud Billiken Parade.(Chicago, IL, 2013.)

213 Dragon dancers rehearsing just before the Chinatown Seafair Parade. (Seattle, WA, 2017.)

214 Walking the streets of Manhattan. (New York City, NY, 2018.)

215 A man in a 49ers jacket running past the "In Progress" Chinatown mural by Mel Waters. (San Francisco, CA, 2016.)

216 A boa constrictor being displayed on the boardwalk. (Wildwood, NJ, 2014.)

217 A father tossing his daughter in the air before the start of the Ahwatukee Easter Parade. (Phoenix, AZ, 2017.)

246 An Indigenous women's rally on the way back to the Arizona Capitol during the Women's March to the Polls event. (Phoenix, AZ, 2018.)

247 The RISE Against Climate Capitalism rally, prior to the Global Climate Action Summit, hosted by Indigenous Bloc at RISE Days of Action. (San Francisco, CA, 2018.)

249 A Palestinian rally on the International Day of Quds, in Times Square before a march to the Israeli Consulate. (New York City, NY, 2018.)

250 A street preacher in Times Square. (New York City, NY, 2018.)

251 Pro-life activists sit outside of Daley Plaza. (Chicago, IL, 2018.)

253 Marchers carrying SCLC (Southern Christian Leadership Conference) "Black Life Matters" placards at the Fiftieth Anniversary Bridge Crossing Commemoration of the "Bloody Sunday" Selma-to-Montgomery March, at the foot of the Edmund Pettus Bridge. (Selma, AL, 2015.)

254 Two days before the main event, there was a School Children's Bridge Crossing March on the Edmund Pettus Bridge as part of the Fiftieth Anniversary Commemoration of the "Bloody Sunday" Selma-to-Montgomery March. (Selma, AL, 2015.)

255 A vendor's booth at the Forty-Fifth Anniversary of the Black Panther Party celebration held in De Fremery Park, unofficially known in the community as Lil' Bobby Hutton Memorial Park. (Oakland, CA, 2011.)

256 A protest march in memory of Rumain Brisbon (age twenty-two, killed by Phoenix police). (Phoenix, AZ, 2014.)

257 A downtown "die-in" during the Rumain Brisbon march. (Phoenix, AZ, 2014.)

258 "Meet & Greet" event at the Forty-Fifth Anniversary of the Black Panther Party at EastSide Cultural Center. The book, *The Black Panthers* (2006) by photographer Stephen Shames, is being held open by the photographer himself. (Oakland, CA, 2011.)

259 Co-founder Bobby Seale and Ruth "Mother" Jones (the oldest living member of the Black Panthers, at age 104) reuniting at the Forty-Fifth Anniversary of the Black Panther Party celebration at the Black Repertory Theater. (Berkeley, CA, 2011.)

260 Tommie Smith, the 200-meter Gold Medalist, autographing a restaged Civil Rights poster of the 1968 Olympics awards podium featuring his historic "Black Power" gloved salute, at an event held during the Fifty-Fifth Commemoration of the Little Rock Nine. (Little Rock, AR, 2012.)

261 A man walking past the weather-aged and tagged African-American heroic historical figures featured in "The African Amalgamation of Ubiquity," a mural by Curtis Lewis. (Detroit, MI, 2014.)

262 A Black Educators for Justice rally being infiltrated by a Confederate flag bearer, on the South Carolina State Capitol grounds. (Columbia, SC, 2015.)

263 In support of the Confederate flag, is a counter-protester who repeatedly circled around the block in his political poster covered truck in front of protesters at the South Carolina State Capitol. (Columbia, SC, 2015.)

265 Police detaining protesters for questioning at the Anti-Islam Rally in front of the Islamic Cultural Center. (Phoenix, AZ, 2015.)

266 A group exiting the Ku Klux Klan rally (note the confrontation in the background) the week after the Confederate battle flag was removed from South Carolina State Capitol. (Columbia, SC, 2015.)

267 A Second Amendment supporter carrying a "He Who Owns the Youth Gains the Future" Nazi banner (paraphrasing Hitler's "He alone, who owns the youth, gains the future!"), counter-protesting the March for Our Lives at the Arizona State Capitol. (Phoenix, AZ, 2018.)

268 Comparing Confederate flags, outside the South Carolina State Capitol. The one on the left depicts the Confederate battle flag in the Pan-African or Black Liberation colors of red, black, and green. (Columbia, SC, 2015.)

269 Dignitaries greeting each other at the close of the opening ceremony of the 150th anniversary celebration of Juneteenth on the grounds of Ashton Villa. (Galveston, TX, 2015.)

270 The scene moments after "Film the Police" was chalked on the street outside of the delegate-and-media entrance gate on the first day of the Republican National Convention. (Cleveland, OH, 2016.)

271 Protest officials linking hands at the end of the "Stop Trump and March on the Republican National Committee" and are closely followed by tactical bike police squads. (Cleveland, OH, 2016.)

273 Protesters at the South Carolina Capitol the day before the removal of the Confederate battle flag from the State House grounds. (Columbia, SC, 2015.)

274 In a ceremony covered worldwide, Governor Nikki Haley (later the United States Ambassador to the United Nations) signs the bill to remove the Confederate battle flag from the South Carolina Capitol grounds, following the massacre of nine women parishioners the previous month at Emanuel AME Church in Charleston. The flag was retired the next day with thousands in attendance, including dignitaries and family members of the victims. (Columbia, SC, 2015.)

275 Following the signing ceremony of the bill to remove the Confederate battle flag from the South Carolina State Capitol grounds, South Carolina Secretary of State Mark Hammond holds the bill signed by Governor Haley before handing it to Wanda Williams-Bailey, the African-American granddaughter of the late segregationist, Senator Strom Thurman. (Columbia, SC, 2015.)

276 Veterans gather in front of the TCL Chinese Theatre (originally Grauman's Chinese Theatre) on Hollywood Boulevard, drawing attention to the fact that twenty-two American veterans take their lives every day. (Los Angeles, CA, 2018.)

277 A U.S. Air Force drill team after the Memorial Day Parade, with the Washington Monument in the background. (Washington, DC, 2017.)

278 Protesters carrying "I AINT VOTING UNTIL" signs and T-shirts during the "Stop Trump" rally and march on the streets outside of the Republican National Convention. (Cleveland, OH, 2016.)

279 A modified Uncle Sam tattoo at Turf Paradise Race-track on Camel Day. (Phoenix, AZ, 2016.)

281 A saxophone player on stilts playing to the crowd in the 231st Bristol Fourth of July Parade. (Bristol, RI, 2016.)

282 A "street circus" scene outside of the Republican National Convention, with a man holding a "Kick My Dog 4 Trump" sign and "walking his dog," while barking his carnival-style message for the crowd. (Cleveland, OH, 2016.)

283 Numerous organizations participating in the "Stop Trump" rally and march, leaving the downtown Public Square staging area across the street from the Tower City and continuing around the Republi-can National Convention secured area. (Cleveland, OH, 2016.)

285 A counter-protester wearing a "Make America Great Again" hat, posing in front of protesters at an anti-Trump rally in Times Square following the appointment of Brett Kavanaugh as an Associate Justice to the U.S. Supreme Court. (New York City, NY, 2018.)

286 Members of the Korean American Association of Rhode Island (KAARI) marching in the 231st Bristol Fourth of July Parade. (Bristol, RI, 2016.)

287 An indigenous rally on the Arizona Capitol grounds as part of the Women's March to the Polls event. (Phoenix, AZ, 2018.)

289 A dancer performing in front of the giant inflatable figures of President Donald Trump (then the GOP presidential candidate, in a KKK robe) and Mar-icopa County Sheriff Joe Arpaio (now former sher-iff, in a prison uniform) at the immigration-rights protest across the street from the Trump rally at the Phoenix Convention Center. (Phoenix, AZ, 2016.)

290 Reverend Jesse Jackson posing with admirers in the South Carolina Capitol following the bill-signing ceremony to retire the Confederate battle flag from the State Capitol grounds. (Columbia, SC, 2015.)

291 A patriotic-themed car in the Veterans Day Parade, featuring several prominent members of President George W. Bush's cabinet on the right-front fender. (Phoenix, AZ, 2018.)

293 President Barack Obama (then a United States Senator from Illinois) surrounded by "Change We Can Believe In" signs, while delivering a campaign speech at Arizona State University on Hayden Lawn, leading up to the 2008 presidential election. (Tempe, AZ, 2007.)

294 A President Abraham Lincoln reenactor at the HB Civil War Days reenactment in Central Park. (Hun-tington Beach, CA, 2018.)

295 A Trump supporter wearing a look-alike mask engaging in a heated debate while the crowd gath-ers for a Trump Presidential Rally. (Fountain Hills, AZ, 2016.)

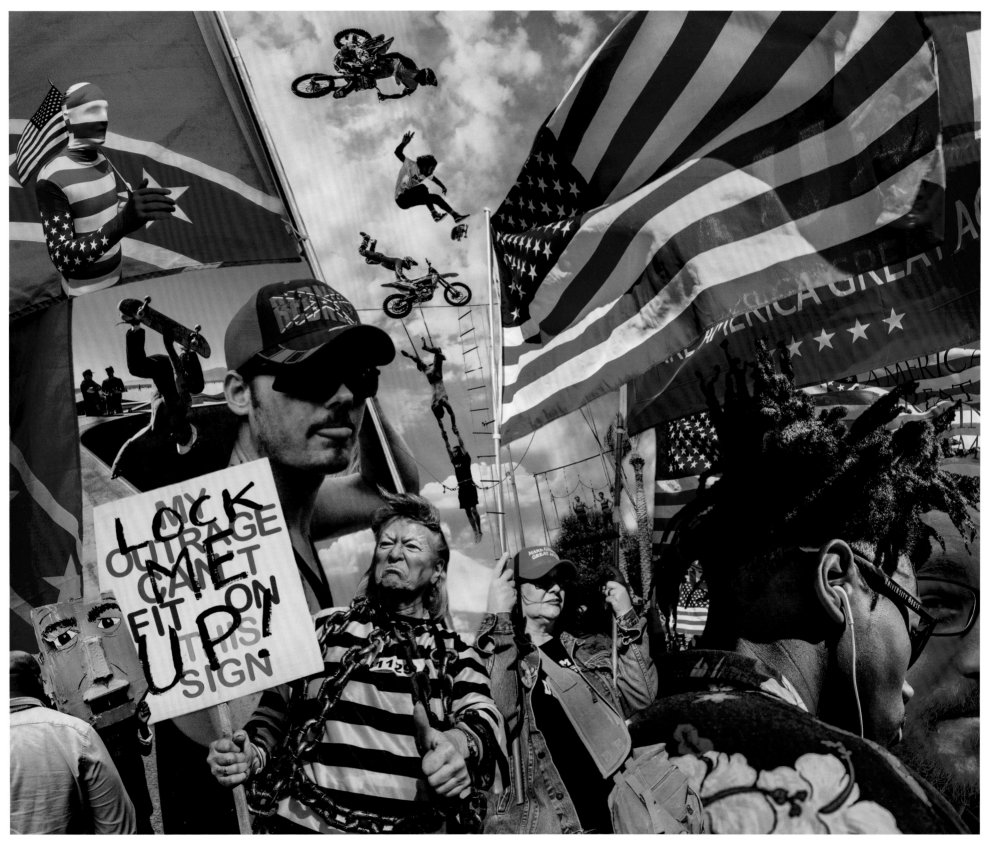

About the Essayist and the Curator

Bill Kouwenhoven (b. 1961), an independent curator and photography critic, is the author of introductory essays to more than fifty artist's monographs as well as contributing to magazines such as *Afterimage*, *Aperture*, *British Journal of Photography*, *European Photography*, *FOAM*, *Photonews*, and *Prefix*, among others. From 1996 to 2001, he was the editor of the San Francisco-based *Photo Metro*; from 2008 to 2014, he was International Editor of *Hotshoe Magazine* of London, England. In 1998, he curated *Rattling the Frame*, the 25th Anniversary show of San Francisco Camerawork. In 2012, he co-curated with Gergely Laszlo the Fotofestiwal in Lodz, Poland. He resides in Baltimore and Berlin.

Rebecca A. Senf (b. 1972) is the Chief Curator of Photography at the Center for Creative Photography at the University of Arizona in Tucson. She received her B.A. in art history from the University of Arizona, and her M.A. and Ph.D. in art history were awarded by Boston University. She is the author of *Reconstructing the View: The Grand Canyon Photographs of Mark Klett and Byron Wolfe* (University of California Press, 2017), *Betsy Schneider: To Be Thirteen* (Radius Press and Phoenix Art Museum, 2017), and *Making a Photographer: The Early Work of Ansel Adams* (Center for Creative Photography and Yale University Press, 2020).

About the Author

Stephen Marc* (b. 1954) is a documentary/street photographer and digital montage artist who was raised on the South Side of Chicago. He is Professor of Art at Arizona State University, where he began teaching in 1998, after twenty years on the faculty of the Department of Photography at Columbia College Chicago. He received his B.A. in practical art from Pomona College in Claremont, California, and his M.F.A. in photography from the Tyler School of Art, Temple University in Philadelphia. Marc is the author of three other photography books: *Urban Notions* (Ataraxia Press, 1983); *The Black Trans-Atlantic Experience: Street Life and Culture in Ghana, Jamaica, England, and the United States* (The Department of Photography at Columbia College Chicago and distributed by University of Illinois Press, 1992); and *Passage on the Underground Railroad* (Stephen Marc in conjunction with the University Press of Mississippi, 2009). Since 2008, *Passage on the Underground Railroad* has been listed as an Interpretative Program of the National Underground Railroad Network to Freedom, a division of the National Park Service, and from 2001–2010 he was an Olympus Visionary in the professional photographers' group sponsored by Olympus, America, Inc. Marc has received numerous awards, including the Society for Photographic Education's Insight Award (2015); the Faculty Achievement Award for Best Art Work or Performance from Arizona State University (2013); an Artist Project Grant from the Arizona Commission on the Arts and National Endowment for the Arts (2011); the 1858 Prize for Contemporary Southern Art from the Gibbes Museum of Art in Charleston, SC (2009); the Betty and Jim Kasson Award from the Center for Photographic Art in Carmel, California (2003); grants from the Illinois Arts Council (1998, 1991, and 1988); an Aaron Siskind Foundation Fellowship (1996); a Visual Arts Fellowship in Photography from Arts Midwest (Regional NEA, 1991); an Artist Fellowship in Photography and an Eli Weingart Chicago Grant, a one-time award for a Chicago photographer through the Friends of Photography in Carmel, California; and Automated Concepts, Inc., Chicago, IL (1983).

*Stephen Marc is the professional name he has used since 1979 (legally Stephen Marc Smith). This change was made after entering a national juried photography competition, where he was one of three Stephen Smiths who were accepted.

About the Book

American/True Colors was brought to publication in an edition of 1,500 hardcover copies. The text was set in Palatino, the paper is Topkote Dull, 100 pound weight, and the book was professionally printed by O'Neil Printing and bound by Roswell Bookbinding in Phoenix, Arizona.

Publisher: George F. Thompson
Editorial and Research Assistant: Mikki Soroczak
Manuscript Editor: Purna Makaram
Book Design and Production: David Skolkin

Published in 2020. First hardcover edition.
Printed in the U.S.A. on acid-free paper.

George F. Thompson Publishing, L.L.C.
217 Oak Ridge Circle
Staunton, VA 24401–3511, U.S.A.
www.gftbooks.com

28 27 26 25 24 23 22 21 20 1 2 3 4 5

Library of Congress Control Number is 2020943769.

ISBN: 978–1–938086–78–6